A CELEBRATION OF
SCOTLAND

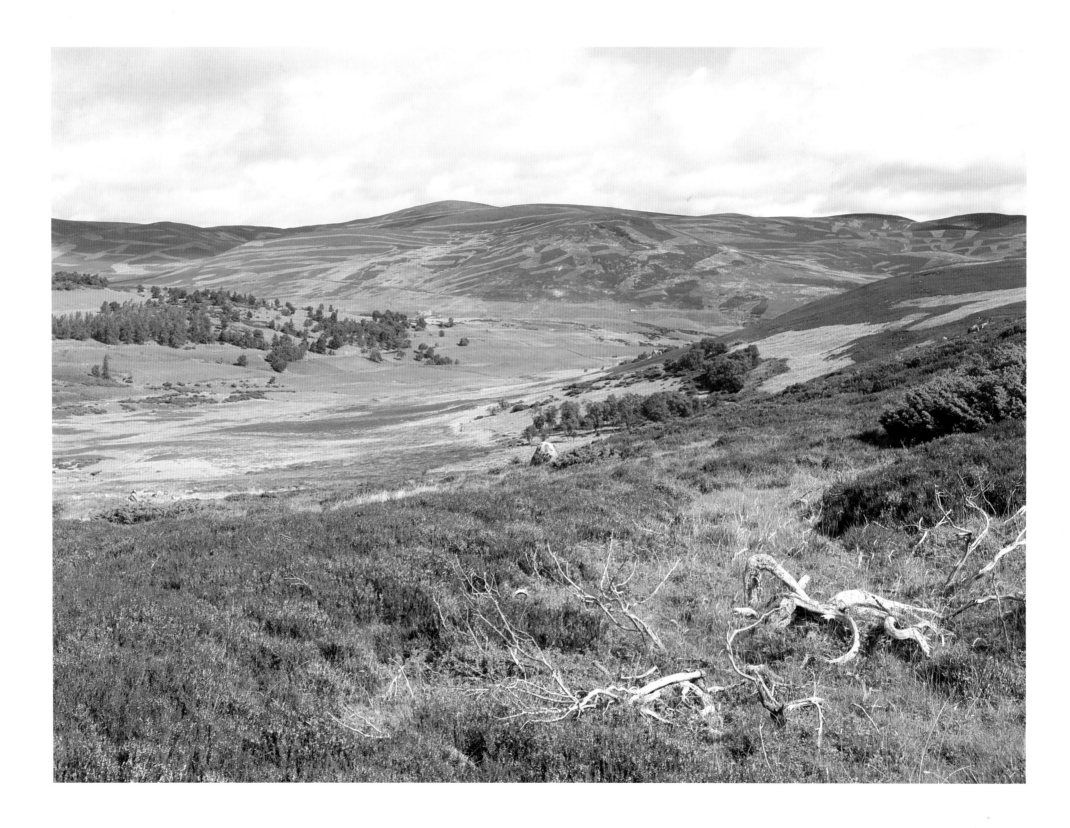

A CELEBRATION OF
SCOTLAND

Janice Anderson

Photography by David Lyons

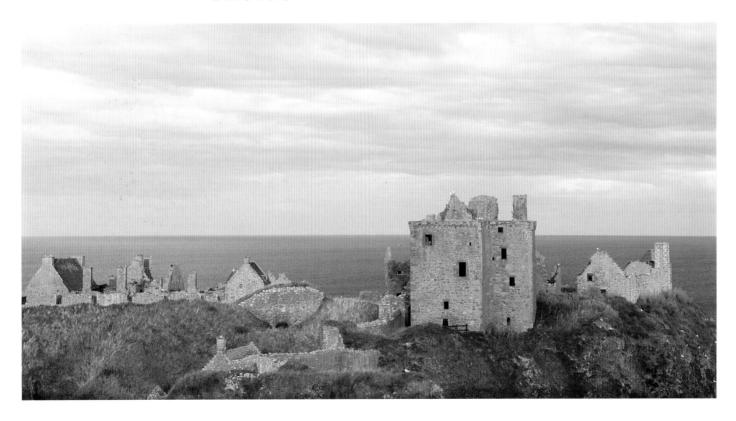

CHARTWELL
BOOKS, INC.

Published in 2008 by
CHARTWELL BOOKS, INC.
A division of BOOK SALES, INC.
114 Northfield Avenue
Edison, New Jersey 08837
USA

**Copyright © 2008 Regency
House Publishing Limited**
Niall House
24–26 Boulton Road
Stevenage, Hertfordshire
SG1 4QX, UK

For all editorial enquiries please contact
Regency House Publishing at
www.regencyhousepublishing.com

ISBN-13: 978-0-7858-2203-5
ISBN-10: 0-7858-2203-8

Printed in China

All photographs supplied by
DAVID LYONS
apart from the one on page 123, which is
supplied courtesy of Art Directors &
Trip/John Davidson.

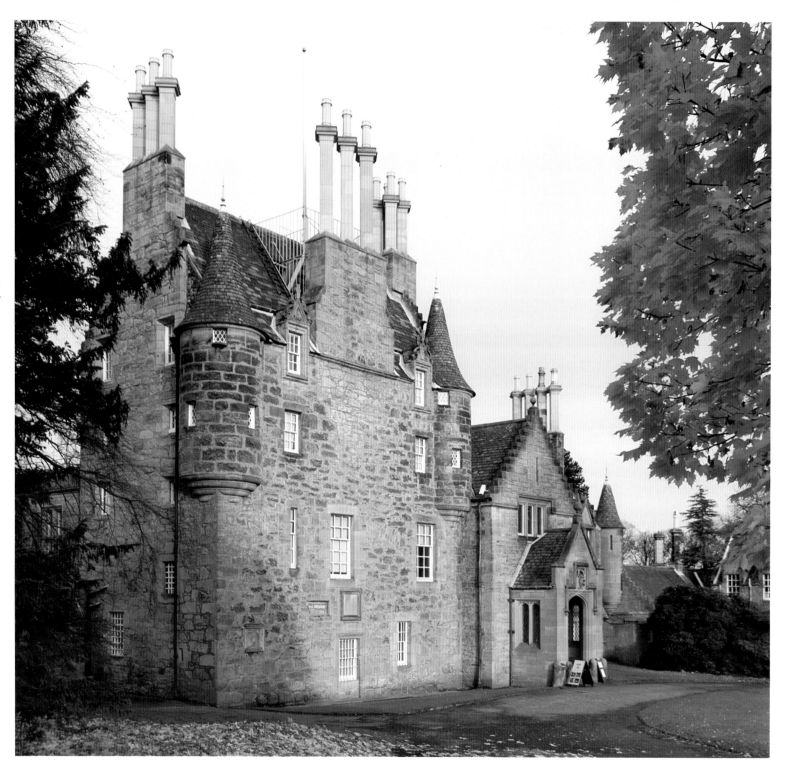

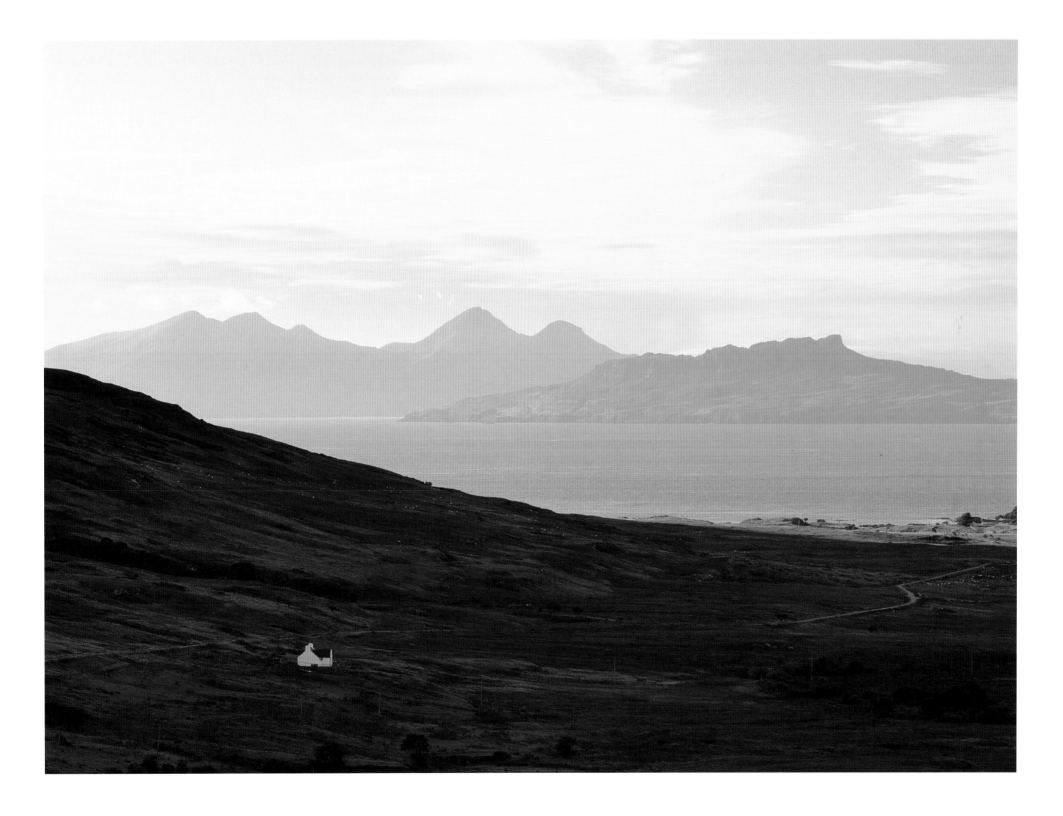

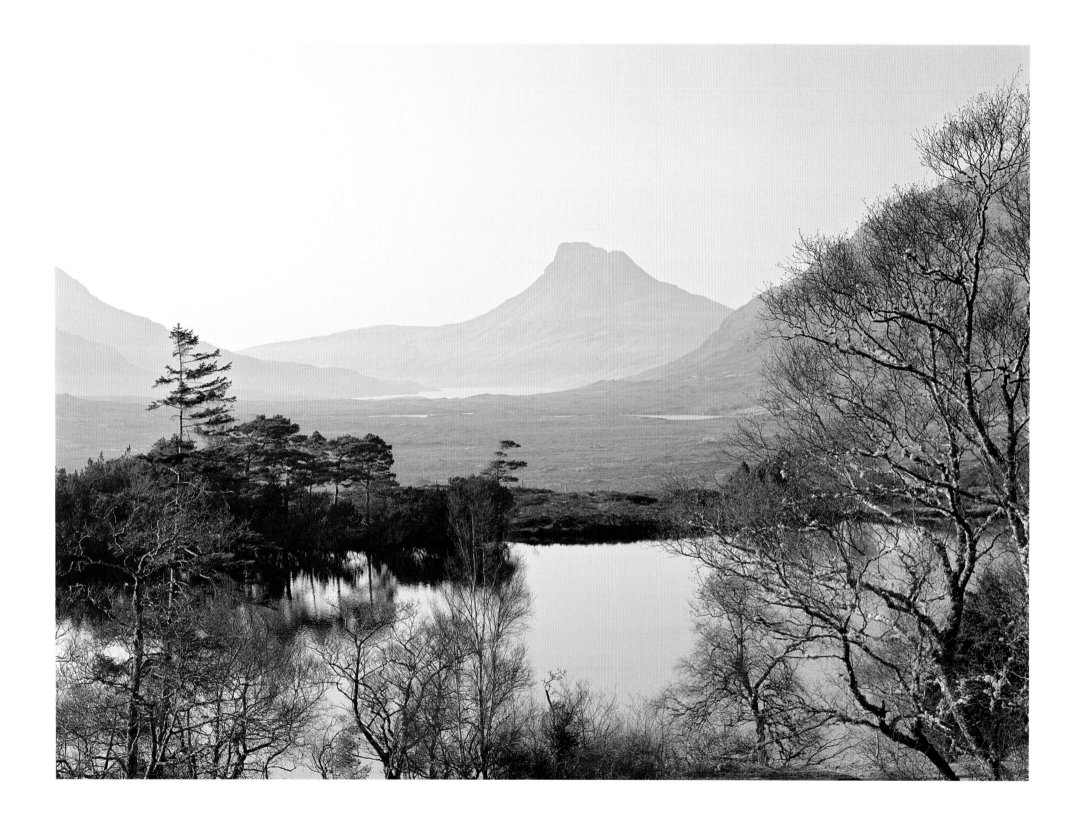

CONTENTS

INTRODUCTION

Scotland is a very bonnie country indeed, and there are any number of picture books, guidebooks and glossy calendars that tell us so. But there is much more to Scotland than the tourist offices would have us believe, and the intention is to describe the country as it actually is, in all its infinite and glorious variety.

Visitors from all over the world are attracted to every part of Scotland, from the green, wooded valleys of the Border country to the wild mountains and peat bog of Sutherland, whose Cape Wrath marks the north-western extremity of the British Isles, and from the pretty fishing and holiday villages along the Solway Firth to the quiet hamlets of Orkney and Shetland.

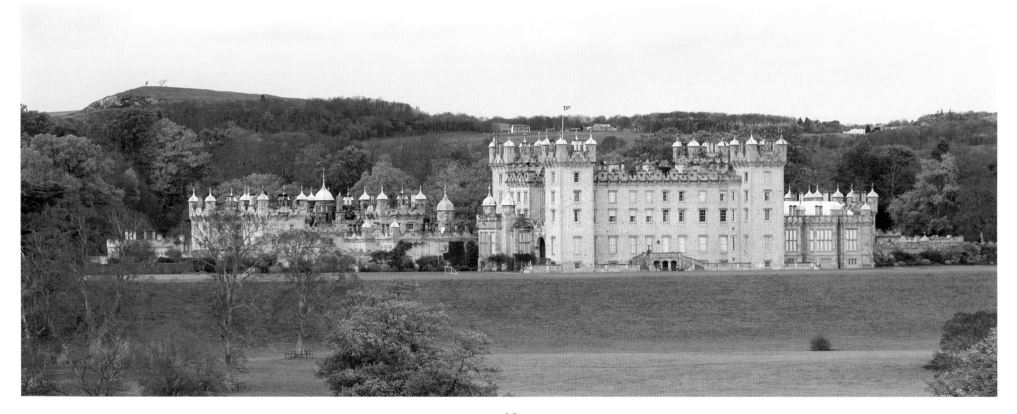

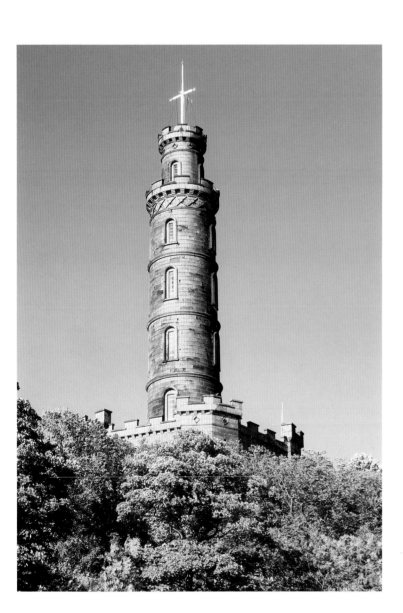

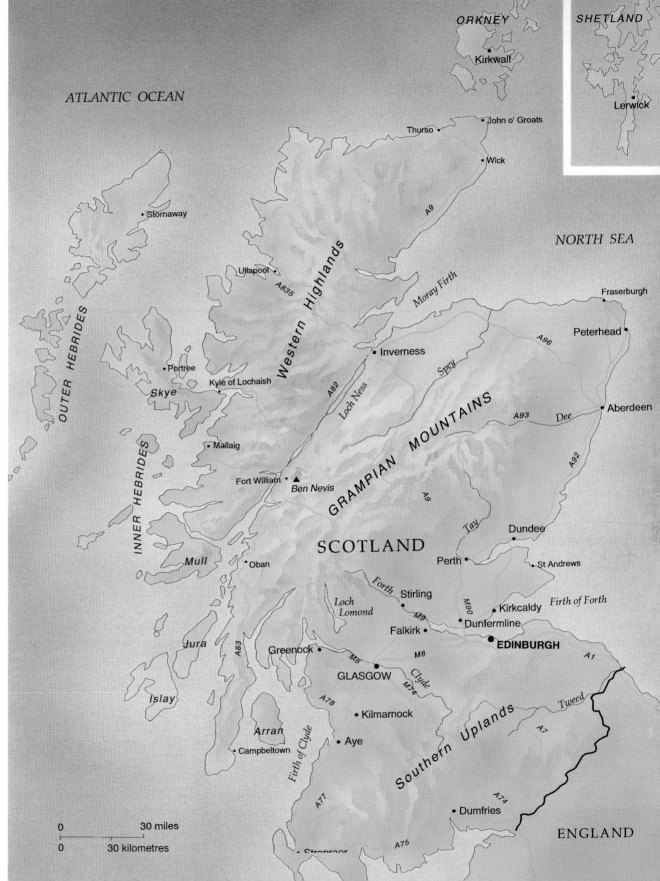

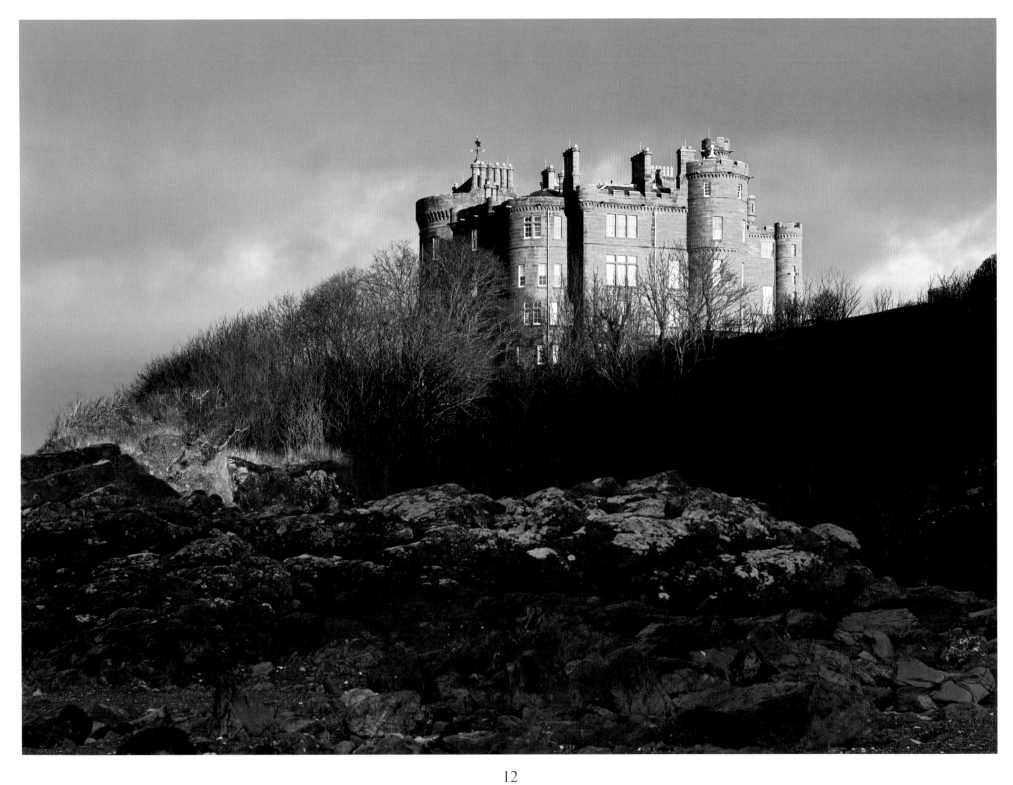

OPPOSITE: Culzean Castle, lying to the west of Ayr and now in the care of the National Trust for Scotland, was the home of the influential Kennedy clan, one of Scotland's oldest families, that can trace its ancestry back to Robert the Bruce. The medieval tower house, originally built as a fortress to protect its inhabitants from marauders, was eventually transformed, over the years, into one of the grandest country houses in Ayrshire.

LEFT: The ivy-covered remains of Dunollie Castle, built in the seventh century as the stronghold of the MacDougall clan, which at one time owned a third of Scotland, dominates a high, rocky promontary between Oban Bay and the mouth of Loch Etive, Argyll.

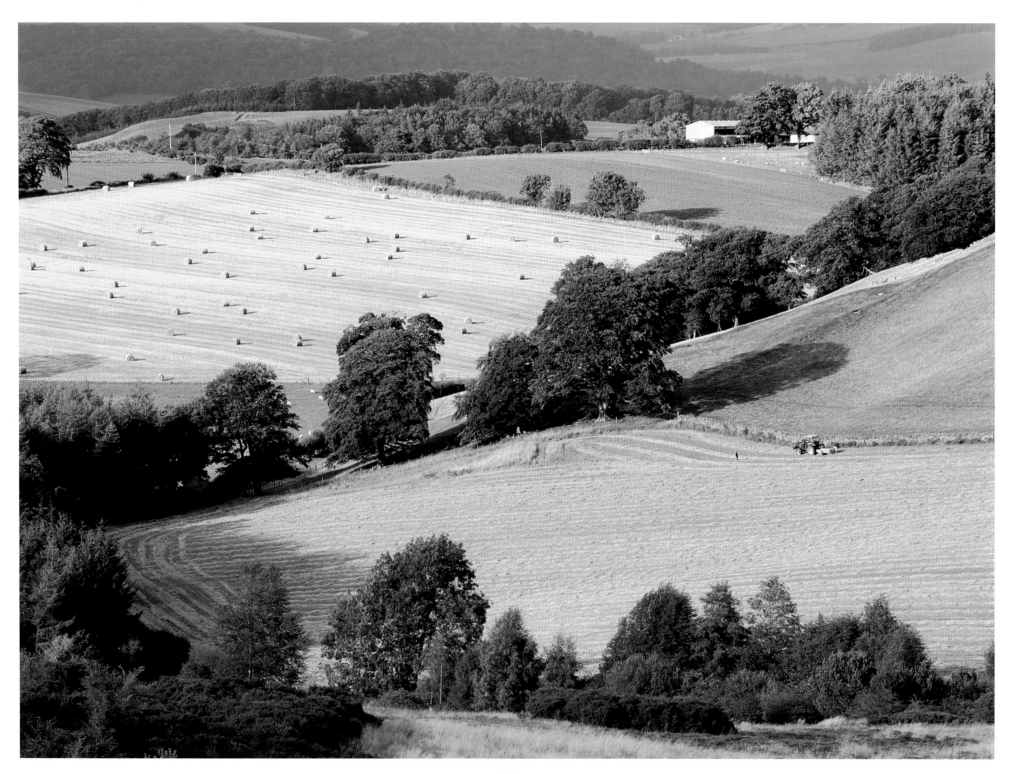

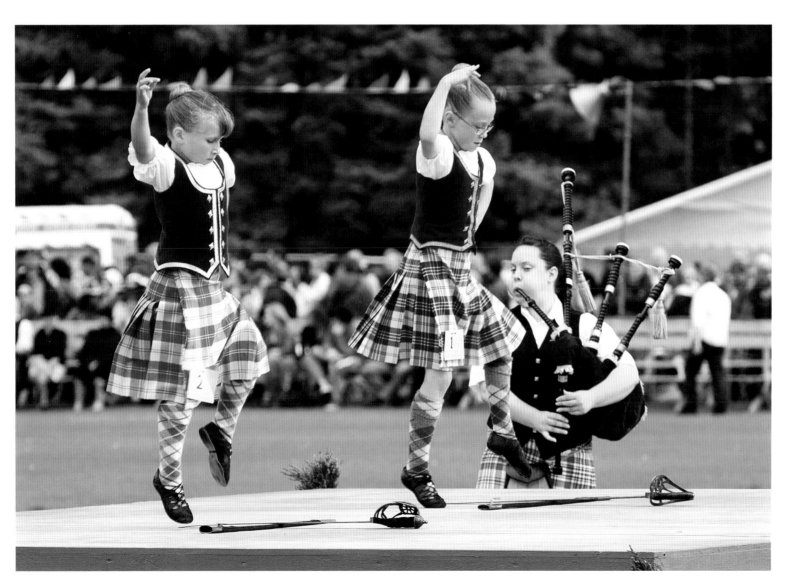

OPPOSITE: Farmland lying to the north-west of Selkirk, a town and former royal burgh located in the Scottish Borders, that lies on the River Ettrick, a tributary of the River Tweed.

LEFT: The Lonach Highland Games, founded by Sir Charles Forbes and described as Scotland's friendliest, have been taking place every fourth Saturday in August since 1823, at Bellabeg Park in Strathdon, Aberdeenshire.

INTRODUCTION

RIGHT: An example of some of Loch Fyne's excellent seafood, that also includes world-famous oysters. Situated on the west coast of Argyll and Bute, Loch Fyne extends 40 miles (65km) inland from the Sound of Bute, making it the longest of Scotland's sea lochs.

OPPOSITE: The town of Oban, in Argyll, is known as the Gateway to the Isles, being the embarkation point for car ferries to Mull, Coll, Tiree, Barra, South Uist, Colonsay, Lismore and Islay. From these islands it is possible to travel further afield to Iona, Staffa and to many of the smaller, less well- known islands.

PAGE 18: Homesteads on the eastern shore of Berneray, an island of the Outer Hebrides.

PAGE 19: The sun sets in mid-winter behind the prehistoric standing stones of Callanish on the Isle of Lewis.

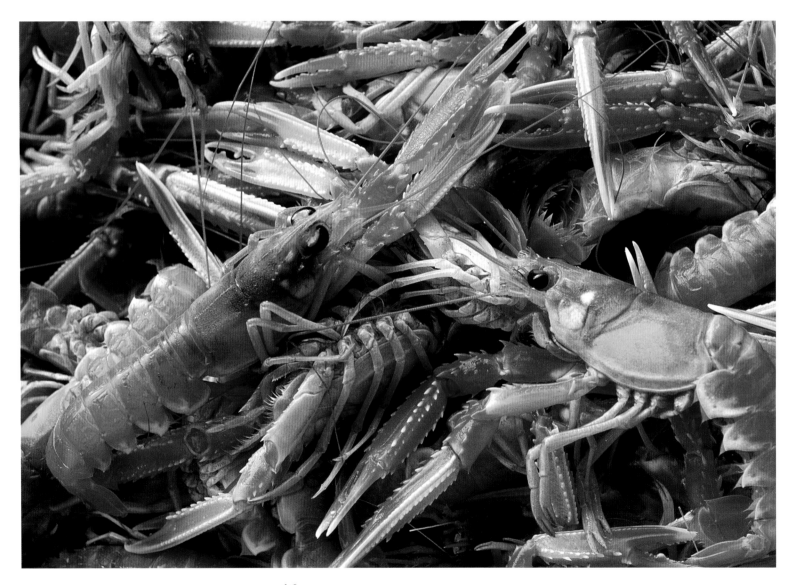

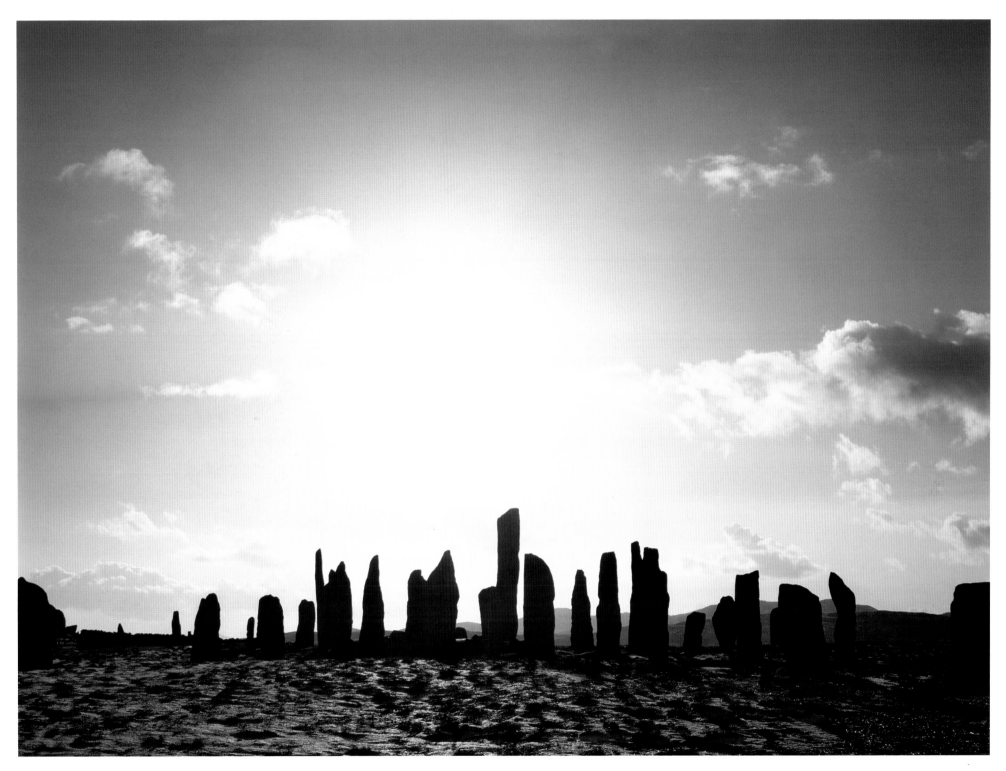

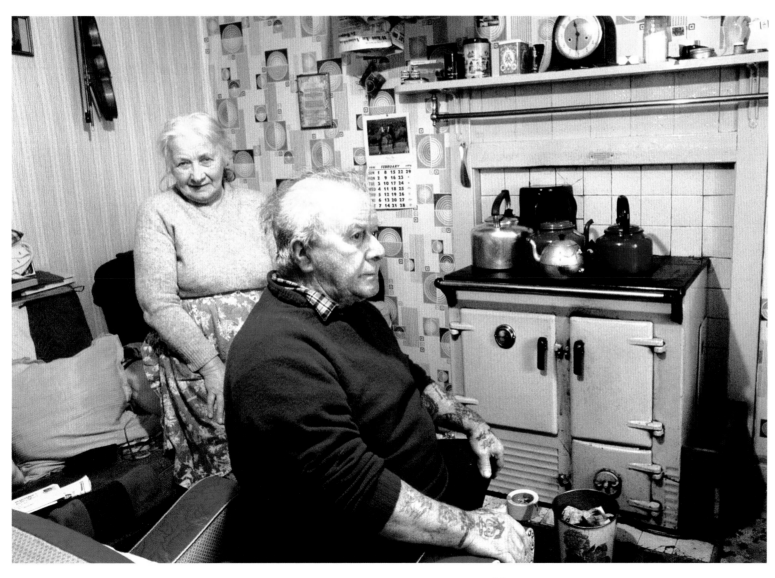

OPPOSITE: *An interior detail of Iona Abbey in the Inner Hebrides. The island of Iona has long been connected with St. Columba, who founded a monastery here in 563. The new Benedictine abbey was built here in 1204.*

LEFT: *The way things were. Elderly crofters, photographed in 1978 at their home on the shores of Dales Voe, a spectacular sea loch located on the east coast of Mainland, Shetland.*

Celebrating a country which, though no longer an independent state is still very much a nation, with its independent legal, educational, local government and church systems, this is a summary of what it means to be a Scot. Of course, we can't hope to better Scotland's first great public relations man, Sir Walter Scott, so perhaps he should have the last word on the matter. This is how he summed Scotland up in 'The Lay of the Last Minstrel' in 1805:

> *O Caledonia! stern and wild*
> *Meet nurse for a poetic child!*
> *Land of brown heath and shaggy wood,*
> *Land of the mountain and the flood,*
> *Land of my sires! what mortal hand*
> *Can e'er untie the filial band*
> *That knits me to thy rugged strand?*

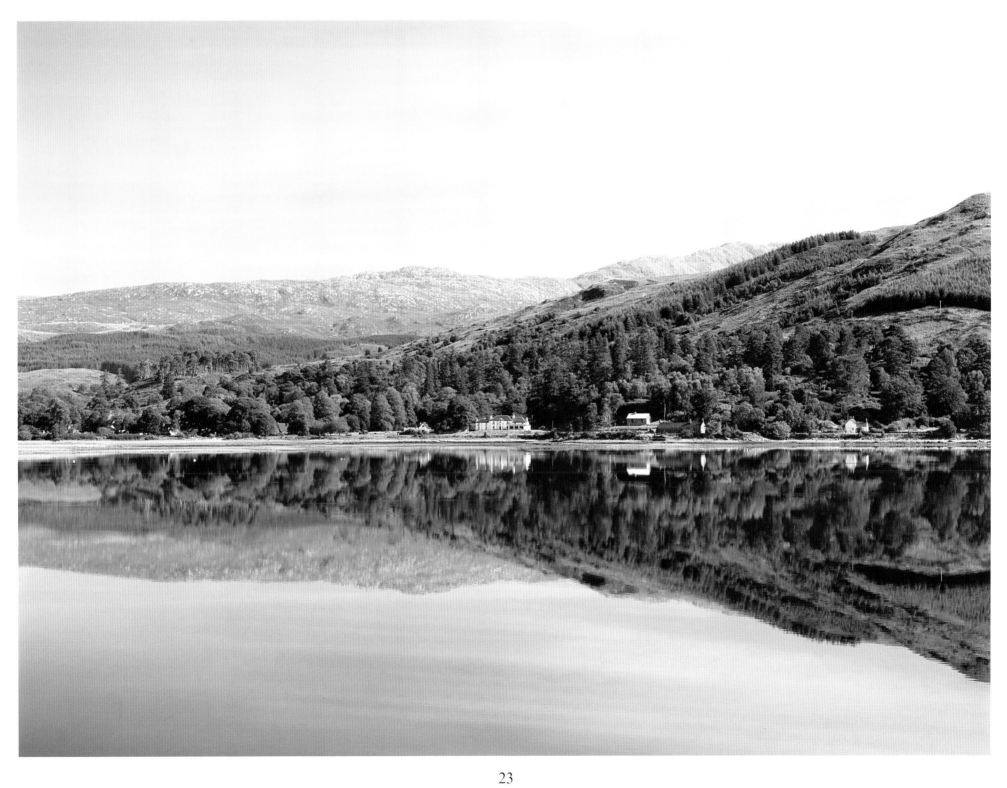

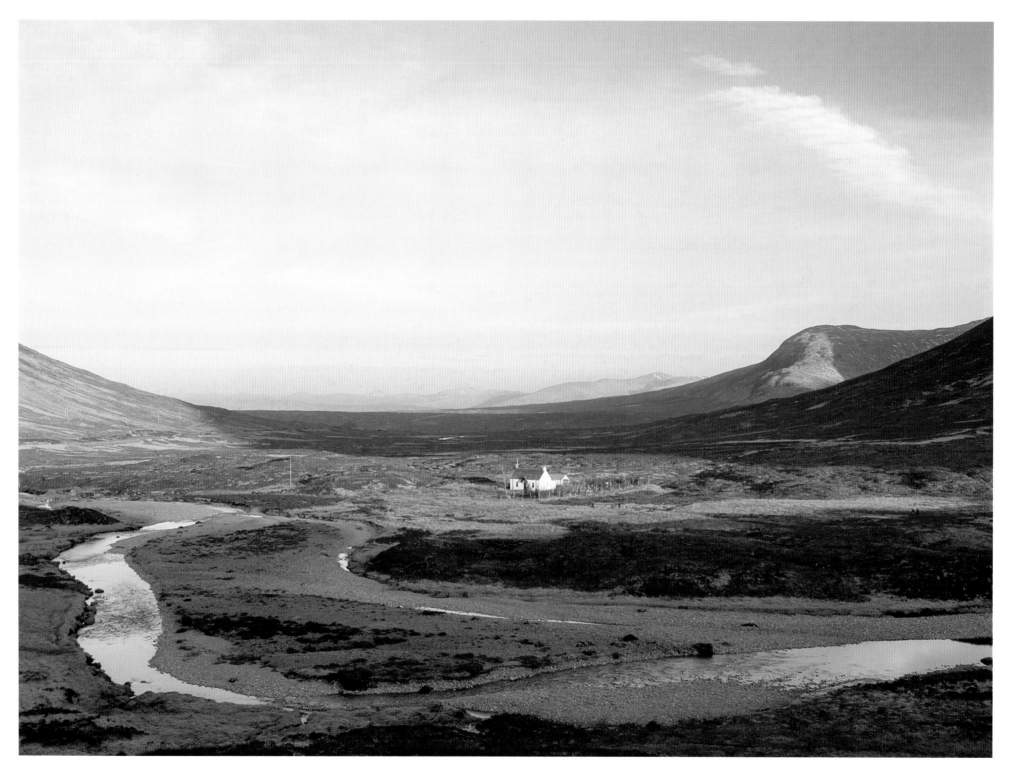

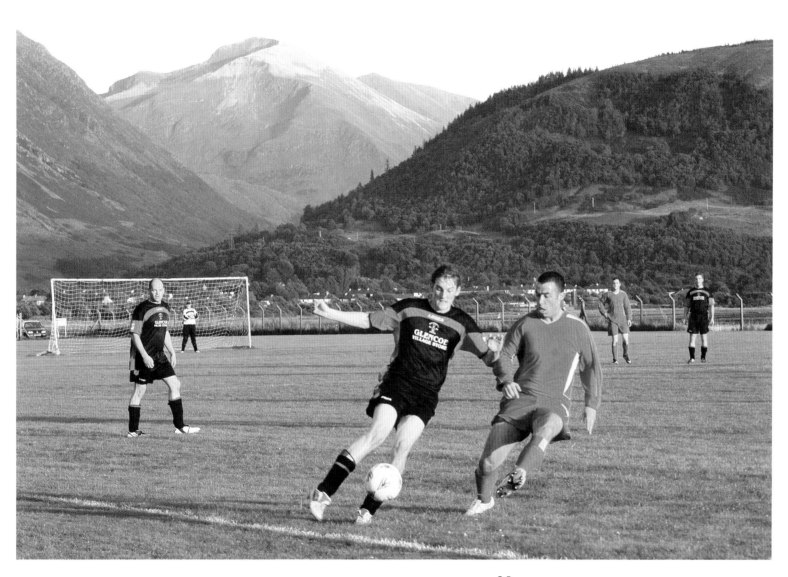

OPPOSITE: Blackrock Cottage, below Buchaille Etive Mor, at the top end of Glen Coe, that stretches from Glencoe village and Loch Leven to Rannoch Moor. On visiting the glen in 1841, Charles Dickens remarked that 'it resembled a burial ground of a race of giants'.

LEFT: Local football teams, Ballachulish and Buckfast, slog it out on the pitch at Fort William, below the entrance to Glen Nevis.

PAGE 26: A fishing boat leaving Mallaig harbour. Mallaig lies at the end of the evocatively named 'Road to the Isles'. It is also where the West Highland Railway from Fort William ends and where a network of services ferry visitors to Skye, the Knoydart peninsula, and beyond.

PAGE 27: Looking north over Lochan na h-Achlaise, in the Black Mount area, towards the western end of Rannoch Moor.

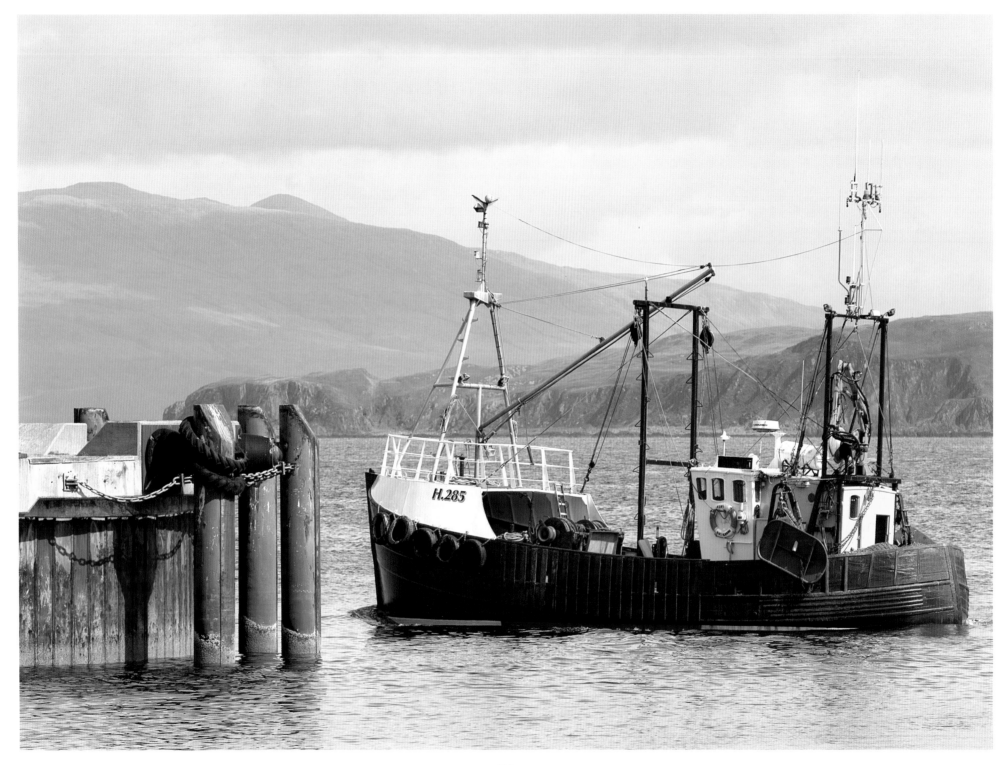

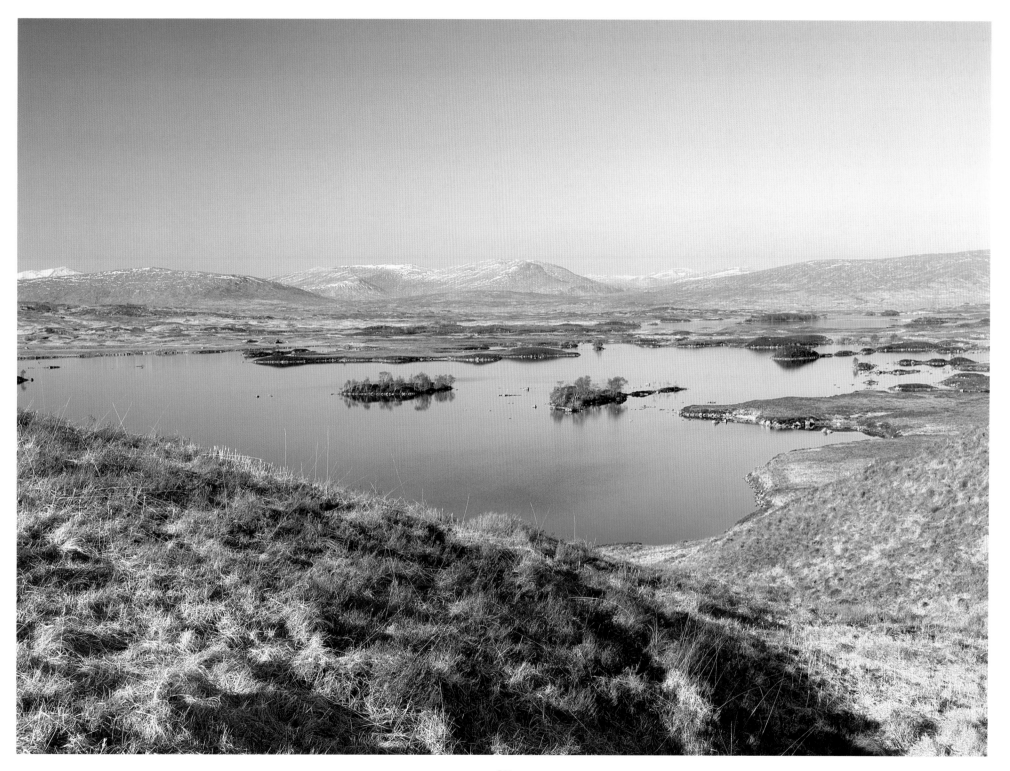

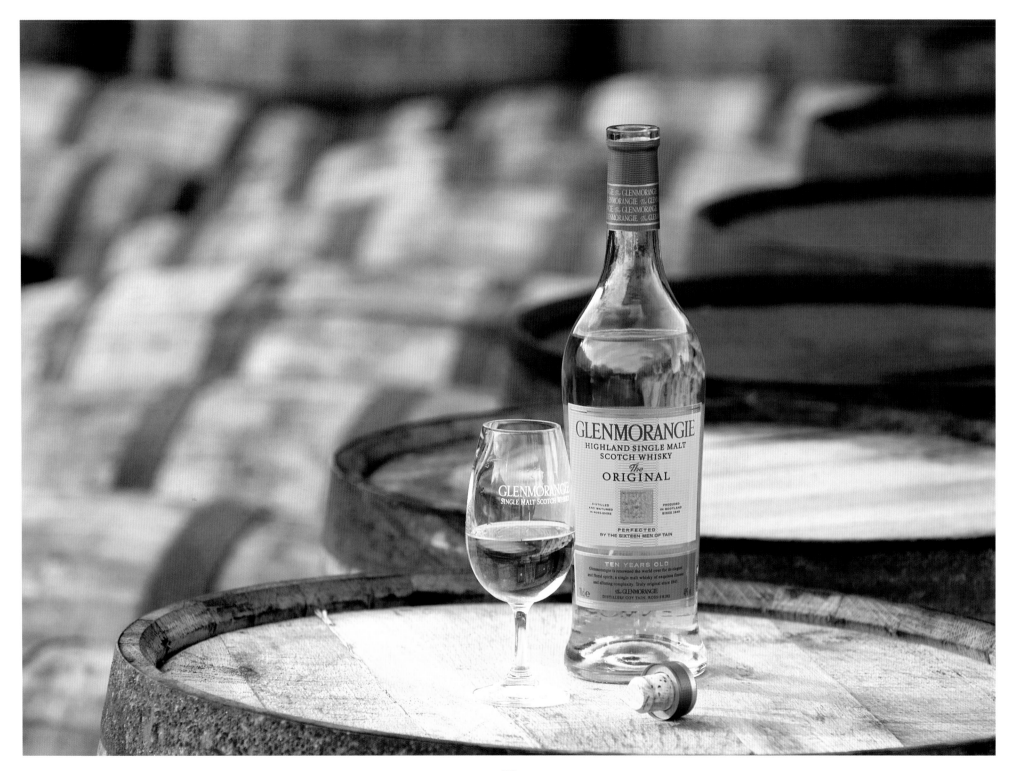

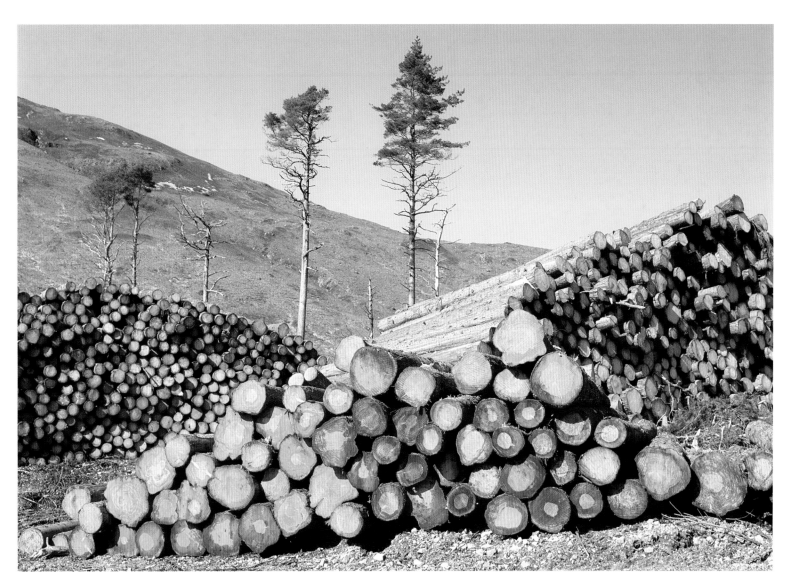

OPPOSITE: The famous Glenmorangie single malt whisky is distilled at Tain, Easter Ross, a former royal burgh in Ross and Cromarty in the Highlands of Scotland.

LEFT: Logging for softwood conifers at Glen Carron, north-east of the Kyle of Lochalsh in north-western Scotland.

PAGE 30: Lying at the heart of Neolithic Orkney's World Heritage Site is the Ring of Brodgar, a prehistoric monument located on a west-facing plateau on the Ness of Brodgar, a thin strip of land separating the Harray and Stenness lochs.

PAGE 31: The famous coloured houses of Tobermory, the Isle of Mull's largest town. It is the setting of the popular children's TV series, Balamory, produced by the BBC.

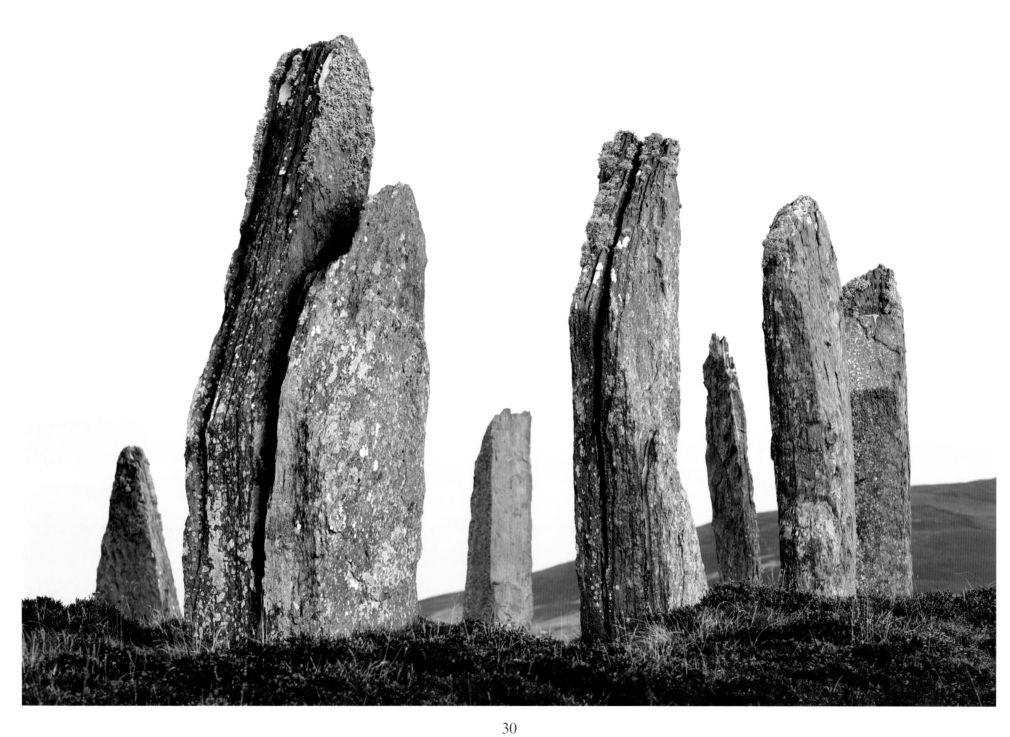

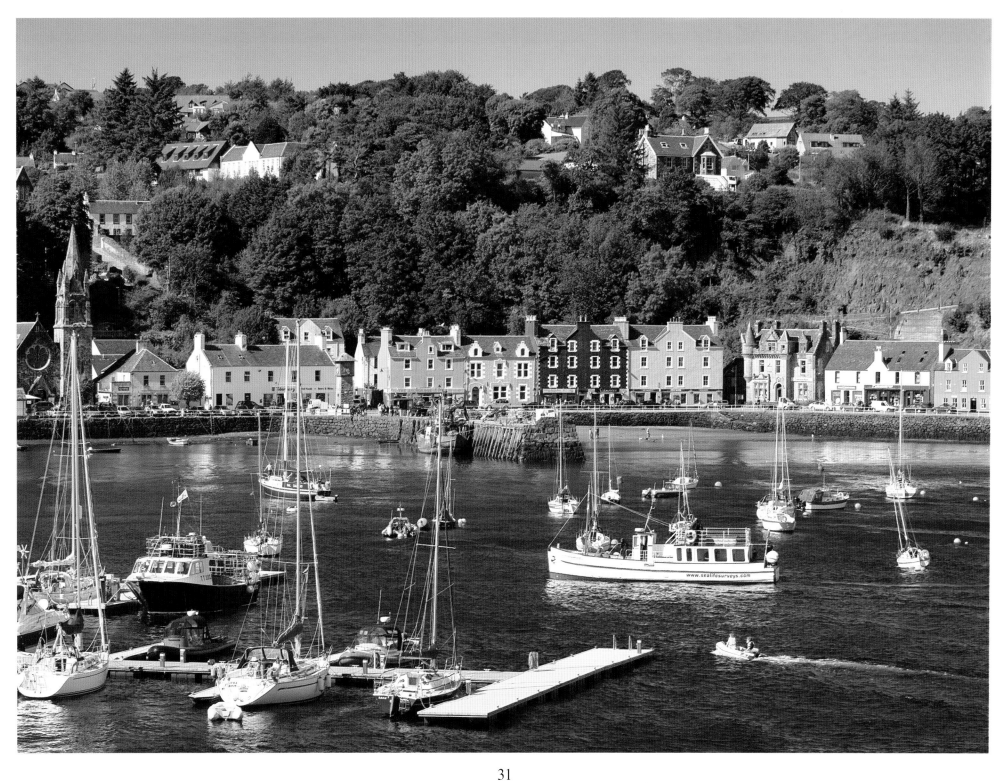

RIGHT: Men of the Lonach Highlanders in the field at the Lonach Highland Games, Strathdon, Aberdeenshire.

FAR RIGHT: A thistle in a lapel. A national flower of Scotland, the thistle, a prickly-leaved purple flower, was adopted in the 15th century as a symbol of defence. The Scottish bluebell is another of Scotland's emblemic flowers.
.

OPPOSITE: The view north-west over Scapa Flow, seen from St. Margaret's Hope, a village on South Ronaldsay, Orkney.

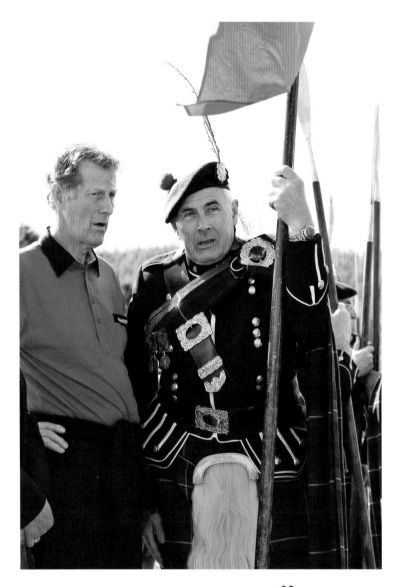

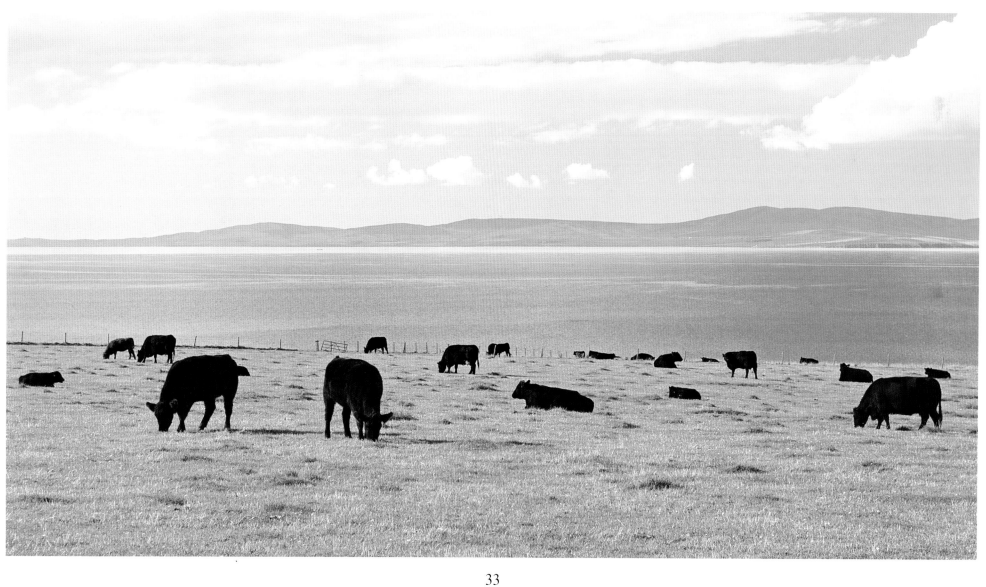

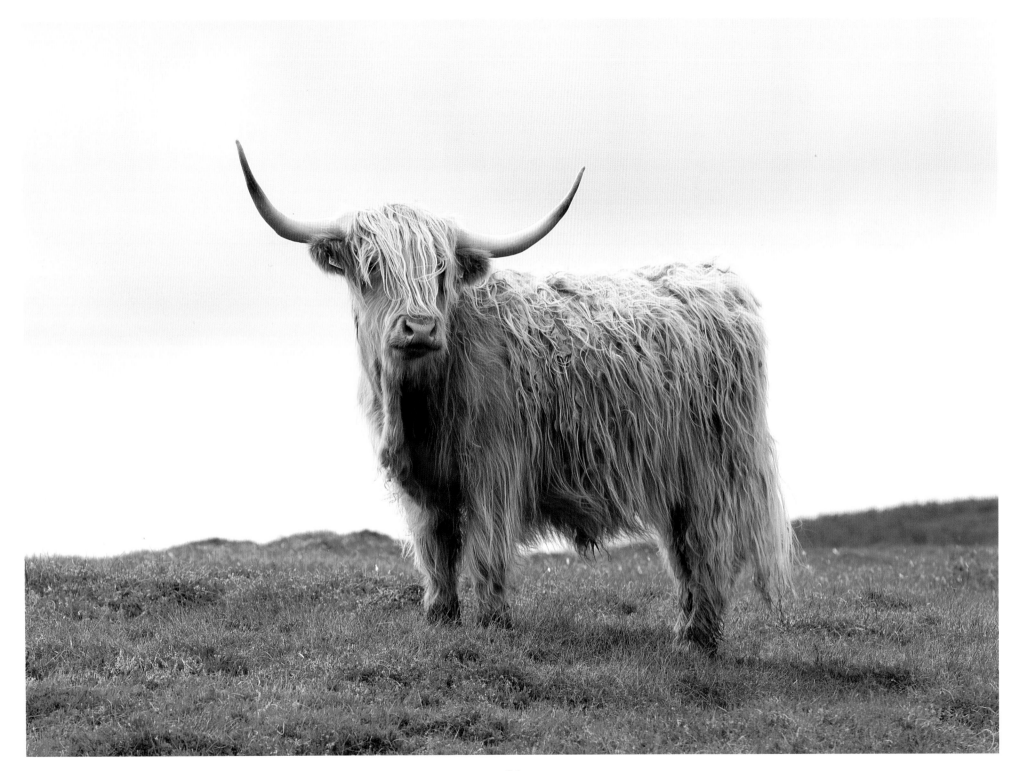

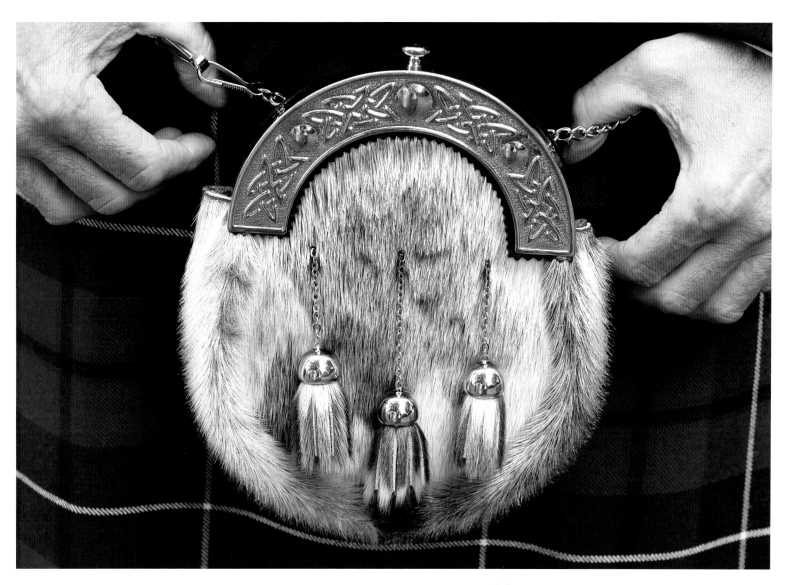

OPPOSITE: Known for its extreme hardiness, the Highland breed of cattle, with its long, thick, flowing coat and majestic sweeping horns, has a long and distinguished history, not only in its Scottish homeland but also in many other parts of the world to which it has been exported.

LEFT: Because the kilt was without pockets, the sporran was originally a practical item in which personal items could be carried. Made of leather or fur, usually with silver or other ornamentation, it is now an important decorative element of Highland dress.

PAGE 36: Ardnamurchan lighthouse, on the westernmost point of mainland Scotland.

PAGE 37: A view of Edinburgh's Old Town skyline, evocative of the days when ordinary people lived cheek by jowl with the highest in the land.

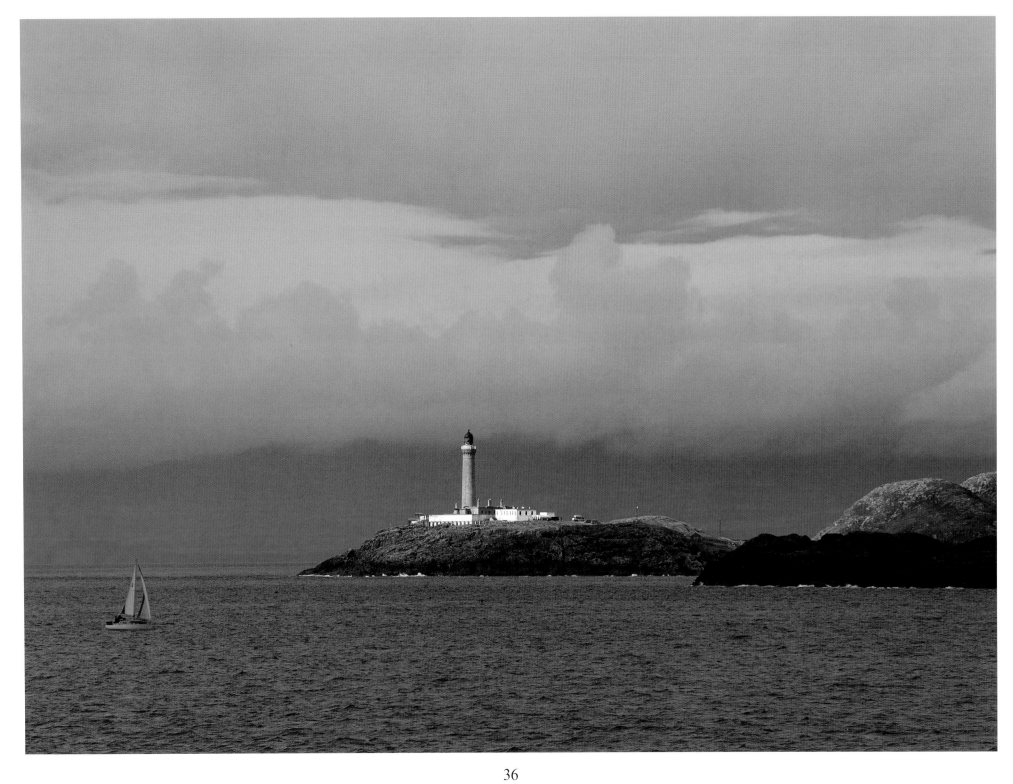

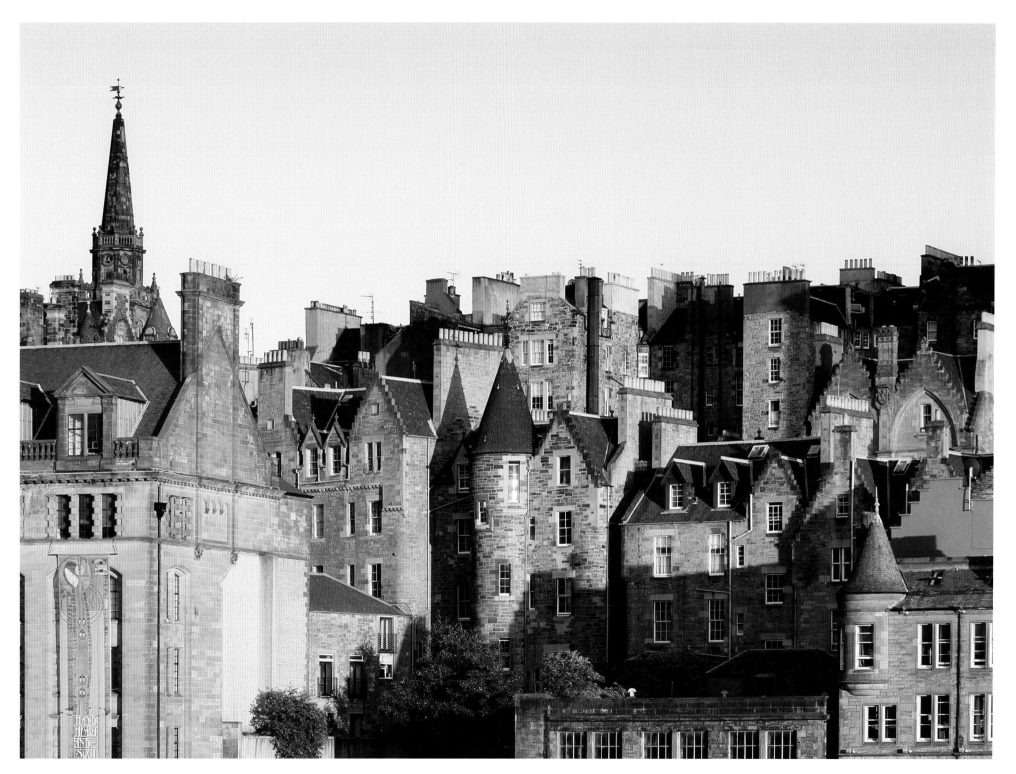

CHAPTER ONE
THE BORDERS

There are two things to establish about Scotland's Border country from the outset. First, despite the long centuries of fighting Norsemen, Englishmen, cattle-rustlers and each other, no traces of war have left their imprint on the land. This is serenely calm, rolling hill country and moorland, broken by the valleys of fine, tree-edged rivers where salmon leap and trout flick through the sparkling waters, and where many of the well-ordered farms have the aspect of parkland surrounding an elegant mansion. There are many of the latter, too, built around the old defensive peel towers once the need for strong defences had disappeared.

Second, you are definitely in Scotland here. This is not some sort of Anglo-Scotia, where people and culture from both sides of the border have merged into something which is not clearly either. There are no need of a sign saying 'Scotland' to tell people they have crossed the border, north of Berwick-upon-Tweed, or at Coldstream, Carter Bar or Gretna Green.

While the south-eastern corner of Dumfries & Galloway comes into this chapter, because the border has its western end here at Gretna on the Solway Firth, most of Scotland's Border country falls within the bounds of the modern local government region known as the Scottish Borders. The Borders region takes in four historic shires in the south-east of the country, Peeblesshire, Berwickshire, Selkirkshire and Roxburghshire, which also give their names to four towns, Peebles and Selkirk being good-sized thriving communities, while Roxburgh is an unremarkable village

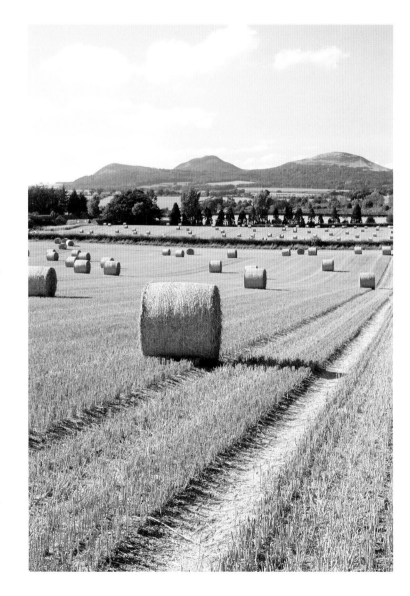

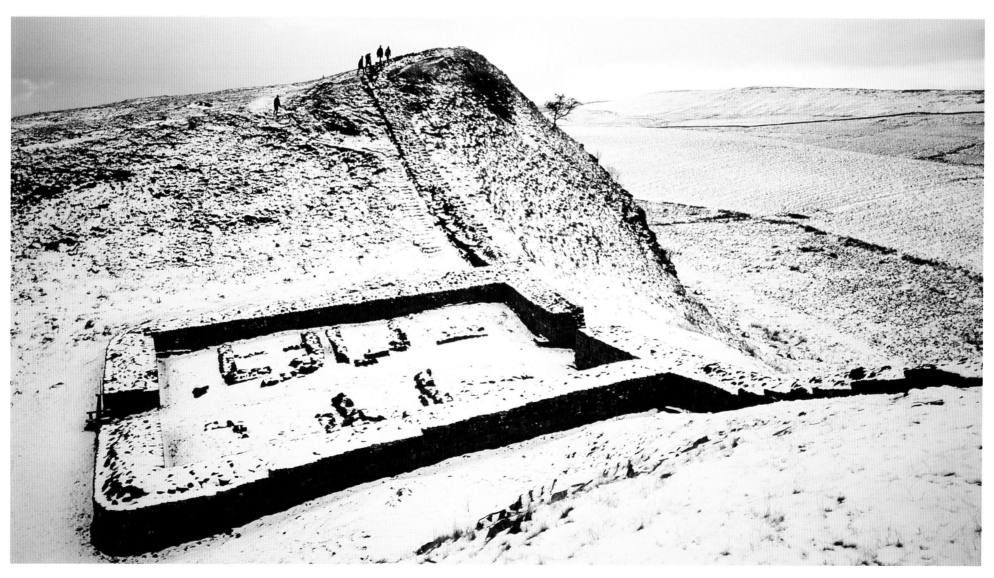

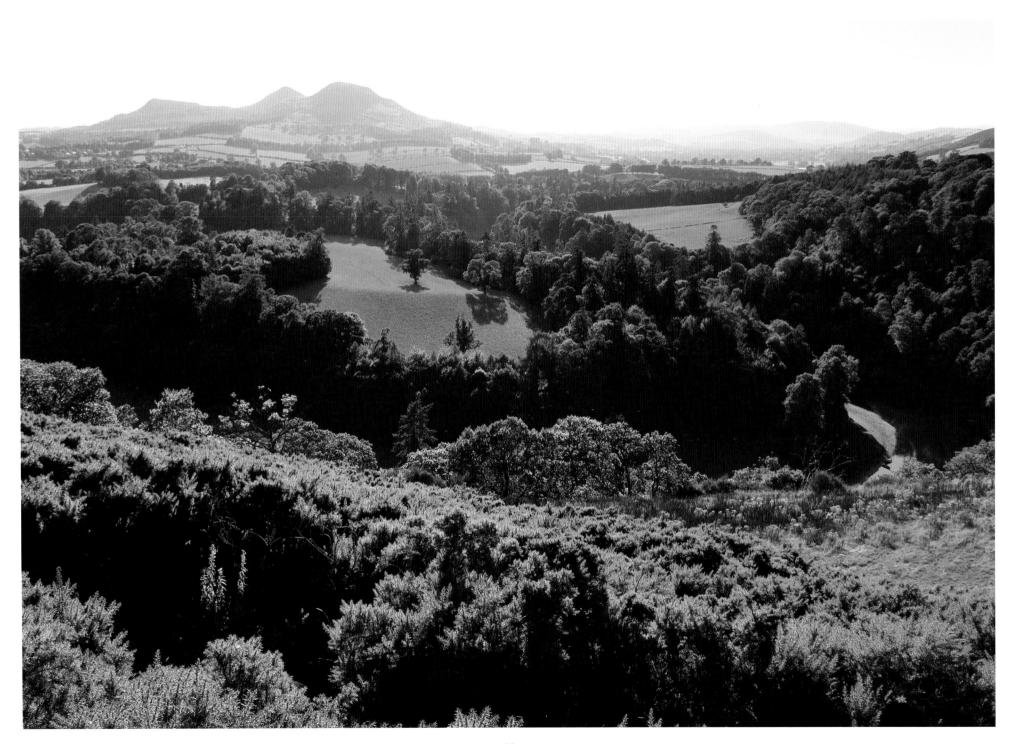

several miles from the site of the old town and once-mighty castle of Roxburgh, whose ruins stand on a mound between the Teviot and Tweed rivers west of Kelso; Berwick-upon-Tweed is no longer in Scotland, having ended up on the wrong side of the net after centuries of being a kind of shuttlecock in the Anglo-Scottish wars which once ravaged this quiet land.

For many centuries the Borderlands were a battleground fought over not only by the armies of Scotland and England but also by sheep-stealers and cattle-raiders, known as Borders reivers, and landowners seeking self-aggrandizement both north and south of the disputed border. The 'official' armies tended to cross to and fro nearer the eastern end of the border, which is why Berwick-upon-Tweed was one of the most heavily fortified towns in medieval Britain. Even so, the town changed hands 13 times between 1147 and 1482, when Richard, Duke of Gloucester, later Richard III, finally took it for England. Another much-used crossing, in the days before bridges existed, was the ford at the Tweed's confluence with Leet Water; today, Coldstream, the village which grew up by this ford, is still a main entry point into Scotland from England, via a main road from Newcastle-upon-Tyne.

Nearer the western end of the Border country, around Teviotdale and Liddesdale, the region was actually referred to as the 'Debatable Land' and was claimed by both Scotland and England from medieval times right up until the 18th century. This was the end of the border where the cattle-rustlers and sheep-stealers tended to operate. Today, the names of Border reivers, such as Johnnie Armstrong and his kinsman, William Armstrong, the subject of Walter Scott's romantic 'Ballad of Kinmont Willie', live on in story and poetry in their former hunting-grounds around Teviotdale and the wildly beautiful Liddesdale, while the remains of grim castles, peel towers and once-magnificent abbeys mark the countryside all the way from Liddesdale in the west across to the North Sea coast in the east.

These places, from the gaunt ruins of castles such as Hermitage, set in the bracken-trimmed hill country of Liddesdale, and Roxburgh, away to the east near Kelso, to the four great abbeys founded in the 12th century – Jedburgh, Kelso, Melrose and Dryburgh – stand out in great contrast to the quiet, gentle, heather- and bracken-covered hill country which makes up most of Borders today. They also make an interesting contrast with the many elegant country houses, including Floors Castle, Mellerstain House, Bowhill House and numerous others, which began to be built in the Borders, often around existing peel towers, in the 18th century, once the centuries-long fighting had come to an end.

It is as if history has decided that, with so much turbulence behind it, the Border country at last deserves some peace and quiet: even the North Sea oil industry, which has brought changes to so many parts of Scotland since the early 1970s, has, outwardly at least, passed the Borders by, and sheep- and cattle-rearing is still as important a business now as it was in medieval times. Sheep

OPPOSITE: The River Tweed, seen from Scot's View, where it forms a loop east of the Eildon Hills. One of the great salmon rivers of Scotland and England, the Tweed, at 97 miles (156km) long, flows mostly through the Borders region that divides Scotland from England, rising at Tweedsmuir at Tweed's Well, near to where the Clyde, draining north-west, and the Annan, draining south, also rise. Its lower reaches mark the Scottish border with England for 17 miles (27km) near Berwick-upon-Tweed.

THE BORDERS

remain the basis of the woollen cloth and knitwear industries of the Borders as they have been for centuries, with the weaving industries in towns like Galashiels and Hawick able to trace their origins back over seven centuries and more.

The Border country is very much hill country, being altogether gentler that the dramatic peaks and great mountains, separated by lonely glens, which mark the Highlands. The Southern Uplands, a range of green-and-purple rounded peaks and moorland stretching westward from a line running between Edinburgh and Peebles, one of the most noteworthy Borders towns, mark the northern edge of the Borders, along with the Pentland, Moorfoot and Lammermuir Hills south of Edinburgh, while to the south the Cheviot Hills and the valleys of several rivers mark the southern edge.

Probably the most famous of the Border country's hills, because they have figured so largely in the myth and legend of the region, are the heather-covered Eildon Hills, a triple-peaked volcanic range rising up behind the town of Melrose in the central part of the Tweed valley. The Romans called these hills Trimontium, and built a fort near Newstead at their base and a signal station on one of the summits, in the process demolishing the ramparts of an Iron Age hill fort, built by a people known as the Selgovae.

Legend has it that the Eildon Hills were originally one hill, cleft in three by the wizard Michael Scot to settle an argument with the devil. It was also on these hills, so another legend tells, that Thomas of Ercildoun met the Queen of Elfland under the Eildon Tree, today marked by a stone, and was carried off to her country for seven years. Sir Walter Scott, who bought a farm three miles west of Melrose, which he rebuilt into the splendid Abbotsford, set his great epic poem, 'The Lay of the Last Minstrel', around the Eildon Hills.

Highest points in the Borders hill country are the 2,750-ft (840-m) Broad Law and 2,680-ft (817-m) Dollar Law, which lie in the craggy, rugged moorland country in the west of the region where the River Tweed rises.

While the Tweed, famous for its salmon-fishing and for having given its name to the woollen cloth manufactured here, is the major river of the region, flowing through three of its most important towns, Peebles, Melrose and Kelso, and with many tributaries flowing into it, it is far from being the only one, for this is a region of many rivers and burns. In the west and south of the region there are the Esk, Liddel Water, a long stretch of which forms part of the line of the border in the west, and the Teviot, all of which have given their names to the dales down which they flow. In the west, another river, the Sark, marks the border's line past Gretna and so on to the coast, while to the north, Yarrow Water flows out of the region's biggest lake, St. Mary's Loch, down a fine valley to join the Tweed a few miles beyond Selkirk.

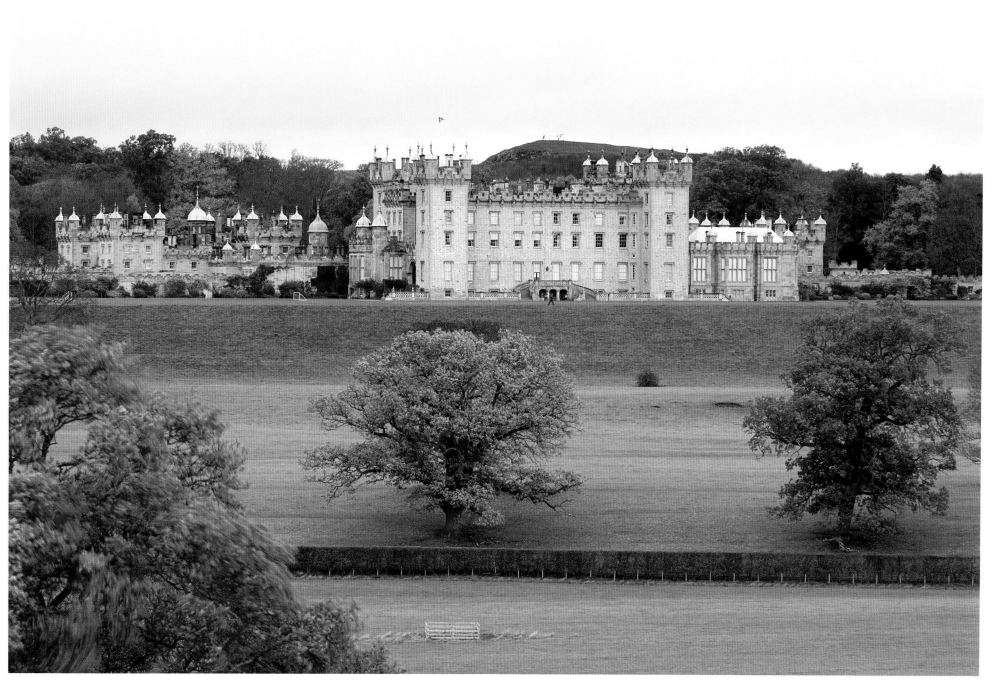

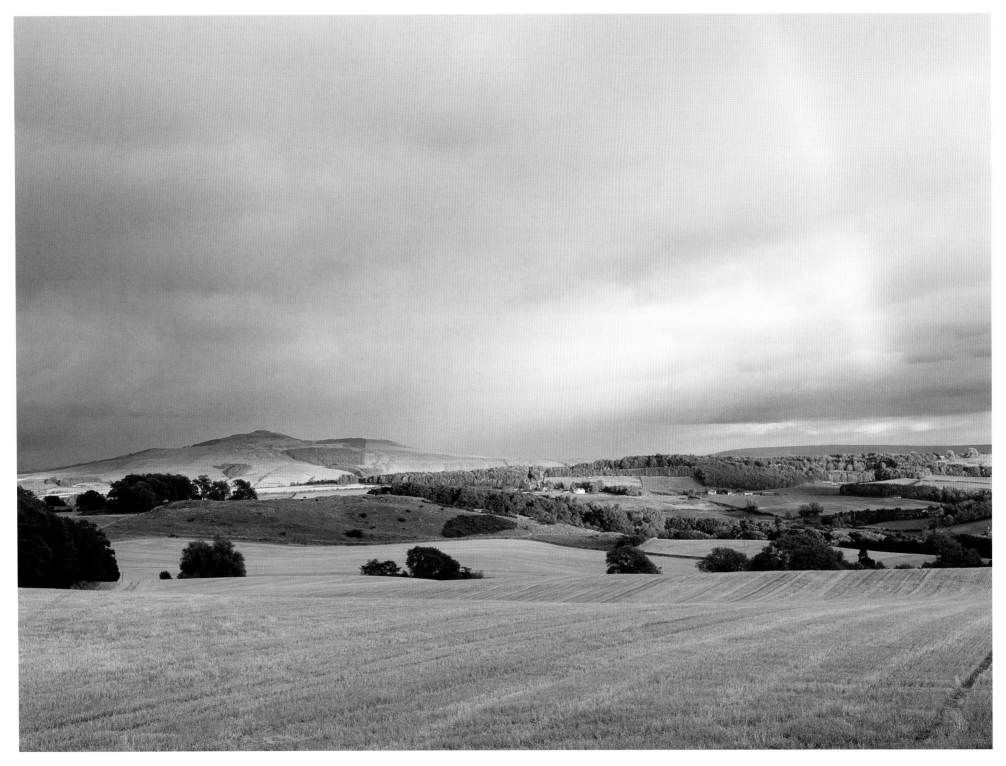

A CELEBRATION OF SCOTLAND

Unlike the rest of Scotland, especially the Highlands, the Border country is not famous for its lochs. Indeed, St. Mary's Loch and the Loch of the Lowes are the only two of any size – and even they were one stretch of water in their youth – but there are several reservoirs, including the Talla, Fruid and Megget. South of the Talla Reservoir and St. Mary's Loch, Loch Skeen, a corrie loch, lies high up in the Southern Uplands. The burn that runs out of it drops via the famous Grey Mare's Tail 200ft (60m) into space, creating the most spectacular waterfall in Scotland outside the Highlands (see page 65).

St. Mary's Loch and the Loch of the Lowes lie in a glacial basin at the heart of the land once covered by the extensive Ettrick Forest, once a rugged terrain and a royal hunting preserve but today mostly peaceful moorland where sheep graze. This has inspired some of Scotland's finest poets, among them Sir Walter Scott, Robbie Burns and James Hogg, the 'Ettrick Shepherd', as well as William Wordsworth, venturing over the border from his beloved Lake District. James Hogg was born in Ettrick and was virtually uneducated, unlike both Scott and Burns. What he shared with Robbie Burns, however, was a wonderful empathy with the traditional ballads and stories of the Borders, which found expression in some very fine poetry indeed.

Once a refuge for hunted Covenanters and fierce Border reivers, the glens and hills of the Ettrick Forest now provide quiet grazing for sheep and cattle and fine walking for ramblers. The

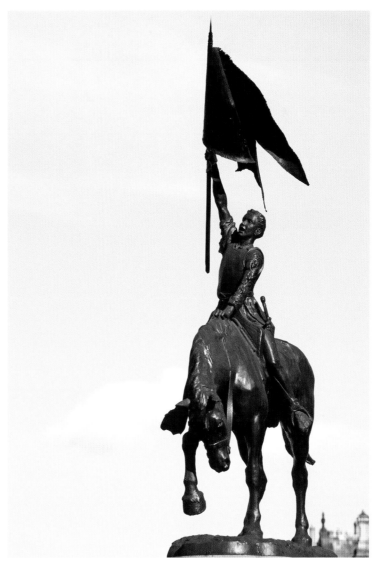

OPPOSITE: Farmland east of the Hawick, the largest of the border towns.

LEFT: 'The Horse' statue in Hawick's high street commemorates victory by local youths over English marauders at nearby Hornshole in 1514, a year after the disastrous defeat at Flodden. Here, a triumphant lad carries the captured Abbot's banner back to Hawick.

PAGE 46: Heavily restored though they are, the ruins of Hermitage Castle still make an impressive sight beside Hermitage Water, north of Liddesdale. The castle dates from the 14th century, when it was taken from the Soulis family of dubious reputation by the Douglases, who later exchanged it for Bothwell Castle, near Glasgow, owned by James, Earl of Bothwell, the third husband of Mary, Queen of Scots.

PAGE 47: Kelso Abbey.

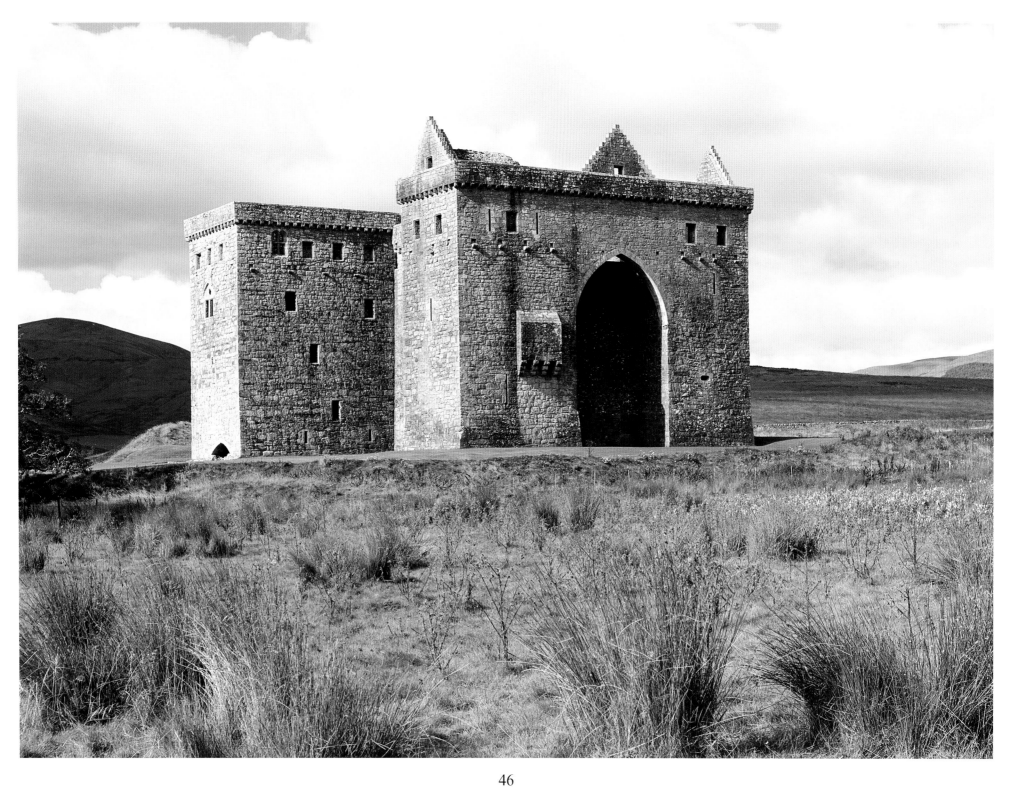

walk which circumnavigates St. Mary's Loch, most of it on footpaths and forestry roads, has been planned to take in as many of the places of particular interest here as possible. Walkers can see the ruins of the impressive Dryhope Tower, once the home of Wat Scott of Harden, a notorious Border reiver; the fine statue of James Hogg, his sheepdog Hector at his feet, which looks towards the Loch of the Lowes; and even the Tibbie Shiels Inn, named after its first landlady, at the southern end of St. Mary's Loch, where James Hogg was a regular customer, often having long talking and drinking sessions here with the much more cultured and sophisticated Walter Scott. 'He was a gey sensible man for a' the nonsense he wrat,' remarked Tibbie Shiels of James Hogg early in the 19th century. Today, the inn's customers are more likely to be walkers and yachtsmen from the sailing club, based on the lochside, rather than poets.

The river that flows from the north-eastern end of St. Mary's Loch is the Yarrow: hence 'the Flower of Yarrow', the name by which Wat (Walter) Scott of Harden's famously beautiful wife, Mary, was known.

Away on the eastern edge of the Ettrick Forest is Selkirk, rising on a hillside above another river of the area, the Ettrick, a Mecca for salmon- and trout-fishermen. Selkirk has been a manufacturing town for nearly four centuries, specializing in the weaving of woollen cloth. It makes a fine base for visiting the many places of interest around it, including Bowhill in the

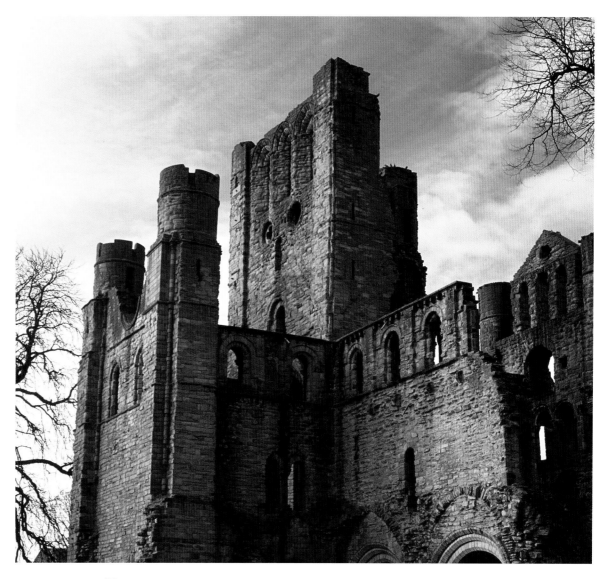

Clatteringshaws Loch, near New Galloway, where Bruce's Stone is to be found. A National Trust for Scotland site, the stone on Moss Raploch is where King Robert the Bruce is said to have rested after defeating the English here in 1307.

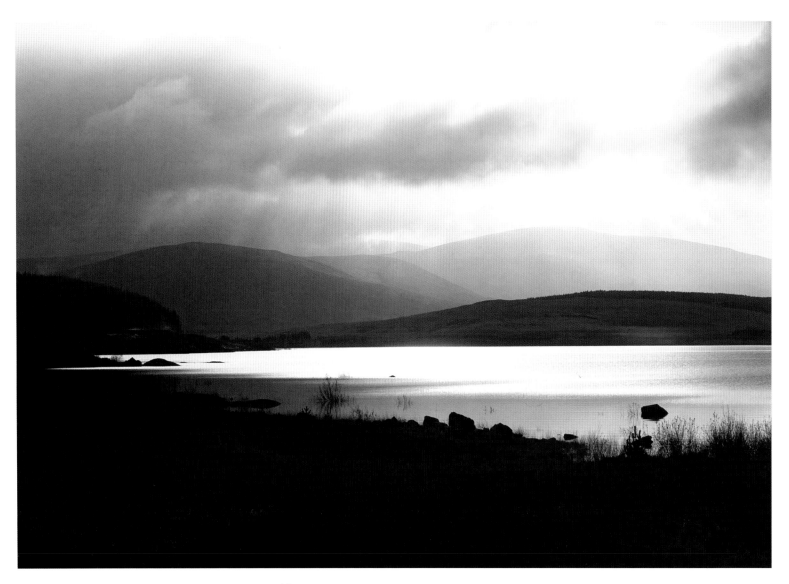

Yarrow valley, which for centuries has been the home of the Scotts of Buccleuch, though the present fine house with its superb art collection was begun only in the late-18th century.

Selkirk really comes alive in June, when the town holds it annual Common Riding; horsemen carrying symbols of their town's independence ride the surrounding countryside to commemorate the heroic part played by the men of Selkirk in the disastrous Battle of Flodden in 1513, in which James IV was killed and the flower of the Scottish army destroyed.

While Selkirk claims that its Common Riding is the biggest mounted gathering in Europe, other Border towns also hold such sizeable events every summer, when the boundaries of their towns are ridden by local people to the accompaniment of brass and pipe bands, revelry and merrymaking. The Common Ridings of the Borders today are used, like the Highland Games, as a way of gathering local people together to celebrate their lives and localities. Their historical significance lies in the fact that it was once essential for every town in the Borders to be able to defend its own territory; in time, the important business of marking a town's boundaries became formalized into a ceremony known as 'riding the bounds'.

Among Border towns which have Common Ridings are Duns, Galashiels, Hawick, Jedburgh, Langholm and Lauder. Peebles, an attractive town on the Tweed to the north-west of Selkirk, includes a Common Riding in its annual Beltane Fair, a

descendant of the great Celtic festival of the sun marking the beginning of summer. Outside the week of its Beltane festival in June, Peebles is a quiet town, which is just as it should be, for Peebles' two great claims to fame are both quiet matters: the fine quality of the salmon-fishing on the Tweed and the fact that

Detail of the early eighth-century Ruthwell Cross, Galloway. The tracery of vines, birds and animals is incised with runic characters referring to the Holy Rood.

William and Robert Chambers, brothers and founders of the fine 19th-century Edinburgh publishing firm, Chambers, were born here. The great Chambers Dictionary still goes strong, with new editions being published every decade or so.

The fact that Peebles has known more warlike times is attested to by Neidpath Castle, perched on a rocky outcrop above the Tweed just a mile from the town. Neidpath, dating from the 14th century and with walls nearly 11ft (3.5m) thick, is a finely preserved example of the peel (or 'pele') tower, which provided defensive fortifications on both sides of the border for centuries. The word comes from the Latin *palus*, meaning 'palisade', and sums up its purpose perfectly.

Traquair House, 6 miles (10km) or so downstream from Neidpath near Innerleithen, was also once a peel tower, although the ancient tower is very much hidden within the 17th-century building which predominates in the house today. Thought to be the oldest continuously inhabited house in Scotland, Traquair has in its long history been visited by many monarchs of both Scotland and England, including Mary, Queen of Scots, who came here with her husband and baby son in 1566. Another fine example of a peel tower in this part of the Borders is Smailholm Tower (page 63), near St. Boswells, west of Kelso, whose romantic history so fired the imagination of the young Sir Walter Scott.

Medieval Border Scots were so sure they were going to be attacked by the English at some time or another that they often

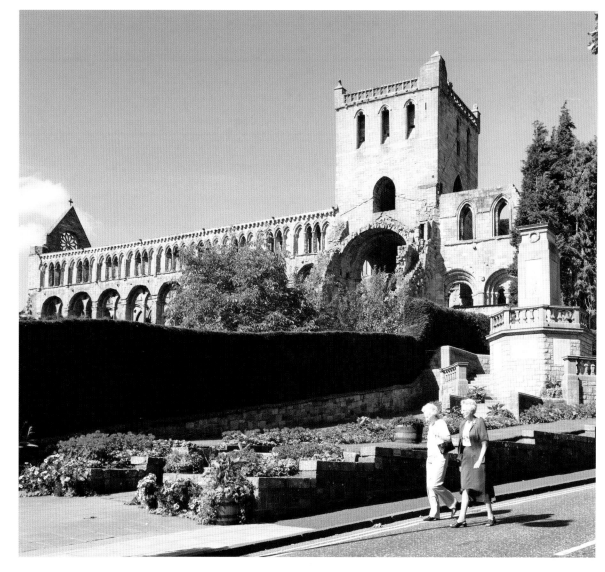

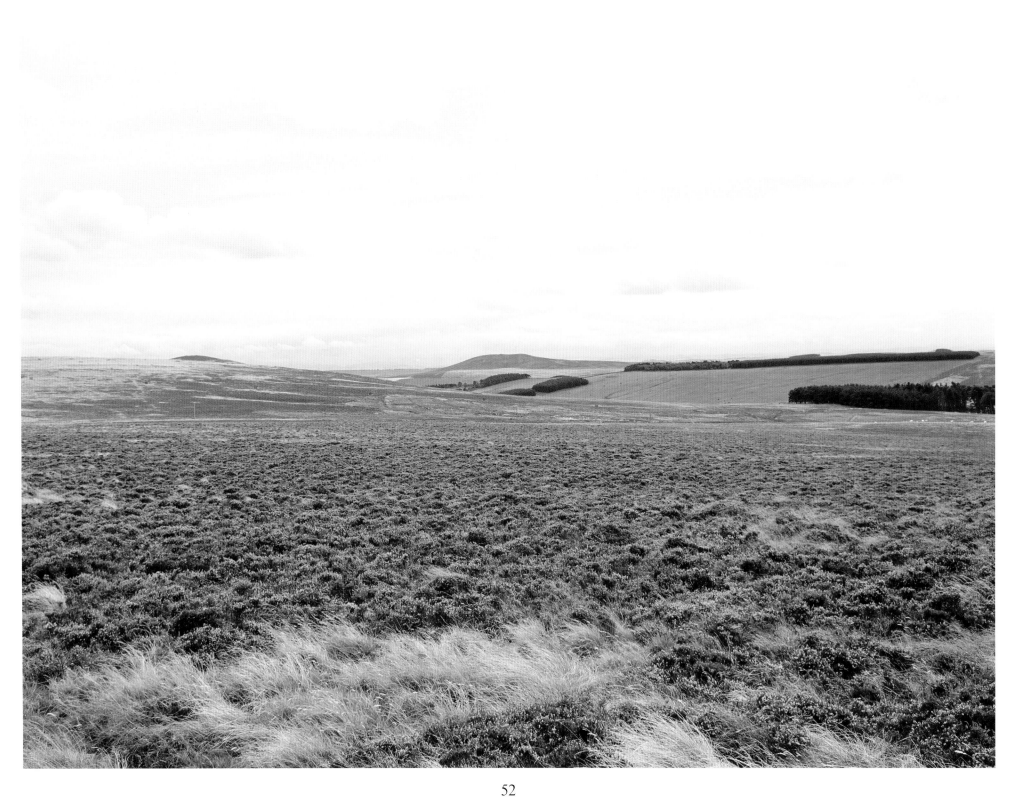

did not bother to build strong family dwellings, making do with posts and branches or other forms of wattle and daub which could be rebuilt quickly, once the attackers had departed and the defenders could emerge from their towers. This is one reason why so many Border towns and villages have few really ancient buildings, apart from the church and the local stronghold. Hardly a trace remains of Old Roxburgh, for instance, though it was an important medieval town near the mighty fortress of Marchmont, later called Roxburgh Castle, where Alexander II was married and where his son, Alexander III, was born.

In 1460, James II was killed by a bursting cannon while attacking Roxburgh Castle, which had been held by the English for over a century. James's grieving widow urged the Scots on to get rid of the English, then had the castle and the town surrounding it entirely demolished, so that they would never again serve as bases for the English.

The little that is left of Roxburgh Castle can be seen today on the south bank of the Tweed, opposite Kelso, far downstream of Peebles and much nearer to the border. Kelso is among the most attractive of the Border towns, with a fine cobbled market square surrounded by buildings dating back to the 18th century. Near the town is the elegant 18th-century mansion, Floors Castle (page 43), seat of the dukes of Roxburghe. A yew tree in the grounds at Floors is said to mark the site where James II was standing at the seige of Roxburgh Castle when the exploding cannon killed him.

Like Floors Castle, Mellerstain House, 7 miles (11km) north-west of Kelso, was designed by Scotland's most famous architects and designers, the Adam family. William Adam began both houses, but where Floors was given its final form by W.H. Playfair in the 19th century, Mellerstain House was very much an Adam family creation, for what William Adam began in 1725 his son Robert completed in 1778. Together they created what has been called the finest and most beautifully proportioned 18th-century mansion in Scotland. As impressively designed and embellished inside as out, Mellerstain House sits today above elegant Italian terraced gardens at the heart of a magnificent wooded formal park.

Kelso was one of the places chosen by David I as a site for the abbeys founded by him in the Scottish Borders in the 12th century at Kelso, Jedburgh and Melrose, the Borders' fourth 12th-century abbey, Dryburgh, having been founded by Hugh de Morville, Constable of Scotland. Kelso's abbey was one of the largest and richest of the Borders foundations, and wielded great influence for several centuries. Although it was virtually destroyed by the English Earl of Hertford in 1545, during Henry VIII's 'Rough Wooing' of Mary, Queen of Scots, there is still much fine Norman and early Gothic work to be seen in what remains, especially on the façade of the north-west transept.

Better preserved is the abbey at Melrose, another quietly attractive town further up the Tweed. Melrose Abbey, founded by

PAGE 50: On the banks of the River Jed, south of Jedburgh.

PAGE 51: Jedburgh Abbey. Founded as an Augustinian priory by David I in 1138, Jedburgh was elevated to the status of an abbey some 15 years later, becoming a wealthy and influential house with three other priories eventually dependent on it. The king's arrogance in siting his monastery only a few miles from the English border, however, resulted in a turbulent history, so it is all the more remarkable that so much of Jedburgh Abbey remains intact to this day.

OPPOSITE: Heather in bloom on the Lammermuir Hills below Meikle Says Law.

THE BORDERS

OPPOSITE: The grand 13-arch Leaderfoot Viaduct, built in 1865, is located 2 miles (3km) east of Melrose in the Scottish Borders. Leaderfoot lies at the foot of the Lauderdale valley where Leader Water joins the River Tweed. A Roman bridge once crossed the Tweed here, carrying Dere Street north from the nearby Roman fort of Trimontium.

David I in 1136, was the first Cistercian monastery in Scotland, which achieved lasting fame because of its place in Walter Scott's hugely successful poem, 'The Lay of the Last Minstrel'. Robert the Bruce's heart is said to have been been buried by the high altar in Melrose Abbey, although it has never been found.

Just short distances from Melrose are two other places connected with Scott, Dryburgh to the south and Abbotsford to the west. Despite his connections with Melrose Abbey, Sir Walter Scott was himself laid to his final rest in Dryburgh Abbey, partly because his family, which had once owned the lands on which the abbey ruins stood, retained the right to 'stretch their bones' there. Also stretching his bones in Dryburgh Abbey is Earl Haig, the First World War general and Allied commander. Today, the considerable and impressive ruins of Dryburgh Abbey stand amid trees in an idyllic spot on the banks of the Tweed.

Abbotsford, 2^1/$_2$ miles (4km) west of Melrose, was an insignificant farmhouse known as Clartyhole (meaning 'muddy place') when Sir Walter Scott bought it in 1811, but by the time he died in 1832, the simple building had been transformed into a flamboyantly turreted pile in mock-baronial style, complete with armoury, library and museum, and much more suited to Scott's reputation as Britain's most famous historical novelist. Even its new name had historical connotations, for it was the place on the Tweed where the monks of Melrose once crossed the river.

The fourth of the great abbeys of the Borders region is to be found at Jedburgh, just 10 miles (16km) north of the border, where Carter Bar is the crossing point on the A68. Jedburgh is perhaps the most historically important of all the Border towns, for it was here that the Romans began the southern end of their Dere Street, that ran from the Firth of Forth to York, more than 2,000 years ago. A Christian chapel was built here some time in the ninth century, which David I replaced with a priory in 1138, becoming the great abbey whose ruins still dominate the town. In around 1300, Jedhart, as the town was then known, became a royal burgh.

Jedburgh Abbey (page 51) is a striking red sandstone ruin, standing above Jed Water, its great tower, rebuilt in 1500, rising proudly above the long line of the nine-bayed nave. While much of the stonework dates from the 12th century and later, examples of stone carvings from two centuries or more earlier, now in the abbey's museum, are evidence of the age of this important religious site.

Jedburgh's once strategically important castle was also a favoured royal residence, and was the scene of the wedding feast which followed Alexander III's second marriage in Jedburgh Abbey in 1285. Legend tells of a ghost at the feast, which prophesied violent death for the king and disaster for Scotland; sure enough, Alexander III was dead a year later and Scotland had been plunged into the several centuries of turmoil that

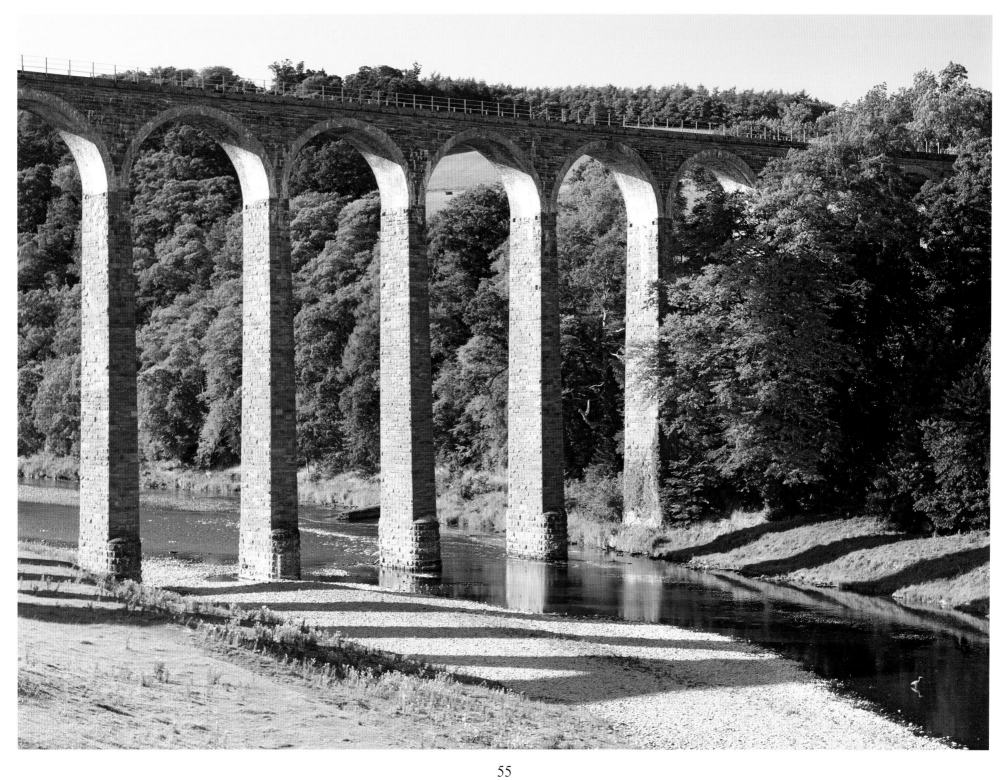

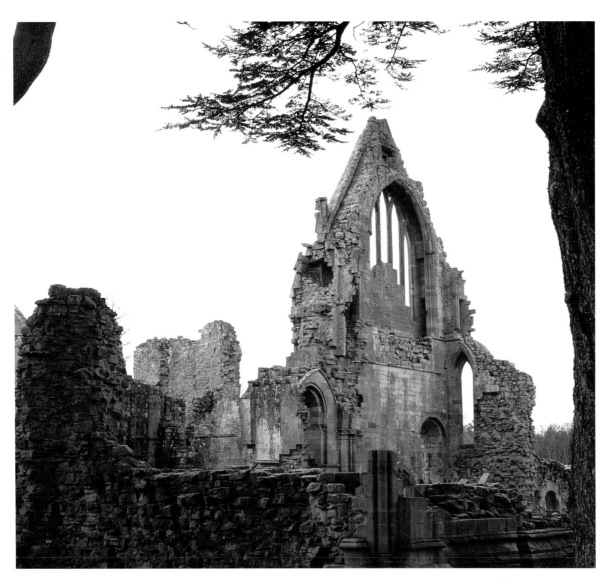

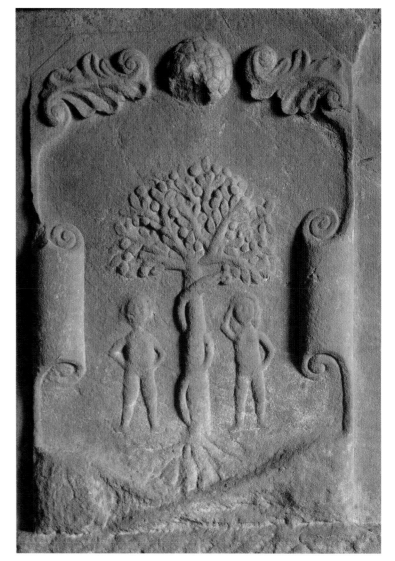

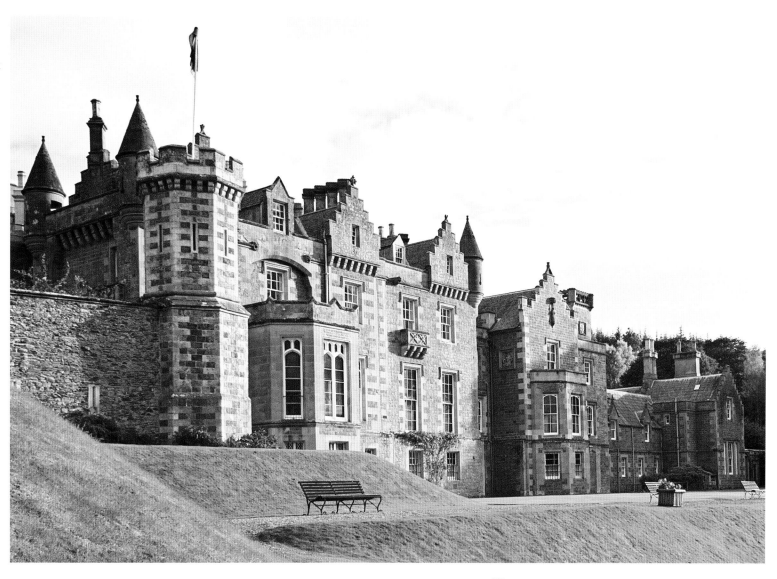

OPPOSITE LEFT: The Ruins of Dryburgh Abbey. It belonged to the Premonstratensian Order (or White Canons), founded by St. Norbert in 1119 at Prémontré, near Laon, in France. The order rapidly spread throughout Europe, where a stricter, purer form of the Augustinian rule , together with elements of the Cistercian rule, was practised, its extreme austerity apparent in the fact that the abbey only had a single fireplace at which the monks could warm themselves during the harsh Scottish winters.

OPPOSITE RIGHT: A relief of Adam and Eve from Dryburgh Abbey.

LEFT: Abbotsford, the impressive home of Sir Walter Scott, near Melrose.

PAGE 58: The Vale of Yarrow, west of Selkirk.

PAGE 59: The town of Selkirk.

preceded the stabilizing of the monarchy under the Stuarts. The castle was reduced to rubble early in the 15th century to keep it from falling into English hands, but its foundations were given a new use in 1825 when the Castle Jail was built on the site. Today there is an interesting museum of local life in the Castle Jail but no ghost.

The most romantic story surrounding Jedburgh, worthy of a place in one of Scott's Waverley novels, concerns Scotland's tragic Mary, Queen of Scots. She came to Jedburgh for the assizes in 1566, choosing to stay, so it is said, in the only house in the town with indoor sanitation (now Queen Mary's House, off the High Street and open to the public in the summer months). While at Jedburgh, news came that Mary's lover, James, Earl of Bothwell, was lying seriously wounded at Hermitage Castle, nearly 20 miles (32km) away beyond Hawick. Impetuously, Mary rode from Jedburgh to Hermitage and back in one day, falling dangerously ill herself on her return. 'Would that I had died at Jedburgh', the Queen was heard to sigh during her long captivity in England.

Mary's reign in Scotland came to an end within a year of her Jedburgh escapade. Early in 1567, her husband, Lord Darnley, was murdered, and within months Mary had married Bothwell, suspected by many of having been implicated in Darnley's death. Not long afterwards, Mary was forced to abdicate in favour of her infant son, James, and she had fled to England by 1568.

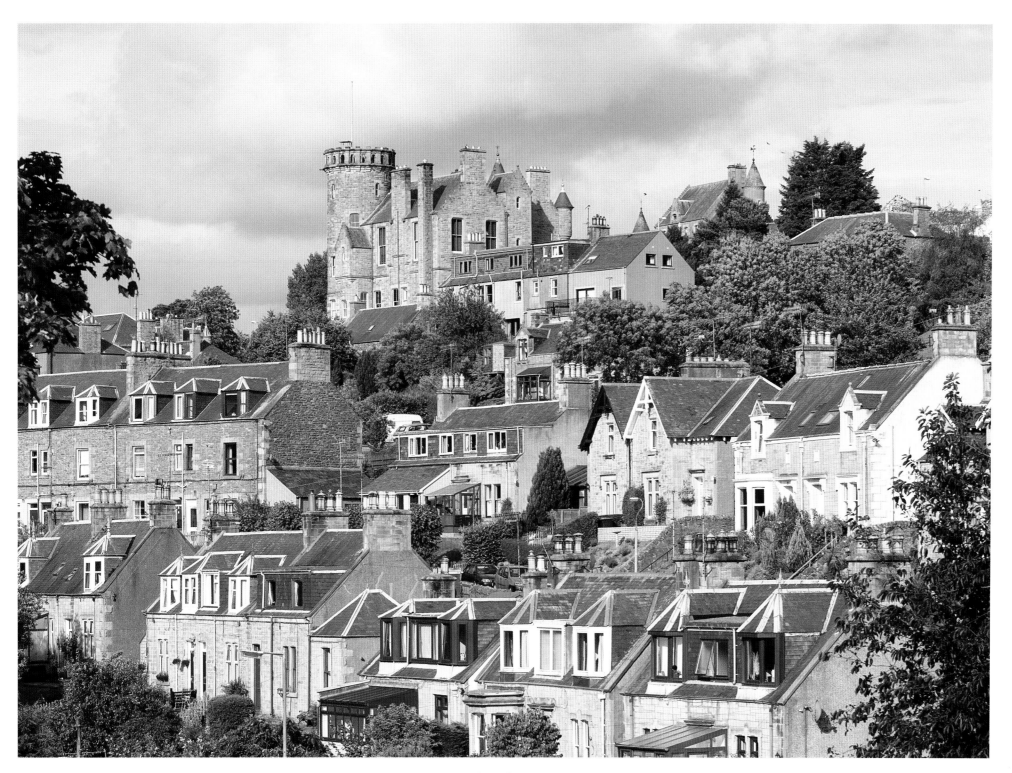

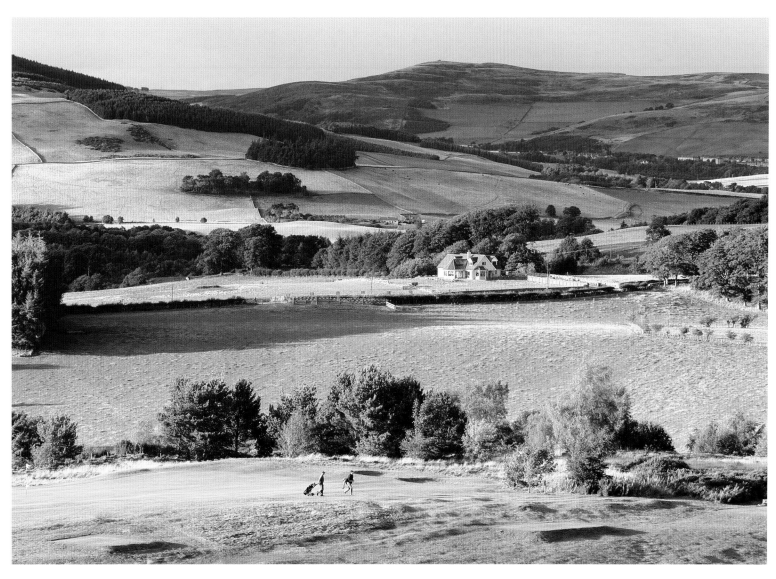

OPPOSITE: The countryside north-east of Selkirk.

LEFT: Looking north over Selkirk golf course.

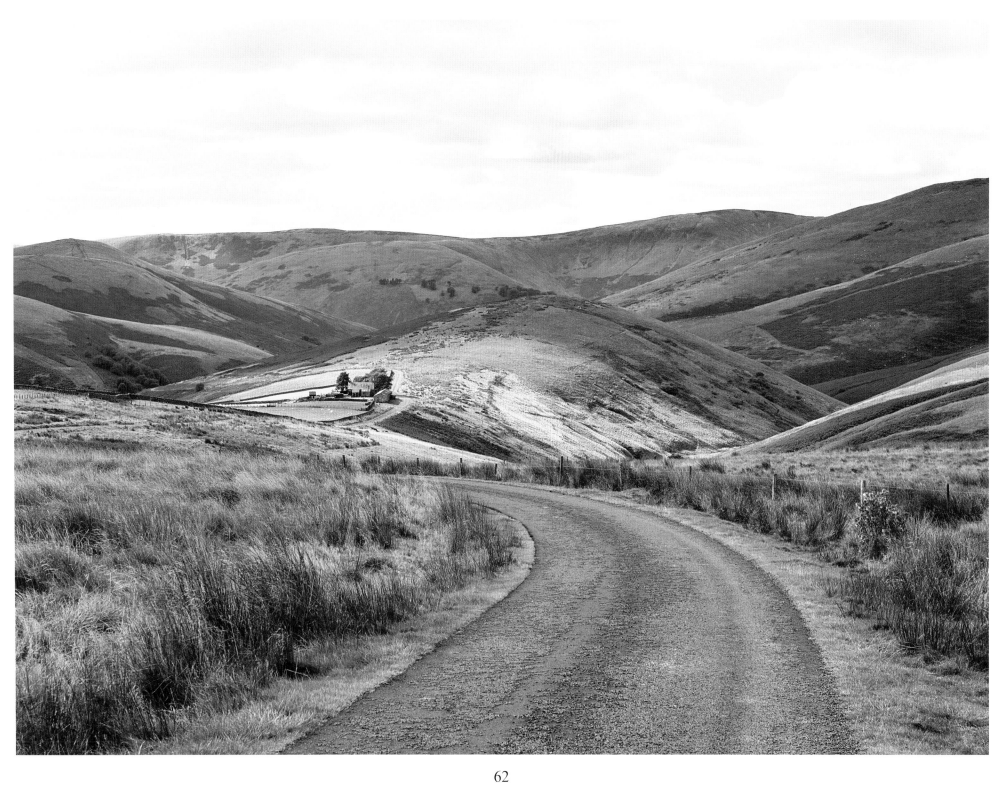

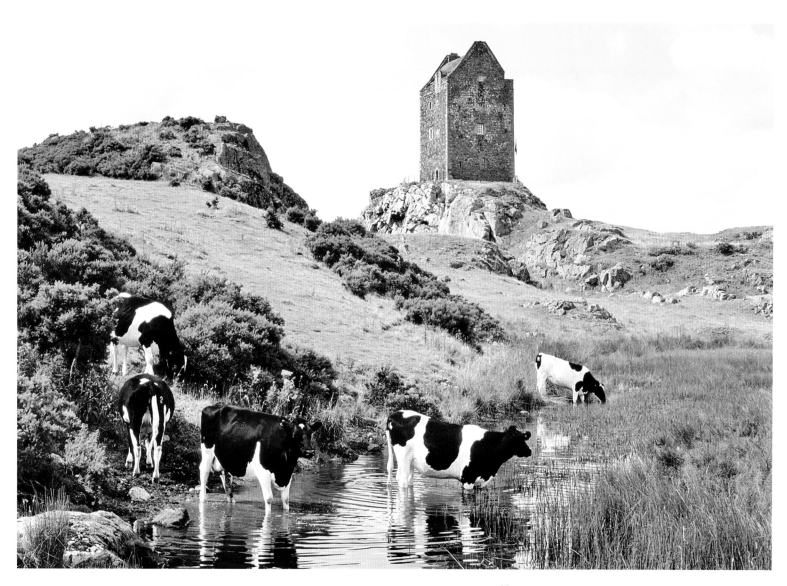

OPPOSITE: Farmland below Geordie's Hill, south-east of Teviothead.

LEFT: Smailholm Tower, west of Kelso, is a fine 16th-century peel tower, and its romantic, isolated setting near a small loch did much to fire the imagination of the young Walter Scott, who spent several summer hoildays at Sandyknowe Farm nearby.

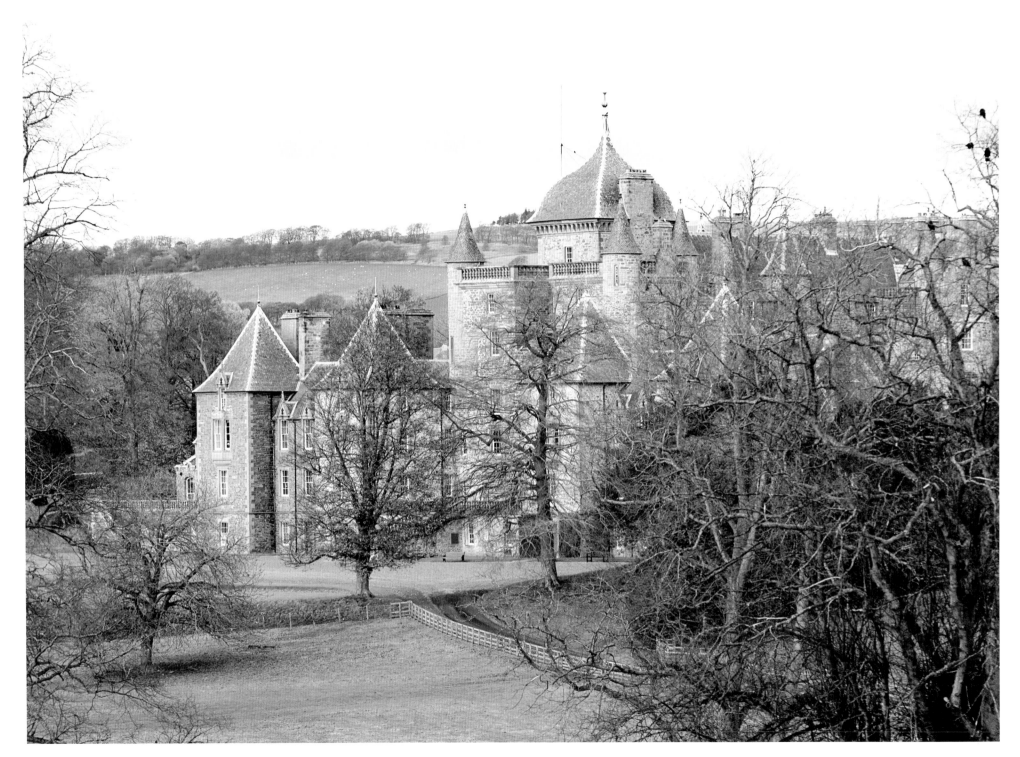

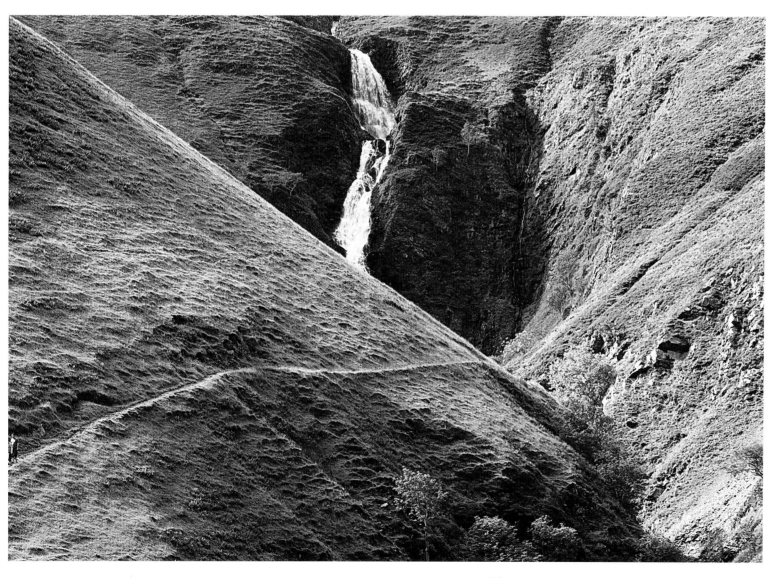

OPPOSITE: Thirlestane Castle, the ancient seat of the earls and dukes of Lauderdale.

LEFT: The famous Grey Mare's Tail, near Moffat in Dumfries & Galloway, is a spectacular waterfall with a drop of 200ft (61m).

RIGHT: Statue of a ram on top of the Colvin Fountain in the Borders hill-farm town of Moffat.

OPPOSITE: The view down Moffat's Well Street.

THE BORDERS

RIGHT: The Star Hotel in the spa town of Moffat appears in the Guinness Book of Records as the 'Narrowest Hotel in the World'.

OPPOSITE: The Buccleuch Arms, another Moffat hotel.

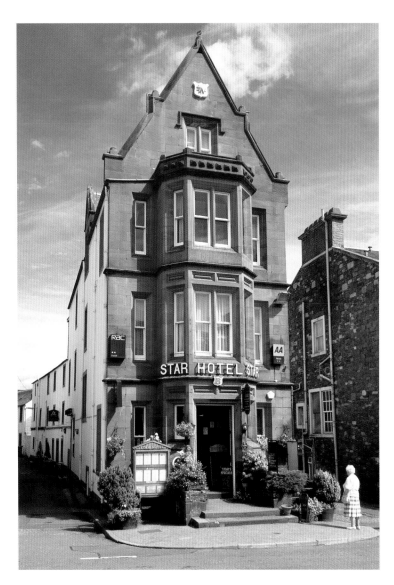

With the flight of the tragic queen, much of the romance departs from the story of the Scottish Borders. But her presence is remembered right across these lands, at Dunbar Castle on the east coast, where she and Darnley took refuge after the murder of David Rizzio, and where she stayed again after her marriage to the Earl of Bothwell, at Jedburgh and Hermitage Castle, at Traquair House, and finally at Dundrennan, west of the border, where she crossed the Solway Firth to England.

It was given to Sir Walter Scott, an Edinburgh advocate, Clerk of the Signet and Sheriff of Selkirk, to bring romance back to the Borders in triumph, using much of the Border country and its ballads and legends in his own poetry and in the long series of romantic and historical Waverley novels.

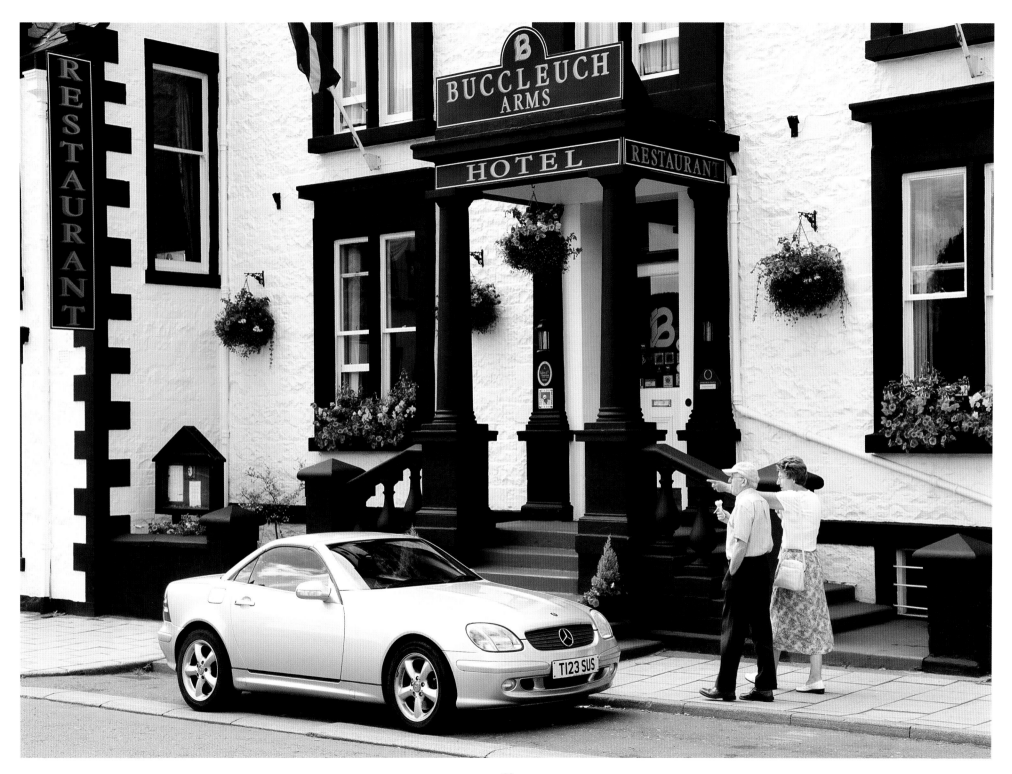

RIGHT: The marble bust of Sir Walter Scott by Sir Francis Leggatt Chantrey (1841) at Abbotsford, Melrose.

OPPOSITE: Abbotsford, perfectly located in the Scottish Borders by the River Tweed.

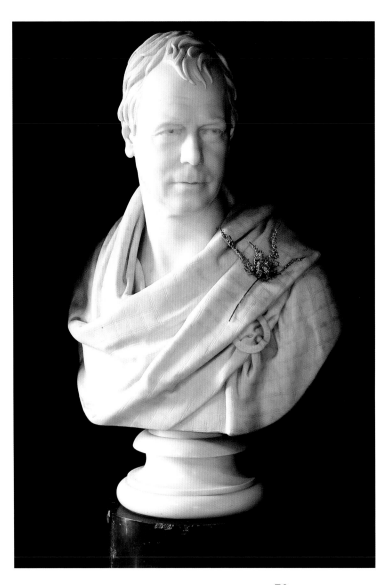

AN INSPIRATION TO WRITERS

The Border country holds a special place in Scotland's literary history. This is because many of its eminent writers, among them Walter Scott, James Hogg, Robbie Burns, John Buchan, and Hugh MacDiarmid, who lived near the small town of Biggar, were either born in the southern lands or did much of their best work here. There are many places associated with them in the area, including their homes, the inns frequented by them, and the buildings written about, which may be visited in the Borders today.

Abbotsford, Sir Walter Scott's home for 20 years, is right at the top of the literary pilgrim's visiting list. Born in Edinburgh into an academic family with connections with the law, Scott spent much of his childhood at his grandfather's farm, Sandyknowe, near Kelso, thus getting to know the Border country early on in his life. He had been keenly interested in the literature and history of his country from childhood, and his first major work, The Border Minstrelsy, *was published in 1802 and 1803; more verse romance, 'The Lay of the Last Minstrel', came two years later, bringing him enormous popularity in both Scotland and England. In 1811, in the heart of the Border country near Melrose, he bought a farmhouse and spent the rest of his life turning it into the splendid Gothic pile which is Abbotsford today. It was here that Scott spent the last years of his life, feverishly writing the novels that would help to repay the debts left by the bankruptcy, in 1825, of the Edinburgh publishing house he had helped to establish. It was also from Abbotsford that Scott*

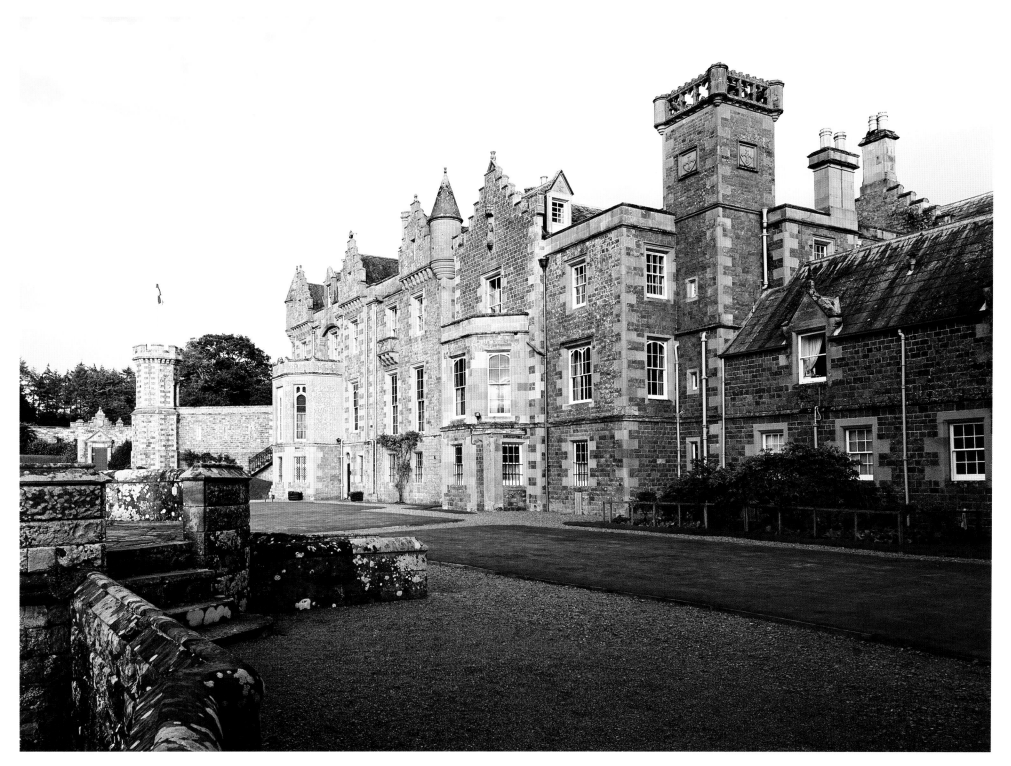

he had helped to establish. It was also from Abbotsford that Scott planned much of the enormously successful public relations exercise, culminating in the State Visit of George IV to Scotland in 1822, that restored Scotland's pride in itself as a nation after the disasters of the Jacobite rebellions of the 18th century.

Abbotsford, where members of the Scott family still live, is open to the public in the summer months. Here visitors can see Scott's study, little altered from the time it was used by him, as well as numerous other splendidly decorated and furnished rooms, many of them containing the fascinating relics of Scottish history that Scott collected, including Rob Roy's purse, a lock of Bonnie Prince

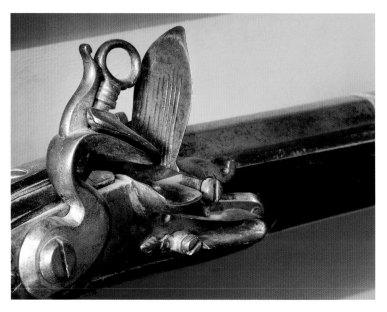

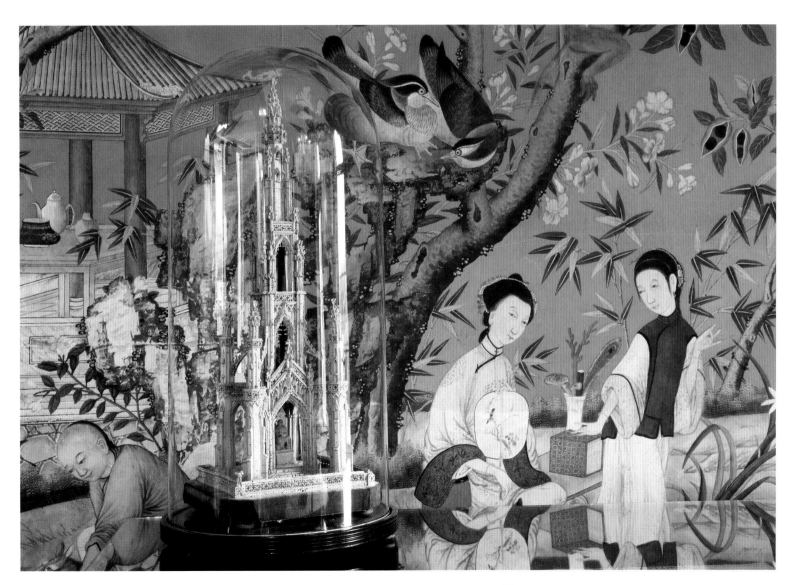

OPPOSITE LEFT: Statuary in the garden at Abbotsford representing characters in Walter Scott's writings: this one is the Antiquary, the subject of his Waverley novel of 1816, who is an amateur historian, archeologist and a collector of items of doubtful antiquity.

OPPOSITE RIGHT: Rob Roy's flintlock musket, part of Sir Walter Scott's collection at Abbotsford.

LEFT: A cork model of Scott's Monument, Edinburgh, hand-carved in the mid-19th century by Sarah Ruding Ward. The Chinese hand-painted wallpaper was a gift from Sir Walter's cousin, Hugh Scott of Raeburn, in 1822.

RIGHT: *James Hogg.*

BELOW: *Sir John Buchan, 1st Baron Tweedsmuir.*

OPPOSITE: *Robert Burns.*

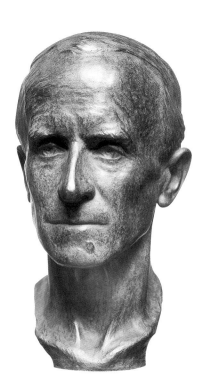

Other places with strong Scott connections are Smailholm Tower (page 63), one of the best-preserved and most interesting of the area's numerous peel towers, which Scott knew well because it was not far from Sandyknowe Farm and Dryburgh Abbey, where he is buried.

Tibbie Shiels Inn, at the southern end of St. Mary's Loch in the heart of the Ettrick Forest region, can boast of connections with both Walter Scott and James Hogg, for the two writers met here several times to discuss their work. James Hogg was born in Ettrick in 1770 and although he had little formal education, he had a fine empathy with the ballads and legends of the Borders, many of them learned at his mother's knee, as well as a natural talent for writing imaginative poetry. Scott published several of Hogg's ballads in his Border Minstrelsy *and, after early disappointments, Hogg eventually became an established figure in Edinburgh's literary world, writing both poetry and prose. His* Private Memoirs and Confessions of a Justified Sinner *is an extraordinary work, which explores the theme of the 'split personality', which Robert Louis Stevenson was later to develop in* Dr. Jekyll and Mr. Hyde. *Hogg is buried in the graveyard at Ettrick, where there is also a monument marking his birthplace.*

Some of Hogg's poetry shows a certain indebtedness to the work of Robbie Burns, which is not surprising since Burns, a decade older than Hogg, brought an entirely new and richly invigorating style to Scottish poetry. Although Burns did not live in the Border

country, coming nearest to it during his years as an excise officer in Dumfries, his famous Borders tour of 1787 left a lasting memory, not least in the many inns at which he stayed and the places he visited during his tour. Near Tweedsmuir, there is a hamlet up on the moors near the source of the Tweed, where the Crook Inn can be found. This was known to Burns, Scott and Hogg, though not all at the same time, and to John Buchan late in the 19th century. Burns, as was his habit, wrote a poem in the kitchen of the Crook Inn called 'Willie Wastle's Wife', which was intended to be sung to a Borders tune.

Tweedsmuir was the name chosen as his title by John Buchan, when he was made a peer in 1935. Although born in Perth, Buchan spent much of his childhood in the Border country, and it was this land, rather than the Highlands, which provided the background for several of his books, including The Thirty-Nine Steps. *There is a John Buchan Centre at Broughton, further to the north, about 5 miles (8km) from Biggar. It was in this village, right on the western edge of the Border country, that Buchan grew up, remarking later on in life that he 'liked Broughton better than any place in the world'. The John Buchan Centre, housed in a former United Free Church, provides an interesting insight into the world of a man who was not only an immensely popular writer, but also a Member of Parliament, a publisher, and a distinguished statesman: as the 1st Baron Tweedsmuir, he was made Governor General of Canada in 1935.*

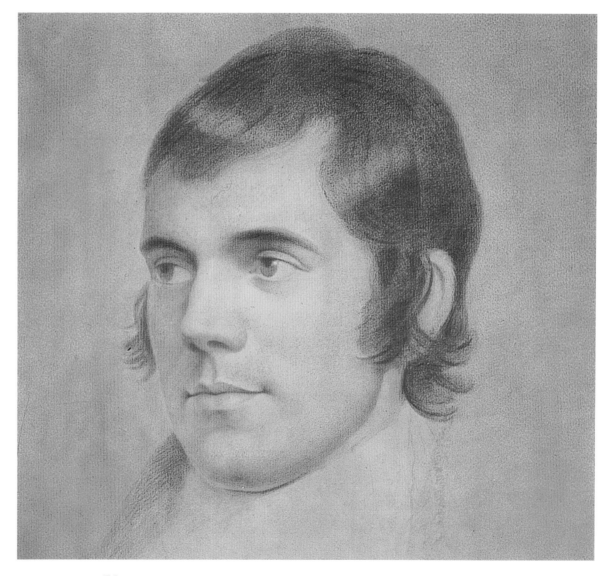

CHAPTER TWO
EDINBURGH &
THE CENTRAL LOWLANDS

RIGHT: The Dunmore Pineapple at Airth, Falkirk. Built as a summer residence in 1761, it is described as the 'most bizarre building in Scotland'. The property has been restored by the National Trust for Scotland, and can now be rented as a holiday home.

OPPOSITE: Stirling is the grandest of Scotland's castles, standing 250ft (76m) above the plain on an extinct volcano. It was of strategic importance during the 13th- and 14th- century Wars of Independence and was the royal residence of choice of many of the Stuart monarchs.

PAGE 78: Looking south-west from Strath Fillan, between Crianlarich and Tyndrum, to Ben Lui in Argyll, the highest and most famous of the four Munros.

PAGE 79: Balgonie Castle, near Glenrothes, Fife.

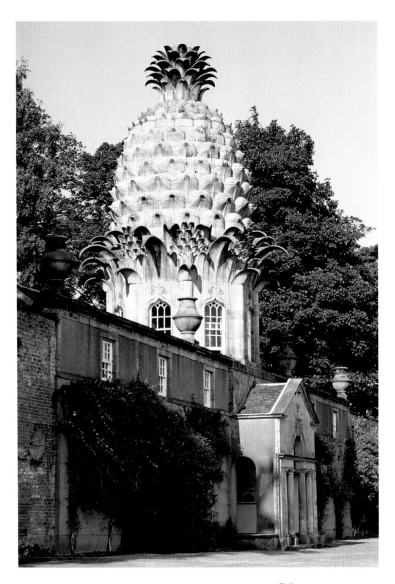

To describe this central part of Scotland as 'lowland', lying as it does on either side of the Firth of Forth, roughly between the northern slopes of the Pentland Hills and Edinburgh in the south and the southern slopes of the Ochil Hills and the rolling country of Fife in the north, is to do something of an injustice to this gentle and attractive country. True, the splendid ruggedness of the north-western Highlands is not to be found here, nor even the fine vistas of rolling hills cut by the waters of many rivers and lochs characteristic of the country from which the Forth flows south-east to the North Sea. What you will find, however, is a terrain that is hillier than much of England, where there are green valleys and rolling grass-clad hill country supporting much highly-developed agriculture and horticulture, and where, in contrast, is also to be found a large part of Scotland's industrial base, centred on places like Grangemouth, on the southern shore of the Firth of Forth, and a high proportion of the country's total population.

The region's place at the northern limit of this relatively simple-to-invade section of the map of Scotland (when surveyed by English kings intent on grabbing their northern neighbour's throne for their heirs) means that it is where many reminders of the centuries-long struggle for control of the country, fought by Scots and English, can be found. Such reminders can be seen at Edinburgh and Stirling, where there are two mighty fortresses, built on strategically placed hills; along the southern coast of the Firth of Forth and around the headland facing the North Sea, where

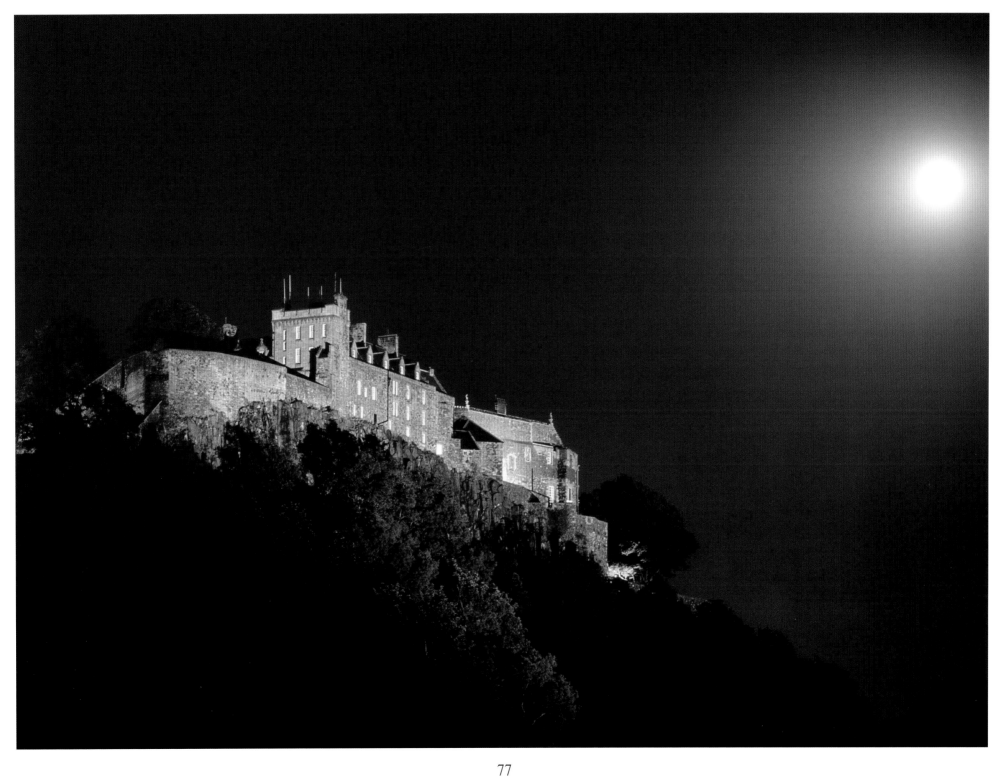

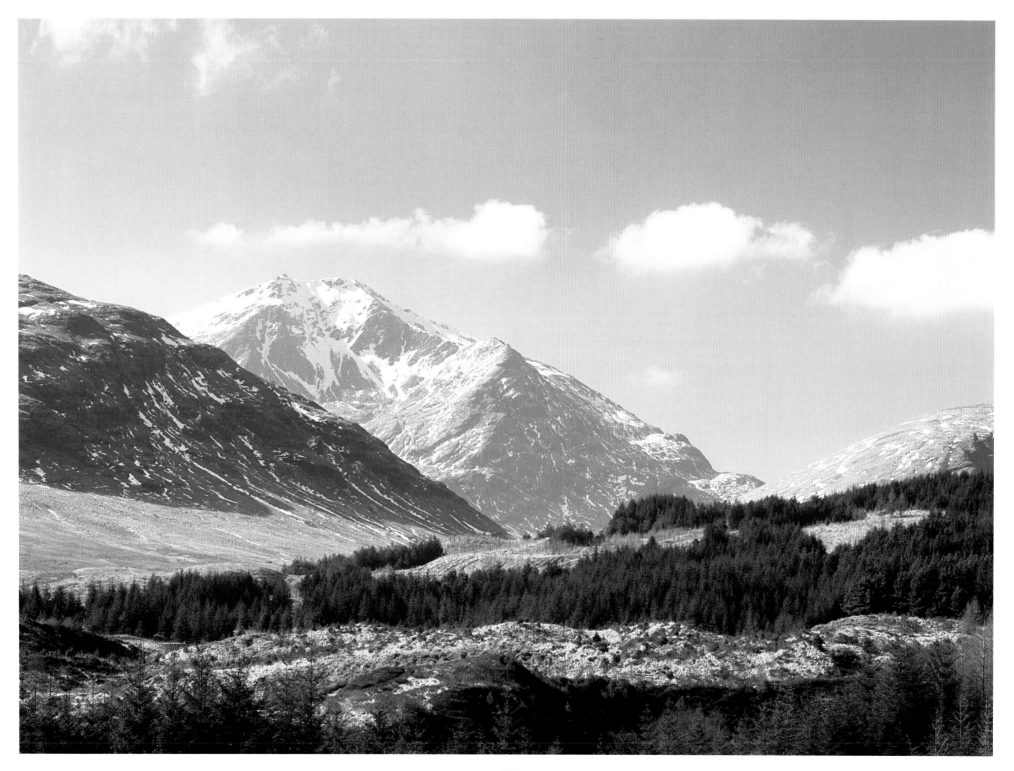

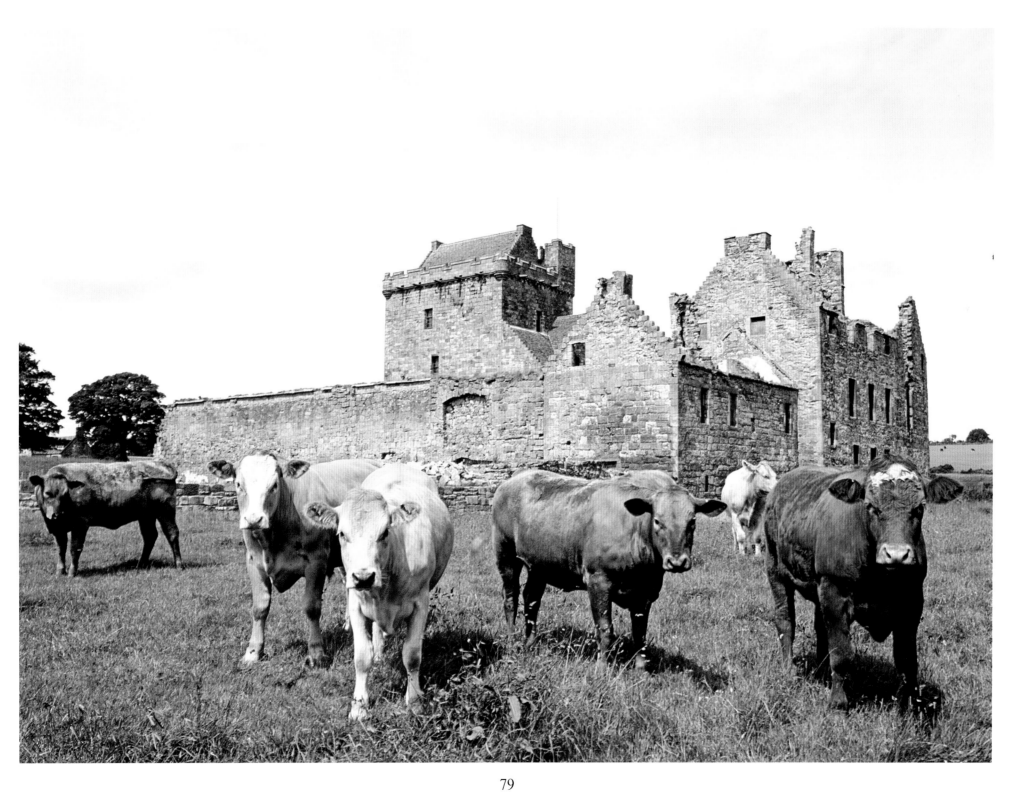

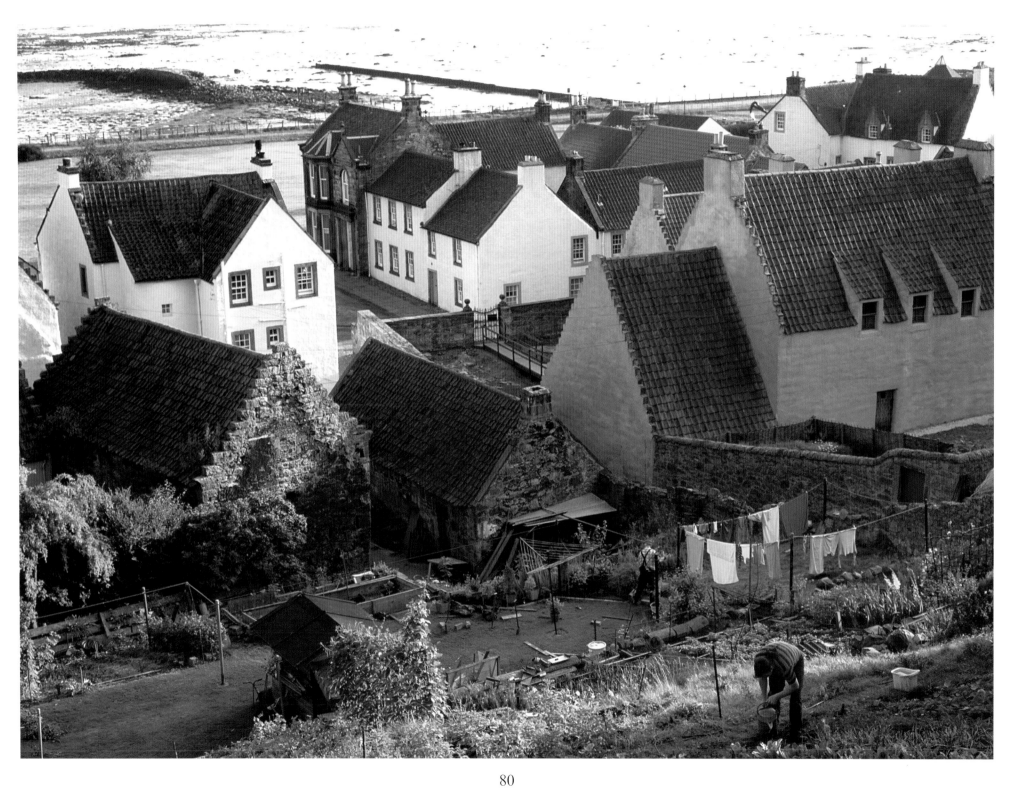

the ruins of castles at Dirleton, Tantallon, near North Berwick, and Dunbar can be seen; at Dunfermline, Linlithgow and Falkland, where there are the remains of once-favoured royal residences; and at places as far apart as Bannockburn, south of Stirling, Prestonpans, east of Edinburgh, and Dunbar, which were the sites of battles fought between Scots and English, rebels and government troops.

OPPOSITE: A view of Culross and the Firth of Forth.

FAR LEFT: The Mercat Cross at Culross.

BELOW: A wedding reception at Culross.

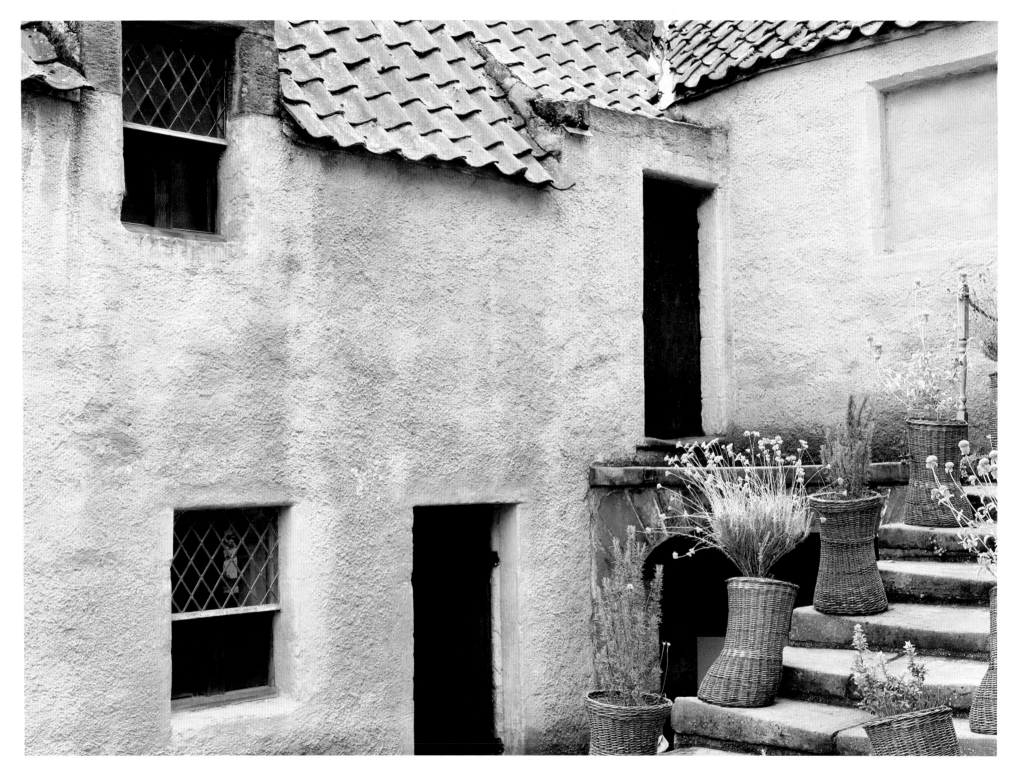

A CELEBRATION OF SCOTLAND

While most of Britain's oldest cities grew along the banks of rivers and up river valleys, Edinburgh, Scotland's capital, probably began as an Iron Age settlement or hill fort, gradually growing along a ridge and feeling its way from the fortified building on what is now Castle Rock down to Arthur's Seat. Here an abbey, called Holyrood, was founded in a forested valley early in the 12th century by King David I, just four years after he had moved his country's capital to Edinburgh from Dunfermline in the old Kingdom of Fife. Early in the 16th century, the abbey's guesthouse was taken over by James IV and developed as a royal residence.

Today, the Palace of Holyroodhouse is still the British sovereign's official residence in Scotland, while the abbey, reduced to only the nave, stands nearby in Holyrood Park. While present-day visitors to the palace can see signs of the present royal family's residence in the later State Apartments, including a harpsichord said to have been a favourite with the late Princess Margaret, it is to the older apartments that most visitors are drawn, seeking reminders of the palace's most romantic resident, Mary, Queen of Scots. Her apartments, in the north-west tower, have been maintained in the style she would have known, and once upon a time visitors would even have seen a stain, left by the blood that dripped from the many wounds of the queen's secretary, David Rizzio, when he was stabbed to death outside her private parlour by a gang which included her husband, Lord Darnley; today, a discreet plaque on the floor marks the spot where Rizzio fell.

A visit to Edinburgh Castle, at the other end of what is today known as the Royal Mile, is possibly less romantic than one to Holyroodhouse, but its military connections make it more thrilling and, for those seeking the names of relatives who died for king and country in two world wars, more moving. Edinburgh Castle's history goes much further back in time than Holyrood's, with the

OPPOSITE: Part of Culross Palace, the 16th-century house of merchant-entrepreneur Sir George Bruce.

BELOW: Alyth golf course, Perth, established in 1894.

RIGHT: The Crowded Logic Theatre Company perform their play 'Chav!' at the Underbelly on Cowgate as part of the Famous Edinburgh Fringe Festival.

OPPOSITE: A precipitous volcanic island, lying off the East Lothian coast, the Bass Rock has had something of a chequered history, but today supports a lighthouse and about 80,000 gannets, the species having been named Morus bassana *after the rock. The colony can be studied by means of remotely-controlled cameras at the Scottish Seabird Centre in North Berwick.*

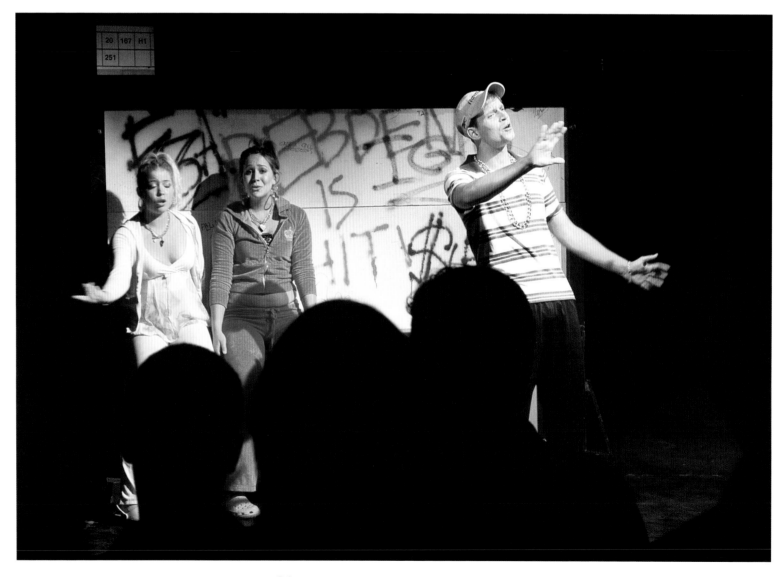

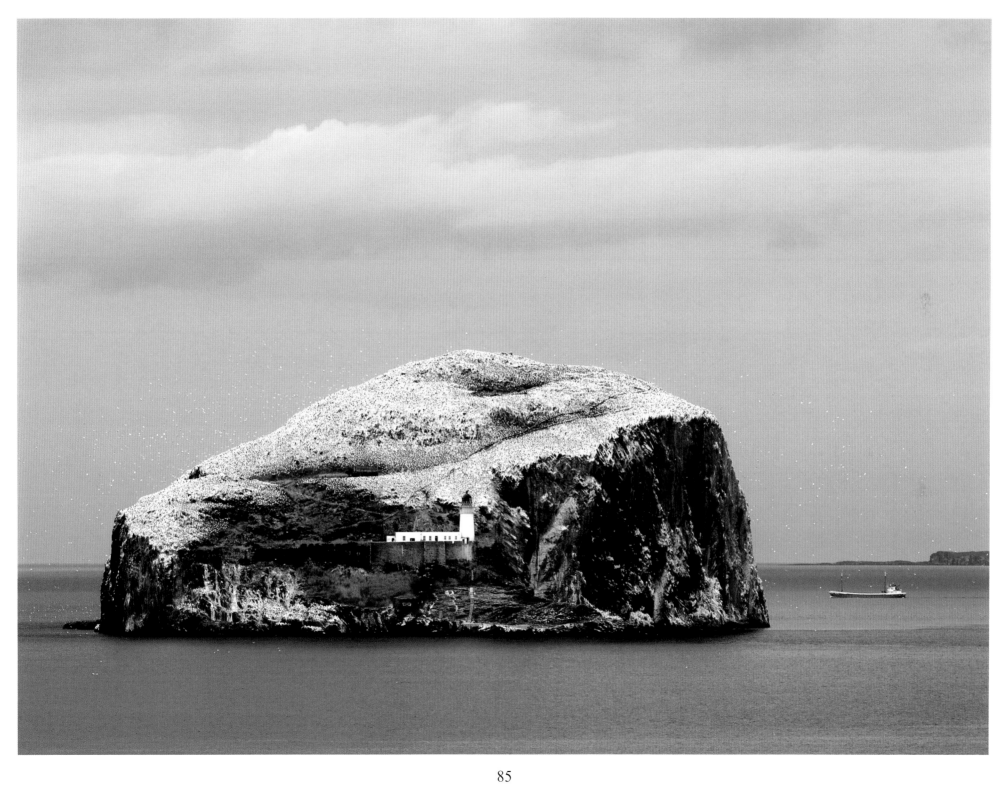

RIGHT: Located 9 miles (14km) west of Edinburgh, the Forth Rail Bridge is a remarkable cantilever structure, regarded as an engineering marvel to this day. Designed by Sir John Fowler and Sir Benjamin Baker, and constructed by Sir William Arrol between 1883 and 1890, it was intended that the bridge should carry the two tracks of the North British Railway over the Firth of Forth, between South Queensferry and North Queensferry, at a height of 150ft (46m) above high tide.

OPPOSITE: Rail tracks approach Waverley Station in front of Edinburgh's Old Town and castle.

PAGE 88: Looking north towards the city centre along the Dalkeith Road at Prestonfield, Edinburgh.

PAGE 89: The Scottish Flag with Nelson's Monument on Calton Hill, Edinburgh.

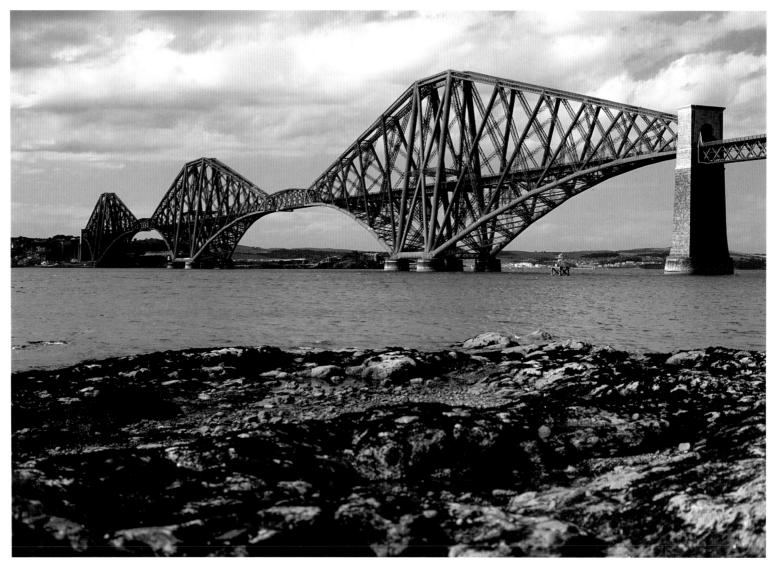

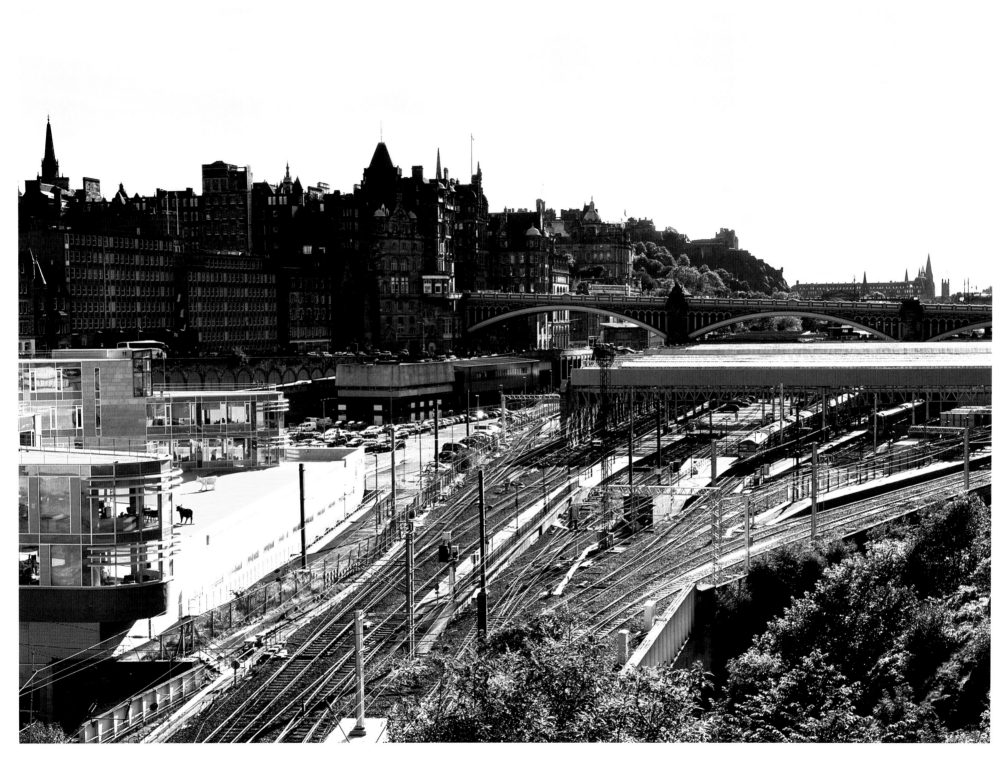

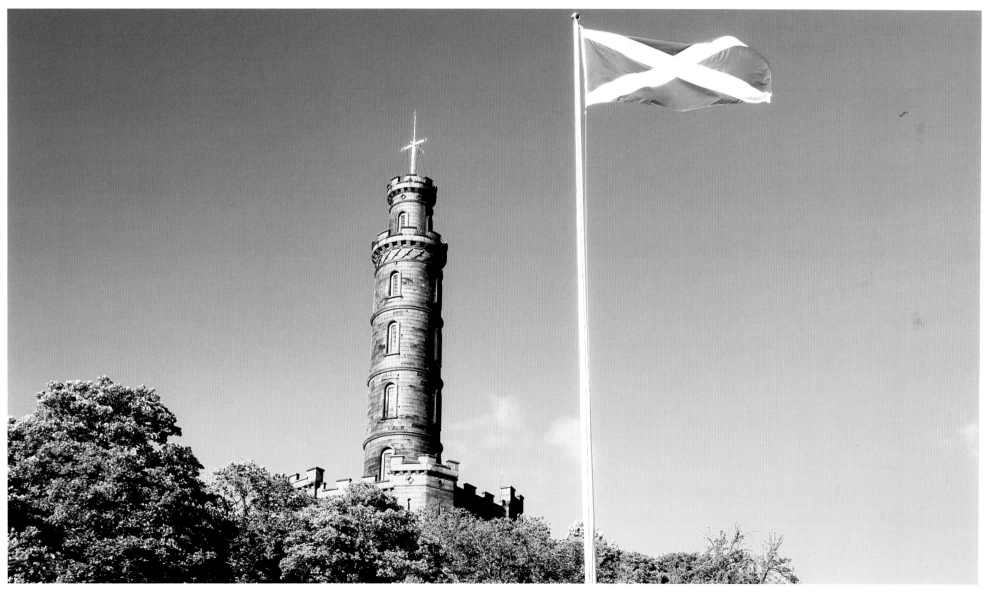

BELOW & RIGHT: The house on the Royal Mile reputed to have been the manse of John Knox, when he was minister of St. Giles'.

.

OPPOSITE: Hamilton's Obelisk and the Governor's House on Calton Hill.

oldest building in the present great edifice (and, indeed, in Edinburgh) being the austerely simple Norman-style chapel built by Queen Margaret, David I's mother, towards the end of the 11th century. Also in Edinburgh Castle is the Scottish National War Memorial; the Crown Room, in which are kept the Honours of Scotland, the crown, sceptre and sword of which is among the oldest royal regalia in Europe; Queen Mary's

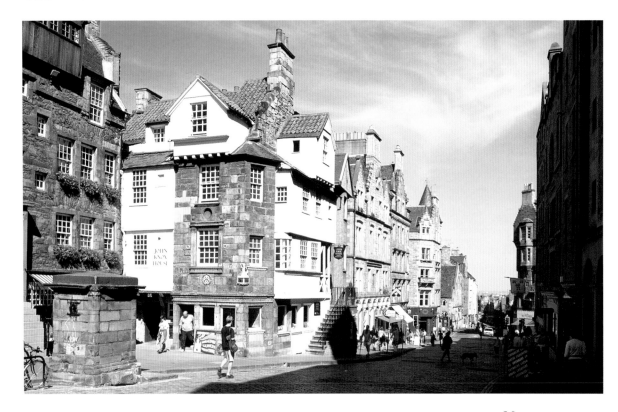

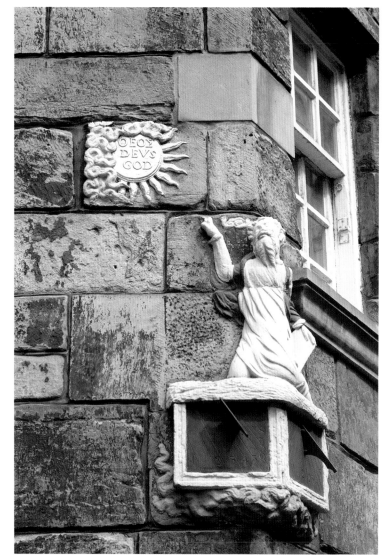

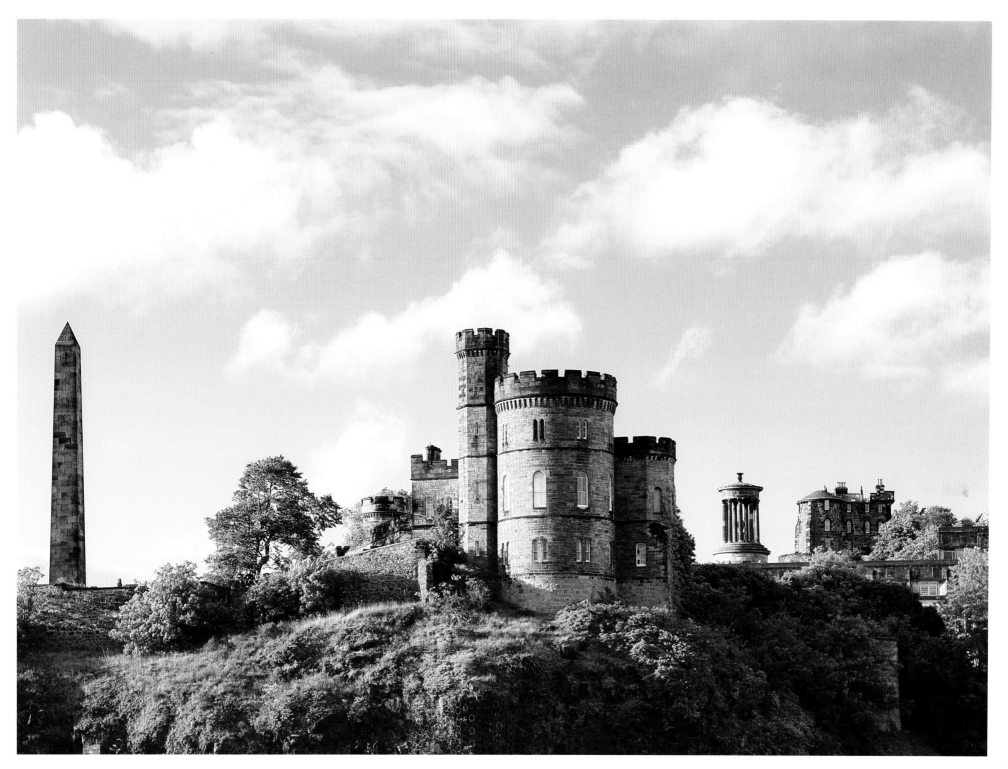

BELOW: The National Monument on Calton Hill.

FAR RIGHT: Detail on a gravestone in Old Calton Cemetery.

OPPOSITE: Looking south-west from Calton Hill towards Edinburgh Castle.

Apartments, of great significance in Scottish history because it was in a small room here that Mary, Queen of Scots gave birth to the son who would combine the crowns of Scotland and England in 1603; and the Old Parliament Hall. The visitor's approach to Edinburgh Castle is by way of the Esplanade, site of the spectacular Military Tattoo, which is a major feature of the Edinburgh Festival every year.

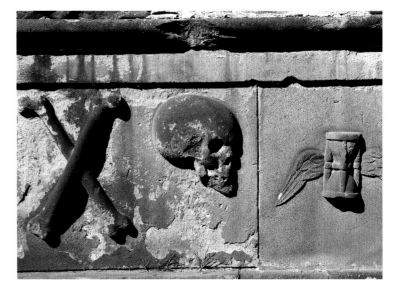

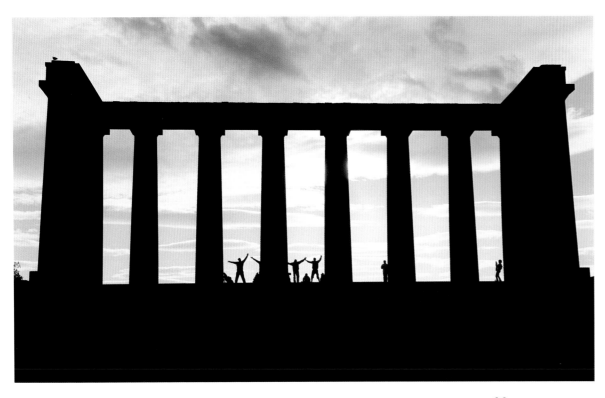

Old Edinburgh, the part growing along and to either side of the route from the castle to the palace, is the Edinburgh around which the Flodden Wall was flung in the panic following the defeat and death of James IV at Flodden in 1513; it is the city which Henry VIII's troops devastated during the 'Rough Wooing', and the Edinburgh of Mary, Queen of Scots and John Knox, of Montrose and Bonnie Prince Charlie, who held court briefly in the Palace of Holyroodhouse in 1745. He never captured Edinburgh Castle, however, and his occupation of the city and palace of his Stuart ancestors was brief. King George IV had better luck, however. He visited Holyroodhouse during his triumphant State Visit to Scotland in 1822, stunning the guests at

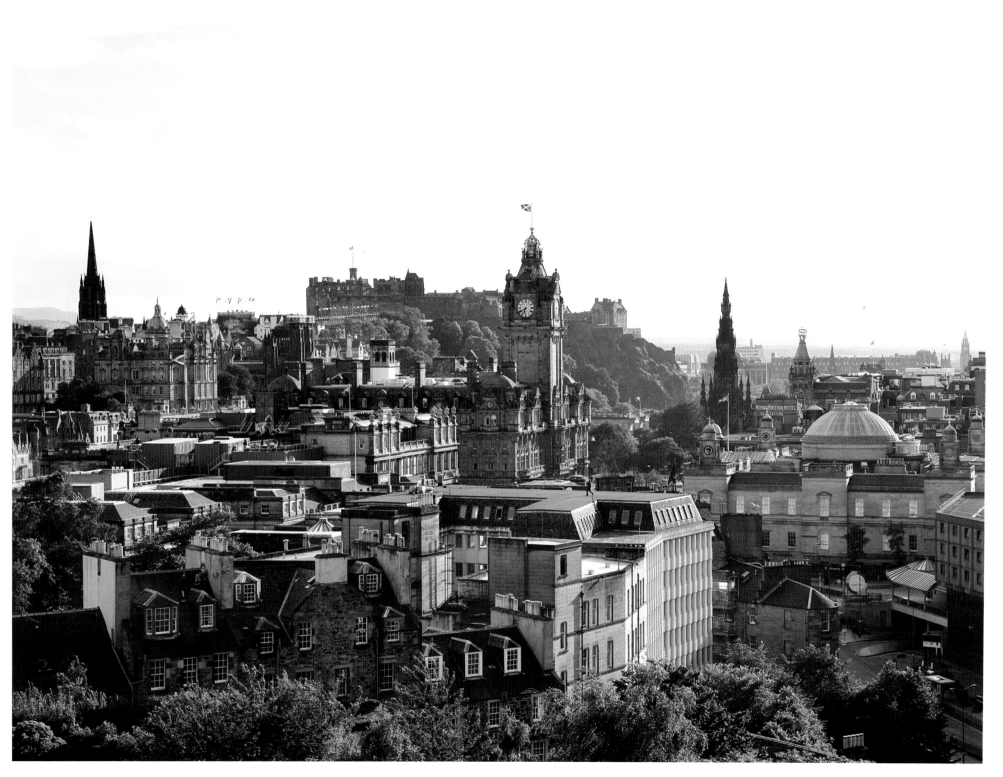

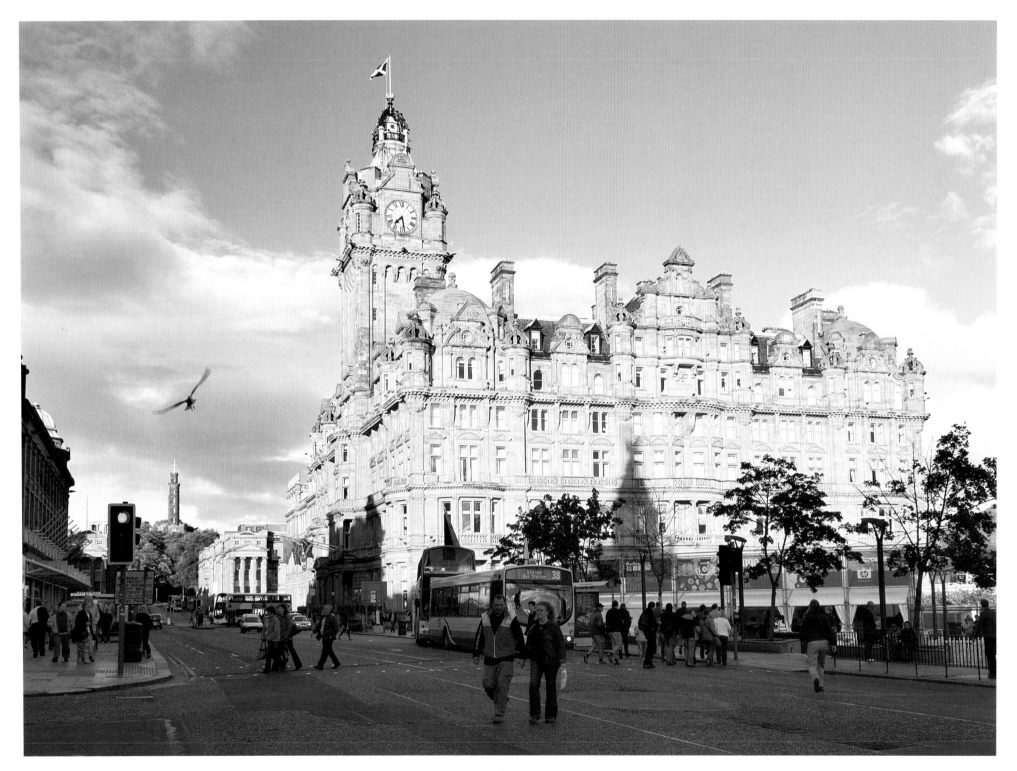

a state ball in the palace by dressing in full Highland rig, complete with Royal Stewart tartan and a pair of pink tights.

Because the Flodden Wall restricted outward building, Old Edinburgh grew tall within its confines, giving rise to the multi-storeyed tenements or 'lands', huddled together in wynds, closes and courts. Tourists still find this area a joy to explore as they wander along the Royal Mile, darting off Lawnmarket to visit Lady Stair's Close and Lady Stair's House, with its relics of the great writers, Walter Scott and Robbie Burns, then popping into St. Giles' Cathedral or visiting John Knox's House off the High Street. More of Old Edinburgh may be discovered by taking the

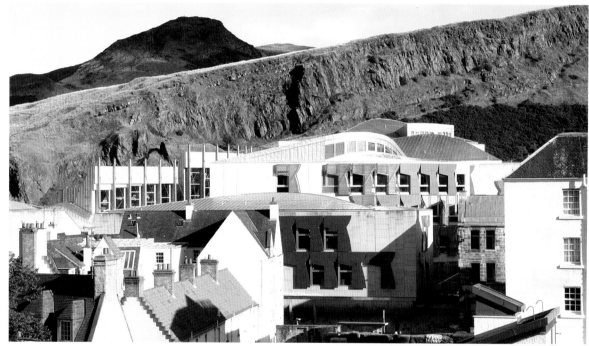

Holyrood Road, which runs south of the Royal Mile back from Holyroodhouse towards Castle Mound. This road becomes Cowgate before it enters the great space of Grassmarket, once the medieval city's main cattle- and hay-market. The area around Grassmarket and Greyfriars Church to the south has seen a considerable amount of modern development, but still retains an atmosphere and style more in tune with the 17th and 18th centuries than the 21st. For a stunningly attractive 18th-century flavour, however, visitors to Edinburgh must make their way to

OPPOSITE: The Balmoral Hotel at the east end of Princes Street.

ABOVE: The Scottish Parliament building at Holyrood, Edinburgh, with Salisbury Crags and Arthur's Seat behind.

FAR LEFT: Wall detail of the Parliament building at the lower end of Canongate, Edinburgh.

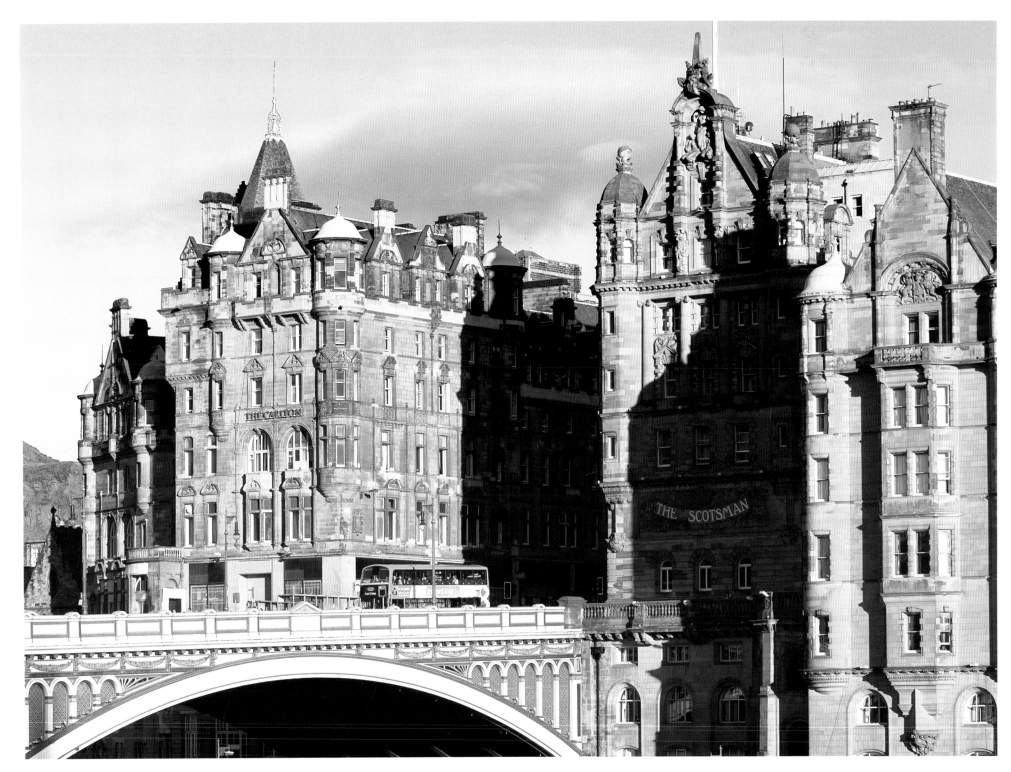

OPPOSITE: Looking south-east from Princes Street over North Bridge to the classic buildings of the Carlton Hotel and The Scotsman newspaper building.

LEFT: A banner advertising an exhibition at the National Gallery of Scotland in Edinburgh's city centre.

PAGE 98: The view south-west from Calton Hill to North Bridge and Edinburgh Old Town.

PAGE 99: Looking north from Calton Hill over Leith Walk to the Port of Leith.

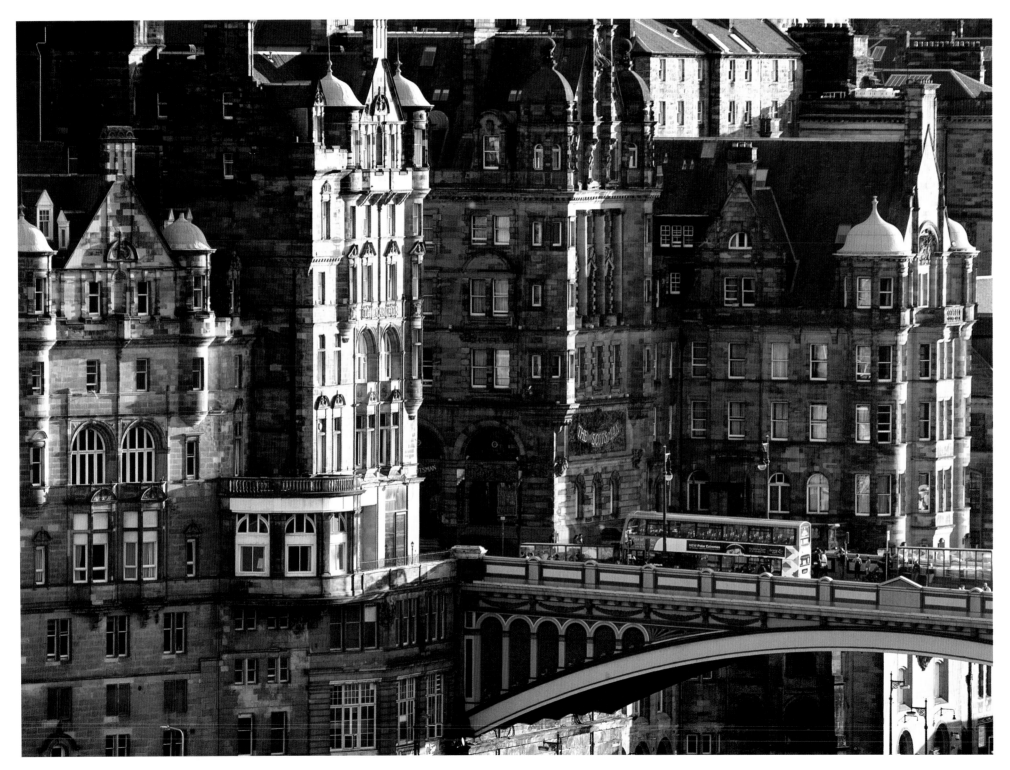

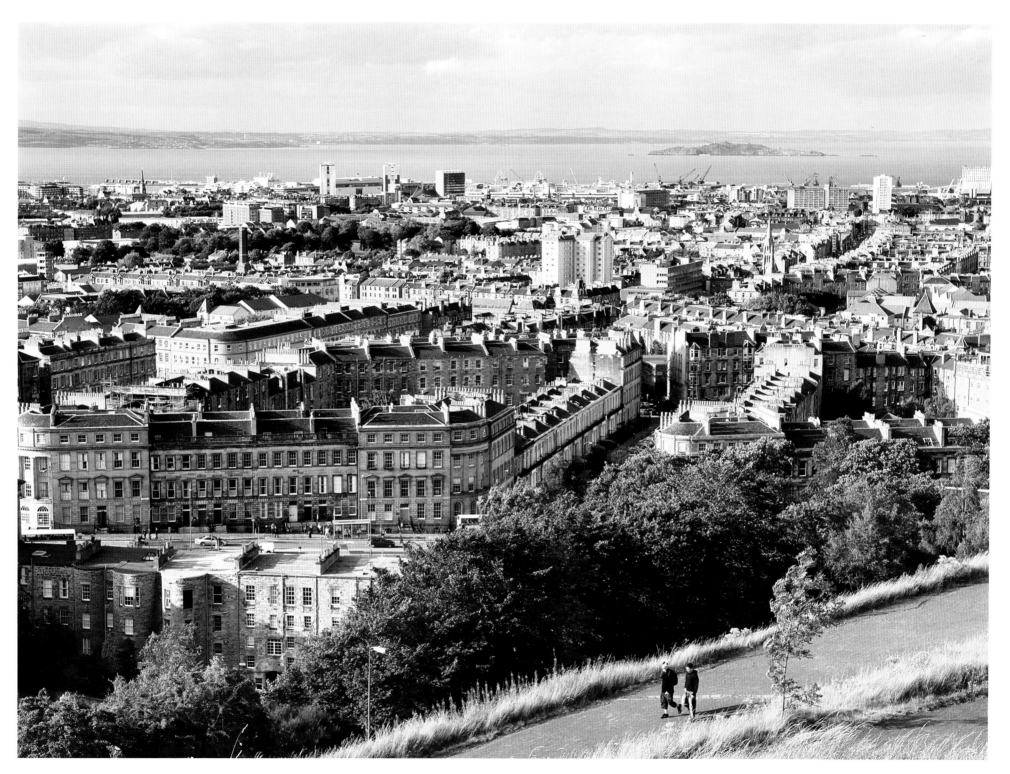

RIGHT: Milne's Court, one of several closes or stepped alleyways leading up through the old multi-storeyed buildings of the Old Town to the High Street and the Royal Mile.

OPPOSITE: The Bank of Scotland, situated on The Mound in central Edinburgh, dates from 1801. It is now the headquarters of HBOS (Halifax and Bank of Scotland Group).

PAGE 102: A garden party takes place in the Palace of Holyroodhouse. Leith Docks can be seen in the distance beyond.

PAGE 103: A view, seen from the north, of the Edinburgh Old Town skyline looking towards the crown of St. Giles' Cathedral.

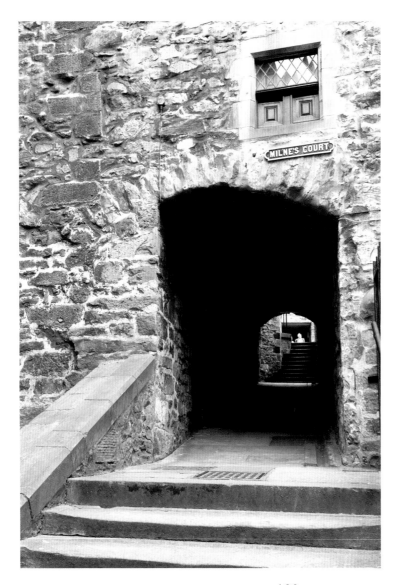

the part of the city north of the Royal Mile, which has been known since it was planned as the New Town. Edinburgh's New Town, conceived by an imaginative Lord Provost early in the 18th century, has been called one of the boldest schemes of civic architecture ever carried out in Europe, helping to give 'Auld Reekie', as Edinburgh has long been called because of its smoking chimneys, the much more elegant tag of 'the Athens of the North'.

The New Town, dominated by two single-sided terraces, Princes Street and Queen Street, with the fine thoroughfare of George Street in between, was laid out on land once known as Barefoot's Park on the far side of the Nor' Loch. Its fine streets and squares, with their elegant Georgian buildings, now housing many of the institutions at the heart of Edinburgh's important financial community, and several fine churches, were completed by the end of the 18th century. Early in the 19th century came the Eastern New Town, built in the Calton Hill area of the city, the names of its main thoroughfares – Royal Terrace, Carlton Terrace, Regent Terrace, Waterloo Place – giving a clear indication of the period of their construction.

The creation of a new Edinburgh in this superbly elegant and distinctly non-fortified style was possible because the country was now at peace. Scotland and England had been united under one crown since 1603 and had been governed by one cabinet and parliament since the 1707 Act of Union. The Jacobite threat,

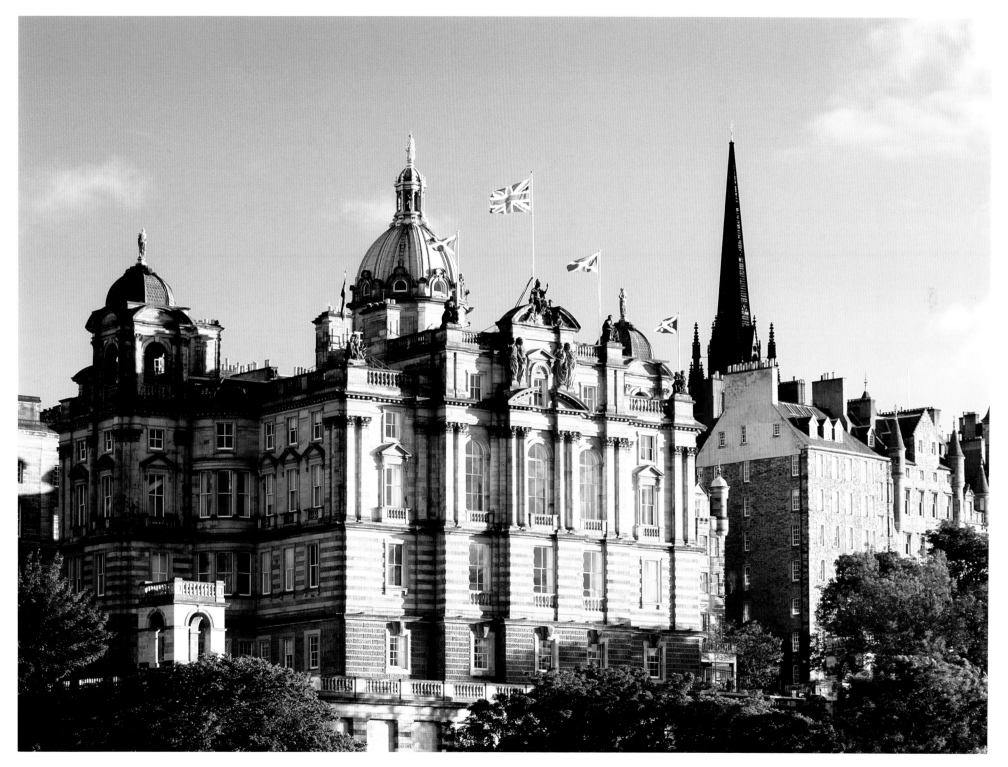

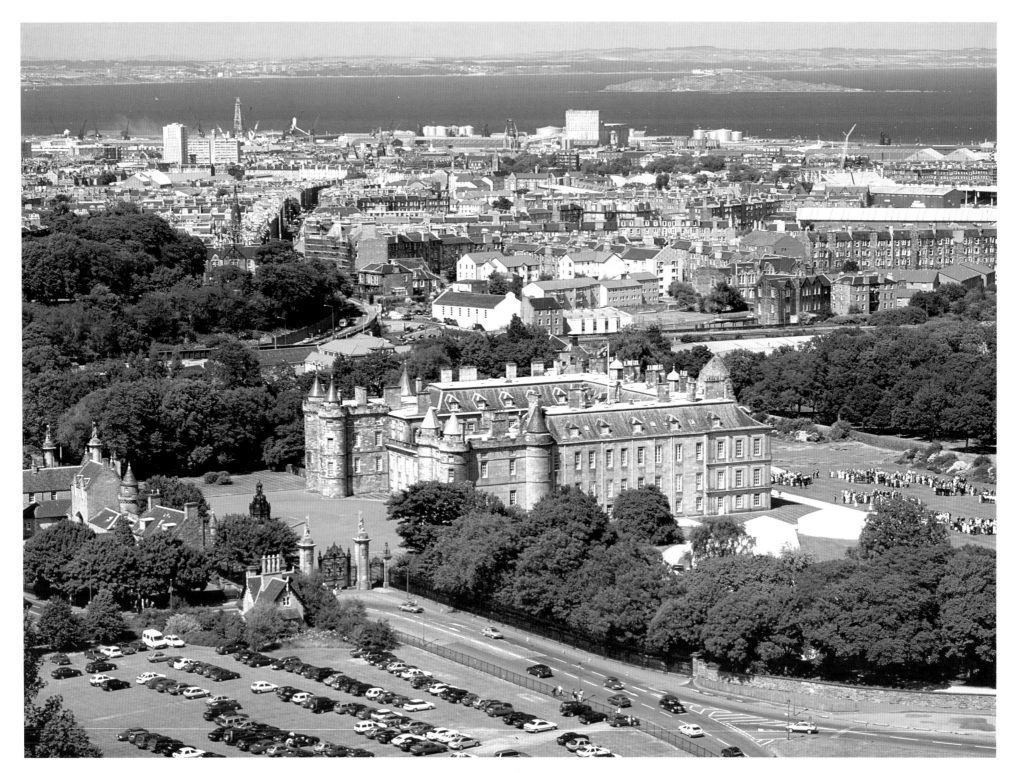

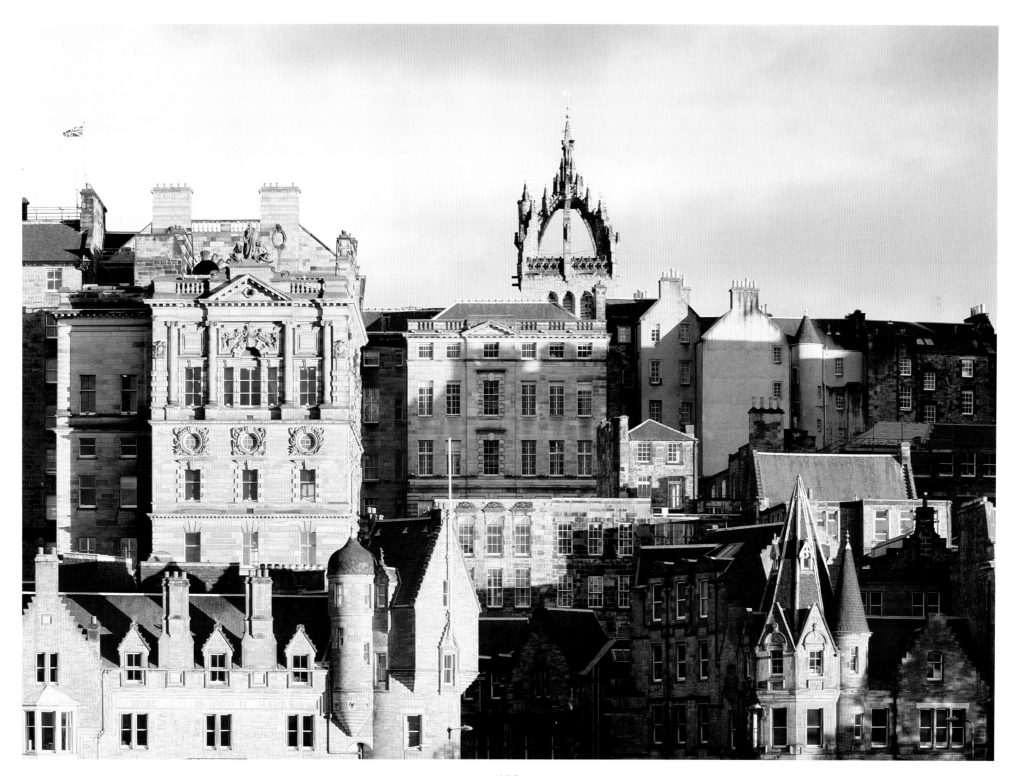

103

RIGHT: Detail of the carved stone entrance to Holyrood Abbey, adjacent to the royal Palace of Holyroodhouse.

OPPOSITE & PAGE 106: Views of the front elevation of the Palace of Holyroodhouse.

PAGE 107: Looking west over the city as an evening flight lands at Edinburgh International Airport. Silhouetted on the right are the cantilever trusses of the Forth Rail Bridge and the suspension bridge that carries one of the main north-south routeways.

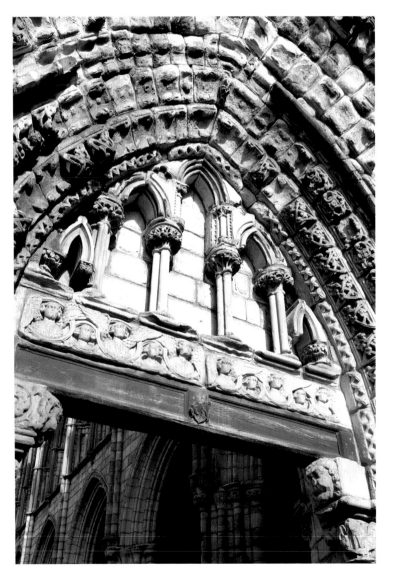

always rumbling away in the background since James VII and II had been forced into exile in 1688, had been seen off forever at Culloden in 1746, although it had all been very different a couple of centuries before. While the kings of Scotland saw Edinburgh as the main seat of their power, they also, with a wary eye on the Border not far enough away to the south, maintained palaces and castles at a safer distance across the Firth of Forth and also to the west of Edinburgh in Lothian.

In West Lothian, in the ancient town of Linlithgow, is the splendid ruin of Linlithgow Palace, where both James V and his daughter, Mary, Queen of Scots, were born. Linlithgow was granted a charter by David I and it was probably a royal residence from that time. The fortified palace was built by James I and it was here that James IV's wife, Margaret, daughter of Henry VII of England, was living when she heard of the death of her husband at Flodden in 1513. From the fine parish church of St. Michael, next to the palace, the bell tolled a gloomy knell for the death of the king and the flower of the Scottish nobility. While the palace is a roofless shell today, accidentally burned down while it was occupied by the Duke of Cumberland's troops in 1746, enough of it remains to give visitors an idea of what life would have been like there in its great days, while St. Michael's Church has been carefully restored and remains one of the finest parish churches in the whole of Scotland.

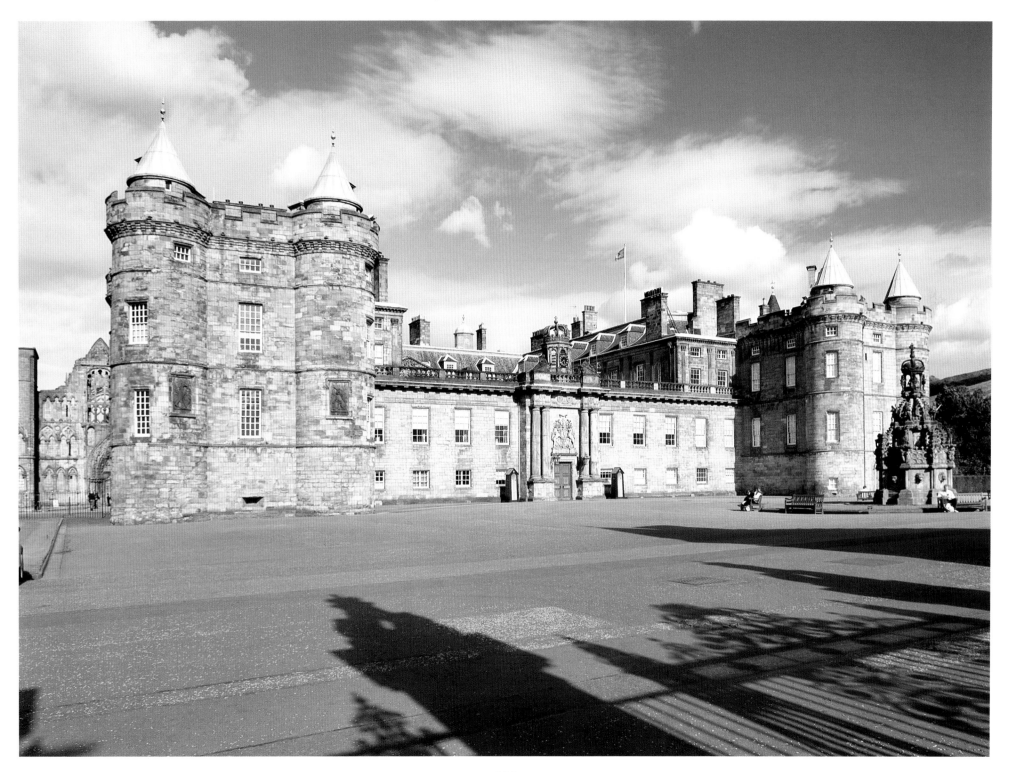

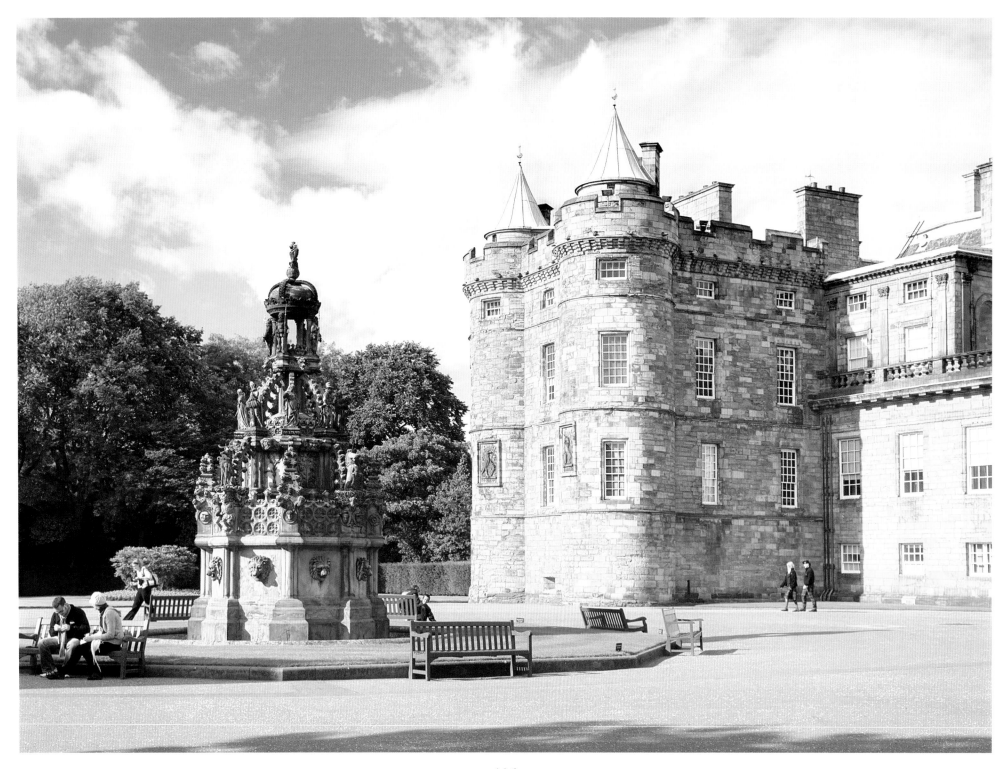

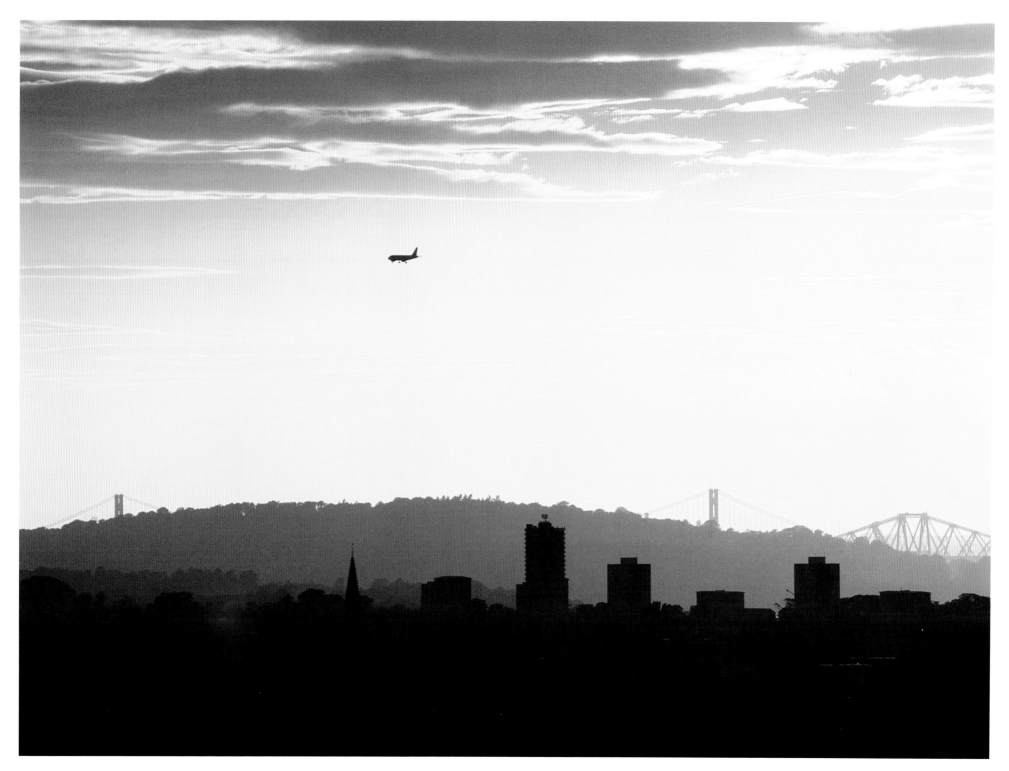

RIGHT: In front of St. Giles'
Cathedral. Living statues are often
seen on the streets of the Old Town
during the Edinburgh Festival.

OPPOSITE: The carved stone
portico at the main entrance to St.
Giles' Cathedral.

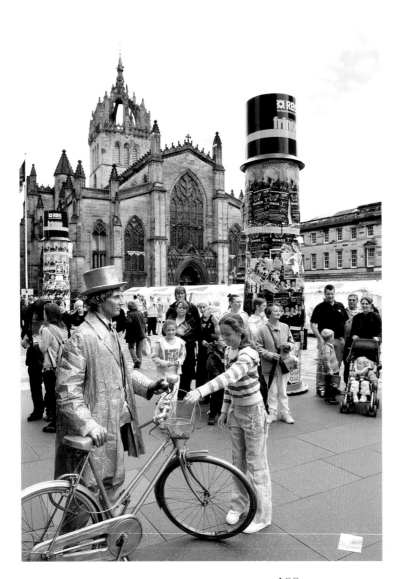

In the country between Linlithgow and Edinburgh to the east lie many fine houses and castles. Prominently set on the Firth of Forth is Blackness Castle, once of such strategic importance that the 1707 Articles of Union specified it should remain fortified, while close by is the House of the Binns, maintained by the National Trust for Scotland. The superb 18th-century mansion, Hopetoun House, seat of the marquesses of Linlithgow, also stands on the shores of the Forth near here, the main part of the house having been the work of Scotland's finest family of architects. William Adam and his son, John, were involved in the creation of Hopetoun House over a period of 50 years, creating a superbly designed setting for fine works of art, including paintings by Rembrandt, Rubens and Titian, and furniture by Thomas Chippendale.

South of Hopetoun House is Kirkliston, where Robert Adam, William Adam's other son, designed the smaller but still elegant Newliston House. A couple of miles away is Niddry Castle, which gave shelter to Mary, Queen of Scots when she escaped from imprisonment in Loch Leven Castle in 1568.

There is also a strong royal connection at Queensferry, a few miles to the east, for this was the site of the ferry which took travellers across the Firth of Forth for 800 years until it was replaced by the two great bridges which now span the Forth upriver from the ferry site. The Forth Rail Bridge (page 86) was opened in 1890 and the magnificent suspension bridge for road

RIGHT: During the day, actors promote their evening performances on the streets of the Old Town during the Edinburgh Fringe Festival.

FAR RIGHT & OPPOSITE: Members of the band, Albannach, Scots-Gaelic for 'Scottish' or 'Scotsman', energetically entertaining crowds outside the Royal Scottish Academy as part of the Edinburgh Fringe Festival.

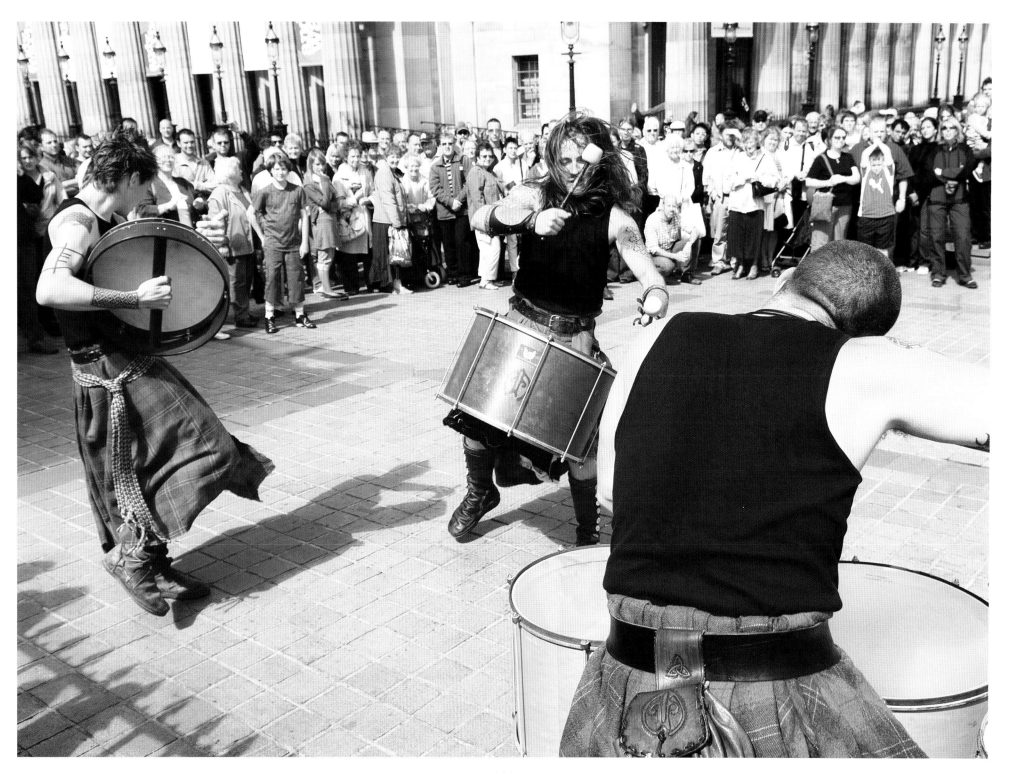

OPPOSITE: Out on the streets during the Edinburgh Fringe Festival.

LEFT: The rock band, Whitefire, playing at The Ark, Waterloo Place, Edinburgh.

traffic in 1964. Queensferry took its name from Queen Margaret (canonized in 1251), who used the ferry many times to get to and from her favourite palace at Dunfermline on the northern shore of the Firth of Forth in the Kingdom of Fife.

Queen Margaret and her husband, Malcolm III, built a palace and a priory at Dunfermline. The palace was occupied by a succession of Scotland's rulers and even, for a time, by Edward I of England, right down to the 17th century when Charles II lived there before marching down to England and defeat at Worcester in 1651. Charles's father, Charles I, and his sister Elizabeth, were both born at Dunfermline, although little remains of the palace that is identifiable, apart from a kitchen; but the great abbey church still stands proudly nearby, sheltering within its walls the remains of Malcolm and Margaret's sons Edgar, Alexander I and David I, and their descendants Malcolm IV, Alexander III, and Robert the Bruce minus his heart, which is said to have been taken on a crusade before being brought back to Scotland for burial in Melrose Abbey.

Today Fife is one of Scotland's local government regions, covering a peninsula of land between the firths of the Forth and the Tay rivers. For many centuries, its geographical position tended to keep the Kingdom of Fife, so-called because Dunfermline had been the home of Scotland's kings from the 11th century, somewhat isolated from the mainstream of Scottish affairs. In our own time, the opening of two road bridges, the

OPPOSITE: The stone carving above the entrance to Jenners Department Store on Princes Street. Dating from 1838, Jenners was the oldest independent department store in the world until it was taken over by the House of Fraser group in 2005.

LEFT: The Church of St. Andrew and St. George on George Street in the New Town of Edinburgh.

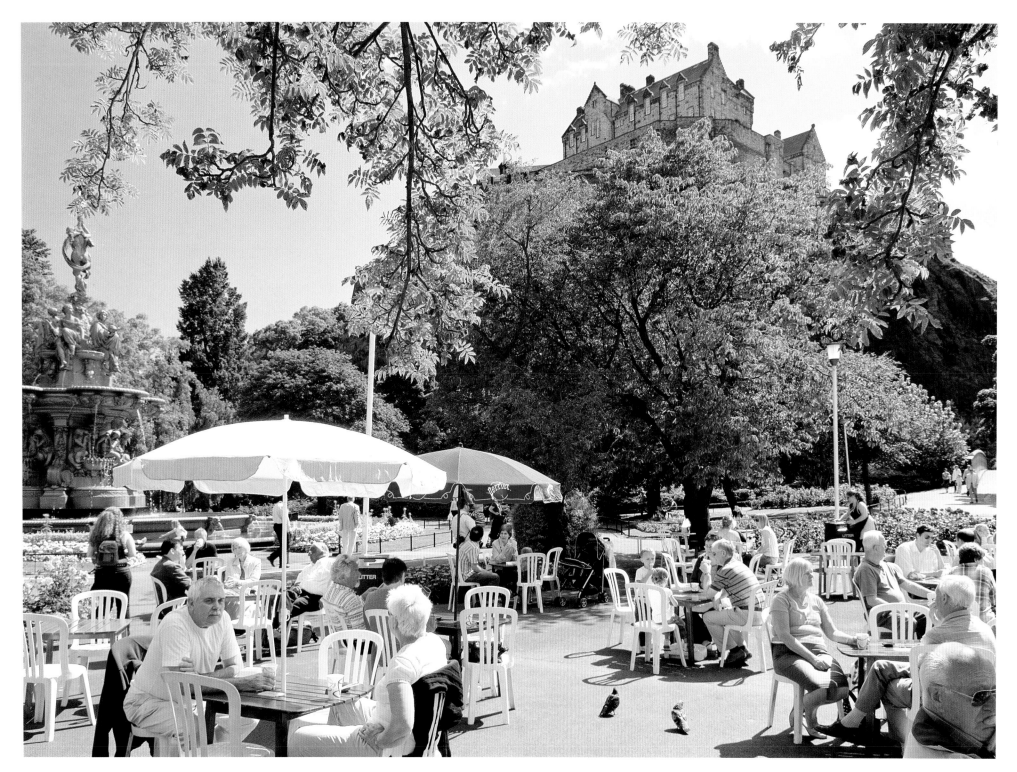

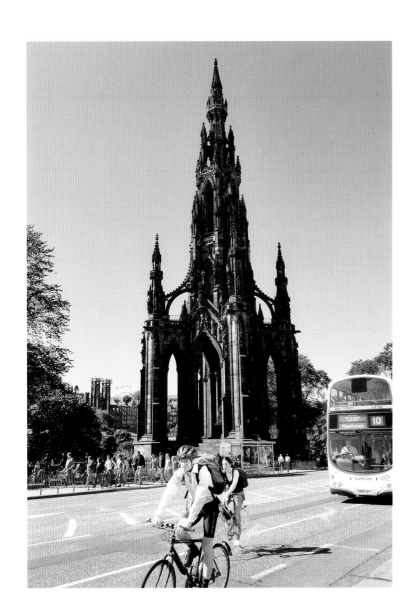

Forth in 1964 and the Tay in 1966, has changed things noticeably, and visitors have been coming in increasing numbers to this country with its fine coastal scenery, attractive holiday resorts and famous golf courses.

Much of Fife is farming country, especially along the agriculturally rich valley of the Howe of Fife, lying at the foot of the Lomond Hills, with stretches of moorland over the higher country. From the holidaymaker's point of view, Fife's most

OPPOSITE: Edinburgh Castle looms over the Princes Street Gardens.

FAR LEFT: The Scott Memorial on Princes Street.

BELOW: Dundas Street in the centre of the New Town.

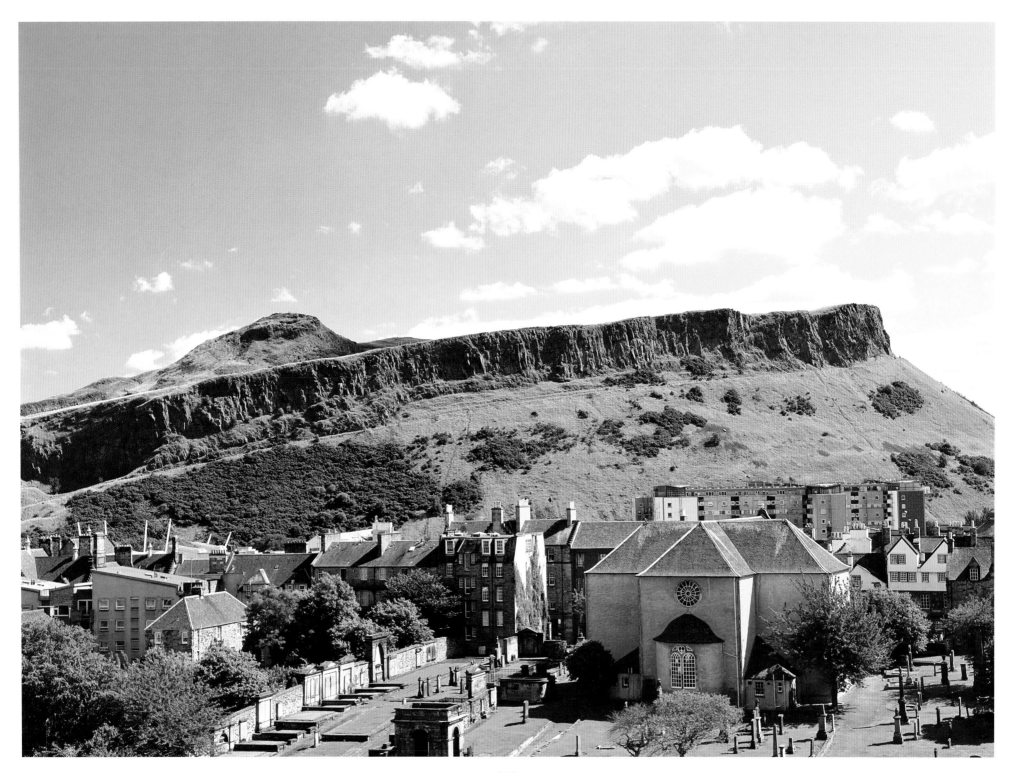

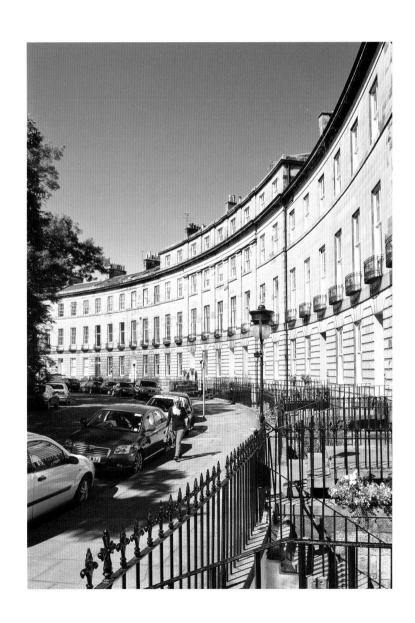

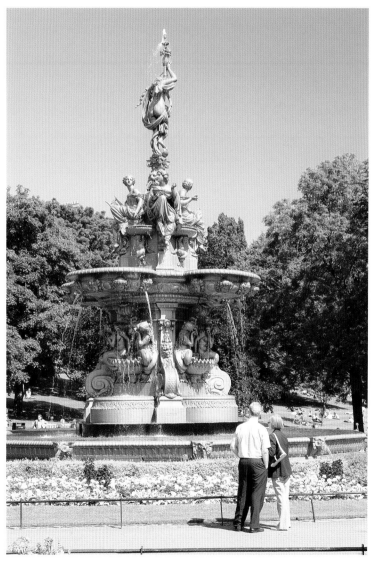

OPPOSITE: Salisbury Crags and Arthur's Seat rise up behind the eastern end of the Royal Mile. The Church of Scotland Canongate Kirk, in the foreground, dates from 1688, its parish including the Palace of Holyroodhouse and the Scottish Parliament. It is also the parish church of Edinburgh Castle, even though it is detached from the rest of the parish.

FAR LEFT: The Royal Circus in the Georgian New Town, designed by Edinburgh's most celebrated classical architect, William Playfair, and built in 1821–23. Playfair was a leading figure in Edinburgh's Enlightenment and designed many of the buildings that gave Edinburgh its most famous views, such as the one across The Mound to Edinburgh Castle and Calton Hill.

LEFT: The Ross Fountain in Princes Street Gardens.

Linlithgow Palace courtyard. The palace was the birthplace of James V and his daughter Mary, Queen of Scots. James V's queen, Mary of Guise-Lorraine, is said to have compared it favourably with the most splendid of France's great palaces.

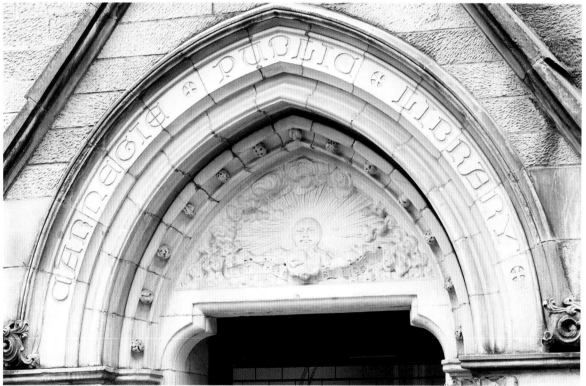

attractive country is the length of coastline at the eastern end of its southern coast, known as the East Neuk, which runs roughly between Elie and Crail, south of Fife Ness. Along here is a string of picturesque old fishing towns which have also become pleasant resorts and artists' colonies.

The main city of Fife is St. Andrews, built around St, Andrews Bay at the eastern edge of the peninsula. St. Andrews

FAR LEFT: Dunfermline, Fife, the historic capital of Scotland.

ABOVE: The carved stone doorway of the original Carnegie Library in Andrew Carnegie's home of Dunfermline.

BELOW: St. Andrews Castle.

RIGHT: The romantic ruins of St. Andrews Cathedral.

OPPOSITE: The Royal and Ancient Golf Club at St. Andrews.

can boast of possessing the oldest university in Scotland, founded in 1410, and the world's oldest golf course, the famous Old Course, scene of many a thrilling British Open. Although golf has been played at St. Andrews for at least 500 years, its famous Royal and Ancient Golf Club dates from only 1754.

St. Andrews' early history was largely church-orientated, so that by the beginning of the tenth century St. Andrews was the

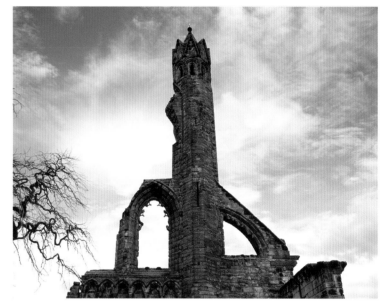

prime bishopric in Scotland. The 15th and 16th centuries saw a good deal of religious strife in St. Andrews, culminating in the burning of a Protestant, George Wishart, at the order of the Roman Catholic Cardinal Beaton in 1546, a deed that was very soon avenged by the murder of the cardinal. By this time, Scottish royalty had begun to make its presence felt in St. Andrews, Mary of Guise having been welcomed to Scotland with much ceremony in the town on the occasion of her marriage to James V in 1538.

Although their daughter Mary, Queen of Scots, visited St. Andrews twice, her longest stay in the Kingdom of Fife was not a happy one. After her hasty marriage to James, Earl of Bothwell in

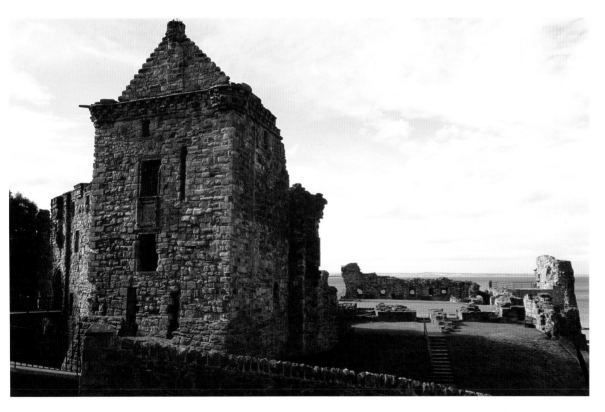

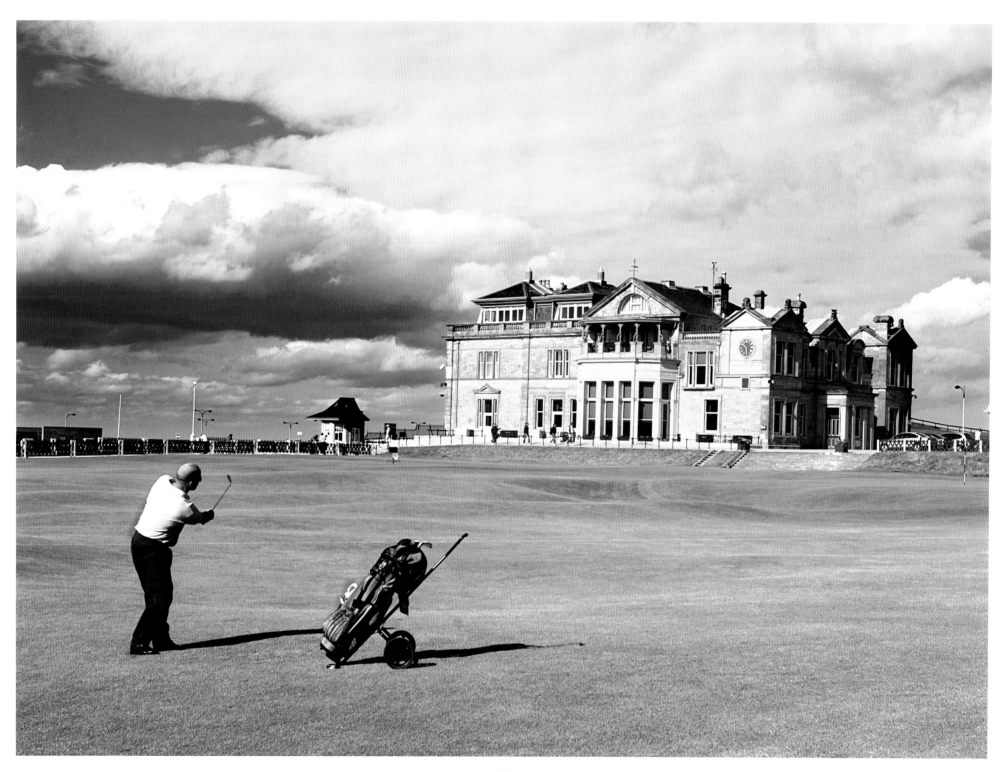

1567 led to her downfall, Mary was imprisoned in a castle in the middle of Loch Leven, at the western end of Fife, where she was kept for nearly a year before managing to make her escape. Today Loch Leven attracts many visitors because of the quality of its fishing, though in the attractive little town of Kinross on the loch's shore, visitors intent on tracing the main events in the queen's ultimately tragic life can arrange summertime boat trips to the castle in the loch.

A few miles north-east of Loch Leven is the picturesque little town of Falkland, where Falkland Palace, now in the care of the National Trust for Scotland, was a favourite royal residence and hunting lodge until James VI's death in 1625.

Although Charles II stayed at Falkland Palace for a time after his father's execution, the palace was later allowed to fall into ruin. It was rescued late in the 19th century by the third Marquis of Bute, who restored it to its early Renaissance glory, complete with beautiful gardens and the oldest tennis court in Scotland, built for James V in 1539.

Quite different from the palaces of Fife is Stirling (page 77), the great castle and royal residence which still dominates the third area of this lowland region, though it has not been used as such since James VI went south to became king of England. The massive bulk of Stirling Castle stands high on a volcanic crag above the Forth, dominating the plain or carse surrounding it. Its position, guarding the ways to Perth and the Highlands over

OPPOSITE: Craigmillar Castle, south-west of Edinburgh. The building of the castle appears to date from the early 15th century, after Sir John Preston had been granted a nearby barony at Gorton by King David II.

FAR LEFT: Set into the wall of Craigmillar Castle is an arrow loop, extended to take a gun barrel at its base.

RIGHT: Loch Leven is a freshwater loch in Perth & Kinross, that is roughly circular in shape. Loch Leven Castle lies on an island a short way offshore, and is where Mary, Queen of Scots was imprisoned in 1567. The island can be reached by ferry, operated from Kinross by Historic Scotland during the summer months.

OPPOSITE: The market place at Falkland, an important town in Scottish history. It was in Falkland Palace, in 1402, that the heir to the throne, David, the eldest son of Robert III, died while a prisoner of his uncle, the Duke of Albany.

PAGE 128: Ruined Hailes Castle, west of Dunbar near Linton, stemmed from an original 13th-century fortified manor.

PAGE 129: Lauriston Castle, originally a 16th-century tower house with 19th-century extensions, overlooks the Forth of Forth to the west of Edinburgh.

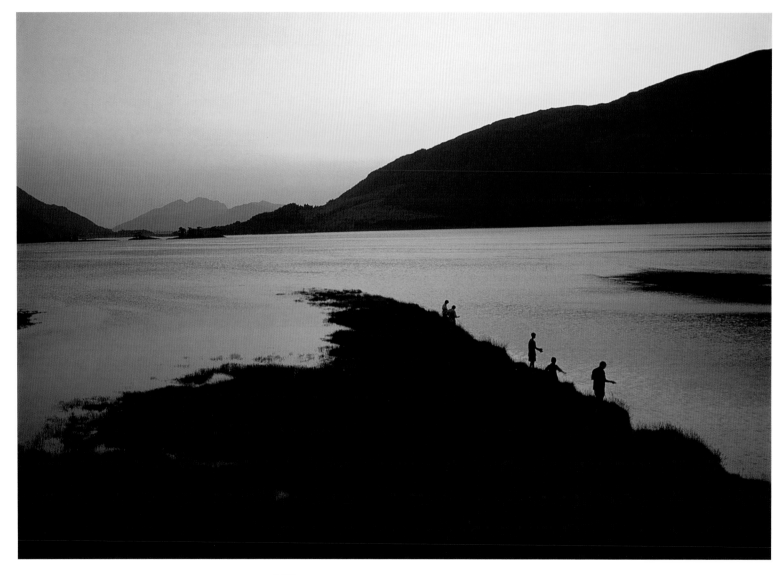

the lowest bridgeable point on the Forth, made the castle of great strategic importance for centuries. In English hands, in 1297, it was recaptured for Scotland by William Wallace at the Battle of Stirling Bridge, only to fall back into English hands a century later.

The castle, which by the end of the 18th century had fallen into such a state of disrepair and neglect that Robbie Burns was moved to comment on it in several scathing lines of verse in 1787, has been carefully restored to its former splendour, as befits a castle in which James II was born and in which Mary, Queen of Scots, was crowned at the age of nine months.

The view south from Stirling Castle is towards Bannockburn, 3 miles (5km) away, where, in 1314, Robert the Bruce routed the greatly superior forces of Edward II of England, recapturing Stirling Castle from the English who had held it for ten years, and securing Scotland's independence from then on. The 58-acre (23-hectare) battlefield site, despite being on relatively uninteresting land edged by modern housing estates, is now a major tourist attraction, where the National Trust for Scotland provides excellent displays detailing the course of the battle. The heroic statue of Bruce on his horse, set where his command post during the battle is thought to have been, is a modern one, and was unveiled by Queen Elizabeth II in 1964.

William Wallace's heroic life, including his earlier victory at Stirling Bridge and his successes in clearing the English out of

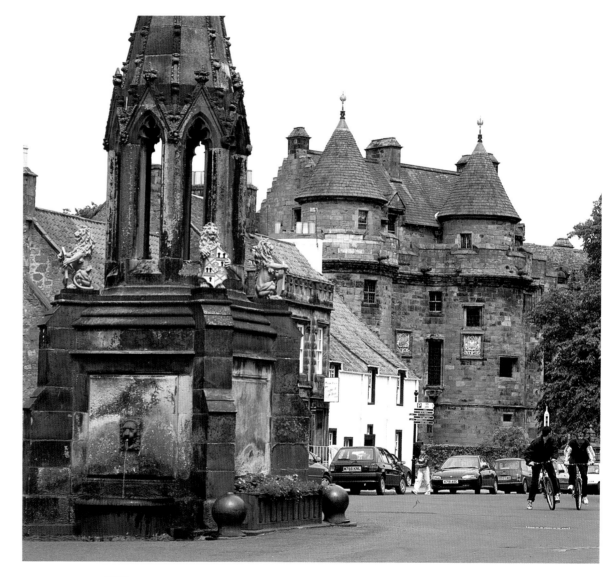

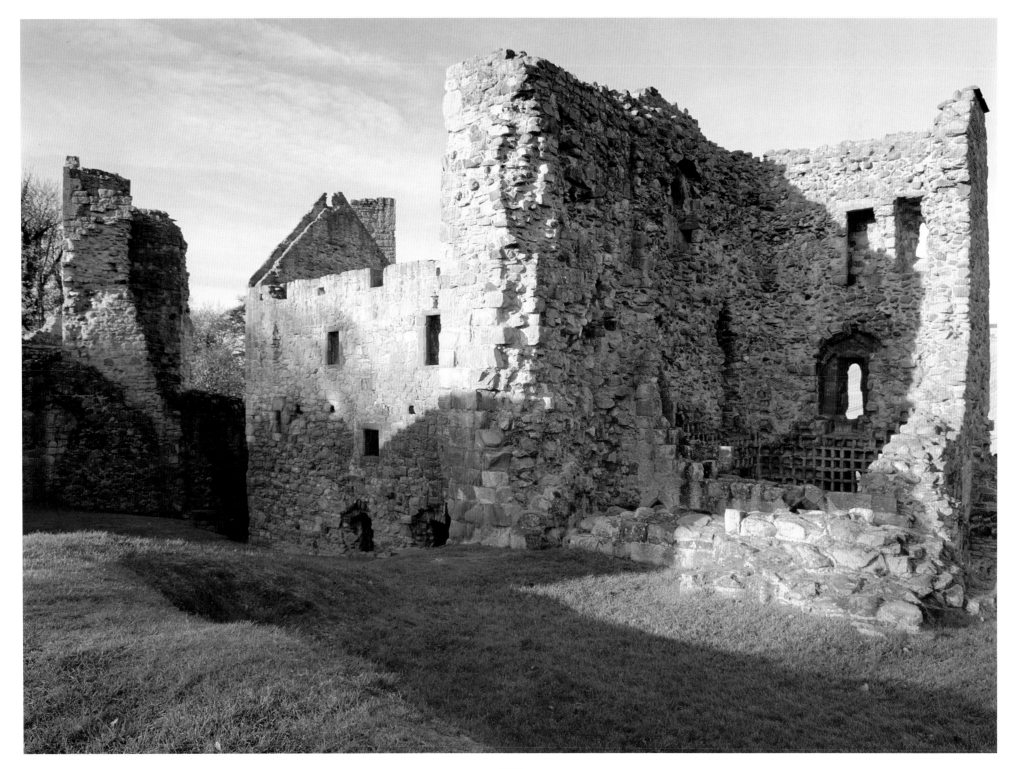

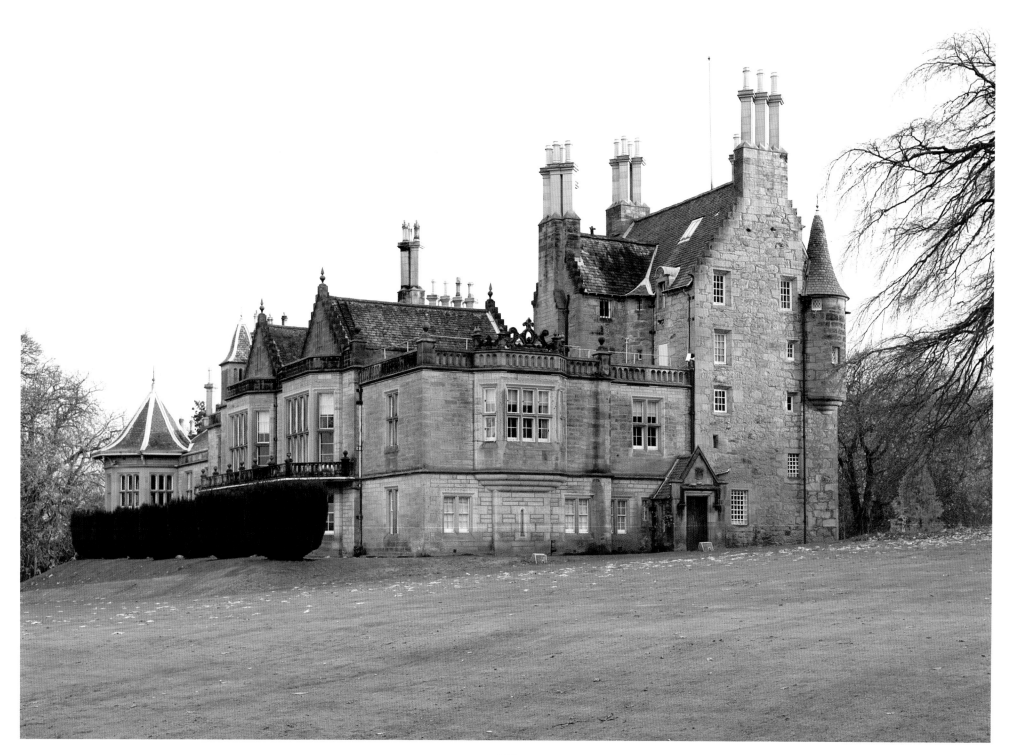

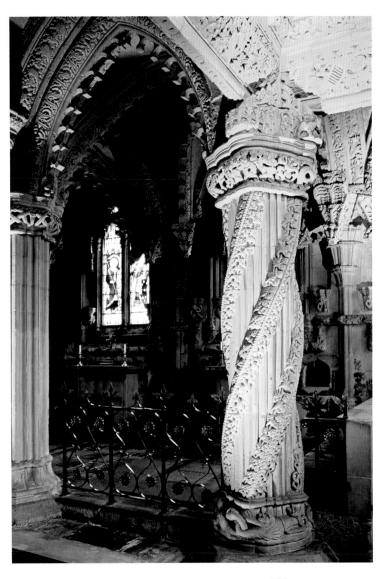

The ornate 'Aprentice Pillar', part of the elaborate stone carving in the beautiful 15th-century Rosslyn Chapel in the village of Roslin, Midlothian, 7 miles (11km) south-west of Edinburgh. The chapel has been linked with the Knights Templar and the legend of the Holy Grail, and has become more popular with visitors since Dan Brown's book, The Da Vinci Code, *was published.*

Perth and Lanark, as well as his execution in 1305, are also remembered in a monument. This is the Wallace Monument at Abbey Craig, near Bridge of Allan, a village whose rural charms so pleased Robbie Burns, after his disappointment at Stirling, that he was inspired to write there one of his best-known songs, 'The Banks of Allan Water'.

Bridge of Allan became a popular spa in the 19th century, which perhaps helps to explain why the Wallace Monument, built in 1870, is in such an over-ornate Victorian style. It is worth visiting, however, not only for having on display what is said to be the great patriot's two-handed sword, but also for the views from the top of the tower of the country over which Scots and English fought for so long. To the north are the southern slopes of the Ochil Hills, with Perth away to the north beyond, while to the south the land stretches away to the Firth of Forth where it is sometimes possible to see the flare-stacks of the petrochemical works at Grangemouth.

SCOTLAND'S KINGS & QUEENS

The earliest people to settle in Scotland had no rulers. They were migrants from the Mediterranean region or from the western seaboard of Europe, who first appeared in around 3000 BC. By the time the Romans reached Scotland, about 80 years after the birth of Christ, the country was populated by tribes from many parts of Europe.

The Romans penetrated far less into Scotland's life than they did England's, leaving no fine network of roads or long strings of forts around which market towns might grow up. By the time they retreated in AD 185, not much more remained to mark their passage than a few Lowland forts and the wall which the Emperor Antoninus Pius ordered to be built between the firths of the Clyde and Forth rivers.

The fourth century AD saw

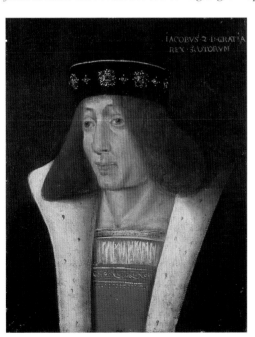

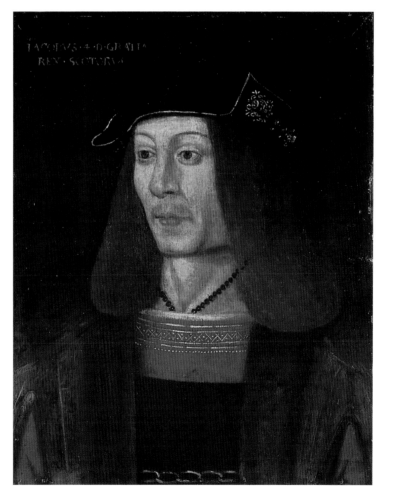

FAR LEFT BELOW: James II. Just six-years-old when his father was murdered in 1436, James II's early years as king were marked by feuding between Scotland's nobles and the boy's mother for his control. Once he was able to gain power, however, he ruled wisely and well. He was killed in 1460, besieging Roxburgh Castle.

LEFT: James IV. As with James II, the murder of his father brought James IV to the throne while he was still a boy. As ruler, he proved effective but was unable to avoid quarrels with the English, despite his English wife, a daughter of Henry VII. His death at Flodden in 1513 was a tragedy for Scotland.

more invasions of Britain by Picts, Scots, Saxons and Franks and the coming of Christianity to Scotland, with St. Ninian founding a church at Whithorn in 397. Gradually, the various tribes in mainland

RIGHT: Mary of Guise. A daughter of the Guises, Dukes of Lorraine, Mary became Regent of Scotland in 1554, her husband James V having died in 1542 when their daughter was less than a year old. Her dependence on French support roused Scotland's Protestant nobles to rebellion, which continued into her daughter's reign.

FAR RIGHT: Mary, Queen of Scots. Scotland's most romantic queen, Mary ruled Scotland for less then six years before she was forced to abdicate in favour of her son, who became James VI (James I of England). Seen as a Catholic threat to the Protestant English throne, Mary spent many years imprisoned in England before being executed in 1587.

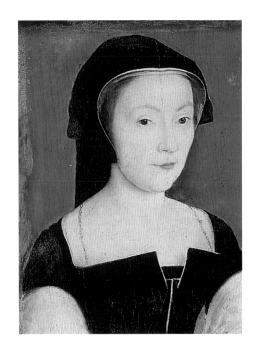

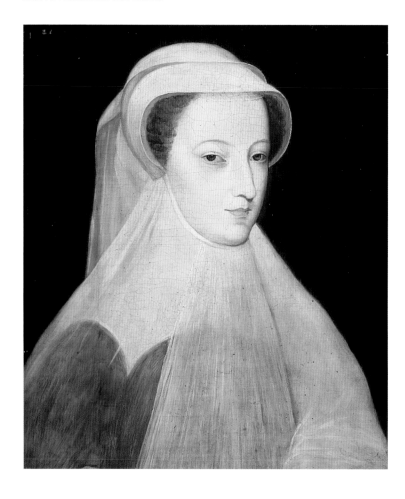

Scotland came together into four kingdoms; in the north were the Picts, a red-haired people who may have been descended from Celts and an earlier people. In the west, around present-day Argyll, were the Scots, Gaelic-speaking Christians who had come from Ireland with St. Columba in the sixth century, and who called their kingdom Dalriada. Also in the west and south were Britons, mostly from Wales, while in the south and east were the same Germanic Angles who had moved into northern England, and whose kingdom was called Bernicia or Lothian. Round about the eighth century, Norsemen from Scandinavia moved into the Hebrides, Orkney and Shetland.

While the Norsemen remained in the Hebrides until the 13th century and, in name at least, in Orkney and Shetland until the 15th century, the kingdoms on the mainland had begun to merge. First, in the ninth century, the Picts and Scots united under Kenneth I (Kenneth MacAlpine), the new kingdom being called first Alba, then Scotia. When Malcolm II of Scotia joined his kingdom with Lothian in the 11th century, he became the first king of a largely united mainland Scotland.

A CELEBRATION OF SCOTLAND

Malcolm II's grandson, Duncan, who reigned from 1034 to 1040, completed the unification of the Scottish kingdoms when he inherited Strathclyde. As William Shakespeare has ensured we all know, Duncan was murdered by Macbeth; contrary to what Shakespeare would have us believe, however, Macbeth ruled Scotland quietly and well for 17 years before he, in turn, was murdered by Malcolm III, called Malcolm Canmore (meaning 'Big Head').

Malcolm's consort was an English princess, the saintly Queen Margaret, whose influence on Scotland's religious and political life was profound. Their three sons, who ruled Scotland in succession, very much in the style of the Normans in England, were all pious Christians in an English rather than a Celtic sense and were English-speaking. Although the anglicization of the Scottish court and the Scottish Lowlands had begun, relations between Scotland and her southern neighbour were becoming increasingly difficult, partly because of disputed claims to the feudal overlordship of lands on both sides of the border.

The last king to rule Scotland in direct line from Malcolm III was Alexander III, during whose long reign in the 12th century Scotland knew a period of prosperity and political stability. When Alexander III died in 1286, his heir was his infant granddaughter, Margaret, the 'Maid of Norway'. In the wings, as it were, were another dozen or so claimants to the throne, including John Balliol and Robert the Bruce. In England, meanwhile, Edward I saw a

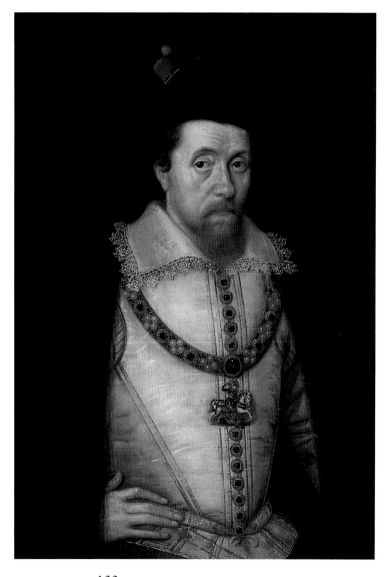

James VI (James I of England). A weak man who ruled through his favourites, James VI's mixture of well-read scholarship and political foolishness earned him the tag 'the wisest fool in Christendom'. Under his rulership, the thrones of Scotland and England were finally united in 1603.

George IV. The first of the Hanoverian kings to make anything of his Scottish blood, however diluted, George IV's State Visit to Scotland in 1822 set the seal on the revival of Scotland's cultural life after the low point of the defeat of the Jacobite cause at Culloden.

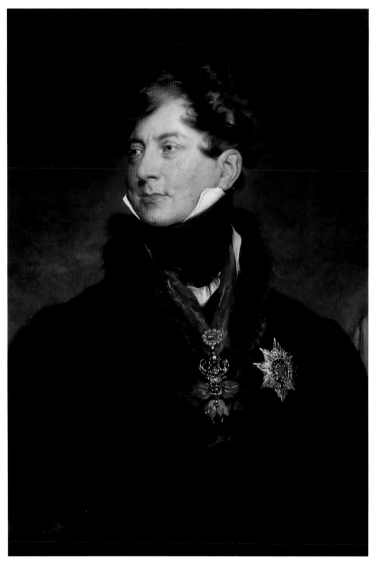

golden opportunity: he agreed to guarantee Margaret's succession to the throne of Scotland in return for her betrothal to his son, Edward. Unfortunately, Margaret died on her way home to Scotland from Norway in 1290 and the chance to unite the crowns of Scotland and England without war or bloodshed was lost. Edward I of England's attempt to force himself on Scotland as the country's feudal overlord, appointing John Balliol as his vassal king, led to a period of Scottish resistance which ended in success for Scotland in battle at Bannockburn in 1314 and then in the political Declaration of Arbroath in 1320, though it was some time before the English crown finally gave up its claims to Scotland. The victor at Bannockburn, Robert the Bruce, was confirmed in his position as king of Scotland.

But Robert the Bruce's son, David II, was a weak king and a period of struggle between the crown and various powerful families, some of which called on the English king for support, now descended on Scotland. The first of the Stewarts to mount the throne, in 1371, was David II's nephew, Robert, son of Robert the Bruce's daughter Marjorie Bruce and Walter the Steward. Under the Stewarts, who changed the spelling of their name to 'Stuart' during the reign of Mary, Queen of Scots, the Orkney and Shetland islands were integrated into Scotland after the marriage of James III to Margaret, the daughter of Christian I of Norway and Denmark in 1468; apparently Christian could not afford to pay his daughter's dowry, so ended up pledging the islands instead.

The Stuart period in Scotland was not without turmoil, in that so many of the Stuart kings died or were killed while still young, leaving as their heirs infants over whom rival powerful families tried to assert their authority. James I was assassinated at Perth, James II was killed by an exploding cannon while besieging Roxburgh Castle; James IV was killed at Flodden, pursuing a pro-French and anti-English policy; and James V also died young after another defeat at the hands of the English at Solway Moss in 1542. His heir, his daughter Mary, was just nine-months-old when she was crowned queen in Stirling Castle. A belligerent attempt by Henry VIII to marry his son Edward to Mary caused the Scots to turn to France for support and five-year-old Mary was sent to France, where she was given a classical education and where she married the Dauphin of France in 1558.

James V's prophecy, expressed on his death bed, that the Stuart line, which had begun with a woman (Marjorie Bruce) would also end with one, was not fulfilled. Despite proving herself quite unsuited to the task of ruling Scotland, Mary, Queen of Scots was forced to abdicate in favour, not of some suitable, preferably Protestant Scottish lord, but of her infant son, James. This Stuart, the sixth to be called James, turned out to be both long-lived and capable of siring healthy children. There is still Stuart blood to be traced in the present royal family: when George of Hanover became King George I in 1714 on the death of Queen Anne, the last of the House of Stuart, it was because he was a

direct Protestant descendant of James VI and I through James's daughter, Elizabeth of Bohemia.

CHAPTER THREE
THE HIGHLANDS: THE NORTH-EAST

RIGHT: Standing on a rocky spur overlooking the River Tay is Broughty Castle, a 15th-century estuary fort. It lies east of Dundee at Broughty Ferry, a fishing village that was once the terminus for ferries crossing the Firth of Tay until the bridges were built. Besieged by the English in the 16th century and attacked by Cromwell's army under General Monk in the 17th, it was restored in 1861 as part of Britain's coastal defences.

OPPOSITE: Queen's View, overlooking Loch Tummel, a long, narrow loch located north-west of Pitlochry in Perth & Kinross. This is one of Scotland's most celebrated vantage points, where the panorama of lake and mountain scenery can even include the distant hills of Glen Coe on a clear day. Some claim the view was named for Queen Isabel, the wife of Robert the Bruce, but it is more likely to have been Queen Victoria, who came here in 1866.

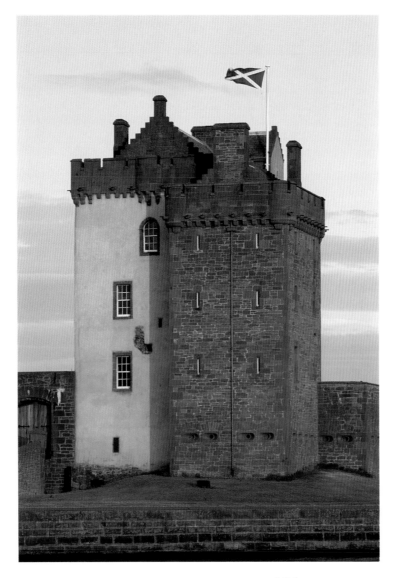

The great triangle of land, its apex jutting out into the North Sea, which makes up the north-eastern part of Scotland, is a country of infinite variety. There is fine hill and mountain scenery, dominated by the Grampians and the Cairngorms; there are lovely vistas of rolling hill country, providing rich agricultural land in the northern counties of Banff, Moray and Buchan, and in Aberdeenshire, Perthshire and Angus. There are beautiful straths, glens and valleys watered by many burns and rivers, including the Dee, the Don and the Spey in the north-east, and the rivers of the Tay basin to the west, the quality of the fishing attracting anglers from all over the world. The quality of the river water itself has for centuries provided the basis for some of Scotland's most famous whisky brands, both malts and blends; in Perth are distilleries whose products carry the labels of some of the world's best-selling whiskies, while the distilleries of the Spey valley are so famous that a Malt Whisky Trail has been devised to guide visitors around a selection of them.

This part of Scotland is also blessed with many of the country's most beautiful lochs, celebrated in song and poetry. Loch Earn, west of Perth, is one of the most popular with Scottish holidaymakers, for it is within easy driving distance through the attractive countryside of Glasgow, Edinburgh and Stirling. Further north, the glorious long and narrow Loch Tay, a classic 'ribbon loch' famous for its salmon-fishing, is set in an attractive region of small farms, dotted with woodland and, in

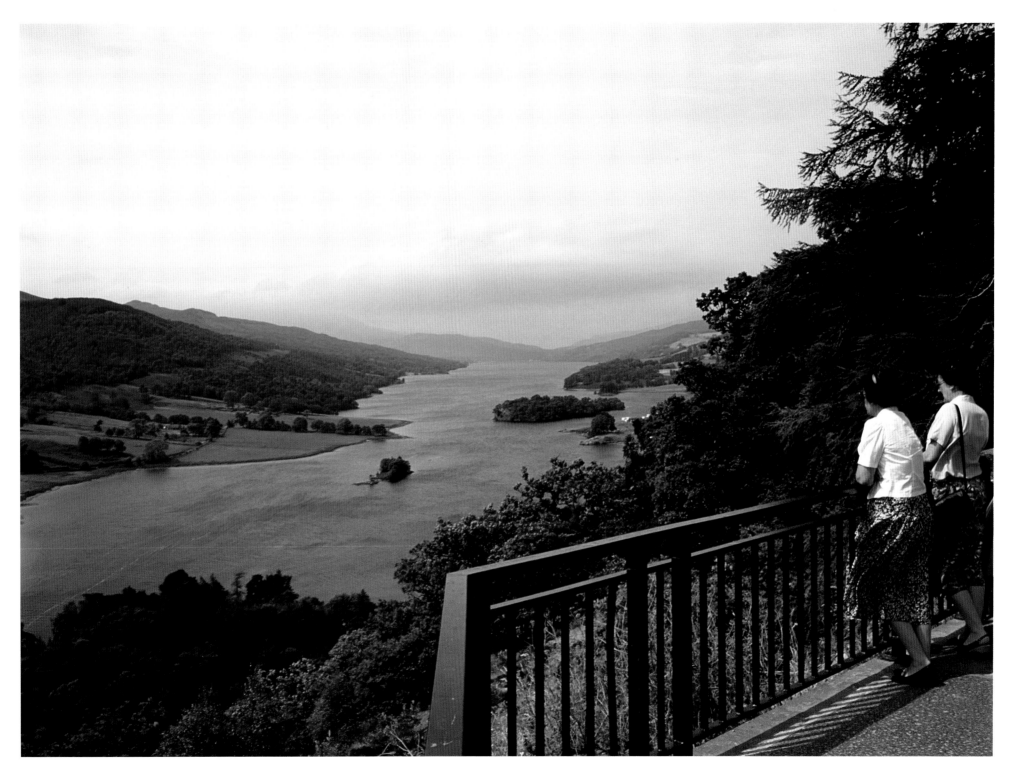

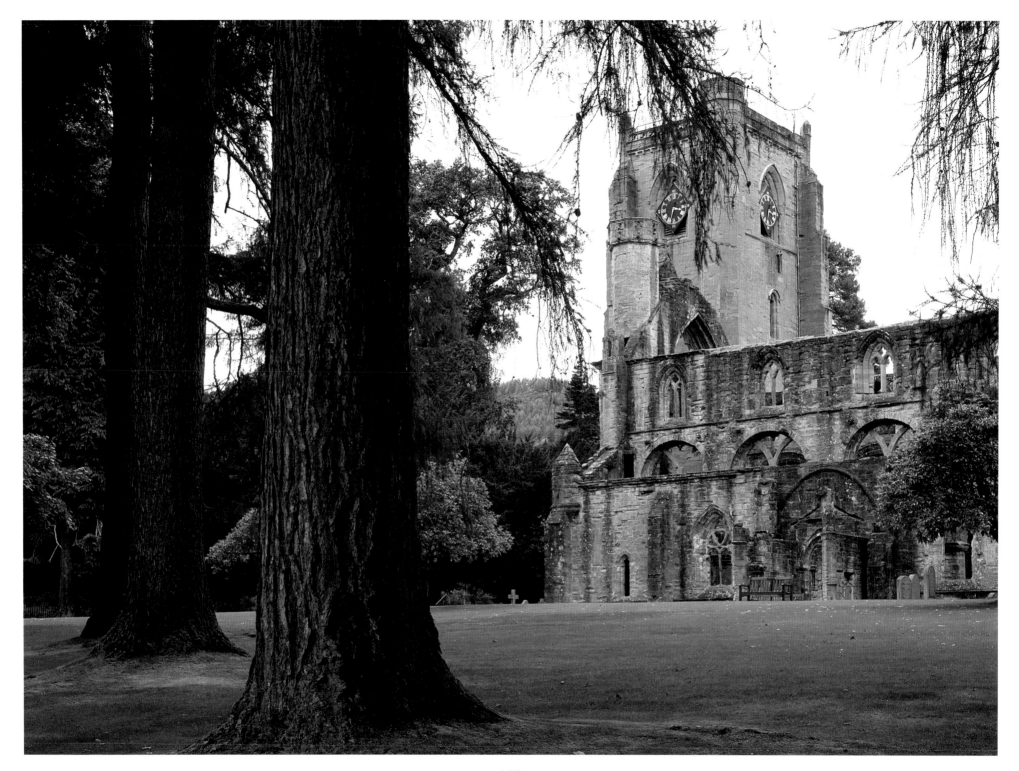

138

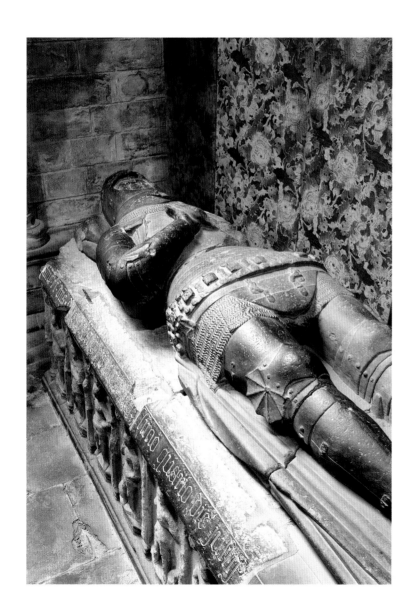

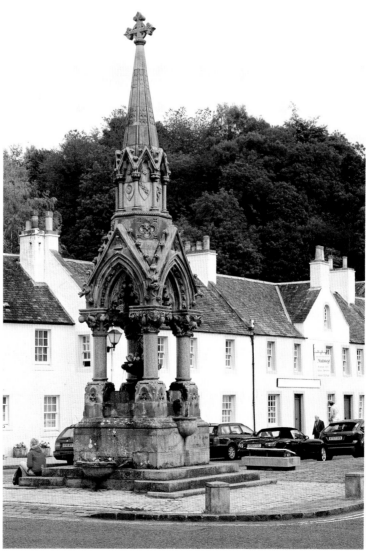

OPPOSITE: Dunkeld Cathedral, in Highland Perth, was begun in the 13th century on the site of a monastery dating from the sixth century. This was rebuilt in stone by Kenneth MacAlpine, King of the Scots, in 848, who made Dunkeld head of the Celtic Church and capital of the newly-formed nation created by the union of the Scots and the Picts. The cathedral was largely destroyed during the Reformation.

FAR LEFT: Tomb of Alexander Stewart, Earl of Buchan, in Dunkeld Cathedral, who died in 1405. He was known as the 'Wolf of Badenoch', and was responsible for burning down Elgin's cathedral.

LEFT: The Atholl Memorial Fountain, built in 1866 to the memory of the 6th Duke of Atholl, who first supplied piped water to Dunkeld.

PAGES 140 & 141: The River Braan joins the Tay near Dunkeld.

fine contrast, the ruins of castles, mills and stone circles, attesting to a long history of settlement. Further north again comes the chain of lochs and streams dominated by Lochs Rannoch and Tummel.

In these valleys and in the rolling hill country of the whole region are many superb examples of that uniquely Scottish style of architecture, the tower house, or keep, rising out of finely kept estate lands to dominate the country that surrounds them. The most perfectly preserved of these is Craigievar Castle, nestling in the foothills of the Grampians west of Aberdeen. The castle was built early in the 17th century for a rich merchant called William Forbes, whose trade in the Baltic had earned him the nickname of Danzig Willie, and has been left virtually unchanged since its construction. Then there is Braemar, in the Dee valley, a real fortress tower, and Cawdor, much further north near Nairn. The original Cawdor may have been the castle where Macbeth murdered Duncan, and although the present castle dates from several centuries after Macbeth, it still has a strong, typically Scottish, fortress tower at its heart.

Other historic castles of the region may have lost their typical tower shape during rebuilding over the centuries, but the tower is usually still to be found somewhere at the heart of the later building. Glamis Castle, for instance, near Forfar in Angus and the historic home of the Bowes-Lyon family, whose head is the Earl of Strathmore and Kinghorne and whose most famous

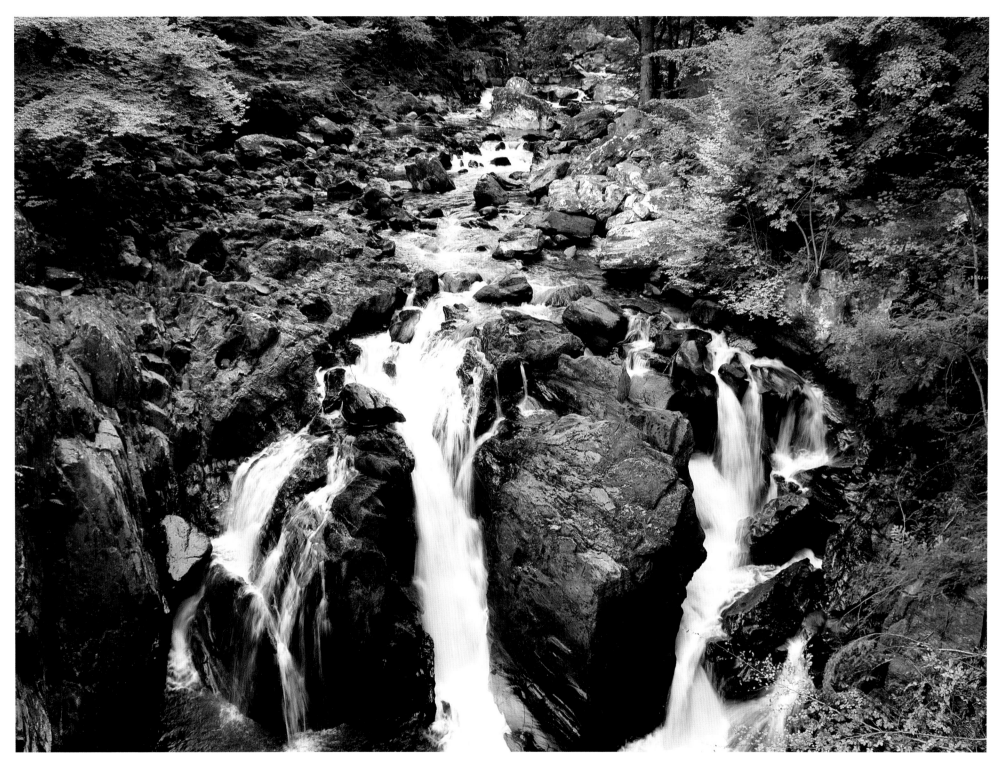

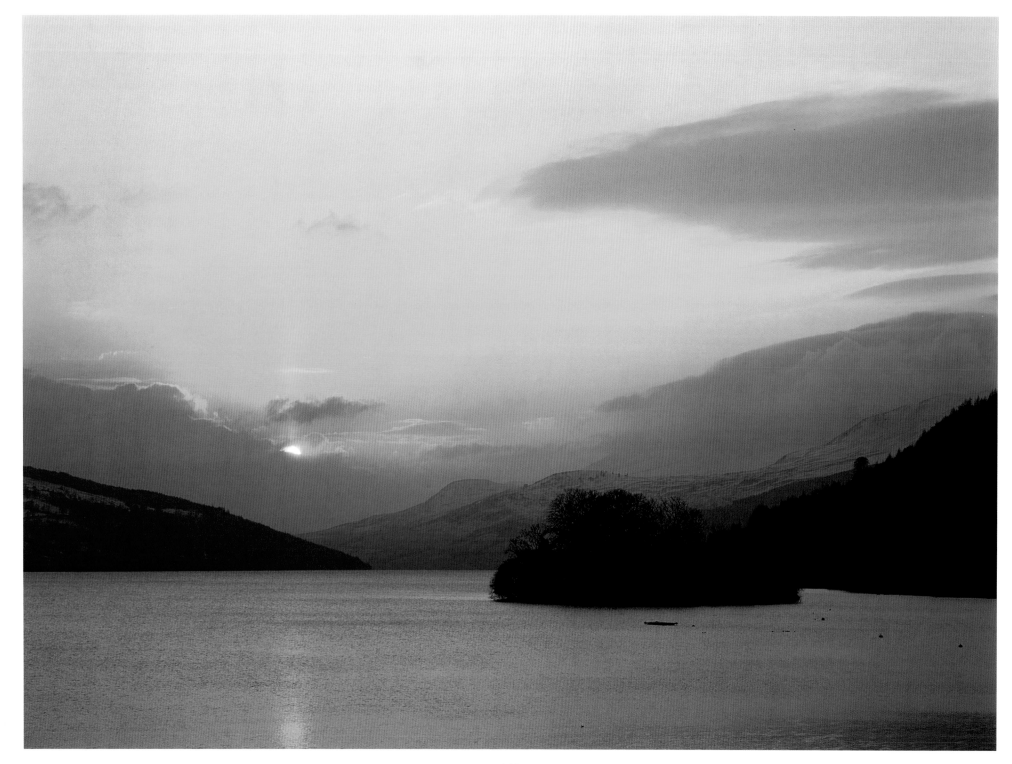

member was Her Majesty Queen Elizabeth the Queen Mother, may appear to be a wonderfully theatrical pile of turrets and battlements, but it is built around an ancient square tower with walls many feet thick. Scone Palace, near Perth, was rebuilt early in the 19th century by its owner, the Earl of Mansfield, but even here the remains of the much older building are enough to alert the visitor to the centuries-long history of this important site.

A glance at the map shows that, for administrative purposes, the north-east of Scotland comprises just two local government regions, Tayside, which includes Perthshire and Angus in the south, and Grampian in the north. In this chapter, we propose travelling beyond the western edges of the local government borders into the southern section of the Highland region, below the Great Glen, which is a more geographically satisfying demarcation line between north-eastern and north-western Scotland.

The eastern and northern borders of this region are North Sea-facing coasts, along which, approaching from the south, are historic towns such as Arbroath, Montrose and Stonehaven; Scotland's third largest city and Europe's 'oil capital', Aberdeen; the important fishing ports of Peterhead and Fraserburgh; and, round the apex of the triangle, the ancient towns of Banff, Elgin and Nairn. As in the triangle of Fife to the south, two rivers and their firths, those of the Tay and the Moray, mark the southern and northern borders of the region.

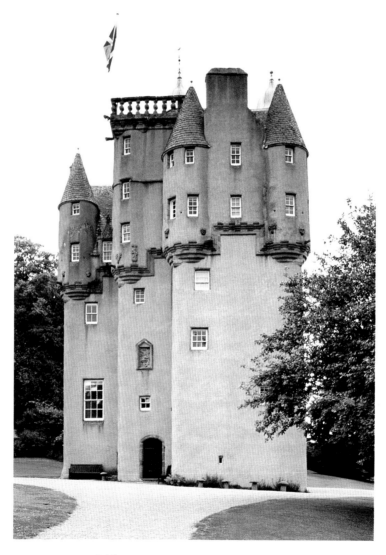

OPPOSITE: Looking south-west over Loch Tay from Kenmore.

LEFT: The pinkish Craigievar Castle, looking like something out of a fairy-tale, is a mass of conical roofs and turrets. It has been continuously occupied since it was built early in the 17th century near the market town of Alford on the River Don. It is one of many castles along Aberdeenshire's Castle Trail.

RIGHT: The River Garry, in Perth & Kinross, flows down through the Pass of Killiecrankie, site of the 1689 battle. Highland Jacobites led by Bonnie Dundee made tactical use of the narrow gorge to overwhelm government troops.

FAR RIGHT: One of the finest examples of Pictish art is the so-called Battle Stone, that stands in Aberlemno churchyard, 4 miles (6km) north of Dunnichen in Angus. It seems to depict the events of the nearby Battle of Dunnichen, fought against the Angles of Northumbria in AD 685.

OPPOSITE: Fishing on the River Tay near Dunkeld.

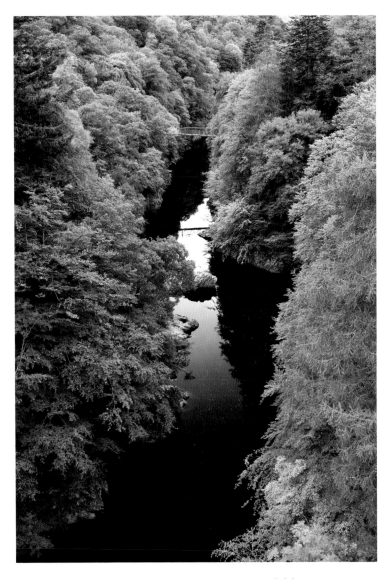

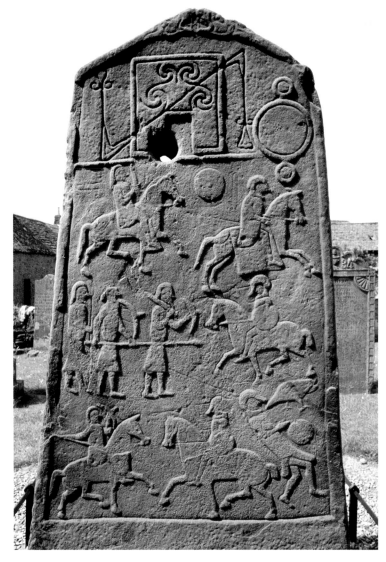

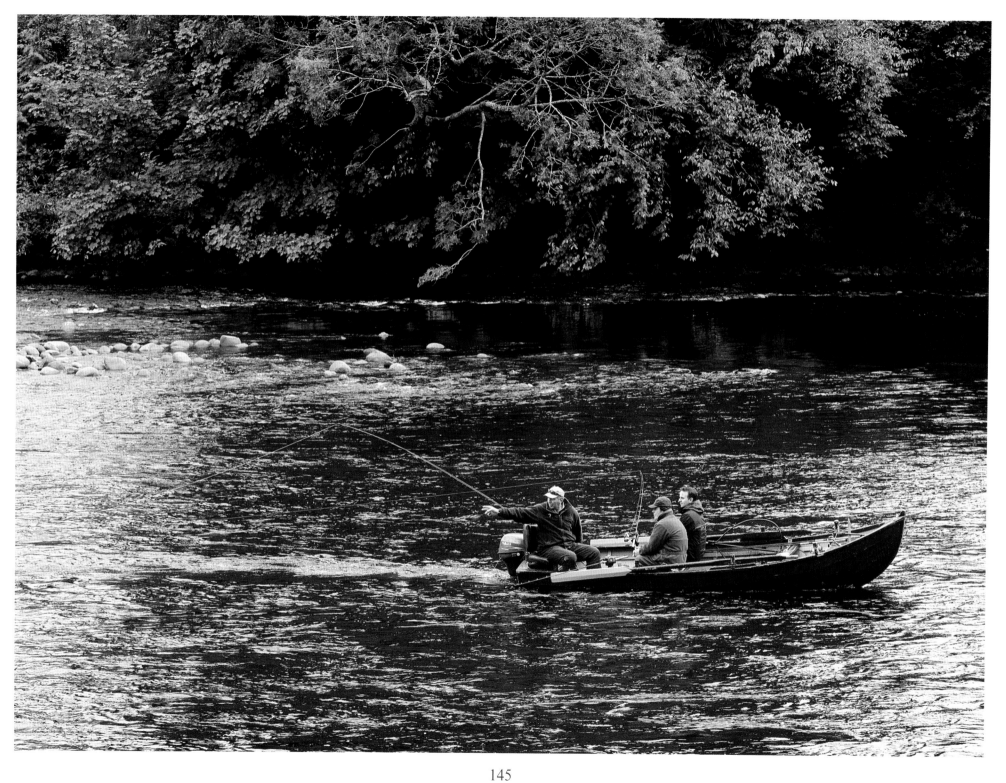

RIGHT: Castle Fraser, in Inverurie, Aberdeen, shows signs of French influence in its construction, which is also evident in other Scottish castles, such Glamis and Fyvie, another Aberdeenshire castle (page 153). It would be more accurate, however, to describe Castle Fraser as a tower house rather than a French château.

OPPOSITE: Cawdor Castle. The origins of the castle lie in the Middle Ages, the earliest part of the present castle, the central keep, having been started in around 1400. Like so many medieval buildings it was fortified, the intention being to protect the clan from neighbouring marauders or even distant kin. Little is known of the early Thanes of Cawdor, and there is no evidence to suggest that Macbeth was one of them, the Shakespearean connection being tenuous to say the least.

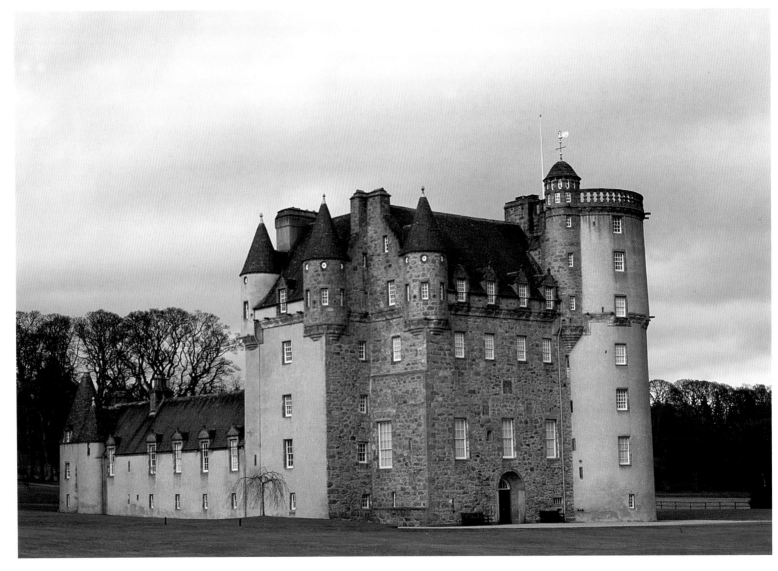

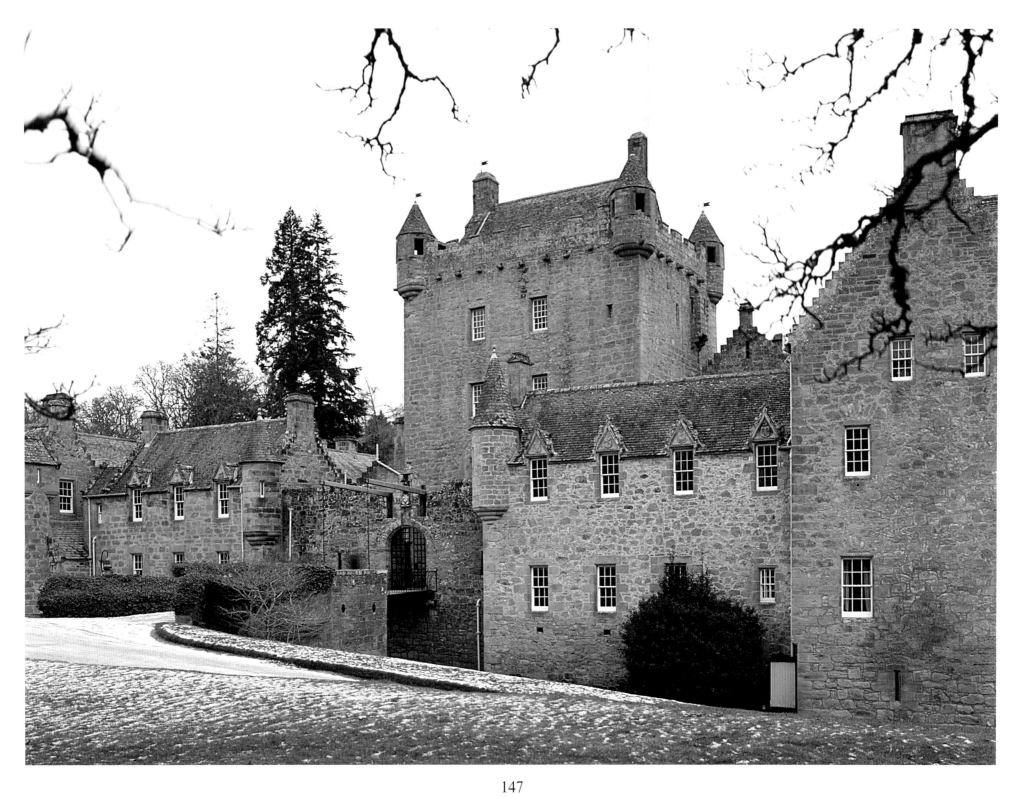

RIGHT: Drum Castle, near Drumoak in Aberdeenshire, was granted to William Irvine in 1323 by Robert the Bruce, and remained in the possession of Clan Irvine until 1975. It is believed to be one of the three oldest tower houses in Scotland, and the least altered, the original 13th-century tower having probably been the work of the medieval architect, Richard Cementarius, who built the Bridge of Don in Old Aberdeen. A crow-stepped gabled mansion was added in 1619, with further alterations in Victorian times.

OPPOSITE & PAGE 150: Part of the elaborate walled gardens at Crathes Castle, near Banchory. Built in the 16th century, Crathes is a superb example of a tower house of the Jacobean period.

PAGE 151: A string quartet playing on the forecourt of Crathes Castle.

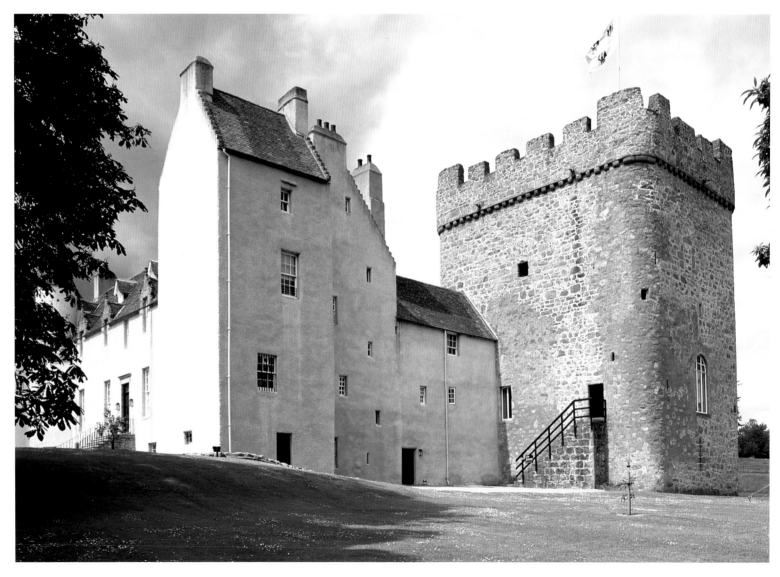

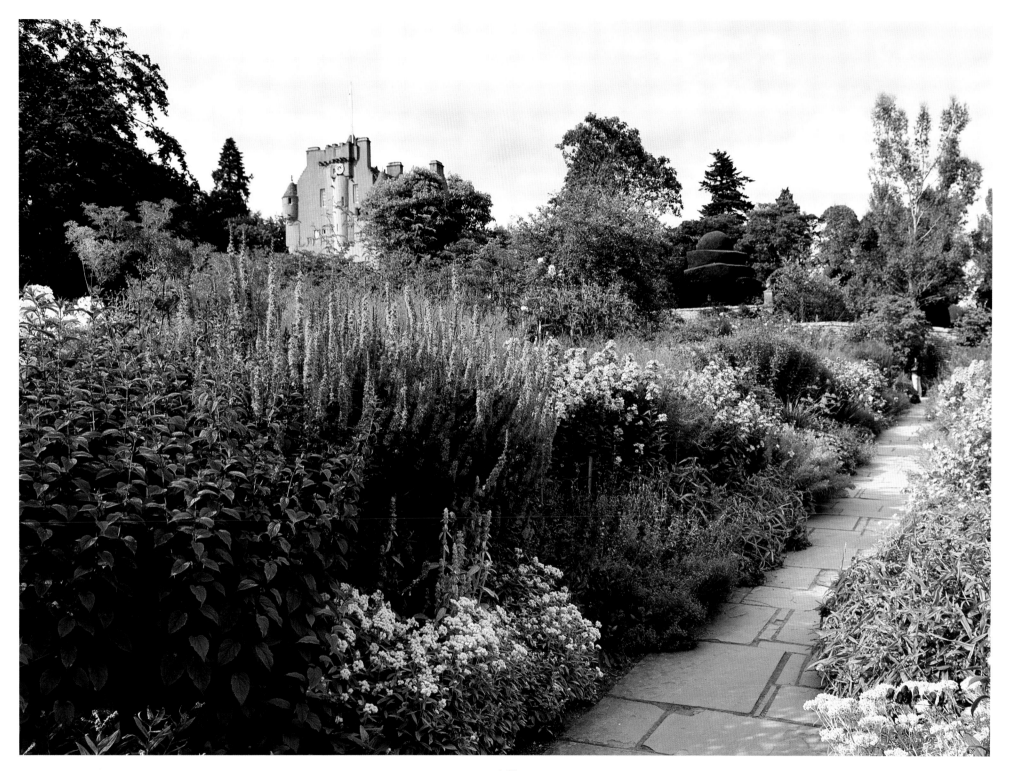

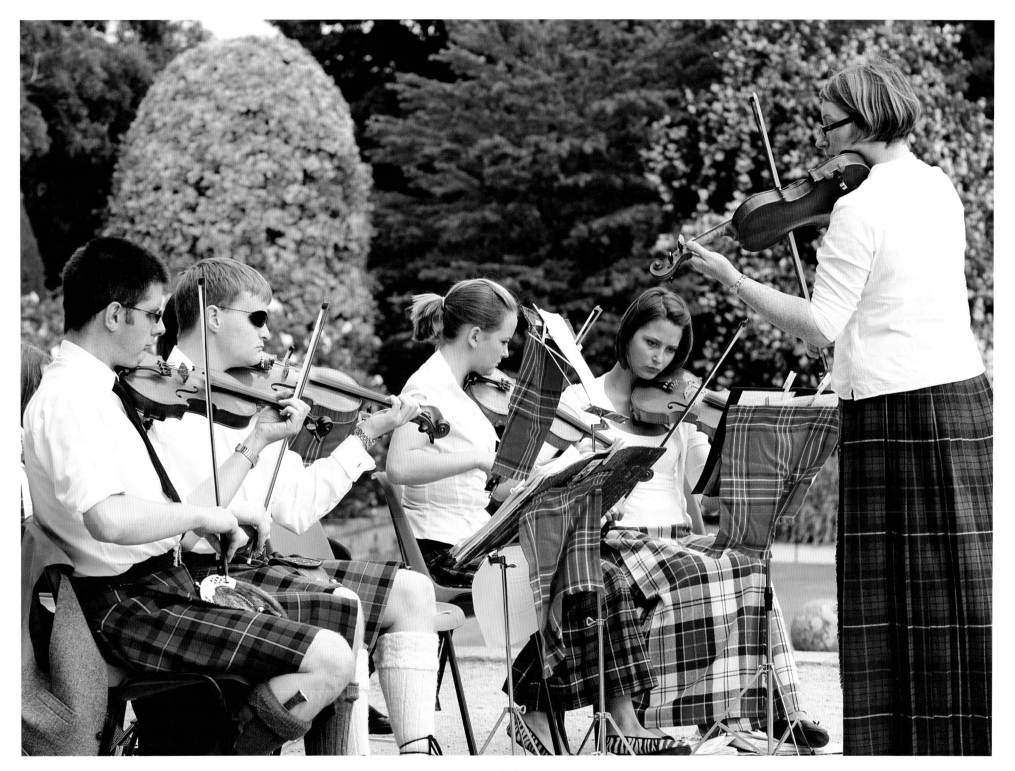

BELOW: Edzell Castle, near Brechin, Angus.

FAR RIGHT: Claypotts Castle, near Dundee, Angus.

OPPOSITE: Fyvie Castle, Turriff, Aberdeenshire.

Two historic towns, Perth and Dundee, lie beside 'the silv'ry Tay', to quote Scotland's favourite bad poet, William McGonagall. Dundee is in Angus, on the northern shore of the Firth of Tay, at the point where the firth narrows sufficiently to be bridged by both rail and road bridges. The collapse, in December 1879, of the first rail bridge, taking nearly 100 train passengers to their deaths in the icy waters below, inspired McGonagall's most famous doggerel:

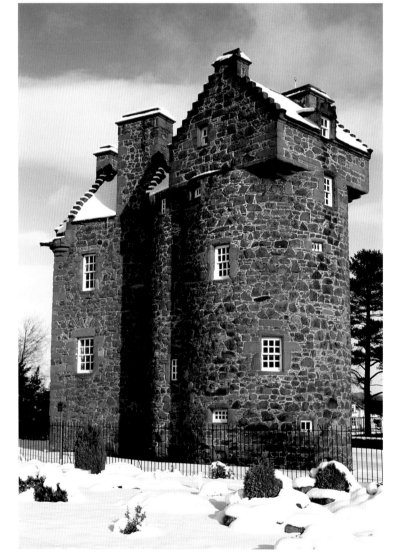

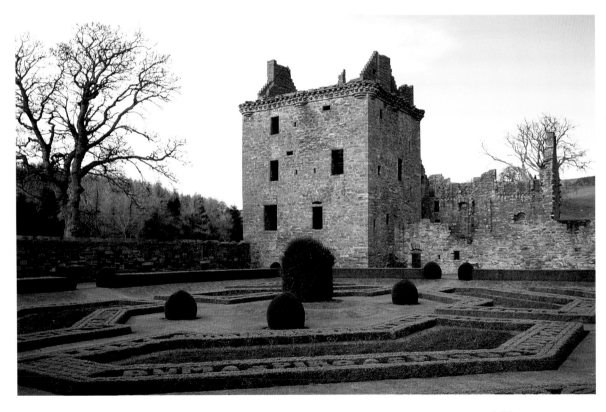

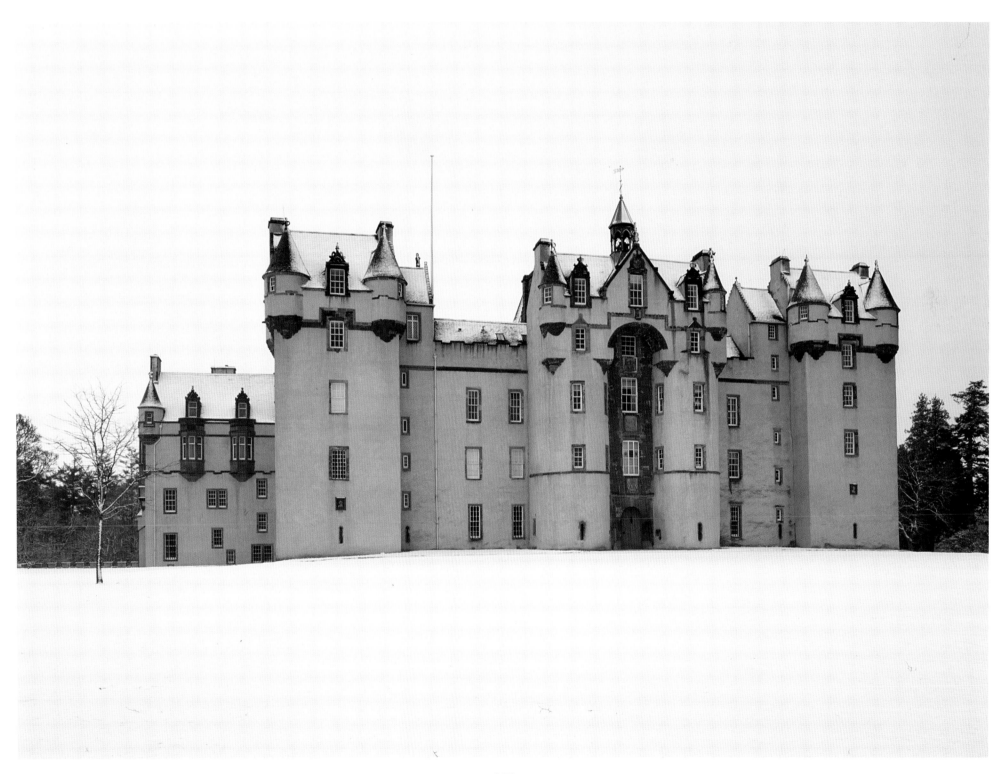

BELOW: Elcho Castle, Tayside.

FAR RIGHT: The Ship Inn at Stonehaven, Aberdeen, built in 1771.

OPPOSITE: Arbroath Abbey, founded in 1178 to commemorate the death of St. Thomas à Becket.

'... Then the central girders with a crash gave way,
And down went the train and passengers into the Tay!
The storm fiend did loudly bray,
Because ninety lives had been taken away,
On the last Sabbath day of 1879,
Which will be remember'd for a very long time.'

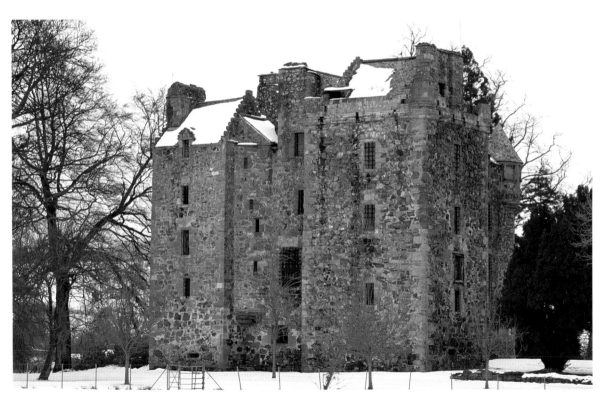

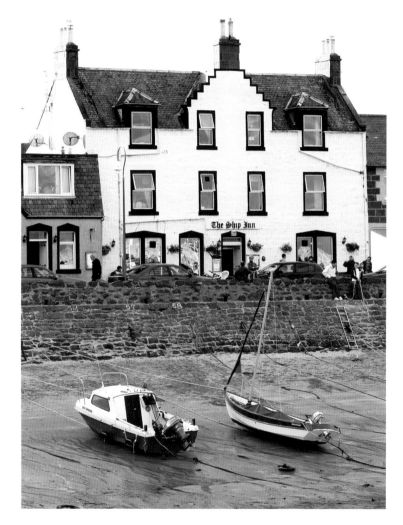

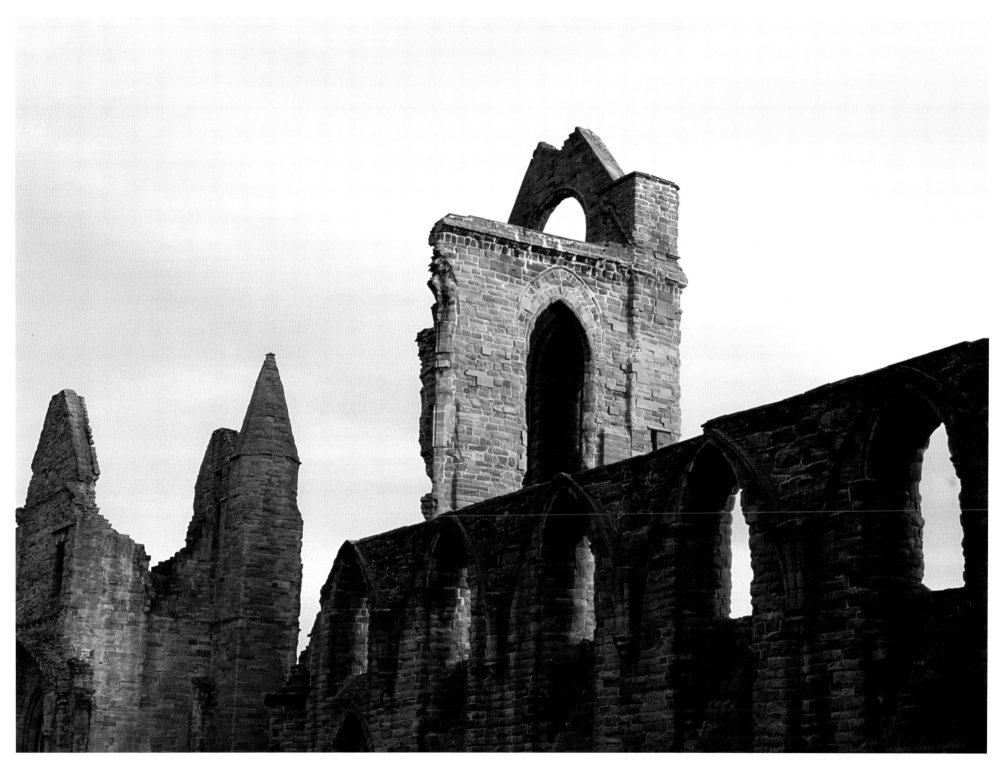

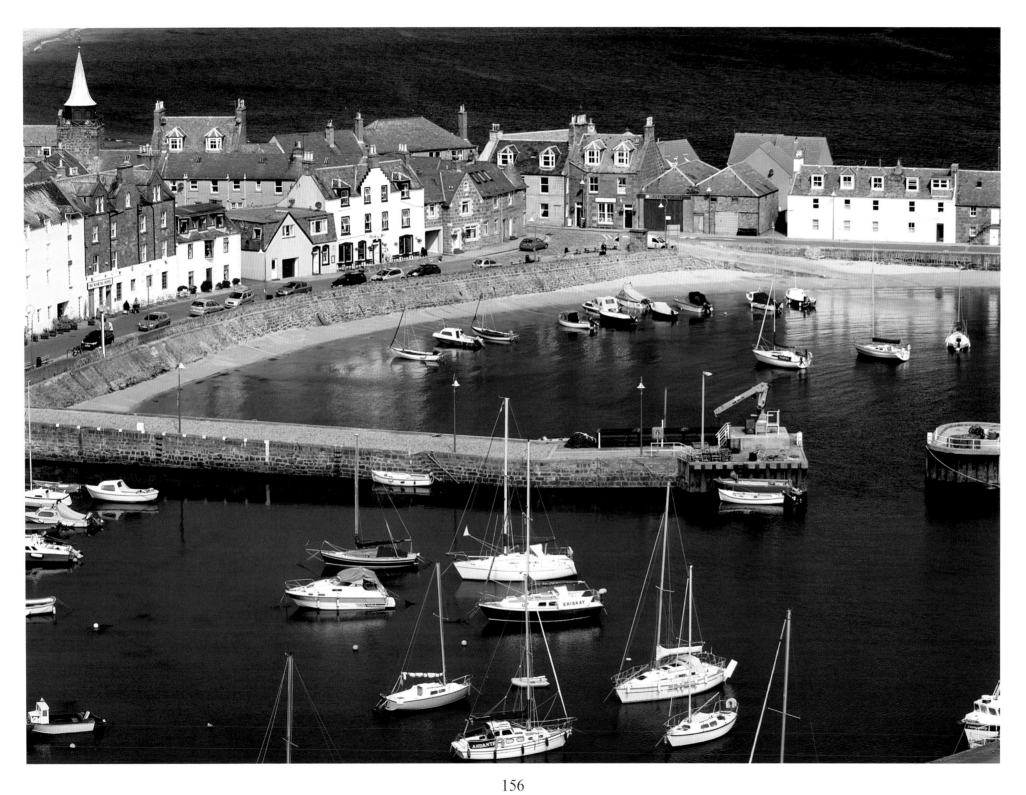

OPPPOSITE: View of Stonehaven, lying on the east coast of Scotland some 15 miles (24km) south of Aberdeen, a proximity that has brought benefits to the town from the oil wealth generated by its more northerly neighbour. Even so, Stonehaven has lost nothing of its own distinctive character, its harbour being the only safe haven along this entire coast in a north-easterly gale. A breakwater was first built here in the 1500s and further harbour construction has taken place over the following centuries.

LEFT: A road sign pointing the way to the village of Lost, in the eastern Cairngorms.

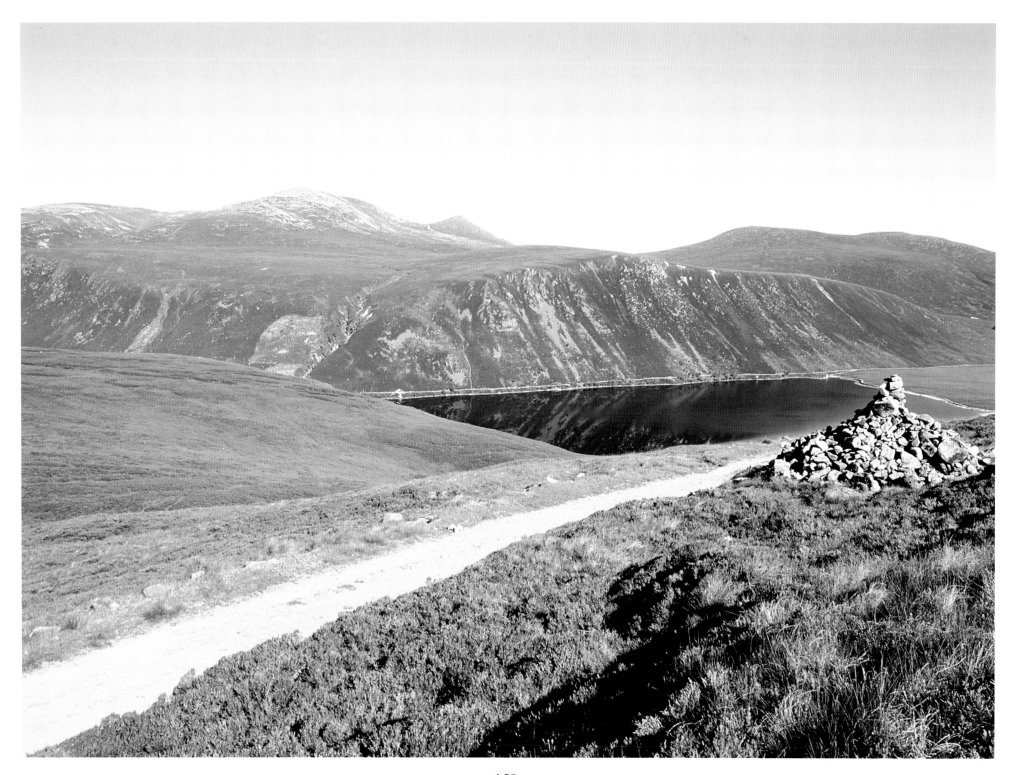

Perth is further inland, lying at the heart of Perthshire, an area of long-established moorland sporting estates, exclusive golf courses, like Gleneagles, and rich farming country set in a fine landscape of lovely wooded glens and quiet lochs. While Perth and Dundee are both ancient royal burghs, which have played significant parts in Scotland's political and economic history, Perth is, perhaps, the more interesting town to visit, partly because much of the ancient centre of Dundee was demolished in the 19th century and there has been a lot of post-war building of the dreary concrete-slab variety.

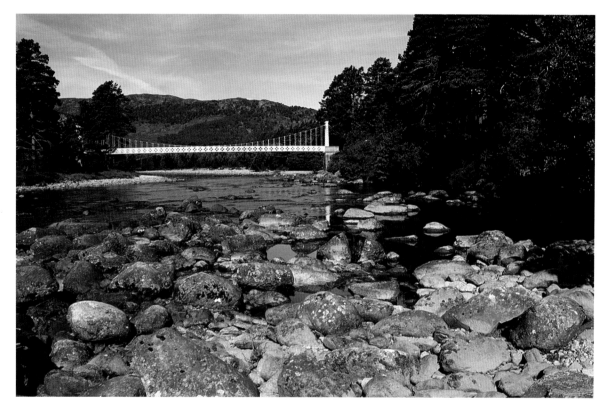

Perth's roots reach far back into history. If the town's rectangular street pattern is anything to go by, the Romans may have built a camp at this point on the Tay which, so legend has it, they likened to the Tiber when first encountering it. In the ninth century, Kenneth MacAlpine, sometimes called the first King of Scots, made Scone, two miles north of present-day Perth, the capital of his kingdom of Alba.

OPPOSITE: Loch Muick in Glen Muick, south of Ballater.

FAR LEFT: Easter Aquhorthies' recumbent stone circle, near Inverurie, dating from c.3000 BC.

ABOVE: The Dee, near Braemar.

RIGHT: The Mercat Cross and market at the top of Union Street, Aberdeen. A mercat cross is a market cross found in cities and towns across Scotland where trade and commerce were important to the area. It was originally a place where merchants gathered, and later became the place where executions took place, and where announcements and proclamations were made.

OPPOSITE: Union Street looking towards Castlegate.

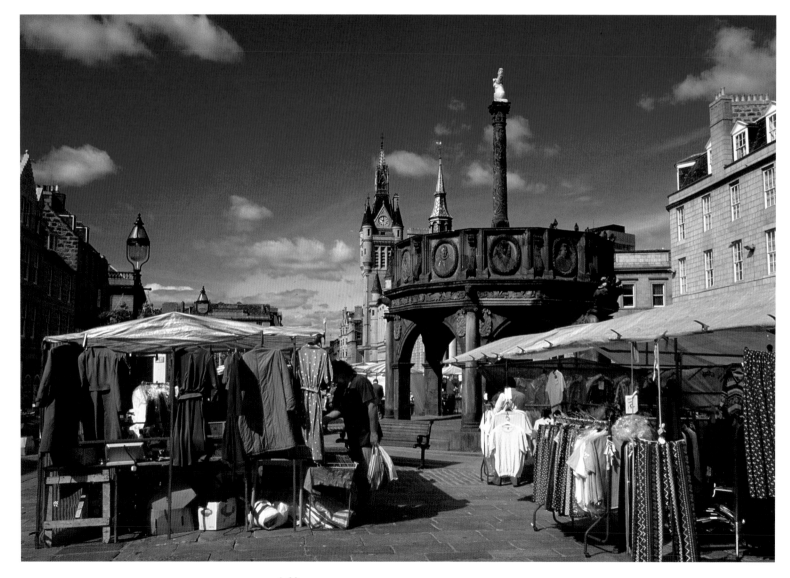

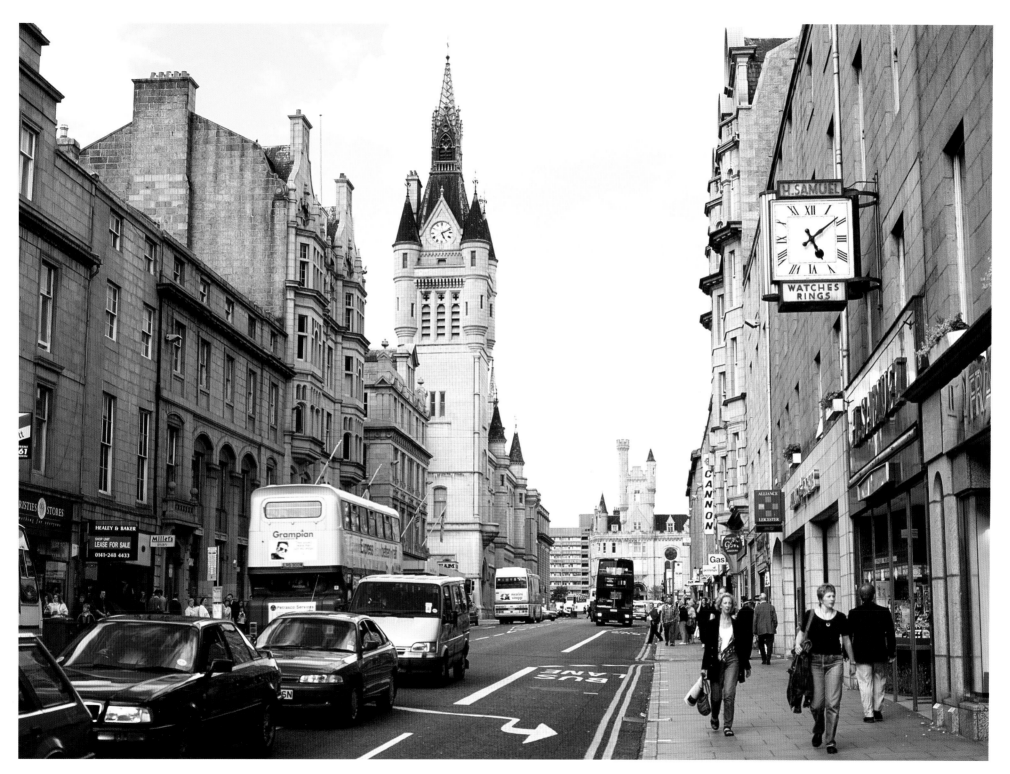

Fresh cod on sale at the Aberdeen Fish Market, the largest in Scotland, where fish has been auctioned and sold for seven centuries.

Perth grew in importance as a civil and religious centre in medieval times: at one time the town contained monasteries belonging to four different religious orders, the White Friars, the Black Friars, the Grey Friars and the Carthusians, all of which were destroyed during the uprising following John Knox's fiery preaching against idolatory in Perth's St. John's Church in 1559.

Its position at the heart of central Scotland meant that Perth, like Dundee, was the focus of much unwelcome military action. The town was occupied by Edward I, the 'hammer of the Scots', taken by Robert the Bruce, re-taken by the English, then wrested back from them by the Scots. This pattern was repeated in the 17th century in the times of Cromwell and Montrose, then again in the 18th century during the Jacobite rebellions. By this time Perth was an important town and port in central Scotland, and had been exporting wool and whisky, still one of the town's major businesses, since the 16th century. It was also, during the period of the Franco-Scottish 'Auld Alliance', a great importer of claret from Bordeaux.

While Perth today is a major business and agricultural centre and a handsome town, with many historic buildings to interest the visitor, including St. John's Church, the 15th-century Balhousie Castle, which houses the Black Watch Museum, and the Fair Maid of Perth's House, the former Glovers' Hall, chosen by Sir Walter Scott as a main setting for his eponymous novel, it is also important as a base from which to explore some of Scotland's loveliest countryside. To the west, beyond the attractive town of Crieff, for centuries an important 'tryst', or cattle market, lie Loch Earn and the Sma' Glen. A main road north-east, the A93, is the route to Aberdeen, taking the traveller via Blairgowrie and Glen Shee, where the Spittal of Glenshee can provide interesting skiing when the snow is right, to Braemar and Royal Deeside.

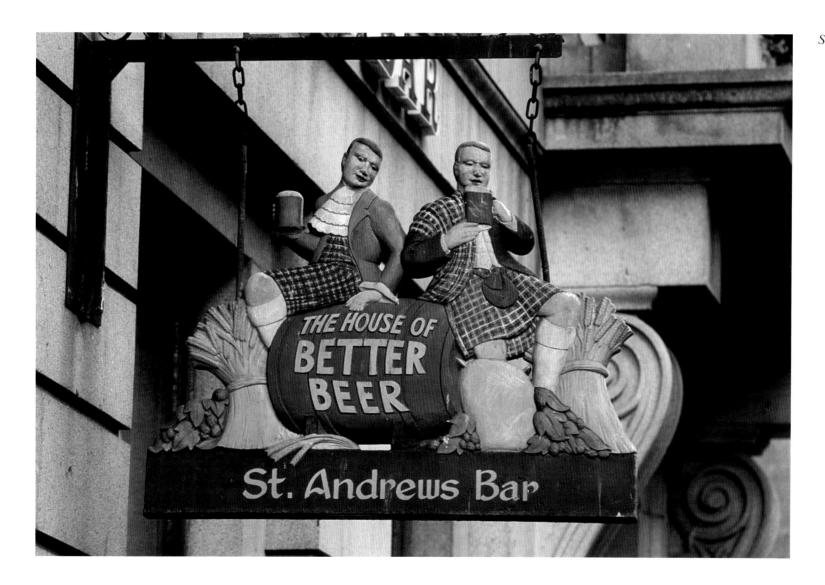

St. Andrews Bar, Aberdeen.

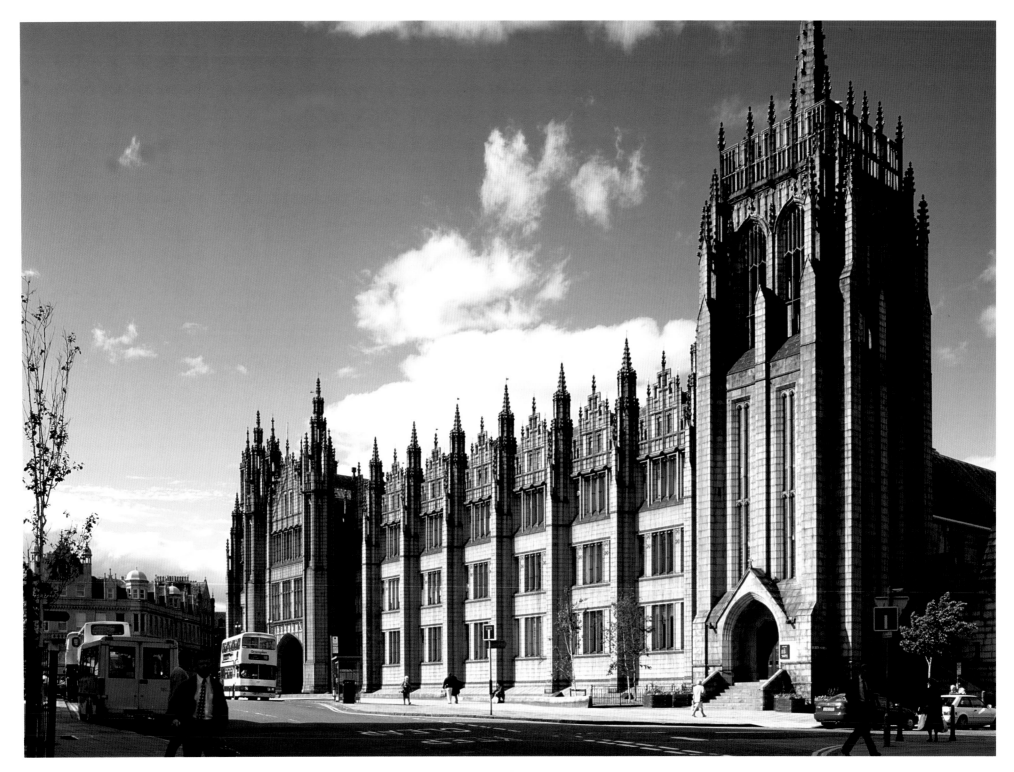

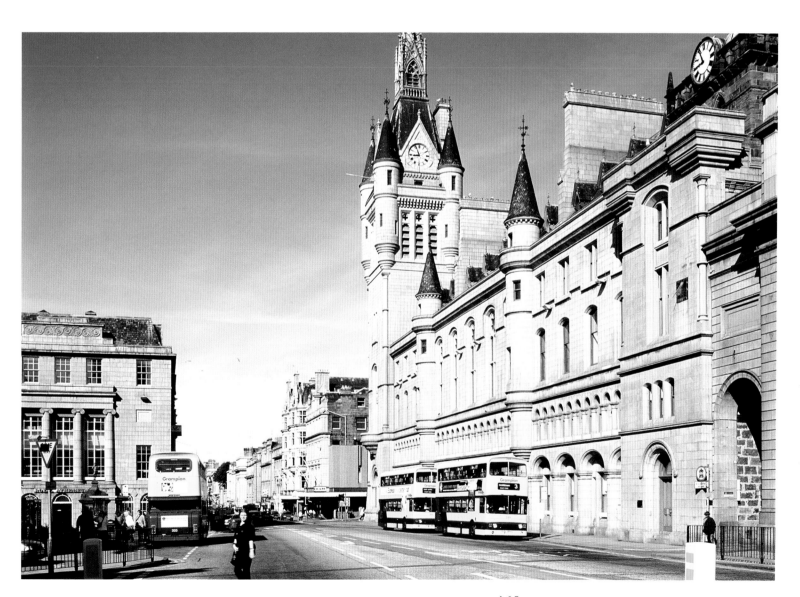

OPPOSITE: *Marischal College was founded in Aberdeen in 1593 by George Keith, 5th Earl Marischal of Scotland. It is now a part of the University of Aberdeen, following unification of the University with King's College in Old Aberdeen. A large portion of the building has been leased to Aberdeen City Council for use as office space.*

LEFT: *The Town House, Aberdeen. Built in the Franco-Scottish Gothic style, the Town House sits at the east end of Union Street. It contains a great hall, with an exposed timber ceiling and oak-panelled walls, the Sheriff Court, and the Town and County Hall with its portraits of various dignitaries. On the south-western corner is the 210-ft (64-m) grand tower, high enough to give a fine view of the city and the surrounding countryside.*

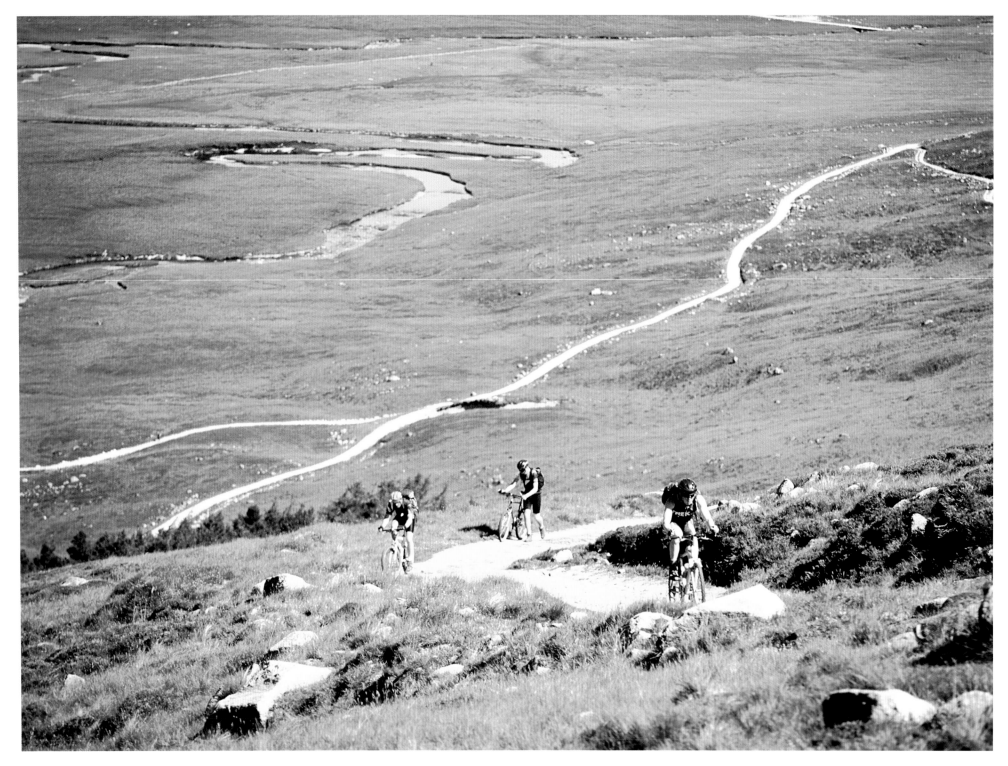

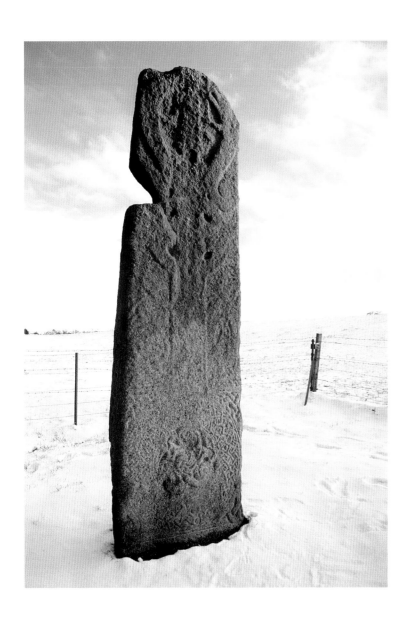

The main road north from Perth is the A9, one of Scotland's major roads, its great attraction for the visitor being the fact that as it curves north-east from Perth, via the historic towns of Dunkeld, Pitlochry and Blair Atholl, to Dalwhinnie, it encloses, to the west, an exceptionally fine area of typically Scottish loch and glen scenery. This is the area of the Tay basin, Scotland's watershed, where the glaciation of the last Ice Age left a myriad of corries in the high mountains to provide the rock basins for some 70 major lochs and countless lochans. These drain into the river systems of four great rivers, the Garry, Tummel, Earn and Tay. Extensive hydroelectric work in this area, including dam-building, has created even more lochs, such as Loch Errochty in the north, and has greatly increased the size of others, including Loch Tummel.

Here is a country of heather moors, of the wild and bleak isolation of Rannoch Moor and Glen Coe in the far west, of forests and glens, some of them open and some enclosed by great walls of rocks down which rivers and waterfalls tumble. The Pass of Killiecrankie, on the A9 between Bridge of Garry, and Blair Atholl, where the River Garry forces its way through a narrow wooded gorge to join the Tummel, is perhaps the best-known and certainly the most romantic of the area's river gorges. Here, in 1689, the English forces of William III were defeated by a band of Jacobite Highlanders led by John Graham of Claverhouse, Viscount Dundee, with 'Bonnie Dundee', as the ballads call him,

OPPOSITE: Trail biking in Glen Muick, east of Braemar.

LEFT: The Maiden Stone, a ninth-century Pictish cross located near Chapel of Garioch, 5 miles (3km) north-west of Inverurie. The top of the front is carved with a cross and a human figure in the grip of fish monsters, its back inscribed with a range of Pictish symbols, together with a beast and a centaur.

PAGES 168 & 169: Highland dancers competing at the Braemar Gathering and Highland Games, held every year on the first Saturday in September.

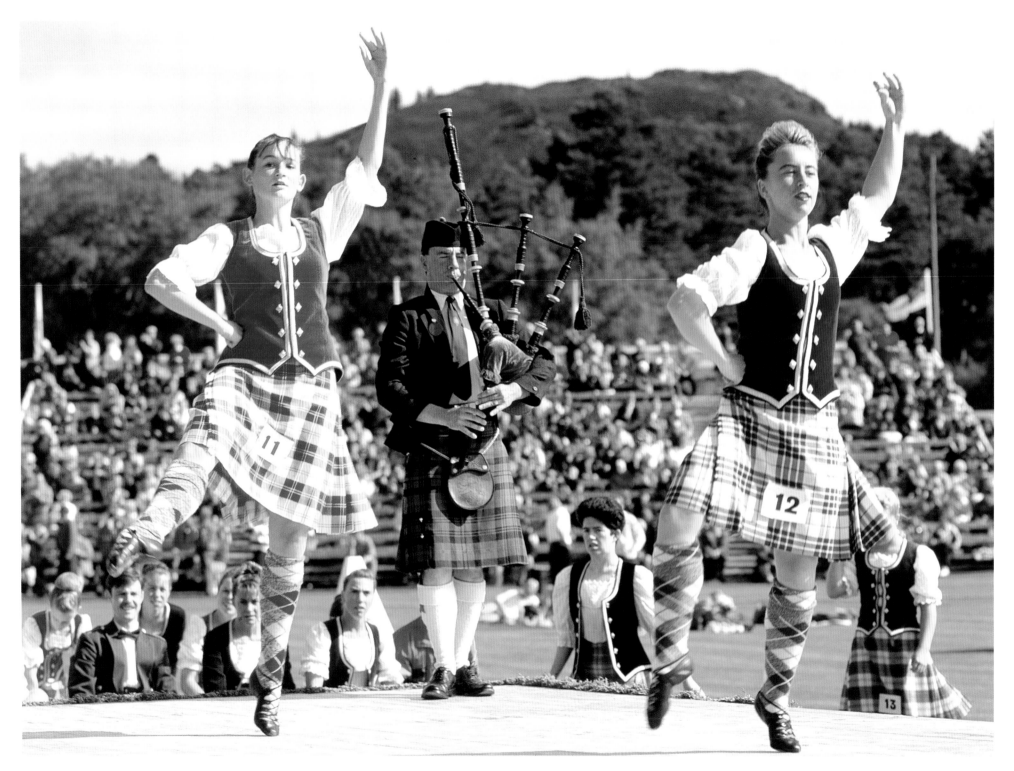

BELOW: Red deer in the Balmoral forest.

OPPOSITE: Balmoral Castle, near Braemar, the Scottish residence of the British monarchy.

being killed in the battle. Robert Burns and Queen Victoria can be counted among the many thousands of people who have paused here to stand before the stone marking the place where Bonnie Dundee fell wounded.

While this area includes several of the most visited lochs in Scotland, including Lochs Rannoch, Tummel, Tay and Earn, it also has many hidden so deep in glens and forests, which are bird-watchers' paradises, that they are accessible only to walkers and

backpackers. It is no wonder that Bonnie Prince Charlie and his small band of followers chose to build a hideout among holly trees near Cluny's Cave, above remote Loch Ericht, set in high moorland surrounded by mountains, to be his last refuge before he escaped to France in 1746.

After the Pass of Killiecrankie, the A9 takes the traveller through Blair Atholl, where the Duke of Atholl, comfortably ensconced in stylish Blair Castle, is the only private citizen in Britain allowed to maintain an army, the Atholl Highlanders. Then the road winds through Glen Garry and up through the Grampian Mountains via the barren Pass of Drummochter past Dalwhinnie at the northern end of Loch Ericht and so into the eastern edge of the Highland region. It passes through Newtonmore and Kingussie, where the bleak ruins of Ruthven Barracks are a reminder of the oppressive treatment meted out to the Highlands after the 1715 Jacobite uprising, and on between the Monadhliath Mountains in the west and the Cairngorms in the east before reaching Aviemore, Britain's best-organized centre for winter sports.

Since it was very much a creation of the 1960s, when grey concrete was too much the order of the day for Britain's architects and town planners, Aviemore is not a particularly attractive town, but it does have all the right amenities to make it an excellent base for snow and ice sports in winter and for some fine walking, backpacking and pony-trekking in the Cairngorms and the Glenmore Forest Park in summer.

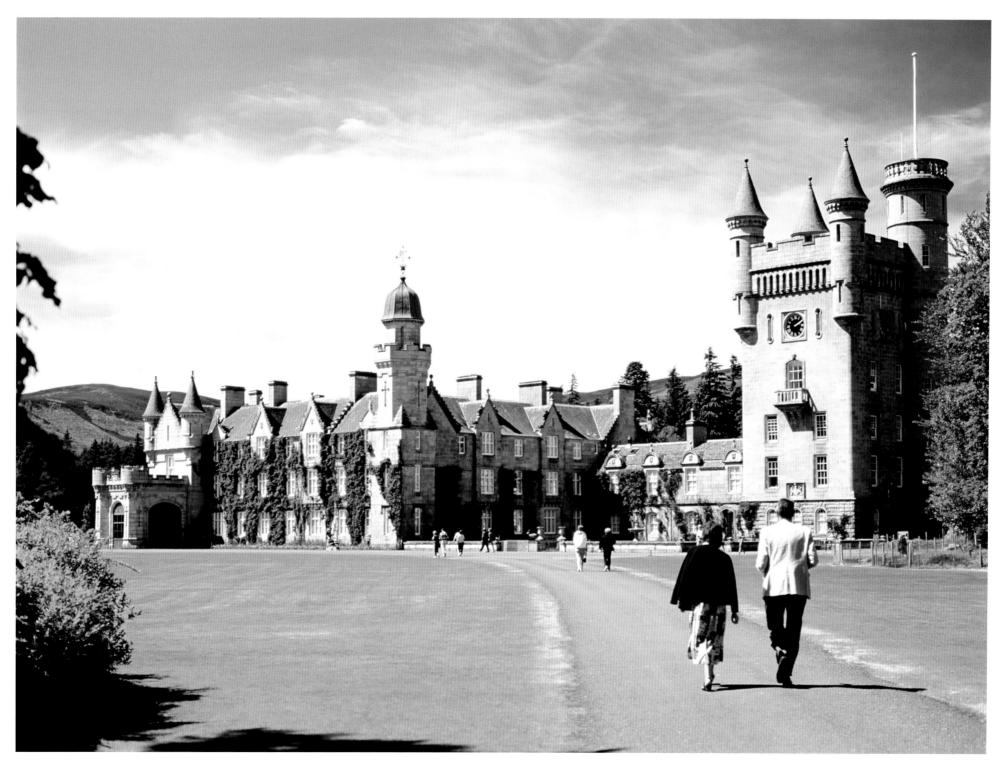

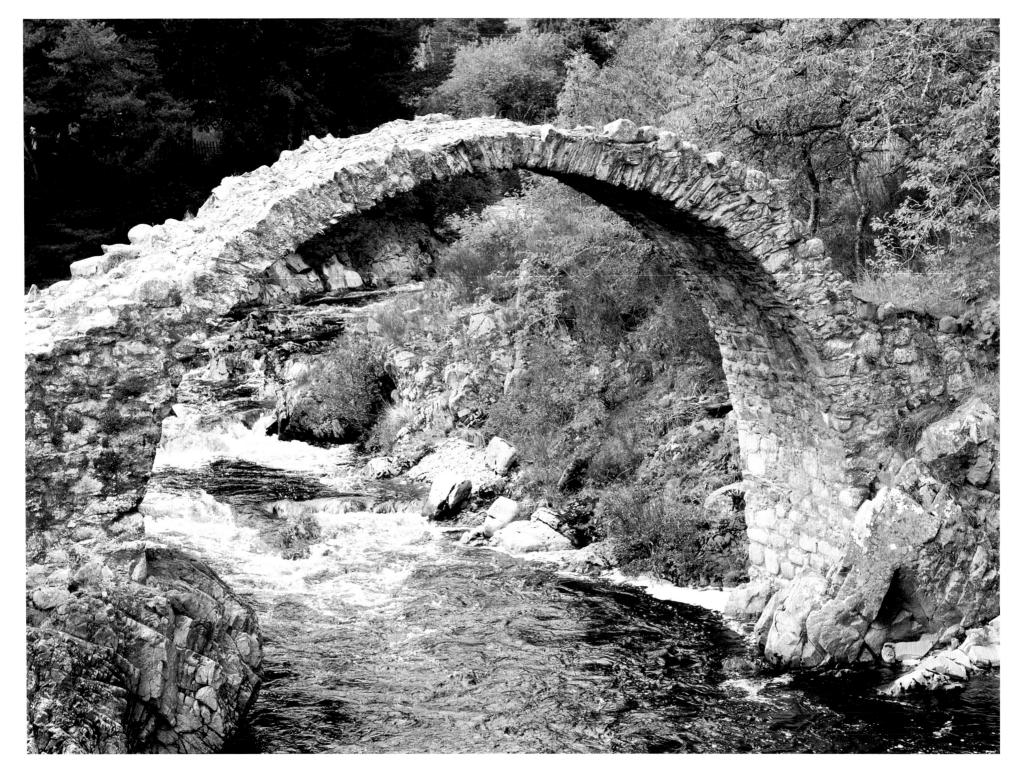

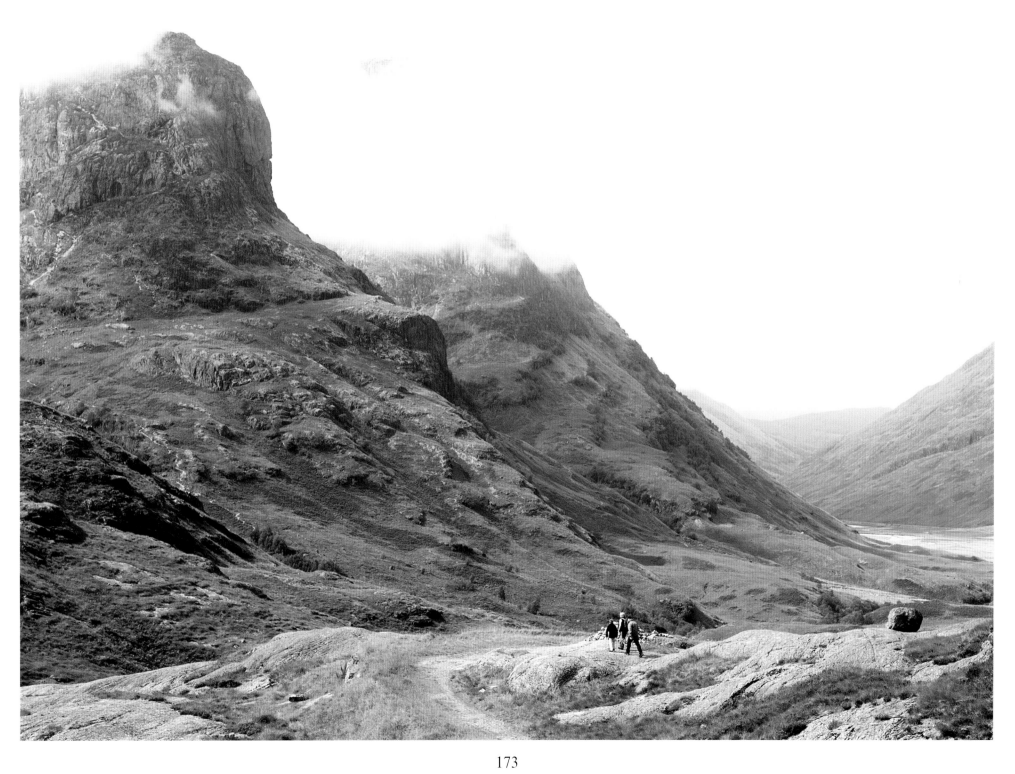

THE HIGHLANDS: THE NORTH-EAST

PAGE 172: The old stone packhorse bridge over the River Dulnain at Carrbridge, near Aviemore.

PAGE 173: Walking in the pass of Glen Coe against the backdrop of the Three Sisters.

RIGHT: The view north over Lochan na h-Achlaise towards the western end of Rannock Moor.

OPPOSITE: High summer at Loch Ba, Rannoch Moor.

PAGE 176: Grouse moor south of Colnabaichin near the headwaters of the River Don.

PAGE 177: Corgarff Castle has long been of strategic importance, guarding the quickest way from Deeside to Speyside, a route later followed by the military road from Blairgowrie to Fort George. Its location ensured that Corgarff Castle would have an eventful and sometimes tragic history.

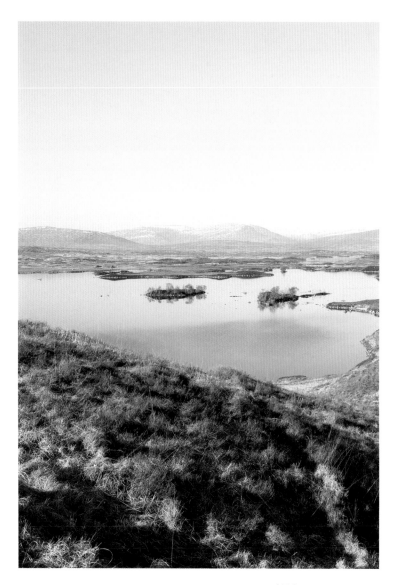

At Aviemore the A9 turns away from the valley of the River Spey, which it has been following since Newtonmore, to head towards Inverness at the top of the Great Glen. The Spey rises in the Monadhliath Mountains and flows north-east across the wildlife-rich wood and farmland of Strathspey to flow into the Moray Firth east of Elgin and Lossiemouth.

Among places of historic interest in this area is Elgin, the administrative centre of Moray. Elgin's 12th-century cathedral, now a picturesque ruin, was once dubbed 'the lantern of the north', until the notorious Alexander Stewart, the Wolf of Badenoch, who was an outlawed son of Robert II, set fire to it. Near Elgin are Gordonstoun School, where all three of the Queen's sons were educated, following in the footsteps of their father, Prince Philip, and Pluscarden Abbey, 6 miles (10km) to the south-west, where a new generation of Benedictine monks is rebuilding and restoring the abbey founded by Alexander II in the early 13th century.

There is no denying, however, that of greater interest than abbeys or schools to most of the Spey valley's visitors are the superb salmon-fishing in the Spey and whisky – especially the latter. Whisky-distilling has been an important activity in the area for so long that Speyside malts are one of the great classifications of Scotch whisky. The area stretches from Grantown-on-Spey all the way to the coast, with so many distilleries operating that the plumes of white steam are a typical sight, rising up into the sky

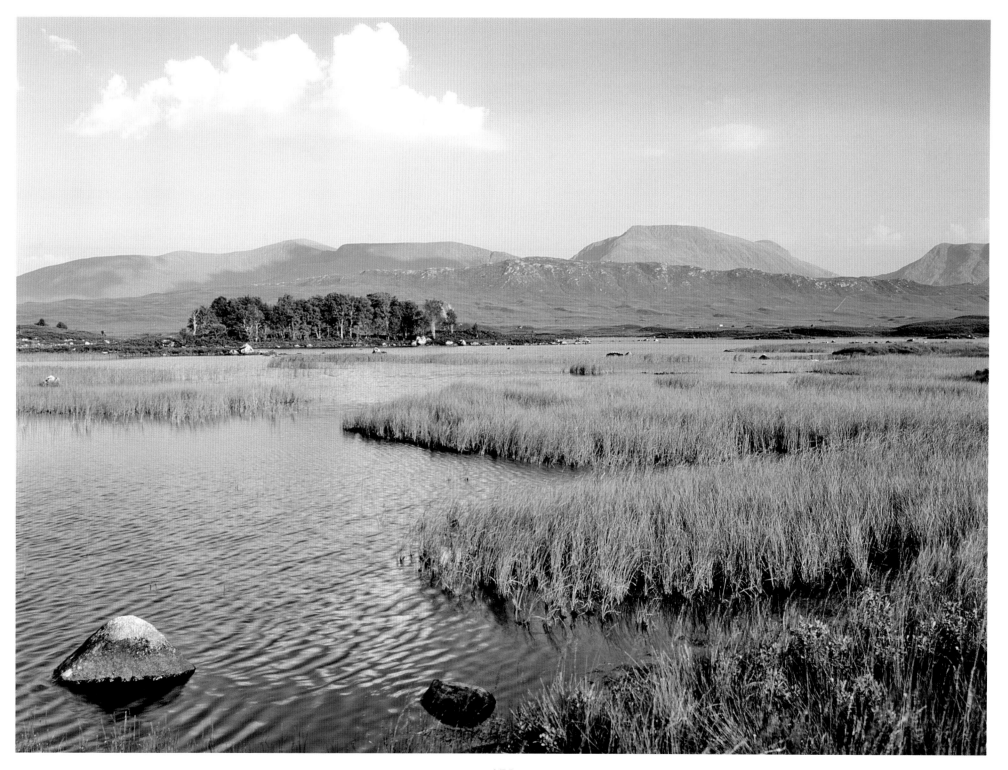

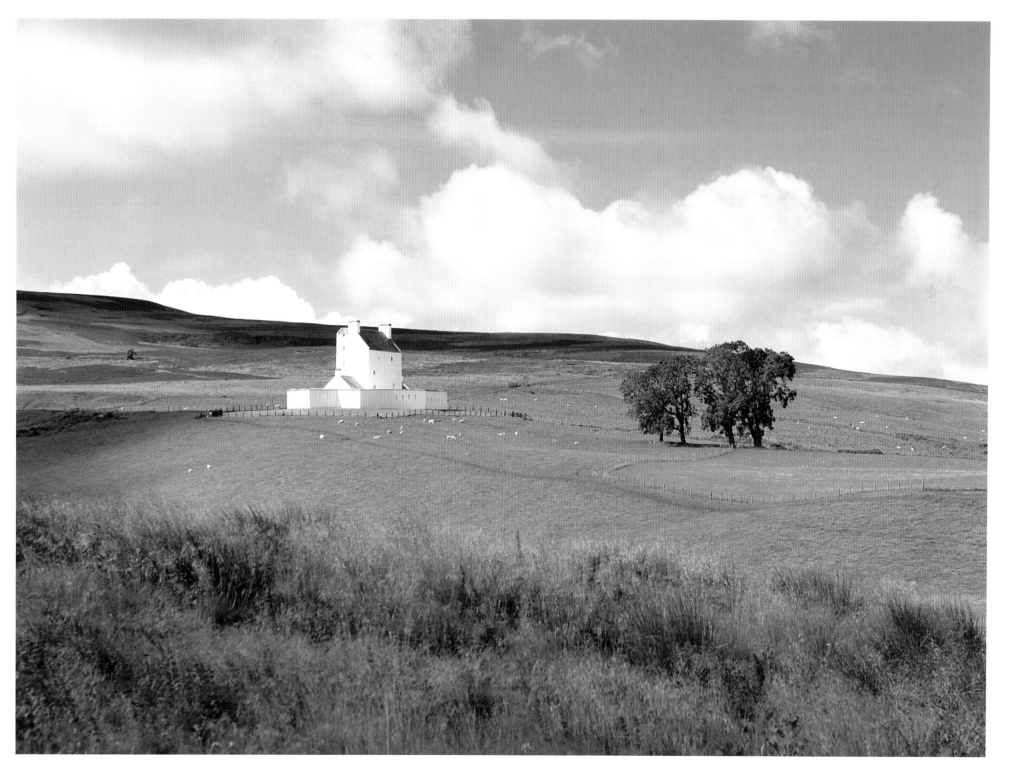

*RIGHT: Heather (*Calluna vulgaris*) grows in abundance on the moors and heathland of the Highlands, covering the ground in a purple haze.*

*FAR RIGHT BELOW: Scotland's emblemic bluebell (*Campanula rotundifolia*), known as the harebell in England, is widespread along grassy coastal dunes.*

OPPOSITE: Dunnottar Castle, on the North Sea coast south of Stonehaven.

from distilleries which would otherwise be hidden from view among the trees and hills. To find out about whisky-distilling, one of the best places to visit is the Glenfiddich distillery at Dufftown. Many of the other famous names of the Speyside malt whisky business also have visitor centres, and there is a Malt Whisky Trail, leaflets about which are available at the tourist information centres of the area, as well as at the distilleries themselves. Walkers on the Speyside Way, which runs 45 miles (72km) from Spey Bay on the coast to Tomintoul, find that their path also passes several distilleries.

Tomintoul, the highest village in the Highlands, was laid out in 1779 by the Duke of Gordon, one of the leading Scots statesmen of the day and a patron of Robert Burns. Here, on this bleak moorland, we can see how the somewhat distant rule of the Stuart kings and queens of Scotland was superseded by the more practical ruthlessness of the Hanoverians. For part of its way the A939, which winds its way across the moorland south of Tomintoul to Deeside, follows the notoriously steep Lecht Road, often the first in Scotland to be closed when winter strikes. This

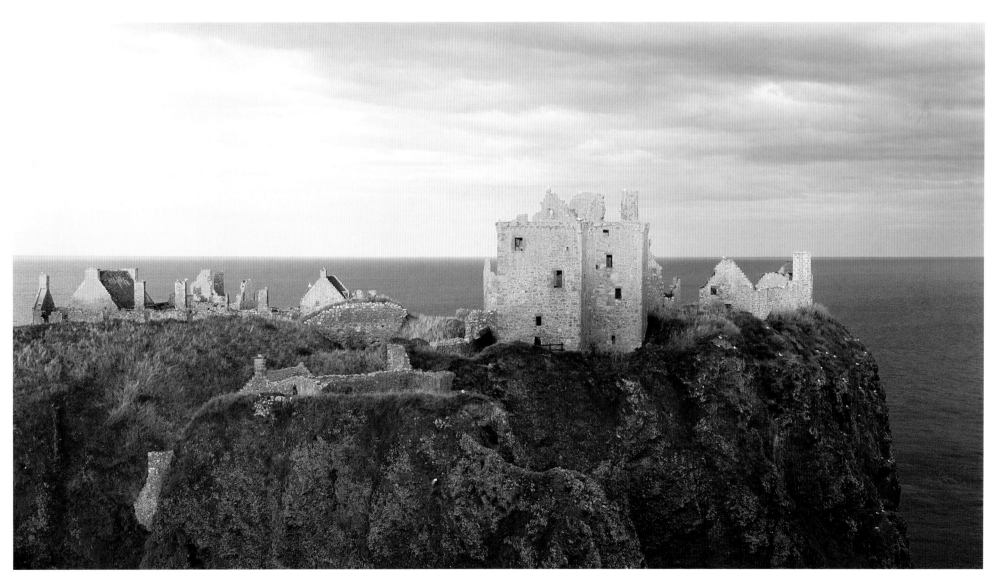

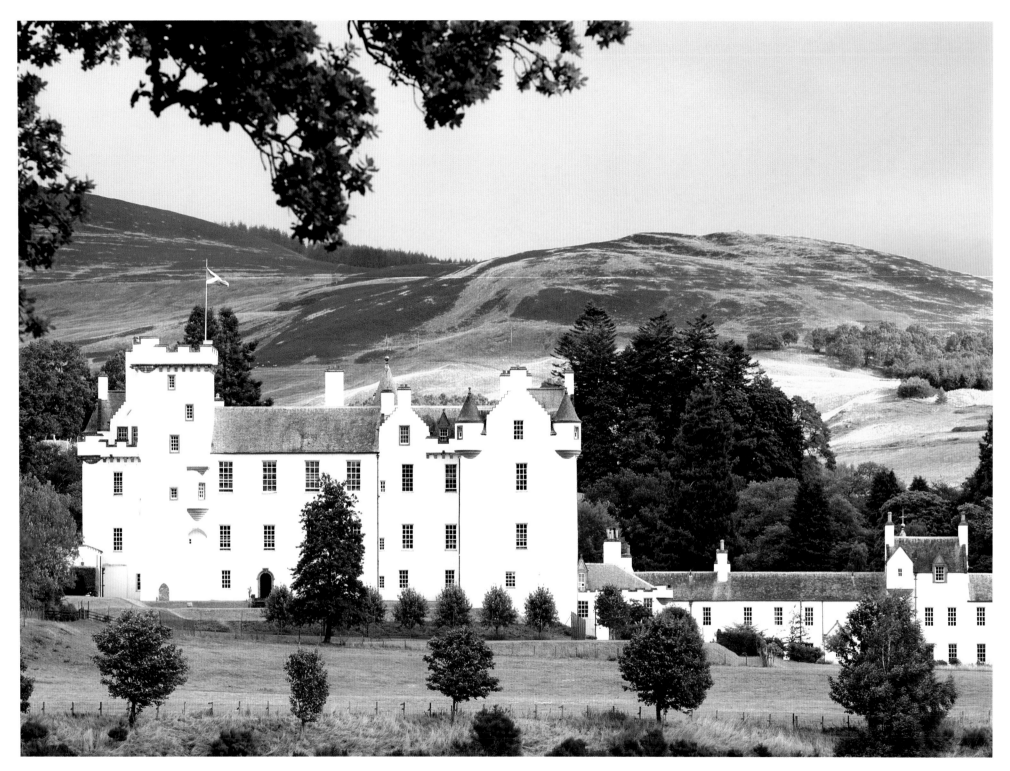

Jacobite threat was past, the barracks formed a useful military base from which the government could suppress smuggling, especially of whisky.

The barracks was still used by the military until only a few years before Queen Victoria ascended the throne. The last of the Hanoverians, Victoria was also the first of the post-Stuart

often the first in Scotland to be closed when winter strikes. This fine piece of road-building was achieved by several companies of the 33rd Regiment of the British Army in the years immediately after the 1745 rebellion. In building the road they were carrying on the work begun by the English General George Wade after 1715; his network of metalled roads and 40 fine stone bridges was a wonderfully tactful way of pacifying the Highland clans and bringing them into the fold of Great Britain. While the Lecht Road was being built, the government also took over the 16th-century Corgarff Castle (page 177), at the road's southern end, and turned it into a bleak-looking military barracks; once the

OPPOSITE: Blair Castle, ancient seat of the earls and dukes of Atholl. The architectural style is mainly Scottish Baronial but the oldest part, Cumming's Tower, dates back to 1269. In 1746, Blair was the last castle in Britain to be besieged.

FAR LEFT: Haggis, served with 'neeps and tatties' (turnips and potatoes), Scotland's national dish.

*LEFT: Rowan (*Sorbus aucuparia*), also known as mountain ash, rivals the Scots Pine as the unofficial national tree of Scotland.*

PAGE 182: Signs of burning on the moorland. Burning is part of grouse management in that it helps heather (the grouse's food) regenerate quicker and destroys the litter which harbours ticks.

PAGE 183: Moorland heather near Garnshiel Lodge, Braemar, once used as a hunting lodge by Queen Victoria.

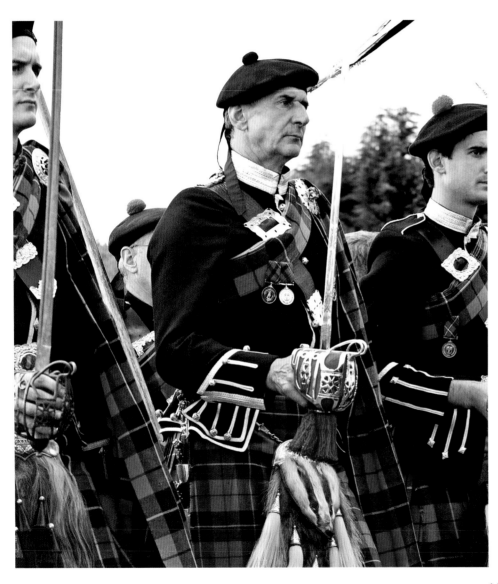

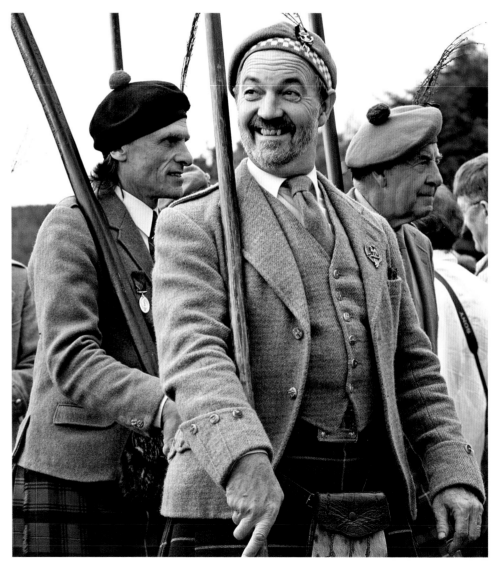

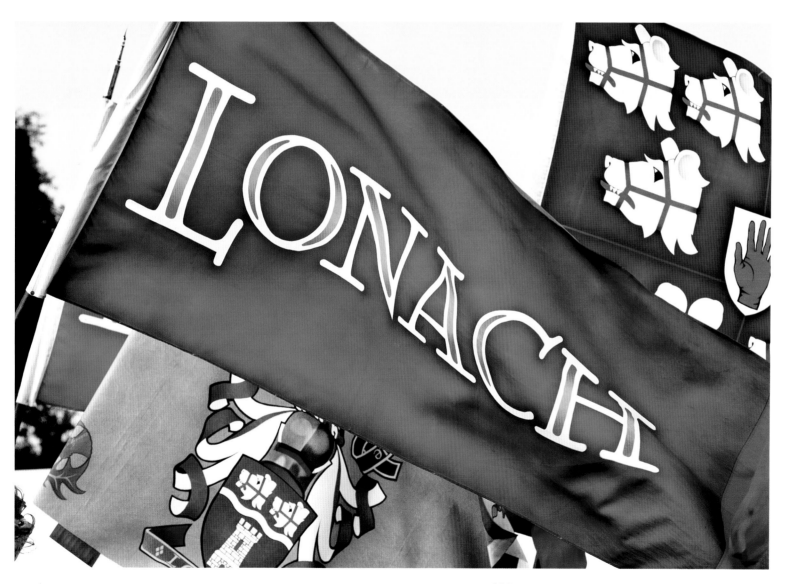

OPPOSITE LEFT & RIGHT:
Men of the Lonach Highlanders
march into the field at the Lonach
Highland Games, Strathdon.

LEFT: The heraldic banners of the
Lonach Highlanders.

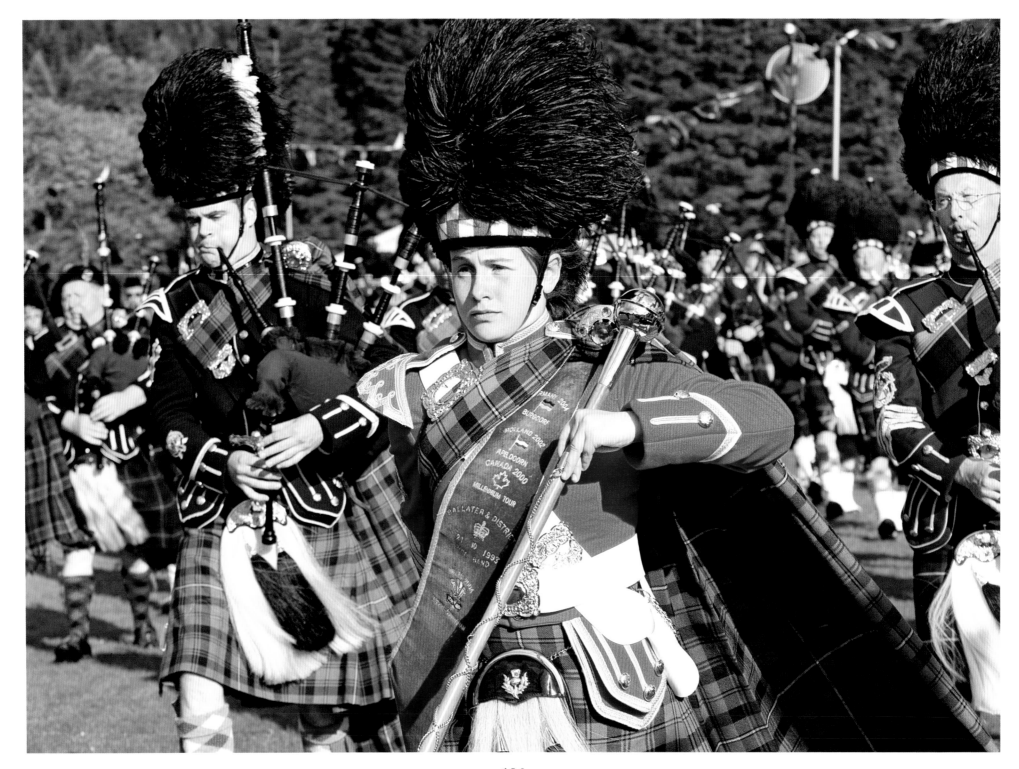

remains undiminished in the royal family today. In 1852, Victoria and her husband, Prince Albert, bought an estate called Balmoral, on the Dee, in a beautiful landscape of moorland, forest and hills, dominated by the 3,786-ft (1,154-m) Lochnagar rising to the south. With the help of Aberdeen's city architect, they replaced the original old tower castle with one in a Victorian style which was copied in so many Scottish estates that it came to be almost as uniquely Scottish an architectural style as the much older tower house. (Many of these Scottish Baronial piles are now comfortable country house hotels, adding greatly to the pleasure of touring in Scotland.) In fact Victoria and Albert started many fashions that are still followed by well-to-do Scots and English people in Scotland, including late summer shooting parties on grouse moors, attending Highland Games (at Braemar for those living at Balmoral), drinking whisky, tartan carpets, servants in kilts, and Scottish country dancing.

Although the gardens of Balmoral Castle are open only when the royal family is not in residence, and only a couple of rooms in the castle itself are shown to the public, the very presence of royalty has helped to turn Deeside into one of Scotland's major tourist attractions, although there is plenty of interest to the visitor in this beautiful part of the Highlands even without Balmoral Castle. Near Balmoral itself is Crathie Church, where the royal family worships when it is in Scotland, and where the Princess Royal married her second husband, Commander Timothy Laurence. The Royal Lochnagar Distillery, which produced Queen Victoria's favourite dram, has a visitor centre and offers tours of the distillery.

Braemar, 9 miles (14km) west of Balmoral, is famous both for its round-towered castle and for the Highland Games held there each September. Nearby, at the beauty spot known as Linn o' Dee, river waters cascade into a series of rocky pools, while in the surrounding Forest of Mar there is much fine walking country, taking in the foothills of the 4,296-ft (1,309-m) Ben Macdhui.

East of Balmoral, the A93, the main road to Aberdeen, follows the bank of the rock-strewn River Dee, a favourite fishing-ground for the royal family, passing several interesting towns including Ballater, built at the end of the 18th century to bring visitors to the nearby spa of Pannanich Wells, and Aboyne, famous for its Highland Gathering each September.

At Banchory, where the Water of Feugh joins the Dee, several roads go north towards the valley of the Don into a country dotted with castles, including Castle Fraser (page 146), a massive building in the care of the National Trust for Scotland near Kemnay, and Craigievar (143) to the north-west. The maps of the area also indicate numerous prehistoric sites, a reminder that 50 per cent of Scotland's standing stones, as well as other prehistoric remains, are to be found in the Grampian region.

Past Banchory, the A93, still following the Dee, passes Crathes Castle (149), one of the finest Jacobean houses in

OPPOSITE: A pipe band leads competitors into the field at the Lonach Highland Games, Strathdon.

Scottish Highland Games: throwing a weight over a bar (right) and tossing the caber (far right).

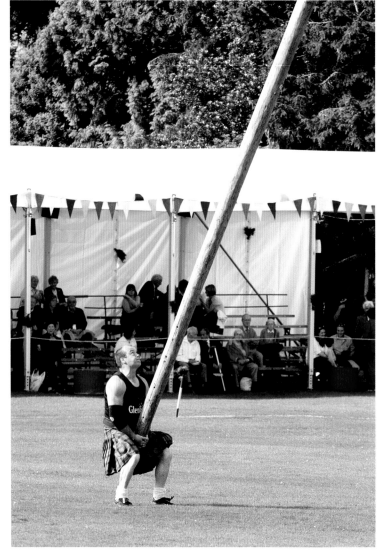

Scotland and well worth visiting, especially for its wonderfully decorative ceilings in areasa with such romantic names as the Room of the Nine Nobles and the Room of the Green Lady, where a ghost is said to walk, with her baby, through several rooms in the castle.

Another 6 miles (10km) down the glen is the National Trust for Scotland's Drum Castle (page 148)), where a crow-stepped gabled mansion was added to the original thick-walled medieval keep early in the 17th century. A few miles' drive from Drum brings the traveller to the outskirts of Aberdeen, Scotland's third largest city.

There is a current belief that Aberdeen, the 'Granite City', which all Scotsmen either love or loathe, has been utterly transformed by the discovery of oil in the North Sea. It is true that the city's airport and harbour, in particular, have been greatly enlarged to cope with the air and sea traffic of the oilfields and that there has been increased construction of offices, hotels and conference centres; but Aberdeen, built on and built out of granite, has been a self-confident, solidly-based city for generations and still retains the rather dour self-confidence it has known since its industrialization at the beginning of the 19th century.

The city of Aberdeen falls into two parts, Old Aberdeen being an area of cobbled streets and houses, many of them dating from the 16th century, with the city's oldest cathedral, St. Machar's,

and King's College, the oldest part of the university, within its bounds, while Central Aberdeen, with its more formal rows of granite-built houses and terraces, is where most of the city's art galleries, museums, markets and university buildings are to be found, dotted around the two main thoroughfares of Broad Street and Union Street. Down in the harbour area, off Market Street, is Aberdeen's Maritime Museum and its splendidly modern Fish Market, the biggest in Scotland, and a reminder that fish has been sold and auctioned here for at least seven centuries.

Although approaching the city from the west tends to give the visitor the feeling that Aberdeen is in a somewhat isolated position, set on the edge of the North Sea between the arms of two rivers, the Don and the Dee, it is, in fact, not much more than a 50-mile (80-km) drive down to Dundee on the Firth of Tay. The city is also the gateway to some of Scotland's most unspoilt coastline to the north; in fact, up to Cruden Bay and on to the busy Buchan fishing ports of Peterhead, Western Europe's biggest whitefish port, and Fraserburgh, stretch many miles of pristine beaches.

The famous Glenmorangie single malt whisky is produced at Tain, Easter Ross.

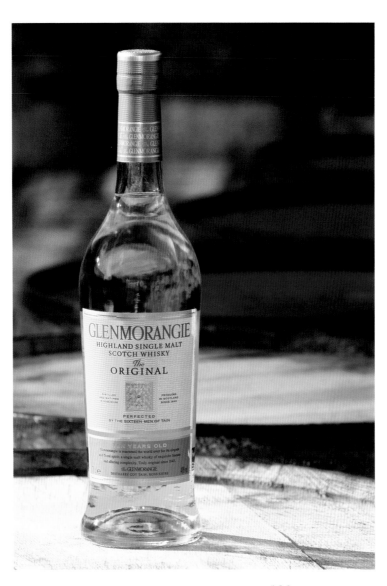

SCOTLAND & WHISKY

Whisky was probably first distilled in Scotland in the 15th century, largely for medicinal purposes. Historians guess that Scotsmen were first alerted to the properties of distilled alcohol by the Irish, who had been making aqua vitae *(or 'water of life', the Gaelic for which is* uisge beatha) *since the 12th century.*

Scotland, with a climate too cold for growing grapes, proved to be ideally suited to the production of distilled alcohol based on grains such as barley. There was plenty of high-quality water, essential in the distillation process, and there were abundant supplies of peat to provide the fuel which gives whisky its unique flavour and taste – or flavours and tastes, for it is the great diversity of both which gives whisky its unique place among the distilled alcohols of the world.

For centuries, whisky-distilling was a home-based affair, with farmers and local lairds producing just enough for family use. It took on a greater importance in national life when Scotland's 'Auld Alliance' with France, during which the trade in wine between the two countries had been considerable, came to an abrupt end with the merger of the crowns of Scotland and England. In time, of course, the government came to see the value of whisky as a revenue-earner and its production and trade came to be regularized by various acts of parliament. Occasionally, in times of poor harvests, the business even had to be strictly limited, so as to preserve the country's grain crops for food. Despite this, by the end of the 18th century the

Robert Nicholson checks the levels in the spirit safe in the still room at Glenmorangie.

RIGHT: *The gleaming elegance of Glenmorangie's copper stills, the tallest in Scotland, that stand around 17ft (5m) high. This ensures that only the purest, most delicate vapours are condensed into spirit.*

OPPOSITE: *The River Spey near Garva Bridge in the Monadhliath Mountains. In Speyside can be found the so-called 'Golden Triangle' of whisky production, centred around Dufftown.*

whisky-distilling industry was part of the fabric of Scottish life – as was the business of avoiding the excise duty imposed upon it. During the 19th century whisky grew into one of the country's biggest export earners.

The production of whisky is a long, drawn-out process, involving soaking the grain before putting it through processes of germination or 'malting', fermentation, distillation and maturation. It is during the last process, which takes place in wooden casks, that a malt whisky assumes its unique character and colour. Unlike wine, whisky does not mature in the bottle, so the best malt whiskies are likely to have spent from eight to 15 or 20 years in the cask.

The Scotch whisky industry is based on two types: single malt whisky, which is made from malted barley, and grain whisky, made from maize and a certain amount of malted barley. Blended whiskies, which are a mixture of the two types, with grain whisky predominating but with their distinctive flavours coming from the malt whiskies used in the blend, account for more than 90 per cent of all whisky sales. To make sure there is a whisky to suit every palate, the distillers and blenders have come up with various special blends, such as de luxe whiskies, which are blends of aged malts and well-matured grain whiskies, and vatted malts, which are blends of malt whiskies only.

Malt whiskies are classified in four groups, depending on their geographical origins: Highland, Lowland, Campbeltown and Islay. Connoisseurs can tell which area a single malt comes from by its

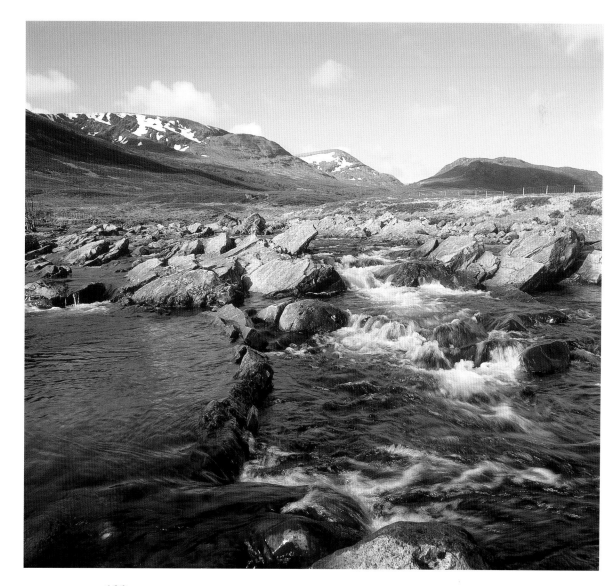

THE HIGHLANDS: THE NORTH-EAST

flavour. Highland malts are the most numerous and include the great Speyside malts; Islay and Campbeltown malts have strong, peaty flavours, and Lowland malts are softer and lighter in flavour than the others and tend to be used as a cushion between the heavier malts and the grain whiskies used in the blend.

For the novice whisky-drinker wanting to become more expert, there is no better place in Scotland to visit than Speyside, in the north-east. Here is the so-called 'Golden Triangle' of the whisky business, centred on Dufftown and containing rivers like the Livet and the Spey, the purity and abundance of the waters of which are vital to the production of fine malt whisky. The fact that the Spey is also one of Scotland's finest salmon-fishing rivers gives the area a double attraction.

Speyside's Malt Whisky Trail is a well-planned and mapped 70-mile (113-km) route taking in some eight distilleries, which offer guided tours with a free 'wee dram' at the end (motorists may take their drams away in miniature bottles). Among the distilleries on the trail are such famous producers as Glenfiddich, whose malt whisky is one of the world's best-known, and Glenlivet, which was the first licensed distillery in the Highlands, established after the 1823 Act of Parliament, which was aimed at cutting out illicit distilling and smuggling.

Another paradise for lovers of malt whisky is the island of Islay, a two-hour ferry trip away from Kennacraig on the south-western coast of Kintyre. Islay's fame lies in its production of malt whiskies with uniquely smoky flavours, and some of its best-known distilleries are congregated around Port Ellen, where the daily ferry from Kennacraig comes in. Along the road which heads east out of Port Ellen to Claggain Bay you will find, first of all, the famous Laphroaig distillery, its white-washed buildings commanding a superb view of the coastline and sea, then the Lagavulin and Ardbeg distilleries. All three may be visited, usually by appointment only.

There has been much illicit distilling and smuggling around Islay over the centuries, especially in the Oa, the windswept land jutting out into the sea west of Port Ellen. While little physical evidence of all this illegal activity remains, there is plenty to be seen of Islay's first legal distillery, set up at Bowmore in 1779 and still occupying its original site. Bowmore, Islay's administrative capital, lies north-west of Port Ellen on Loch Indaal, and from the road between the two can be glimpsed the Duich Moss peat bog, source of the peat which is essential to the flavour of Islay malt whiskies.

In the 19th century Campbeltown, on the west coast of Kintyre, boasted 34 distilleries. Today there are only three producing the distinctive Campbeltown malts, Springbank, Glen Scotia, and the newest, Glengyle. Again, visits are by appointment and there are even holiday cottages in the area for rent. It should also be noted that Scotland's distilleries must sell their product on site at the same retail prices as elsewhere.

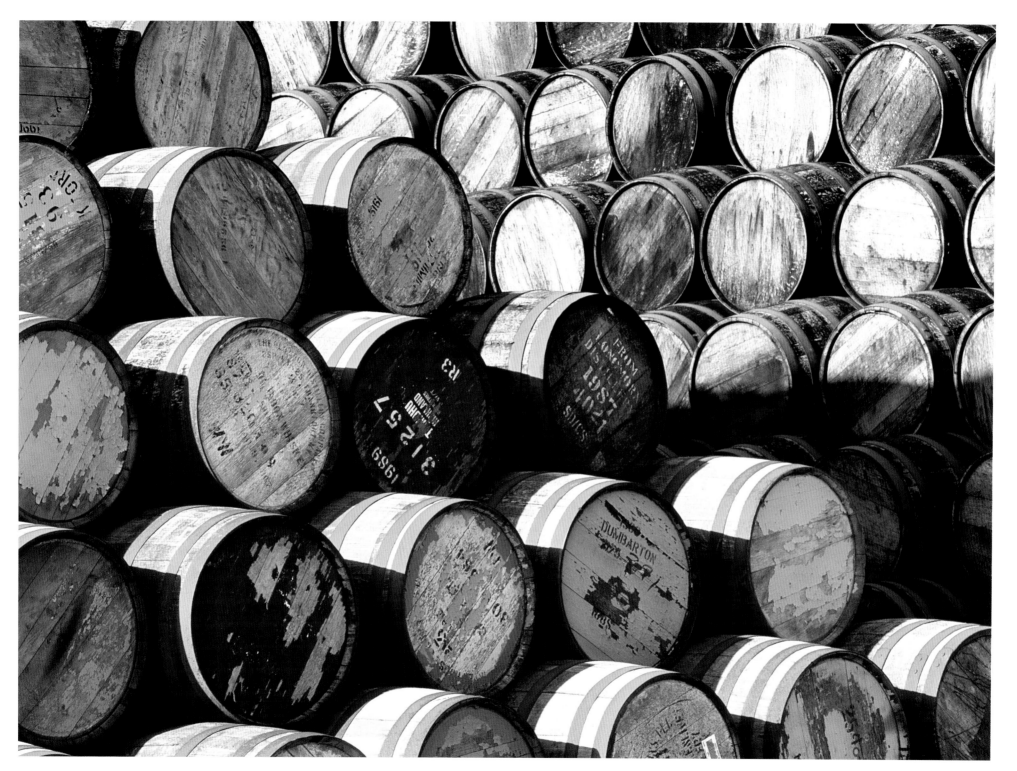

CHAPTER FOUR
THE HIGHLANDS:
THE NORTH-WEST

BELOW: Inverness's St. Andrew's Cathedral and the Victorian Tower Hotel on the banks of the Ness.

OPPOSITE: Douglas Row and Bank Street, on the east bank of the River Ness looking towards Inverness's city centre.

The north-western Highlands of Scotland include mainland Britain's most westerly point at Point of Ardnamurchan in the south-west and its most northerly point at Dunnet Head, between Thurso and John o' Groats, in the north-east. They also include its wildest, most scenically spectacular and most sparsely populated country in the great spread of land, much of it in Sutherland, which reaches towards Cape Wrath, the north-westerly tip of mainland Britain, where long lochs, like Erriboll and the Kyle of Durness in the north, and Lochs Inchard and Laxford round on the west coast, cut deep into the land.

This extraordinary country is cut off from the rest of Britain by Glen Mor (or Glen Albyn), the Great Glen, a mighty landslip formed some 350 million years ago, and which is Britain's most impressive geological feature. The Great Glen contains a string of four lovely lochs, Ness, Oich, Lochy and Linnhe. The completion of the 60-mile-long Caledonian Canal in the 19th century, running from the sea at Loch Linnhe in the south-west to the waters of the Moray Firth in the north-west, via all four lochs, effectively made north-western Scotland an island, for it provided a line of water the length of the Great Glen. The man-made part of the canal, for which James Watt was the surveyor and Thomas Telford the builder, accounts for just 25 miles (40km) of its total length; it is not as heavily used today as its pioneering builders imagined it would be.

Although the Caledonian Canal's draught is too shallow and its 29 locks too small to allow larger working craft to use it to cut the distance from Scotland's west coast to the east, it is still much used by fishing boats and pleasure craft, whose owners wish to enjoy the many pleasures of the Great Glen. Besides the lochs and canal, these include the ruins of various historically interesting castles, such as Castle Urquhart on Loch Ness, near to where the Loch Ness Monster is supposed to have his/her lair (as

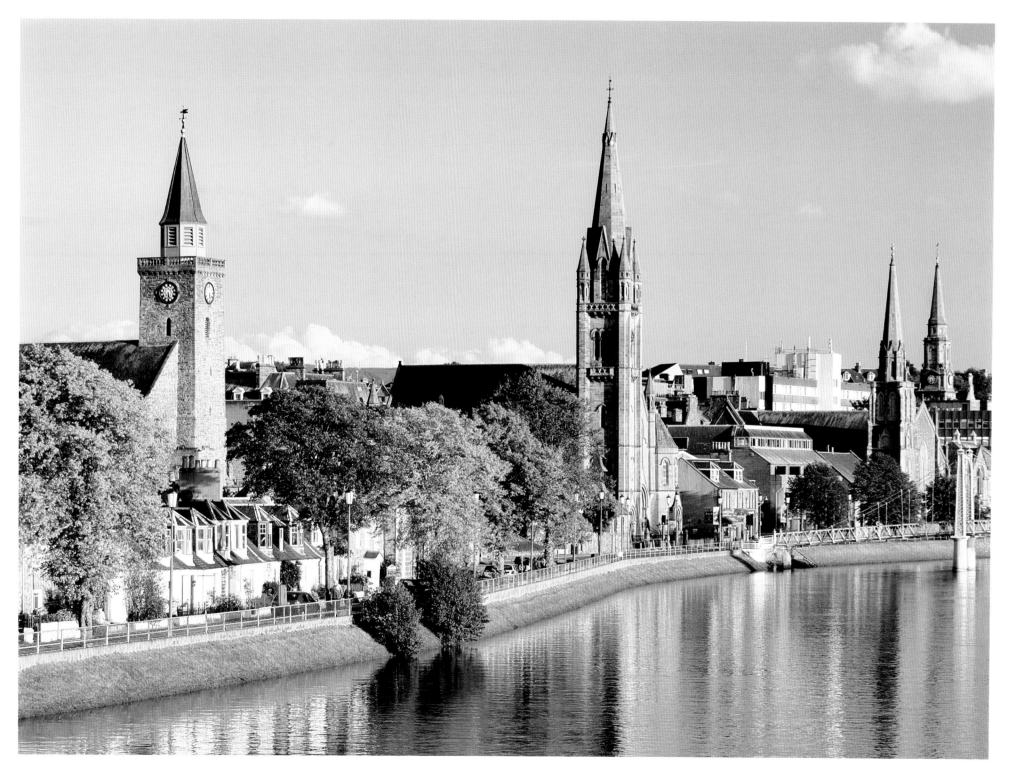

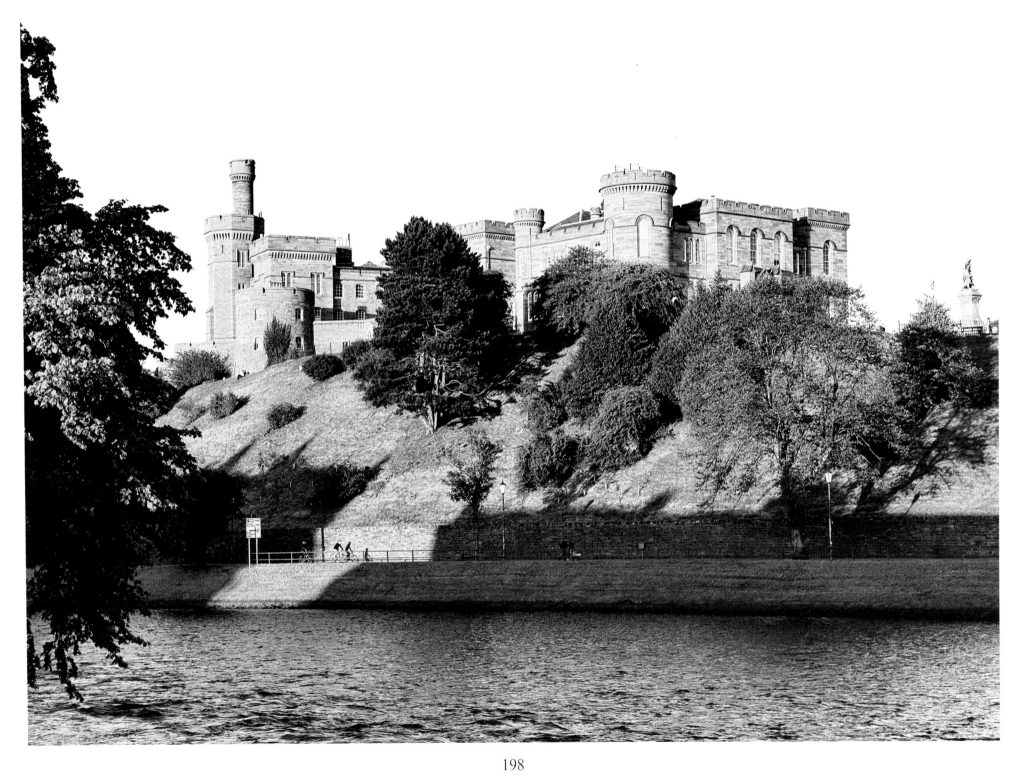

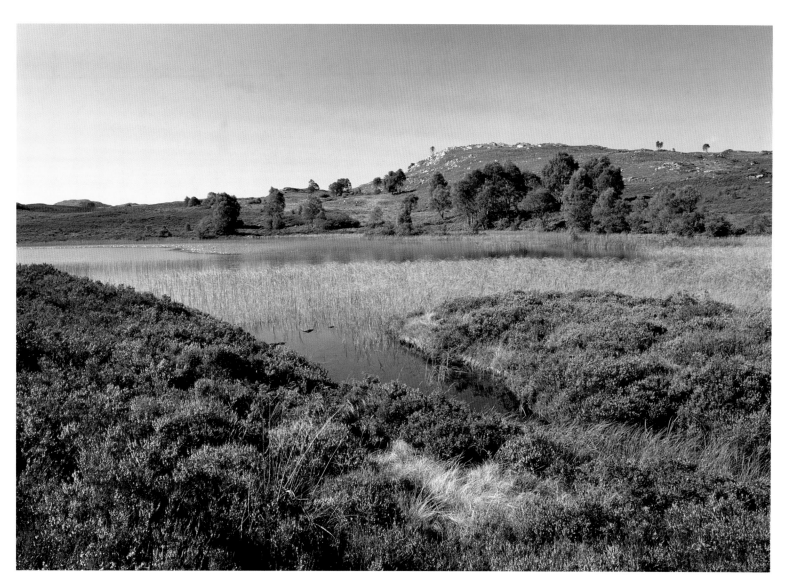

OPPOSITE: Inverness Castle looms above the River Ness, where it dominates the centre of the city. A succession of castles has stood on this site since 1057, but the red, castellated sandstone structure standing today was built in 1836 on the site of a much earlier structure by William Burn as the County Hall of Inverness-shire, and is today home to the High Court and council offices. The castle is the starting point (or end of) the Great Glen Way, that was designated as such in 2002.

LEFT & PAGE 200: Beautiful Glen Convinth rises to the north of Loch Ness between Drumnadrochit and Beauly.

PAGE 201: The romantic ruins of Castle Urquhart, possibly dating from the 13th century, sit on a rocky promontary on the banks of Loch Ness. It is now in the care of the National Trust for Scotland.

FAR RIGHT: The Memorial Cairn at Culloden, Inverness, with the battlefield site beyond.

BELOW RIGHT: A lock-keeper's cottage at Dochgarroch.

OPPOSITE: A passenger steamer and pleasure boats in the lock at Dochgarroch on the Caledonian Canal, at the north end of Loch Ness.

PAGE 204: The early 19th-century bridge built by Thomas Telford at Invermoriston near Loch Ness.

PAGE 205: The view west over Loch Garry and Glen Garry from the road leading from Invergarry to Kyle of Lochalsh.

described at the Loch Ness Monster Centre at Drumnadrochit, a couple of miles up the road from the Castle), and Invergarry Castle, razed by 'Butcher' Cumberland after Culloden because its Jacobite owners had given shelter to Bonnie Prince Charlie.

Today Invergarry's ruins provide the object of a pleasant before-dinner stroll in the grounds of the Glengarry Castle Hotel, one of those Victorian baronial piles, complete with glass cases of stuffed birds and tartan carpets, that help to make touring in Scotland such a pleasant experience. The demands of holidaymakers since the mid-19th century have, of course, brought many changes here. The pleasant towns of Fort William, a major touring centre at the southern end of the Great Glen, and

Fort Augustus, a popular angling centre at the southern end of Loch Ness, both began life as forts built to pacify the Highland clans in their wild glens to the north. Even the good roads, which take the touring motorist so quickly from place to place along the Great Glen, in places follow the line of General Wade's Military Road which, reaching the Great Glen between the Grampian and Monadhliath Mountains via the Corrieyairack Pass, crossed it near Fort Augustus.

Rising out of beautiful Glen Nevis, south of Fort William, the 4,418-ft (1,347-m) Ben Nevis, Britain's highest mountain, lures

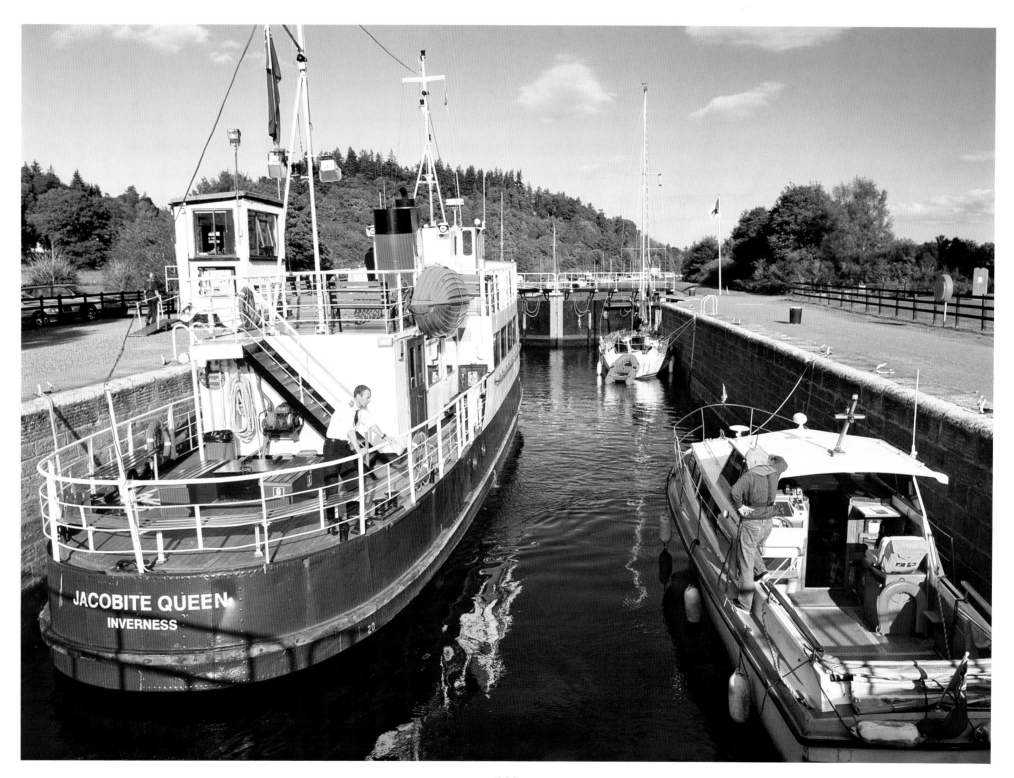

seems a world apart, a land of soaring mountain peaks, of rivers flowing over stony beds, of mighty waterfalls such as the 370-ft (113-m) Falls of Glomach in the Kintail Forest, of still remote inland lochs, many of them with ruined castles on their shores attesting to a time when Highland clans and families were often at war with each other, and, on the west coast and in the far north, great sea lochs cutting into the land. Despite those ruined castles, the impression this country gives is one of nature and geography still being paramount, of a land on which people have made scant impact.

It is a false impression, for parts of this country have been inhabited for longer than elsewhere in Britain, particularly the fertile flatlands of the eastern North Sea coasts. This is a country rich in prehistoric remains, from the Pictish brochs at Glenelg on the west coast to the many cairns, burial chambers, brochs and field systems which dot the eastern coastal country, especially between Loch Brora and the coast at Brora, and in the country inland from Latheron and Lybster. At Achavanich, inland from Latheron on the A895, the 40 remaining Achavanich Standing Stones are of particular interest because of their oval, rather than circular, layout, while a minor road, off the A9 just beyond Lybster, leads to the massive Grey Cairns of Camster, a complex layout of burial cairns dating back to the Stone and Bronze Ages which have been carefully restored.

thousands of walkers, backpackers and climbers to its slopes every year, at the same time giving a foretaste of the spectacular scenery to come away to the north of the Great Glen.

Although it has hundreds of miles of good roads and plentiful links by sea and air, Scotland beyond the Great Glen still

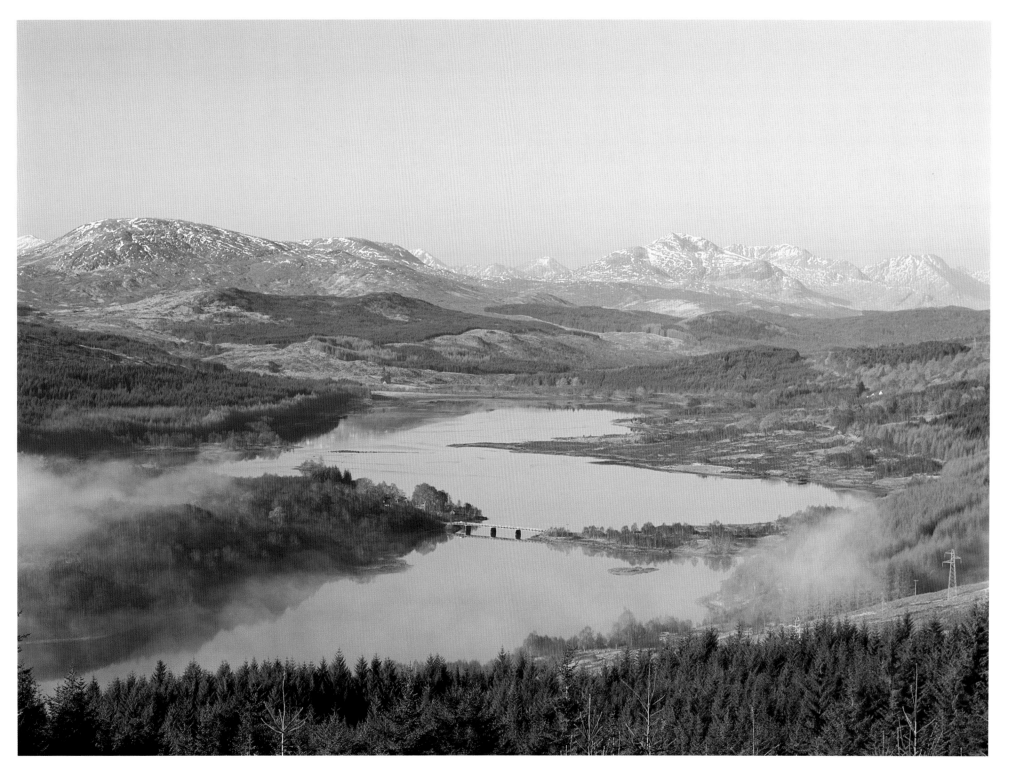

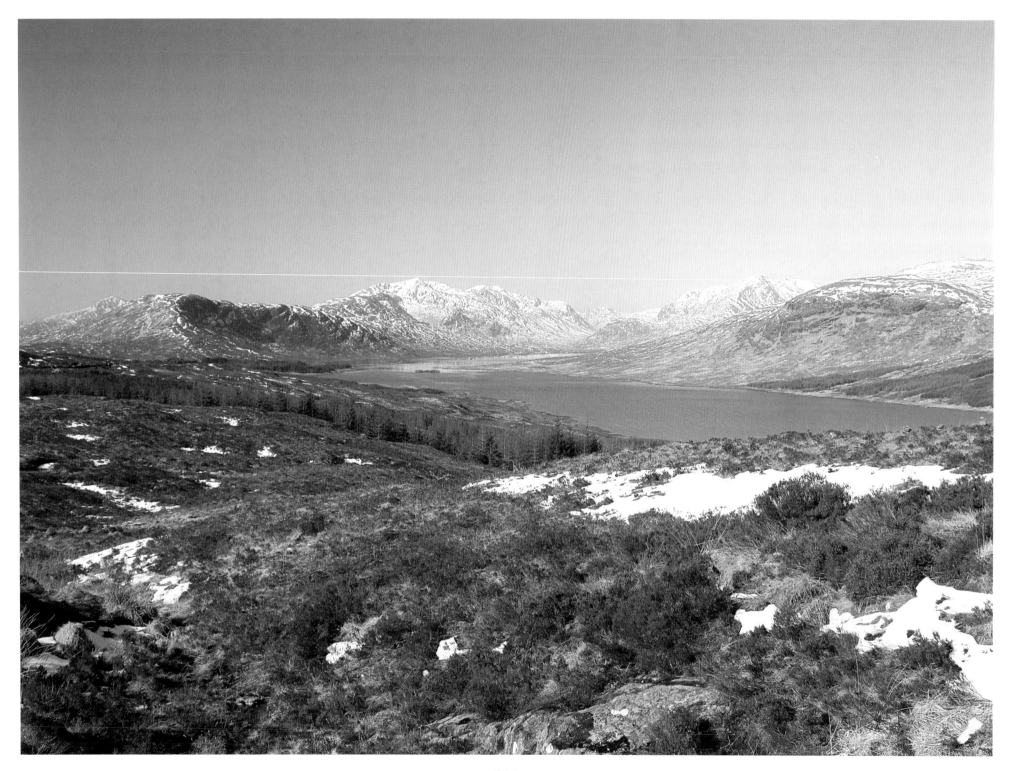

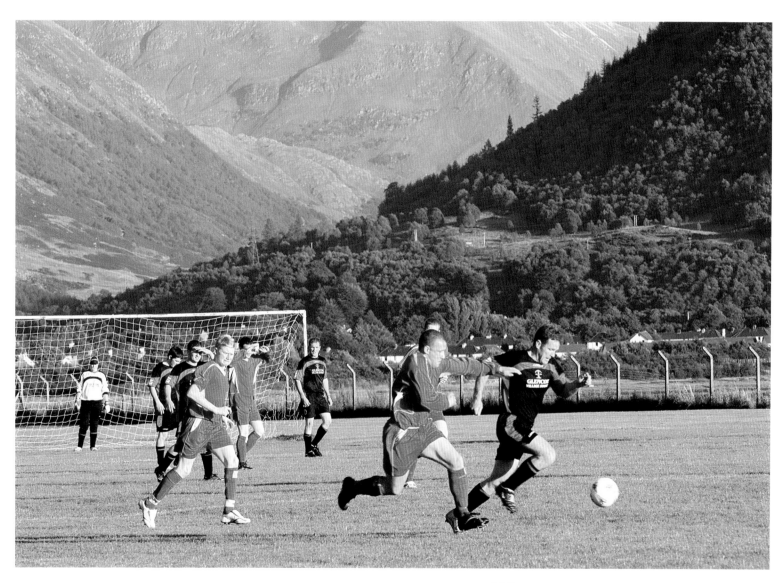

OPPOSITE: The view west over Loch Loyne.

LEFT: Local football teams, Ballachulish and Buckfast, on the pitch at Fort William.

PAGE 208: Ben Nevis rises above the town of Fort William at the head of Loch Linnhe.

PAGE 209: Boats berthed at the entrance to Neptune's Staircase, Banavie, on the Caledonian Canal. It comprises eight locks, and is the longest staircase lock in the United Kingdom.

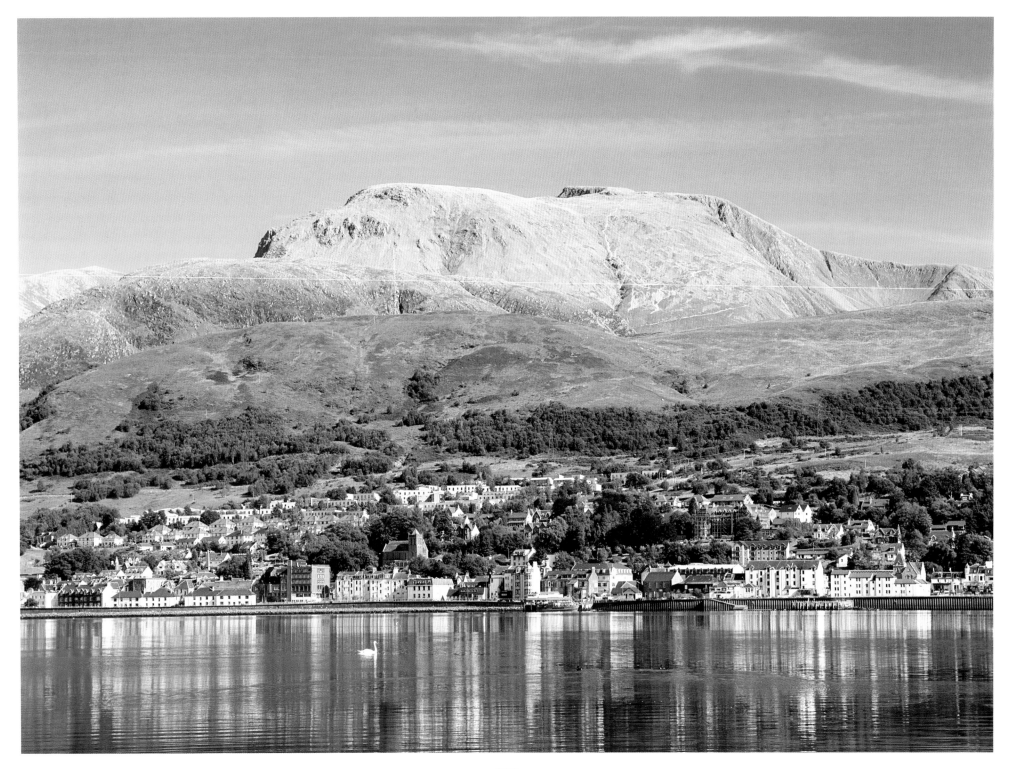

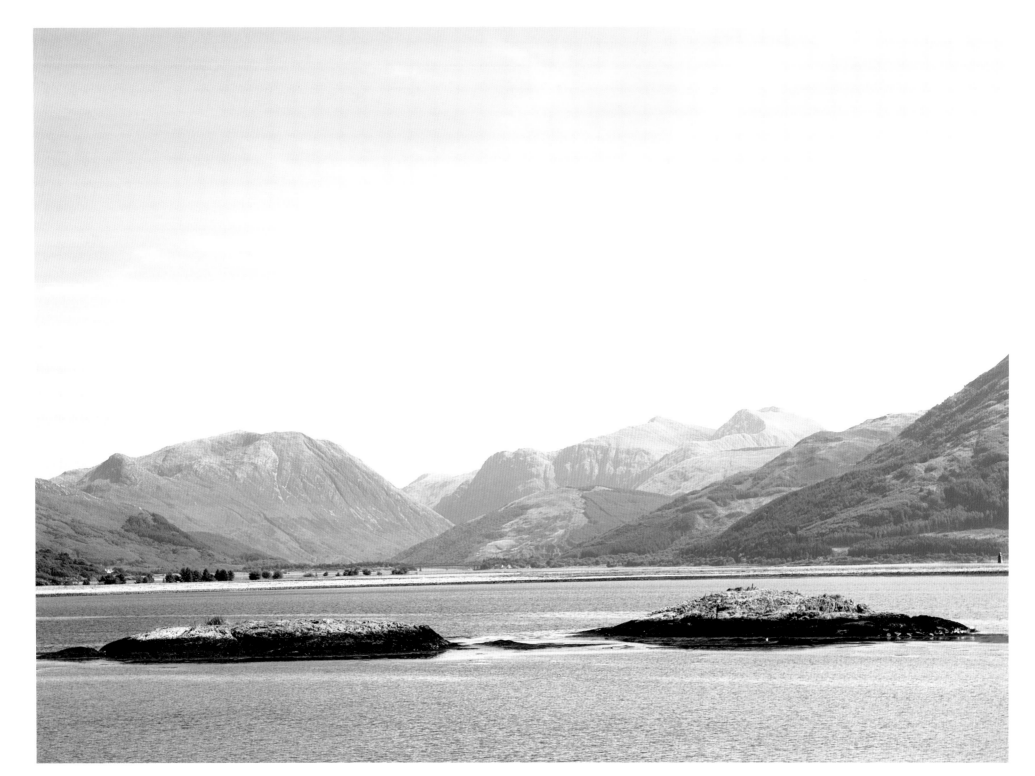

On the eastern coast of the region, stretching north from Inverness, the 'Capital of the Highlands' at the top of the Great Glen on the Moray Firth, and the Black Isle right up to Duncansby Head, the land is a low-lying fertile strip backed, first by the hill country of Easter Ross, then by the brown moorland and flow, or marsh, country of the Caithness plateau. It is the country further west, broken by those great west-coast sea lochs reaching far inland, and marked by jagged mountain peaks rising from a strikingly underpopulated country, that has led this part of mainland Britain to be called the last great wilderness in Europe.

Although Inverness, the headquarters of the Highland Region and the largest local government division in Scotland, is the only

OPPOSITE: Looking north-east over the upper reaches of Loch Linnhe to the Ben Nevis massif.

BELOW: The lighthouse at Point of Ardnamurchan.

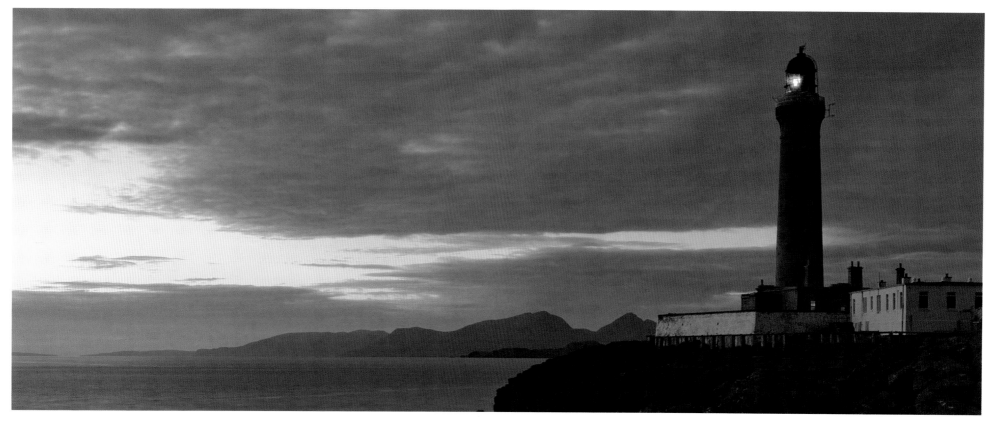

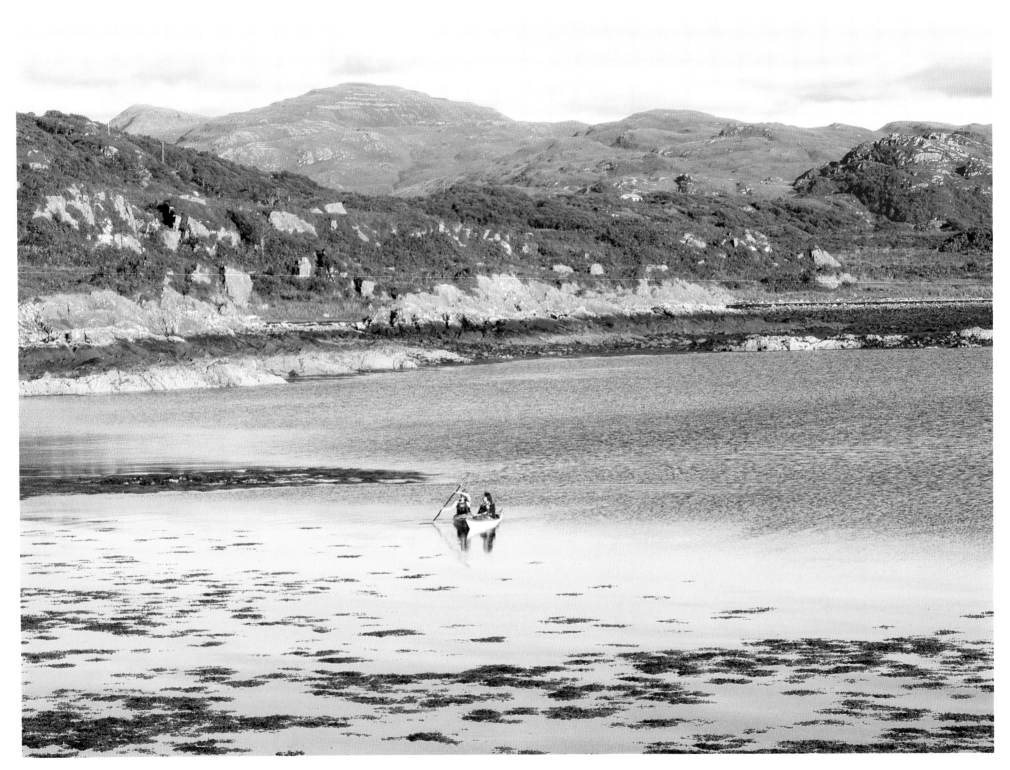

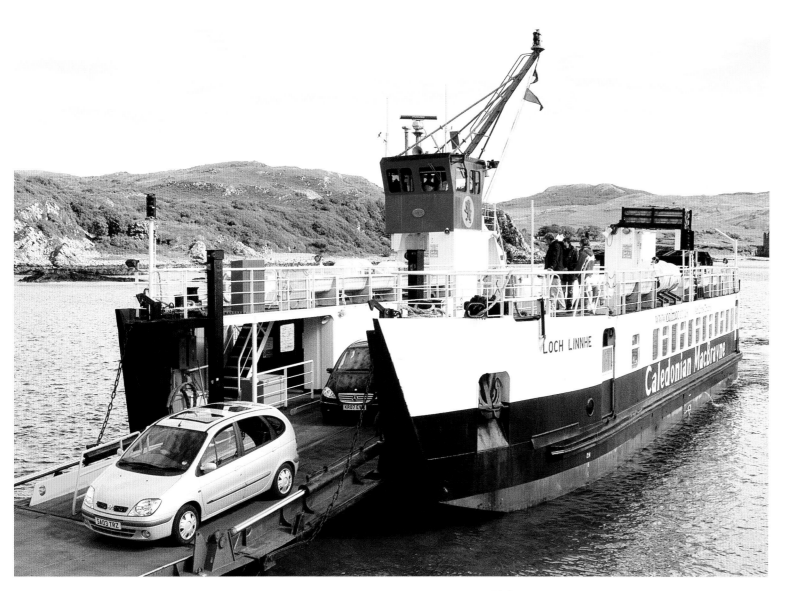

OPPOSITE: *Sea-kayaking in Loch Sunart, near Ardnamurchan.*

LEFT: *The Tobermory ferry seen at the Kilchoan pier on the southern coast of the Ardnamurchan peninsula.*

PAGE 214: *The Hebrides provide some of the finest waters in the world for experienced sailors. Here, a rain storm hits the Ardnamurchan mountains north of the Sound of Mull.*

PAGE 215: *Looking north from Beinn nan Losgann, Ardnamurchan, to the Cuillin Hills on the Isle of Skye.*

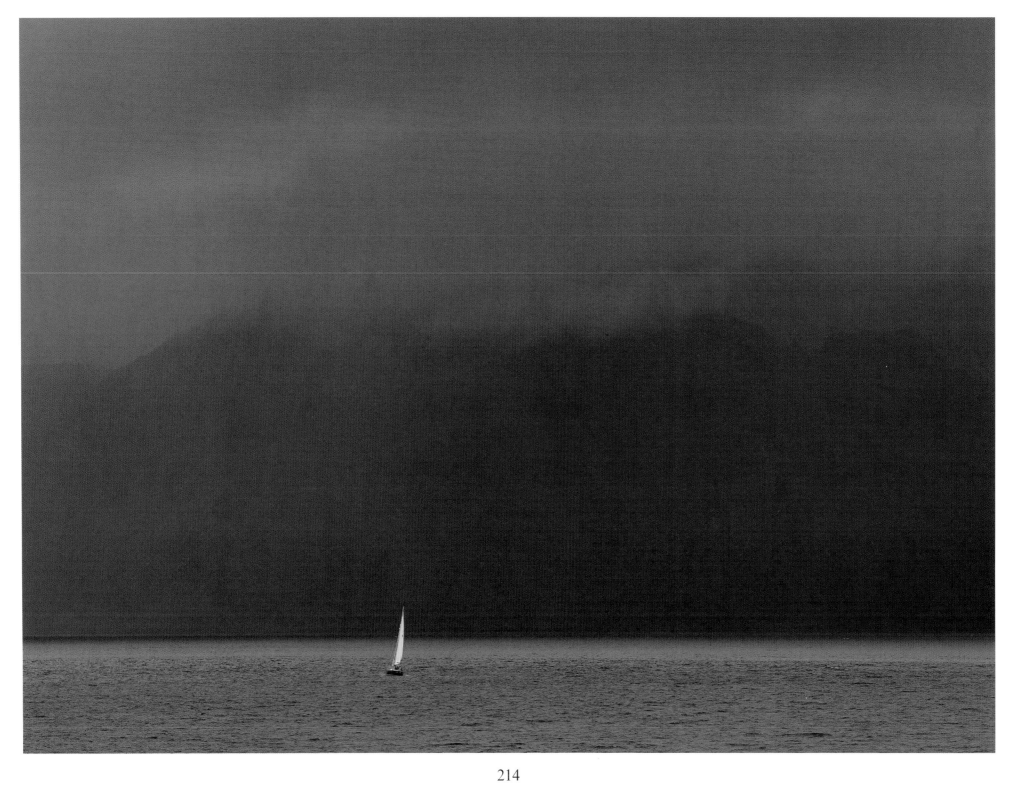

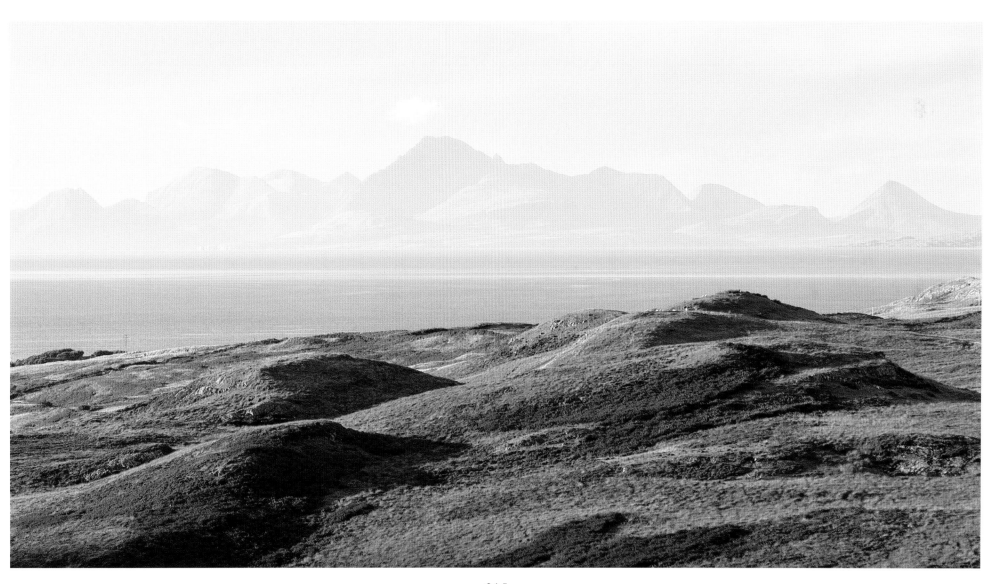

BELOW: Kilchoan Bay.

OPPOSITE: The north shore of Loch Sunart near Glenbeg.

major town of the region, there are numerous fine smaller towns, including Gairloch and Ullapool in the north-west, Thurso in the north and, over on the east coast, Dingwall, birthplace of Macbeth on the Cromarty Firth, whose northern shore has seen much new building connected with the North Sea oil industry, Dornoch, the home of the world's third oldest golf links, and Wick, which has been a royal burgh, albeit a small one, since the 12th century.

Strathpeffer, west of Dingwall, popular in the 19th century as a spa, its water coming from sulphur and chalybeate springs, is still a pleasant place, ideal for exploring Wester Ross, where the highest peak is the 3,465-ft (1,056-m) Ben Wyvis at Monroe.

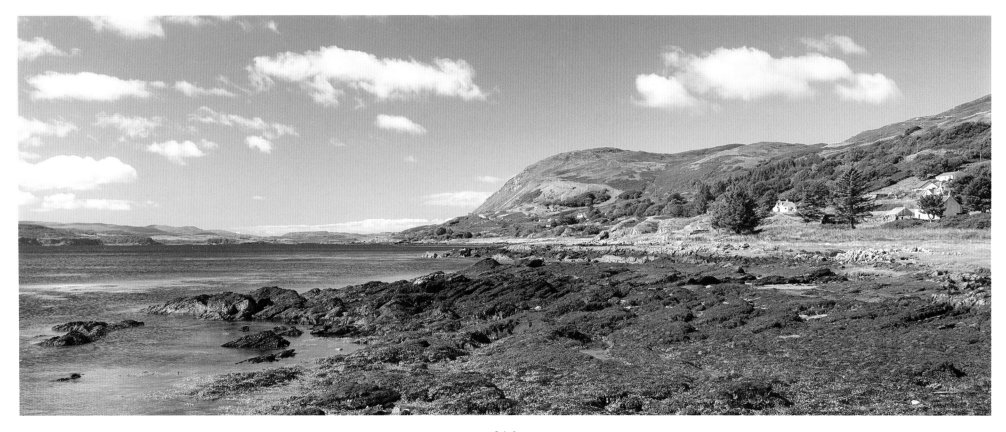

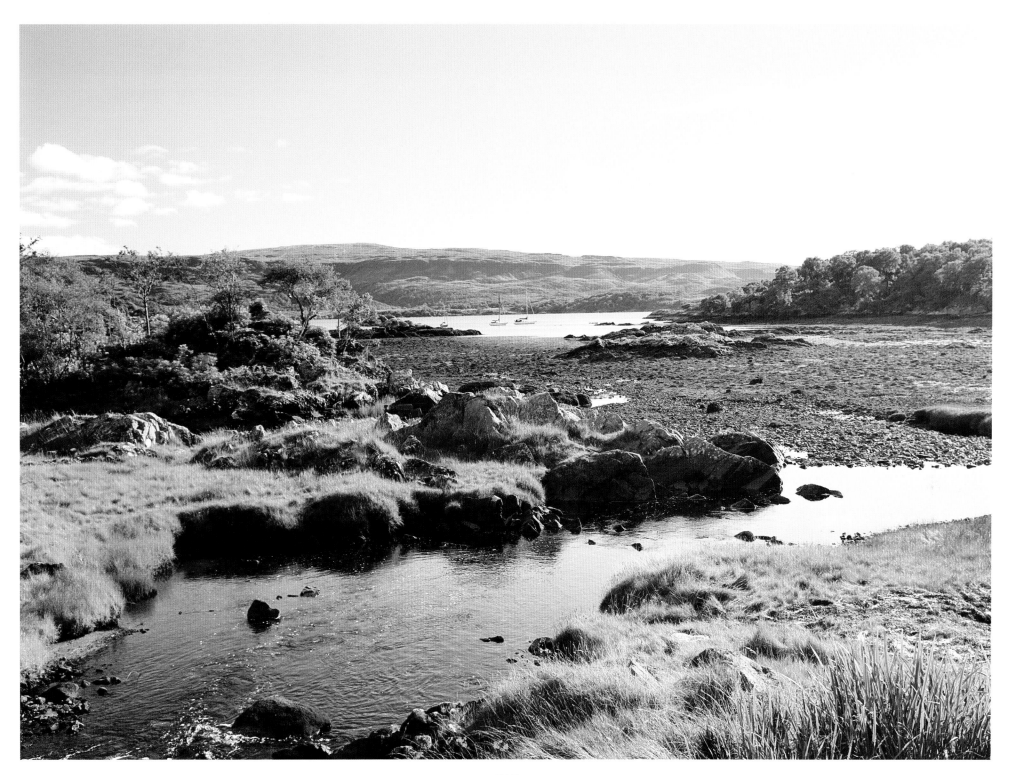

Few other places in the north-western Highlands are big enough to counteract the impression that this is a land where geography and nature, with its animal and bird life, is dominant over man. Lairg, at the eastern end of Loch Shin, is a pleasant market village at a crossroads of the Highlands, whose August sheep sales are a major event for Sutherland's sheep farmers. But most people go there for the breathtakingly wild and beautiful country surounding it, most of them failing to notice that Loch Shin is, in fact, a reservoir and part of the Shin Valley hydroelectric scheme, one of the largest in the country. Tongue, on the northern coast, is again an attractive little town, with a good hotel and an essential garage and petrol station; but it is the

OPPOSITE: The road to Salen, looking north to Moidart, Ardnamurchan.

BELOW: White beaches at Arisaig, a small village in Lochaber, south of Malaig.

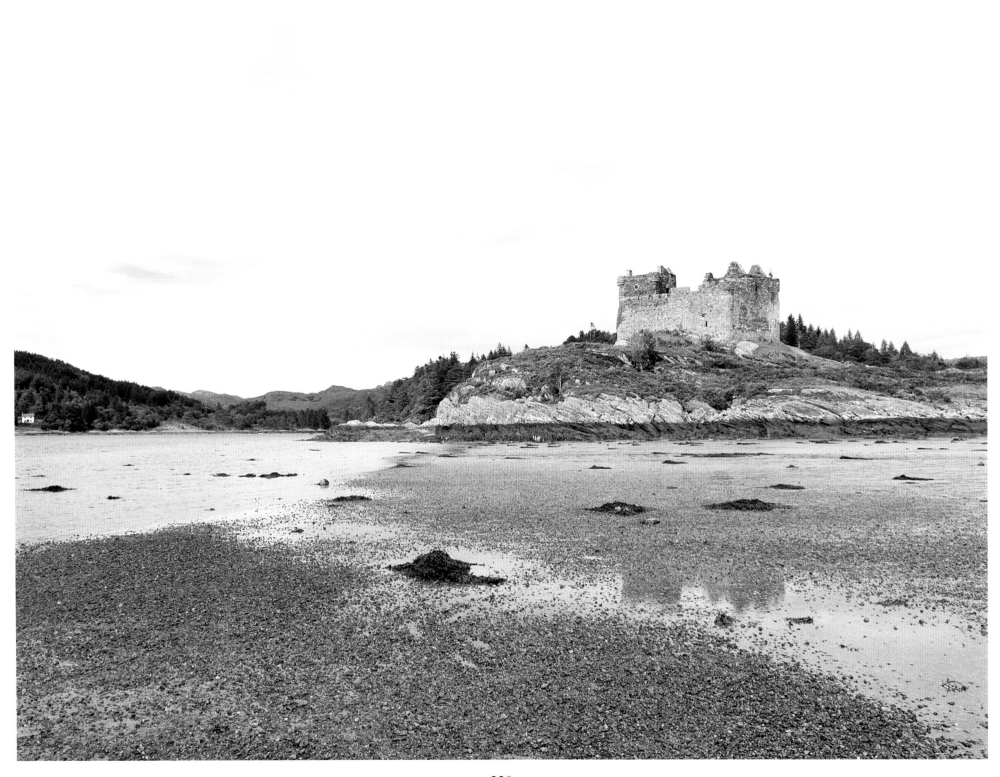

OPPOSITE: Castle Tioram overlooks the south channel of Loch Moidart, south of Mallaig. Now reduced to ruins, it was once a centre of power of the medieval Lords of the Isles, and later of the Macdonalds of Clanranald. It was burned down on the orders of the last chief before he left to join the doomed Jacobite rising of 1715.

LEFT: Coastal landscape at Morar, south of Mallaig.

PAGE 222: A mountain stream flows through heather-covered moorland in Tarbet Glen, lying between Strontian and Loch Linnhe.

PAGE 223: The steam engine, Lord of the Isles, *pulls a passenger train across Glenfinnan Viaduct, on its way from Fort William to Mallaig.*

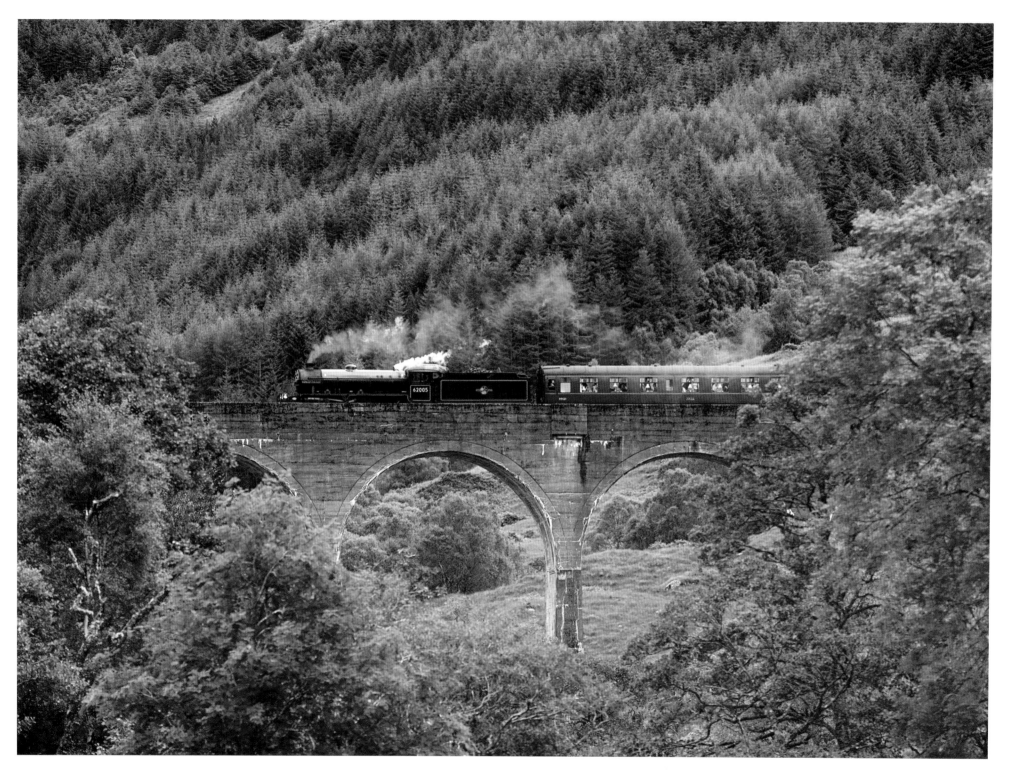

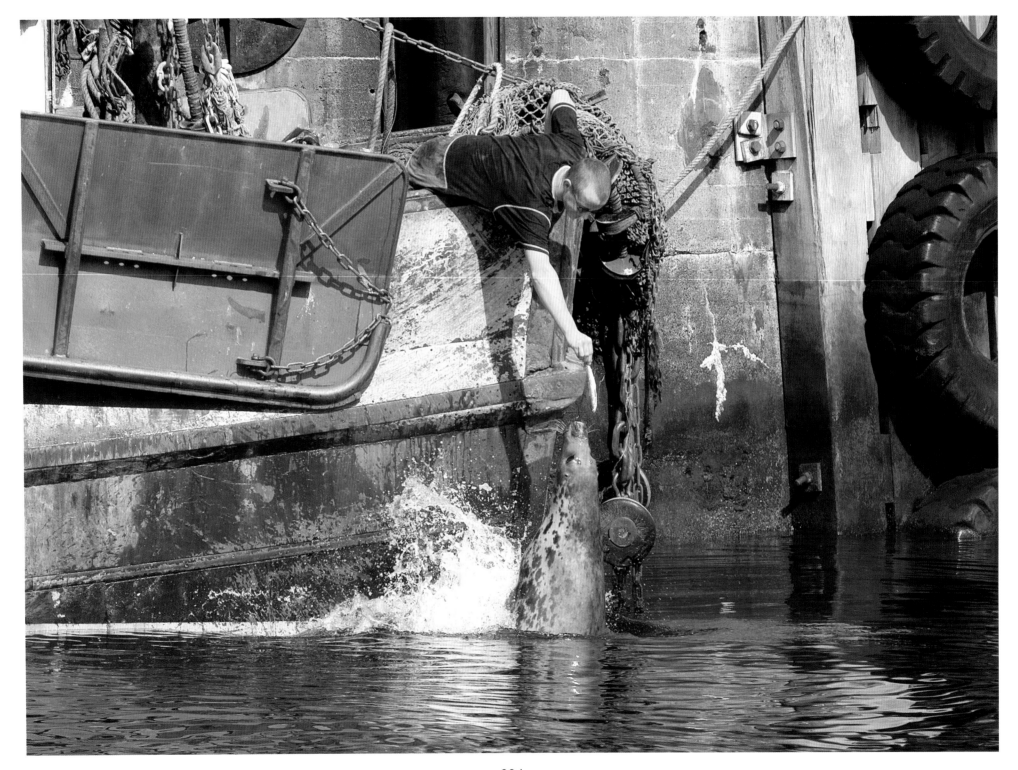

The afforestation of the Flow Country of the north-western Highlands, much of it used as tax avoidance exercises by rich people, has caused much bitterness, with conservationists and ecologists deploring the destructive march of the pine trees over peatland, which has for centuries provided ideal habitats for many species of birds. The counter argument is that forestry helps the economy and provides jobs – and the Highlands certainly need people. Two hundred years ago, about 20 per cent of the population of Scotland lived in the Highlands; today, the figure is about 5 per cent.

OPPOSITE: A fisherman feeding a seal in Mallaig harbour.

FAR LEFT: The inner face of the massive double wall of the Dun Troddan broch, dating from the first millennium BC.

BELOW: The Skye Bridge at Kyle of Lochalsh, with the Cuillin Hills beyond.

dramatic coastline with its empty, golden-sanded beaches and geological wonders, like the Smoo Caves away to the west near Durness, that bring people here, usually by way of Strathnaver or the road which skirts Loch Loyal on its way up from Altnaharra, a village given importance by its well-known hotel.

It should not be forgotten, however, that while people and civilization do not seem to have made a huge impact, outwardly at least, on this country, it has been inevitable that the the times in which we live should have brought many changes, such as the Shin Valley hydroelectric scheme and the vast acreages of the Forestry Commission's pine plantations.

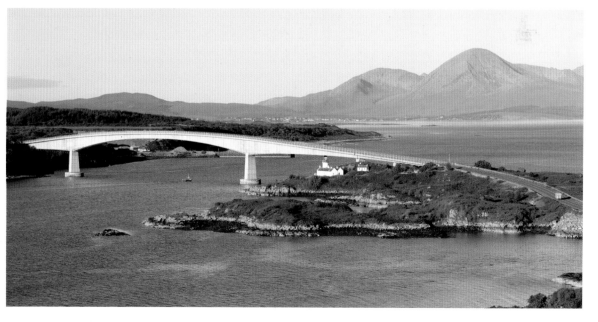

RIGHT: Snow-covered hills reflected in the still waters of Loch Duich, between Kyle of Lochalsh and Glenshiel.

OPPOSITE: The old ruined church at Clachan Duich, at the south end of Loch Duich near Kyle of Lochalsh, the ancient burial ground of the MacRaes.

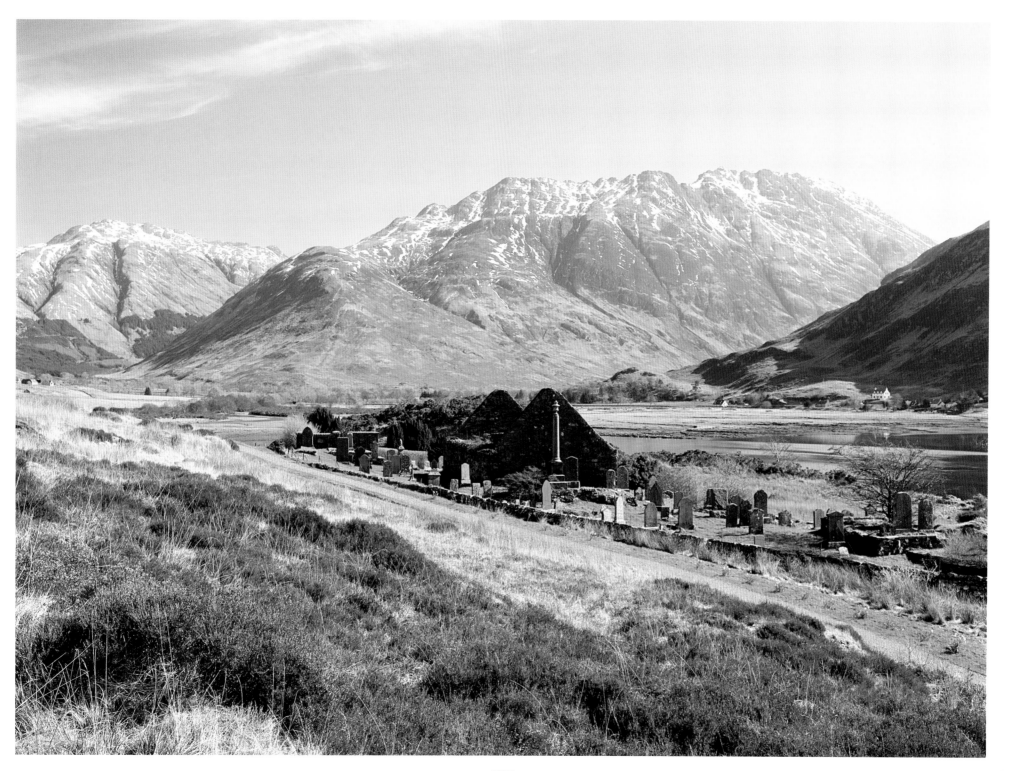

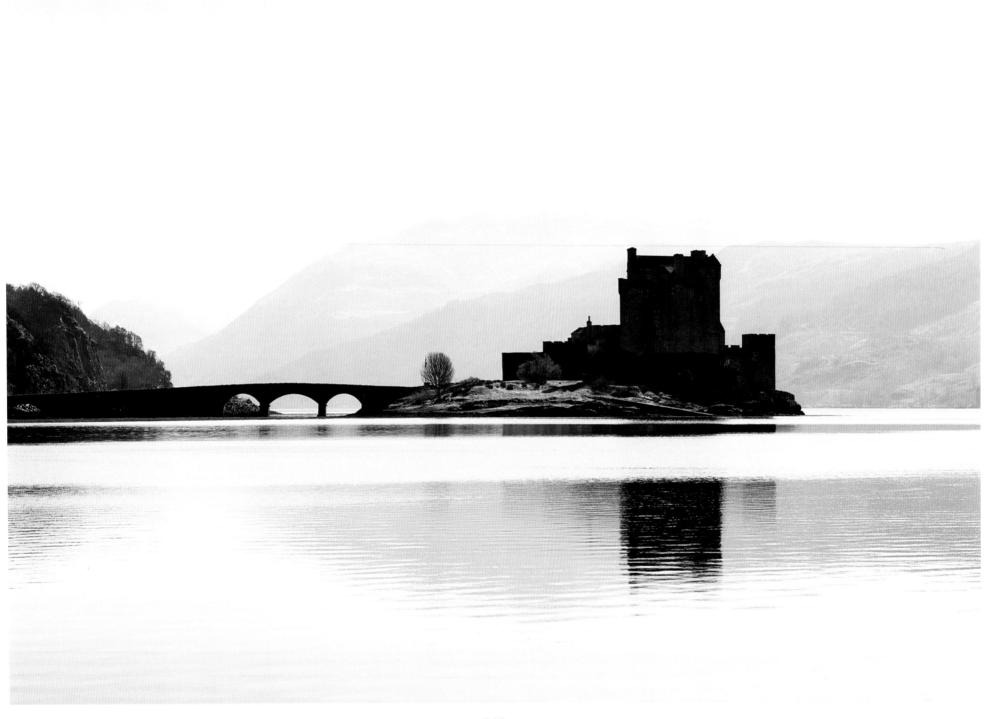

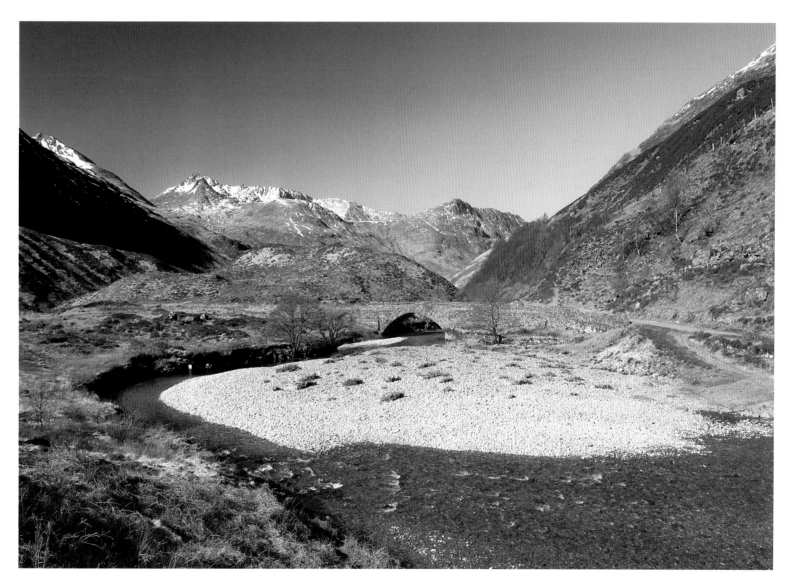

OPPOSITE: Eilean Donan Castle, built on a small island in Loch Duich, is probably Scotland's most iconic image. Although a habitation existed here in around the sixth century, the first fortified castle was built in the mid-13th century for Alexander II as a defence against the Vikings. Since then, at least four different versions of the castle have been built and re-built as the feudal history of Scotland unfolded through the centuries. Restoration took place between 1919 and 1932, which included the construction of an arched bridge to give easier access to the castle. In 1983 a charitable trust was formed by the MacRae family to ensure that the castle continued to be preserved.

LEFT: The River Shiel, looking north-west down Glenshiel with the Five Sisters hills beyond.

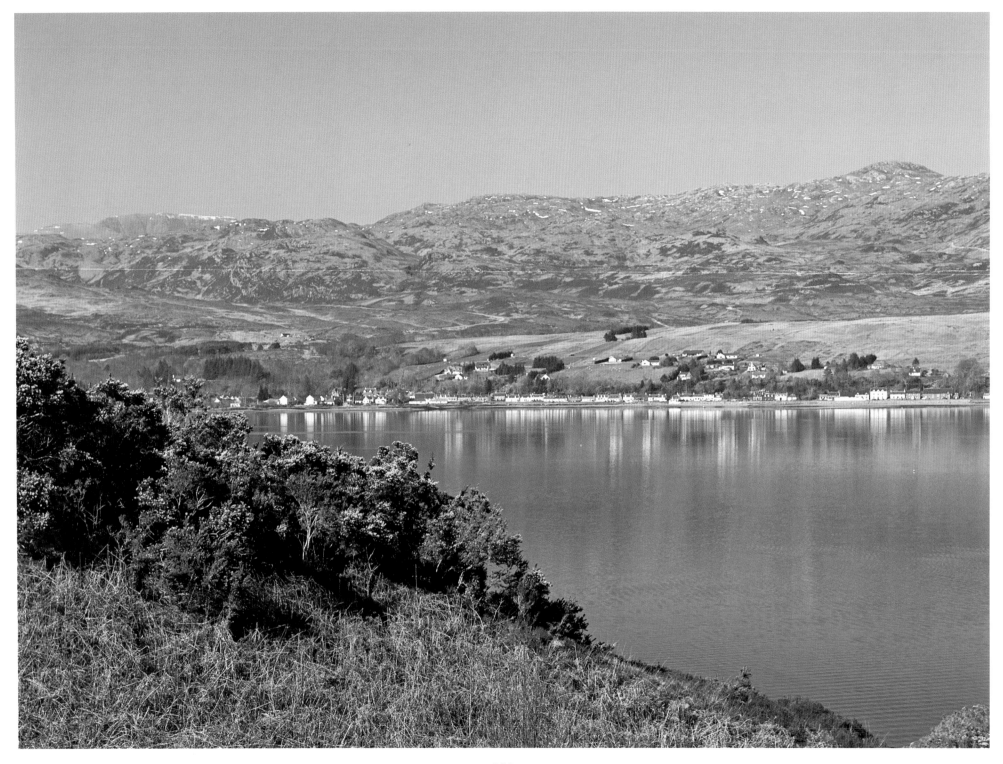

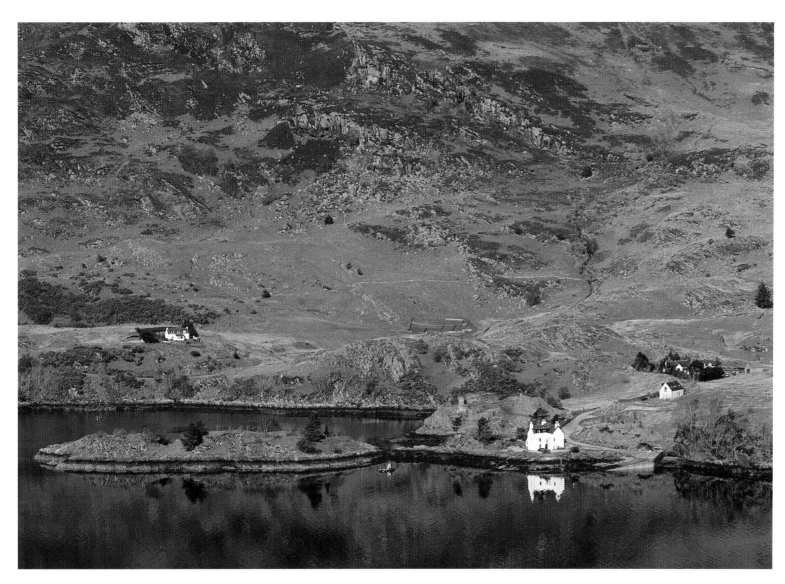

OPPOSITE: The view west across Loch Carron, a sea loch on the west coast of Ross & Cromarty, looking towards the village of Lochcarron.

LEFT: The jetty at Stromemore on Loch Carron, seen from Stromeferry near Kyle of Lochalsh.

THE HIGHLANDS: THE NORTH-WEST

OPPOSITE: *Logging conifers in Glen Carron, north-east of Kyle of Lochalsh.*

PAGE 234: *Woodland in Morvern, north of Lochaline.*

PAGE 235: *Ardtornish Castle in Morvern, approximately a mile south-east of the village of Lochaline, stands on a headland on the northern shore of the Sound of Mull. It was once an ancient stronghold of the Lords of the Isles.*

The reason why Strathnaver is so empty of people that it is possible to drive all the way up its narrow unfenced road without needing to pull into a passing place to make space for another vehicle, is that this lovely valley was hit particularly hard during the Highland clearances, that infamous time in the early 19th century when landowners, led by the first Duke of Sutherland, based in his splendid Dunrobin Castle at Golspie on the east coast, cleared people out of their crofts and off the land to make way for sheep, deer and forestry. Bettyhill, on the coast north of Strathnaver and east of Tongue, was specially built by Elizabeth, Marchioness of Stafford, to house crofters evicted during the clearances. Another parish to suffer particularly badly during these evictions was Kildonan, near Helmsdale on the east coast, where almost four-fifths of the population disappeared from the Strath of Kildonan between 1801 and 1830.

On the plus side of the man-environment equation is the work being done by organizations like the much-maligned Forestry Commission, the Nature Conservancy Council, and the National Trust for Scotland to preserve this superb wilderness and make its remote geography and wild nature accessible to people. At the impressive Corrieshalloch Gorge, south of Ullapool, for instance, where the Falls of Measach plunge 120ft (36m) into the ravine, the National Trust for Scotland preserves a good observation platform and a suspension bridge built by John Fowler, the engineer of the Forth Railway Bridge.

While there are sanctuaries and reserves in many places – near Bettyhill, for instance, there is a bird sanctuary at Torrisdale Bay and the Invernaver Nature Reserve, with a fine collection of rare alpine plants, while the whole of tiny Handa Island, just offshore south of Loch Laxford, is one of Britain's most important bird sanctuaries – nature is to be found at its most spectacular in north-western Scotland in areas like the Inverpolly Nature Reserve, at the Beinn Eighe National Nature Reserve in Torridon, and at Inverewe Gardens.

The Inverpolly Nature Reserve is in the far north-west, 10 miles (16km) by road north of Ullapool. Comprising 27,000 acres (10,925 hectares) of virtually unpopulated mountain and loch wilderness, with few trees or large plants, Inverpolly's habitats include marine islands, peat bog and moorland, and birchwoods that provide shelter for wildcats, pinemartens, golden eagles and deer. Above them rise the jagged shapes of geologically ancient mountains, including Cul Beag, the sugarloaf-shaped Suilven, and Stac Polly (or Pollaidh), whose splintered outline resembles some fairytale castle rising out of the land. There is fine fishing in many of the lochs of the reserve, especially Loch Sionascaig.

At the reserve's western edge, Knockan Cliff stretches for a mile above the road from Ullapool. This is a geological rarity, a rock formation where the topmost layers of schists are older than the limestone and quartzite beneath, suggesting that tremendous upheavals of the land must have occurred here many millennia

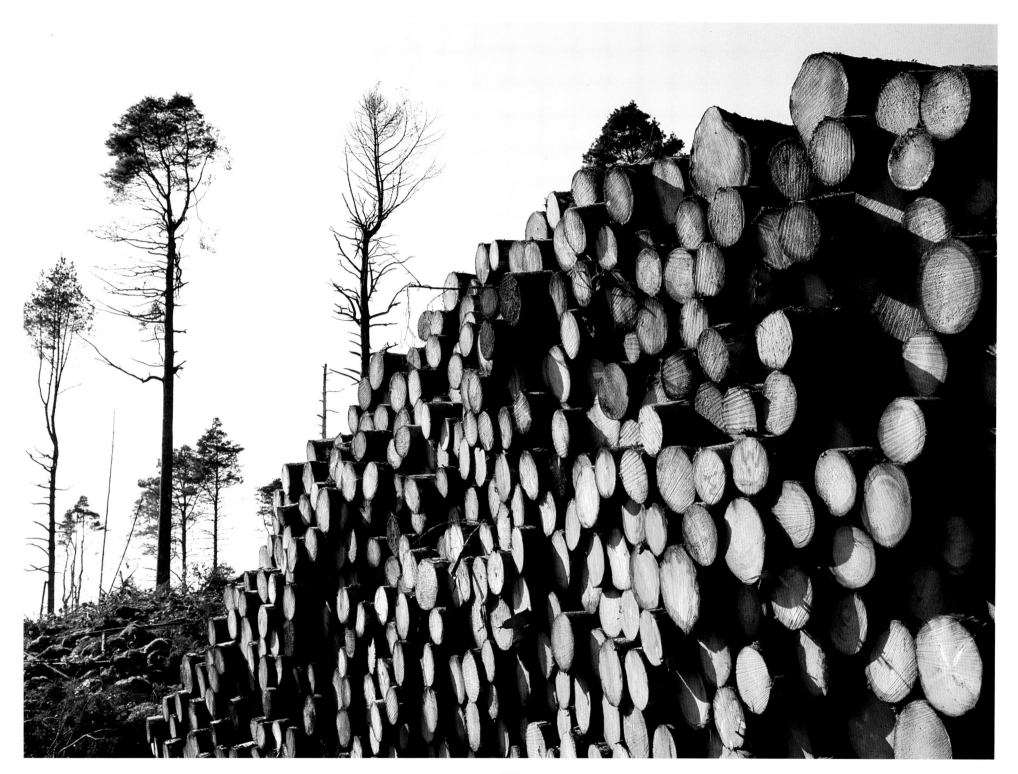

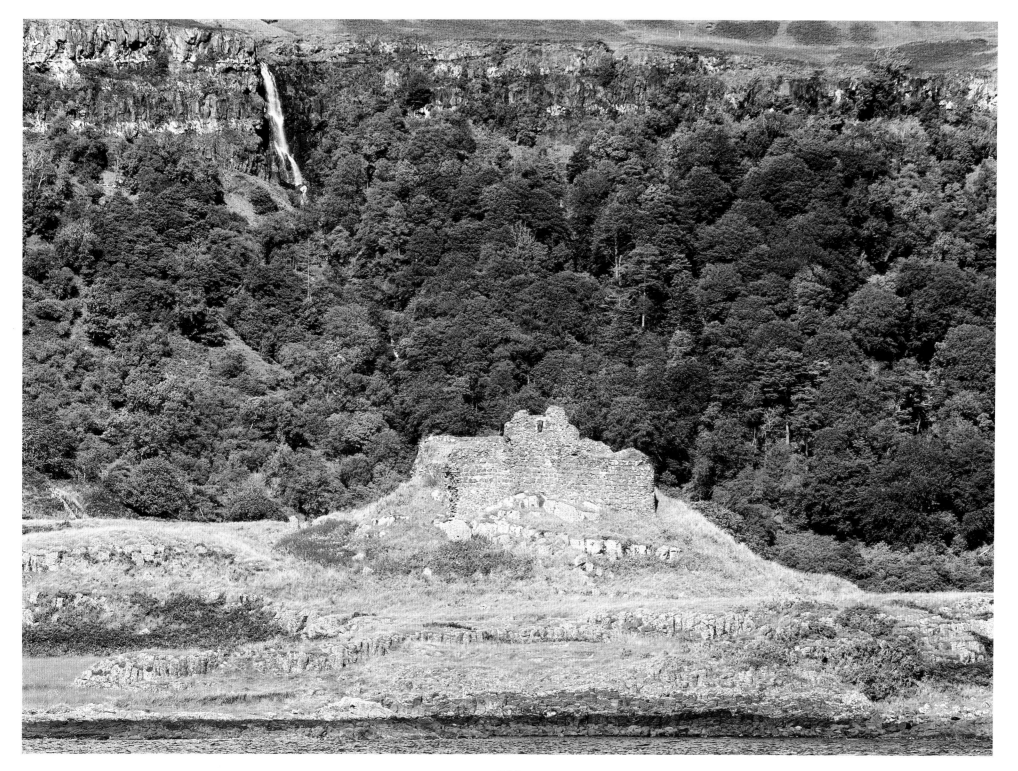

RIGHT: Glen Geal, lying in the heart of Morvern.

OPPOSITE: Looking north from the Sound of Mull to Loch Aline, with Ardtornish House located at the far end of the loch.

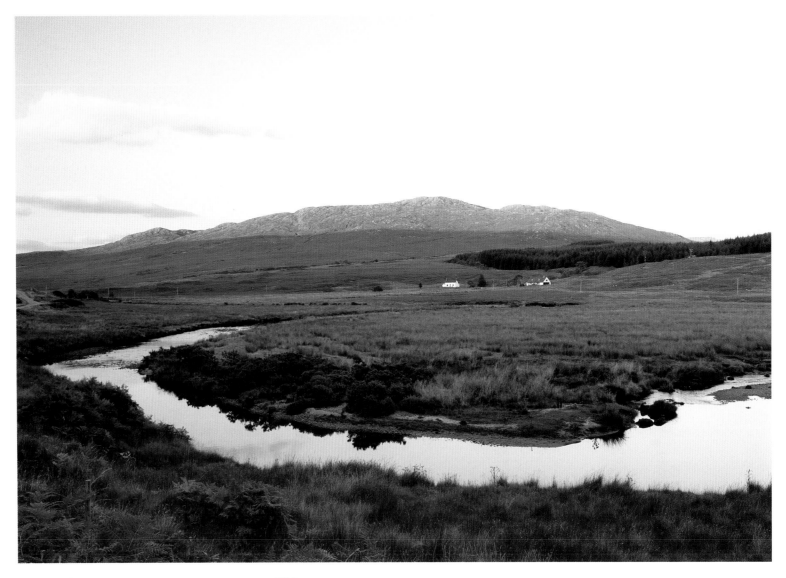

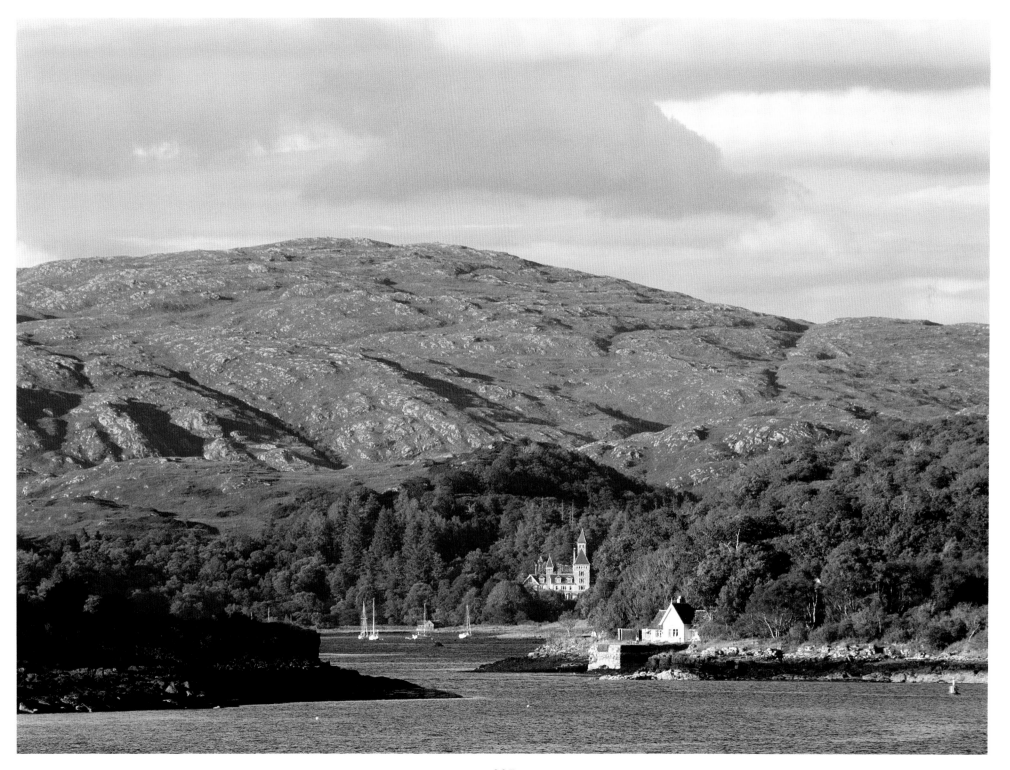

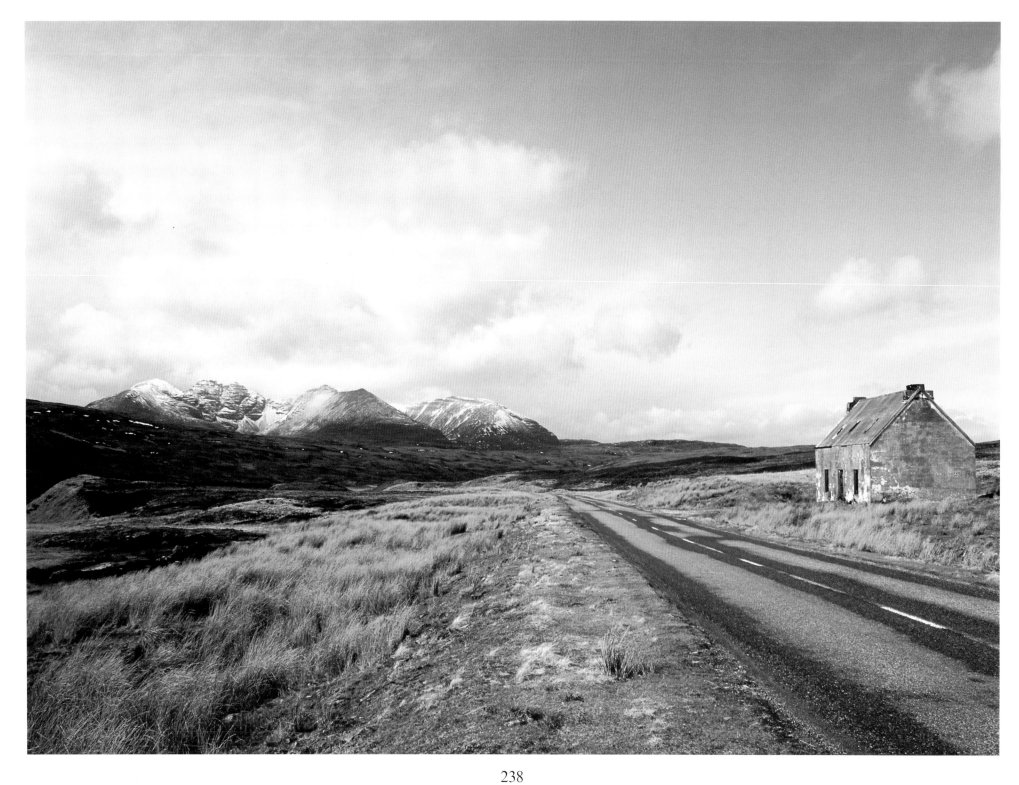

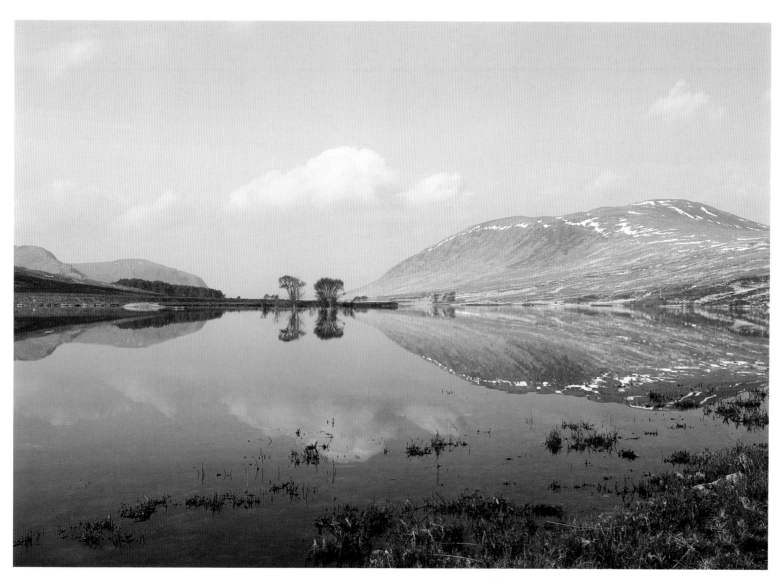

OPPOSITE: The road north-west towards An Teallach in the Dundonnell Forest area, south of Ullapool in Wester Ross. It is one of the most impressive of Scotland's mountains, located in an area often referred to as the 'great wilderness'.

LEFT: A Scottish Highland landscape a few miles south-east of Ullapool and Loch Broom, looking west over Loch Droma to Beinn Enaiglair mountain.

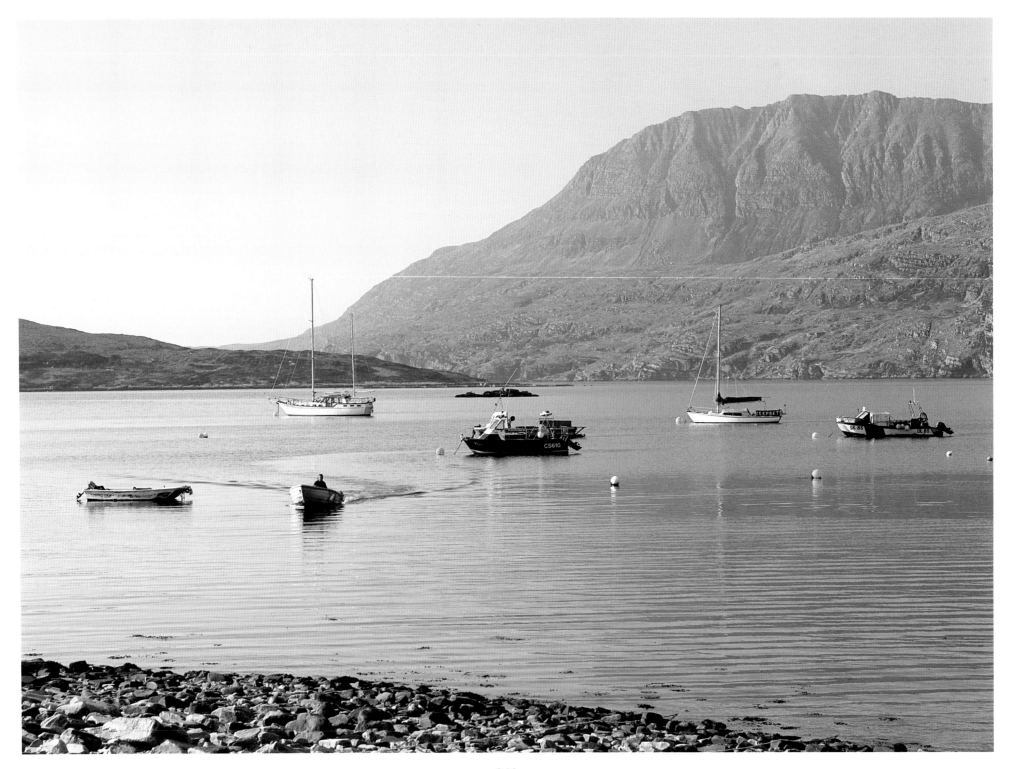

ago. Knockan Cliff has been turned into a nature trail by the Nature Conservancy Council, where viewing-points have been marked out along a one-and-a-half-mile walk, many of them giving fine views over the Inverpolly Nature Reserve.

Quite different from the Inverpolly Reserve, because they are entirely the work of man, are the National Trust for Scotland's spectacular Inverewe Gardens. These lie at the head of the lovely sea loch, Loch Ewe, south-west of Loch Broom, the sea loch on which Ullapool was founded as a fishing port in the late 18th century. Inverewe Gardens, a mile north of the village of Poolewe, were created just over 100 years ago out of barren rock and today house a collection of some 2,500 plants, from alpine to subtropical, in a latitude further north than Moscow – a 'miracle' made possible by the Gulf Stream.

Loch Maree also lies south of Ullapool, inland from Gairloch, a popular holiday resort with a fine sandy beach superbly set on Loch Gairloch, looking over the sea to the Outer Hebrides. Along Loch Maree's southern shore stretches the Beinn Eighe Nature Reserve, covering some 10,000 acres (4,050 hectares) and named after one of the highest peaks here, the 3,313-ft (1,010-m) Beinn Eighe, one of five in this area that rise above 3,000ft.

The Beinn Eighe Nature Reserve, the earliest in Britain, was set up in 1951 to preserve the remnants of the Caledonian Forest that still exist. The hand of man has fallen heavily on this ancient

forest, with the Vikings felling trees for their ships and then burning any stands they did not want, and later warlords, including Robert the Bruce and Alexander Stewart, the Wolf of Badenoch, burning the forest to smoke out enemies or fugitives from justice. Today, not only is the forest in the Beinn Eighe reserve carefully preserved and made available for people to discover, via mountain trails and walks, but the land is also being replanted with Scots pine and native oak and birch.

From the high points of the Beinn Eighe mountain trail it is possible to experience fine views along the 12-mile (19-km) length of Loch Maree, of the islands in the loch, including Isle Maree, where the Irish St. Maelrubha established a hermitage, and of the wild mountain scenery away to the north, dominated by the 3,218-ft (981-m) peak of Slioch, 'the spearhead'.

A drive south from Kinlochewe, a hill-walking, climbing and fishing base at the head of Loch Maree, to the village of Torridon on Upper Loch Torridon, leads down to Glen Torridon, one of Wester Ross's and, indeed, the whole of the Highlands' wildest glens and, according to the National Trust for Scotland in whose care it is, one of its most beautiful, too. Both sides of the glen are lined with mountains which, having been formed of horizontal strata of red Torridon sandstone, have a distinctive appearance, made all the more impressive by the stands of pine, remnants of the Caledonian Forest, which clothe headlands and lower mountain slopes.

OPPOSITE: Boats in Loch Kanaird at Ardmair, north of Ullapool, with Ben Mor Coigach in the distance.

PAGE 242: Early morning on the still waters of Loch Broom at Ullapool.

PAGE 243: The Caledonian MacBrayne *passenger and car ferry leaves Ullapool bound for Stornoway in the outer Hebrides.*

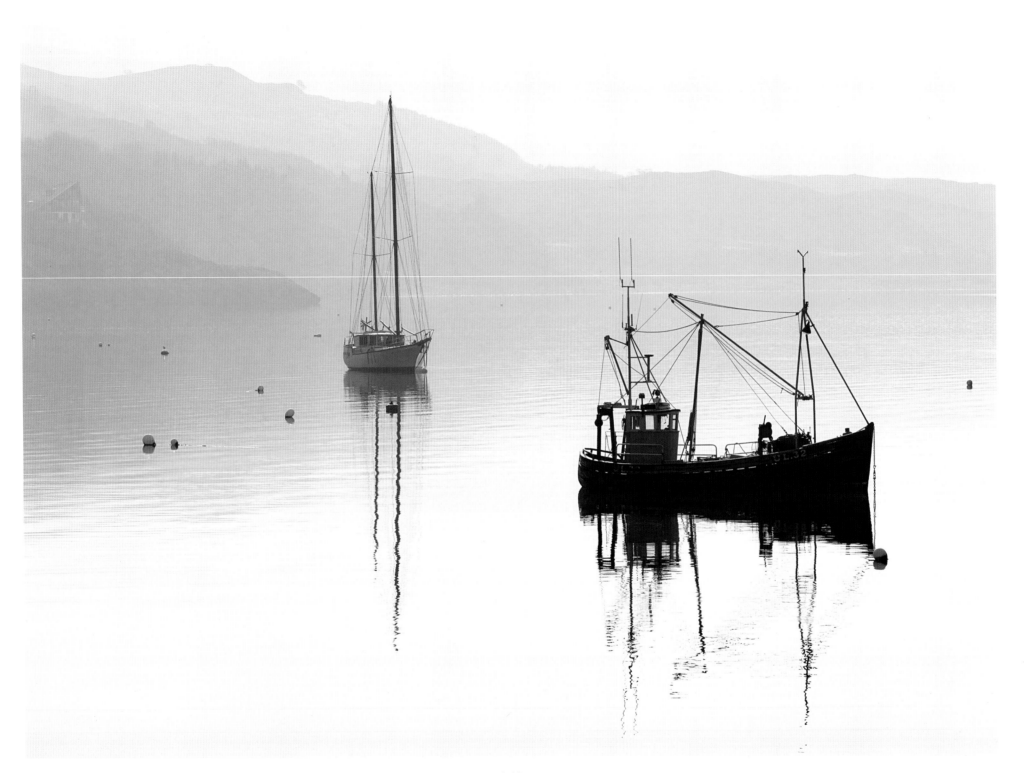

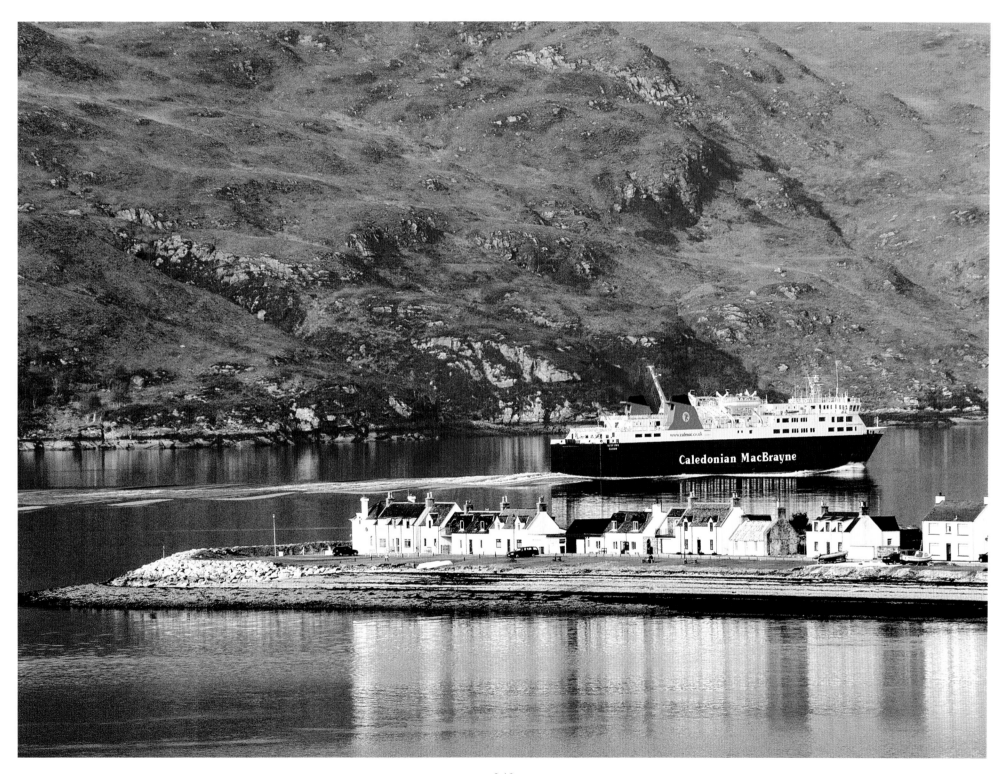

BELOW & OPPOSITE: Looking across Lochan an Ais to the Stac Pollaidh mountain in Inverpolly National Nature Reserve, Assynt region.

Geologists have found that several of the peaks here are capped with white quartzite, containing fossils of some of the first living creatures on Earth, an indication of the length of time these mountains have been in existence, having been worn into their fantastic shapes by time and the erosion of wind and rain.

The National Trust for Scotland has established a countryside centre at Torridon, which includes a deer museum and a fine audiovisual presentation of the wildlife to be found in Glen Torridon and the surrounding mountain country.

South of Torridon the country takes on a new flavour. The beautiful, river-drained, mountain-surrounded glens are still here, including Glen Affric which, with the Dog Fall near the Affric Bridge, was one of the painter Landseer's favourite subjects, and Glenshiel, steeply enclosed by high mountains before the main road passes Shiel Bridge and on between Loch Duich and the Five Sisters of Kintail.

History is beginning to intrude now, for military roads, old forts and ruined castles come up more frequently on the map.

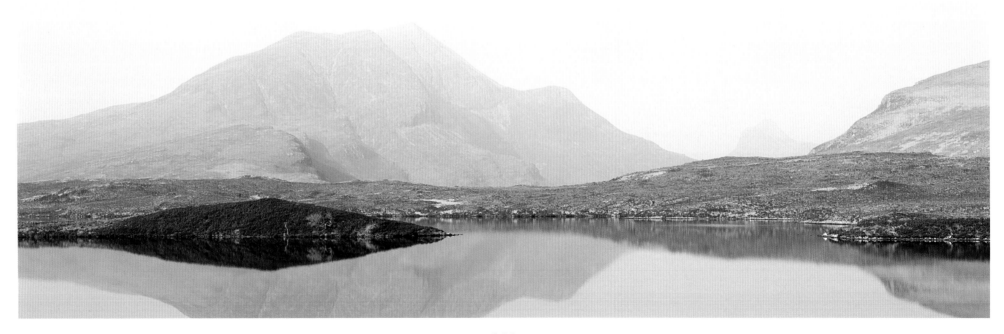

BELOW: Water lilies and reeds form patterns in the dark waters of a mountain loch above Kylestrome, south of Cape Wrath.

FAR RIGHT: Looking from Loch More towards Arkle mountain, Cape Wrath.

OPPOSITE: A quiet beach at Traigh na h Uamhag, 6 miles (10km) east of Durness.

Among the most evocative of these is Eilean Donan Castle (page 228), built by Alexander II on an island at the meeting-point of Lochs Duich, Alsh and Long. Blown up by the English warship, *Worcester*, in 1719, because of the Jacobite sympathies of its owners, the MacRaes, the castle was rebuilt earlier this century by a later generation of the family. The castle is a clear hint that for those wishing to follow in the footsteps of that most romantic figure in Scottish history, the Young Pretender, Prince Charles Edward Stuart, this is the part of the Highlands to visit first.

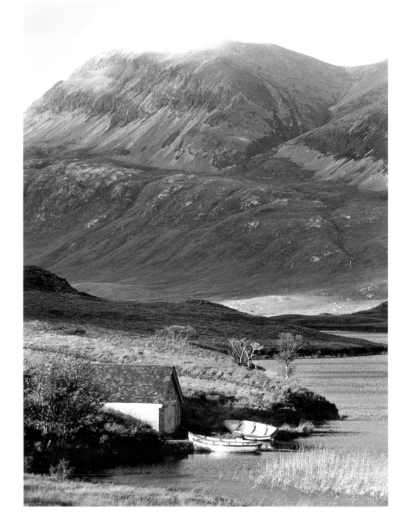

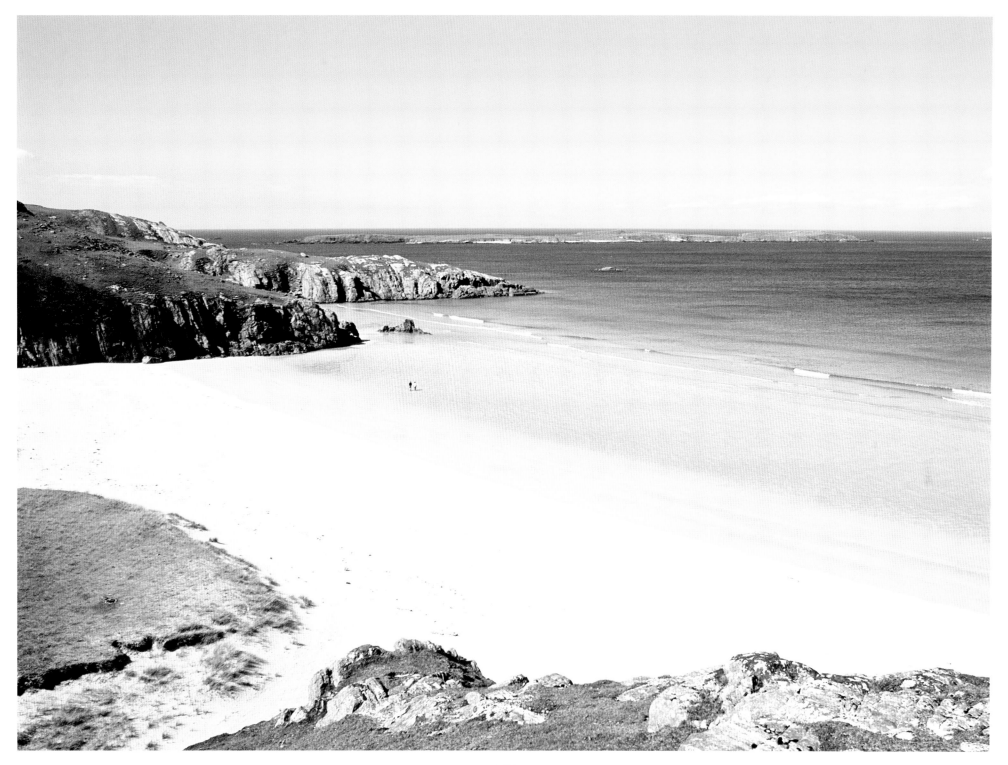

RIGHT: A ruined cottage at Invernaver, with Torrisdale Bay behind.

OPPOSITE: The view north-east over the beach at Traigh na h Uamhag,

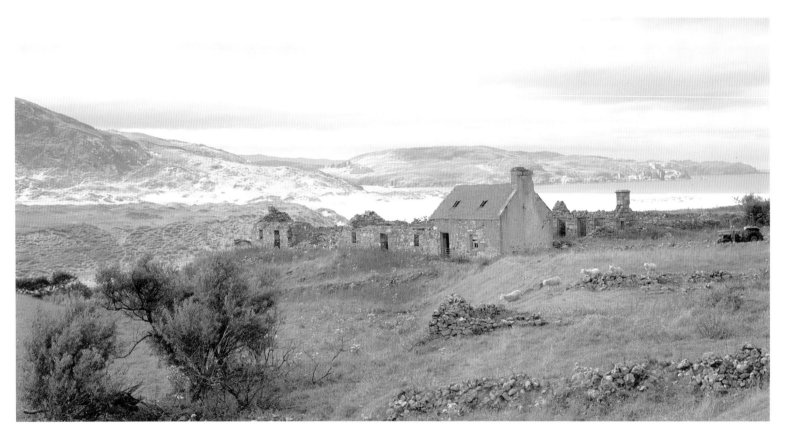

Bonnie Prince Charlie, coming from France in the brig *Du Taillay*, first set foot on Scottish soil on the tiny island of Eriskay on 23 July 1745, reaching the mainland, accompanied by just seven men, on the shore of Loch nan Uamh two days later. By 19 August, those of the Highland clan leaders who chose to throw in their lot with the Stuart prince had come with their men to Glenfinnan, at the head of Loch Shiel, to hear Charles proclaimed regent for his father, James III, and to see his standard raised.

The Glenfinnan Monument, a round tower topped with a statue of a kilted Highlander, was erected at the spot in 1815 by Macdonald of Glenaladale, whose ancestor's support had been

crucial to the prince. The National Trust for Scotland maintains one of its interesting and informative visitor centres nearby.

From Glenfinnan, Bonnie Prince Charlie's great adventure took him up the Great Glen, via Fort William (built by William III to help prevent such Jacobite risings as the prince was now engaged upon) and Invergarry, and so into the south, where he stayed at Blair Castle in Perth. Here he proclaimed his father king, and in Stirling, where his army took the town but not the castle. By 17 September, the prince was in Edinburgh, where, having again taken the city but not the castle, he remained until early November. While he was in Edinburgh, the Jacobite army achieved a confidence-boosting victory over a government force at Prestonpans on 21 September.

By mid-November, Bonnie Prince Charlie and his army were in England, where Carlisle fell to him after a five-day siege. On 4 December, the prince reached Derby, stayed there for two days to take stock of his situation with his generals, and then began the retreat to Scotland, which ended in crushing defeat at Culloden on 16 April 1746. The Scots, starving and exhausted, lost 1,200 of their 5,000 men, while only 76 of King George II's 10,000 redcoats, led by his son, the Duke of Cumberland, were killed.

For nearly five months after Culloden, the fugitive Prince Charles Edward Stuart and his dwindling band of supporters hid out in the homes of loyal clansmen, in caves and out in the open in the Highlands, on Skye and the islands of the Outer Hebrides,

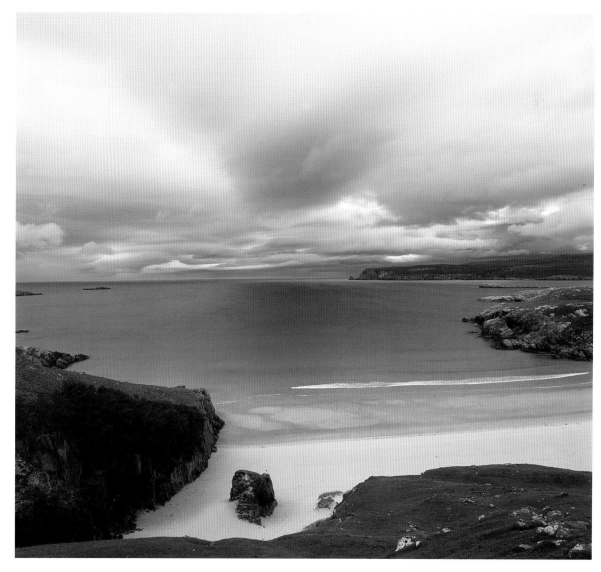

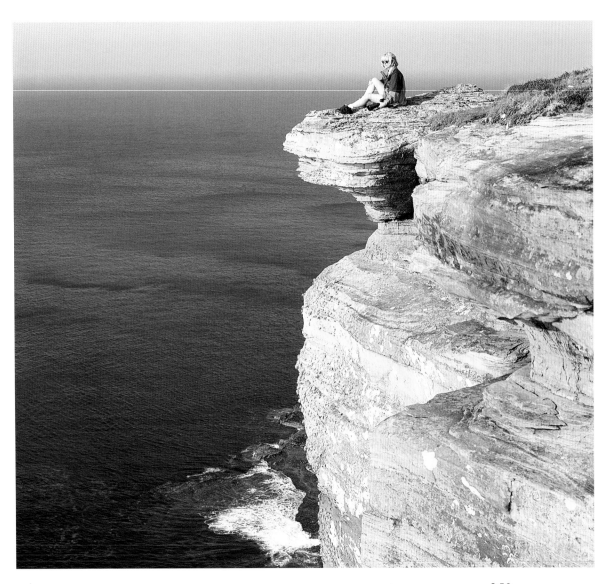

as they waited for a ship from France to rescue them. Although there was a price of £30,000 on his head, a huge sum in those days, and although the victor of Culloden, the Duke of Cumberland, pursued him relentlessly, no one betrayed the prince. On 19 September 1746 the prince left Scotland from the same loch shore to which he had come in July 1745, never to return.

After Culloden, the Highlanders' way of life changed forever. Hitherto, they had lived in small communities in a near-feudal society existing mainly on cattle-breeding and in which loyalty to a laird or chief, who could provide a force to protect the cattle, was paramount. Now the Hanoverian government set out to destroy this militant society. Firearms and the kilt (a martial dress and a badge of loyalty) were proscribed, and the old legal powers of the clan chiefs were abolished. Gradually life became more prosperous and more settled in the Highlands; money rents began to replace feudal dues, new crops were introduced, and capitalists from both Scotland and England began sinking money into projects such as fishing harbours and ports (for example, Ullapool, was established by the British Fisheries Society in 1788), iron foundries and woollen mills. At the same time, the far-sighted prime minister, William Pitt, began a system of recruiting the young men of the clans into the British Army, where the Highland regiments were soon to be an outstanding force.

Ironically, it was the defeat of Napoleon at Waterloo in which the Highland regiments played such a glorious role, and the end of

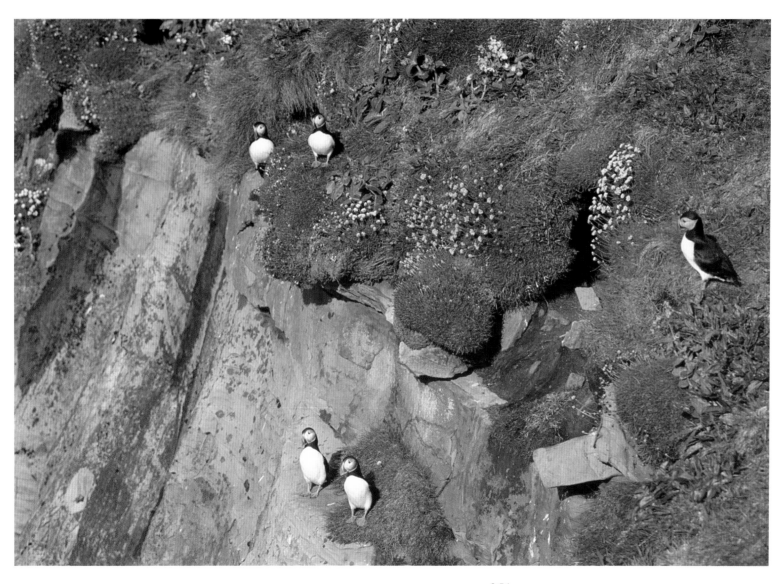

OPPOSITE: *The sandstone cliffs of Dunnet Head rise sheer above the Pentland Firth, north-east of Thurso.*

LEFT: *Puffins on the cliffs at Dunnet Head.*

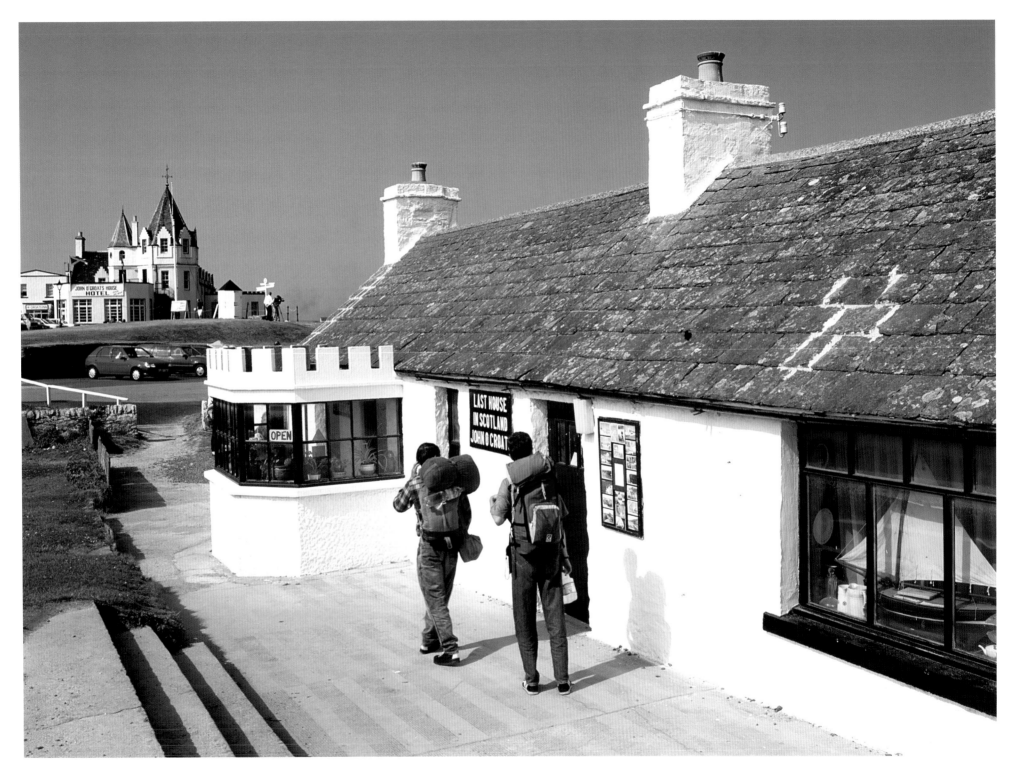

252

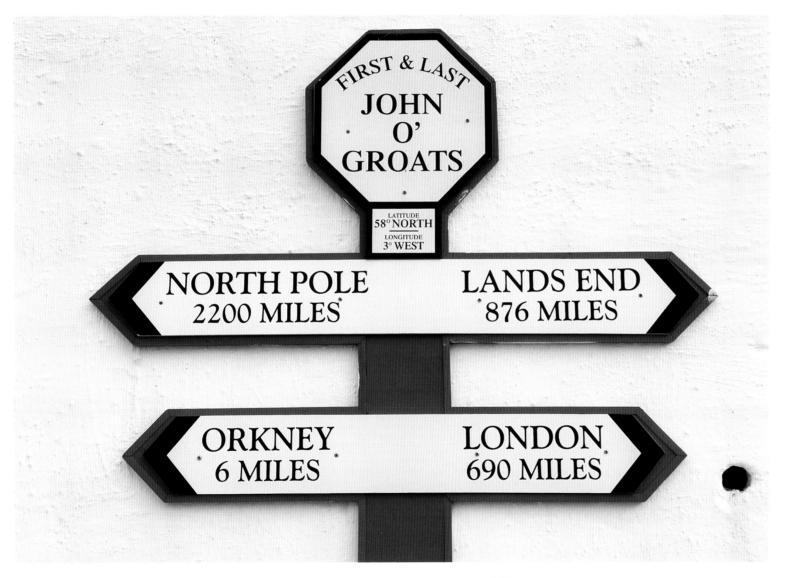

FIRST & LAST
JOHN
O'
GROATS

LATITUDE
58° NORTH
LONGITUDE
3° WEST

NORTH POLE
2200 MILES

LANDS END
876 MILES

ORKNEY
6 MILES

LONDON
690 MILES

OPPOSITE: John O'Groats' Last House in Scotland and its museum is where visitors can enjoy a pictorial history of the area and see some of the artifacts of bygone times that have been loaned to the museum by local residents. Postcards and letters can also be given the official 'Last House' stamp and be posted from inside the building.

LEFT: Distance signs at John O'Groats.

PAGE 254: Souvenir shops at John O' Groats.

PAGE 255: Sea stacks at Duncansby Head near John O' Groats.

254

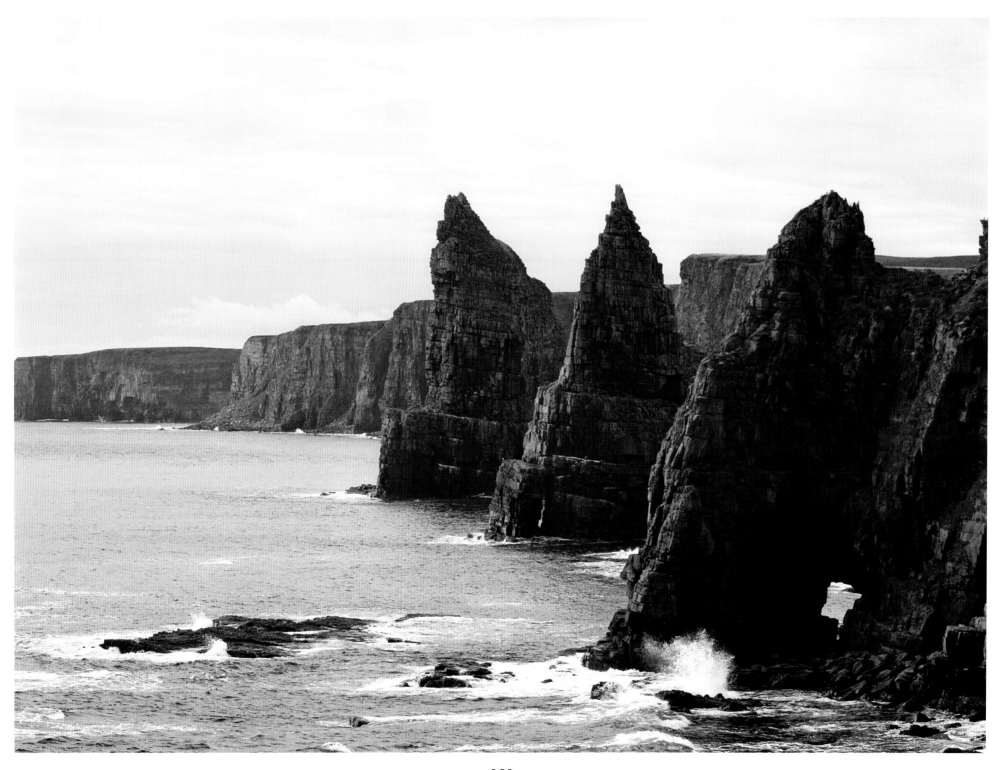

OPPOSITE: Looking north over the Loch of Yarrows, 7 miles (11km) south-west of Wick.

LEFT: An eccentric garden shed at Whaligoe, south of Wick, with stag antlers and windows taken from old telephone boxes.

OPPOSITE: The medieval St. Drostan's Church, Canisbay, near John O'Groats.

LEFT: Whaligoe Steps, south of Wick. A flight of 330 flagstone steps, dating from the mid-18th century, lead from the narrow landing quay up steep cliffs to the herring-curing station above.

the Napoleonic Wars that brought severe depression to the Highlands, a major result of which was the clearances to make way for large farms for sheep, the only form of farming that would bring in any profit. Many of the Highland's crofters moved south to the industrial cities of the Lowlands, while many more emigrated to the United States or to the British colonies in Canada, Australia and New Zealand. The population figures in the Highlands have never returned to what they were before the clearances, and the land is still very much worked in large estates, where forestry, fish-farming, deer-hunting and grouse-shooting, along with tourism, play major roles in the economy.

OPPOSITE: The Highland clearance village of Badbea on the North Sea coast, 5 miles (8km) north of Helmsdale. Landowners removed Highlanders from their homes, leaving them to hack out plots on these barren, exposed cliffs.

LEFT: The old stone bridge at Latheronwheel, located on the coast 20 miles (32km) south of Wick.

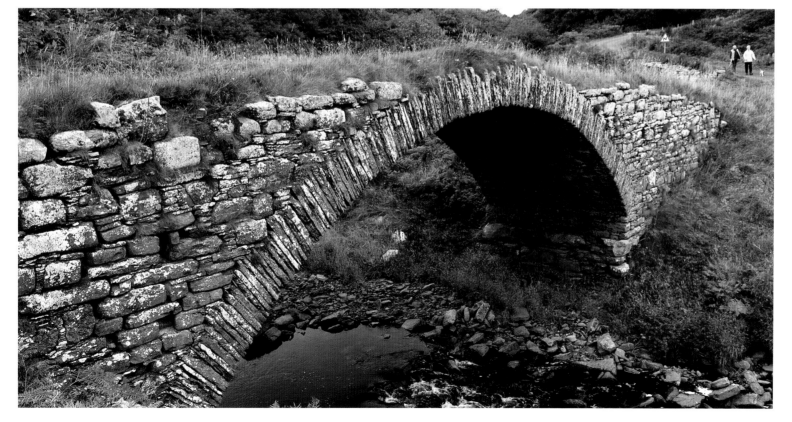

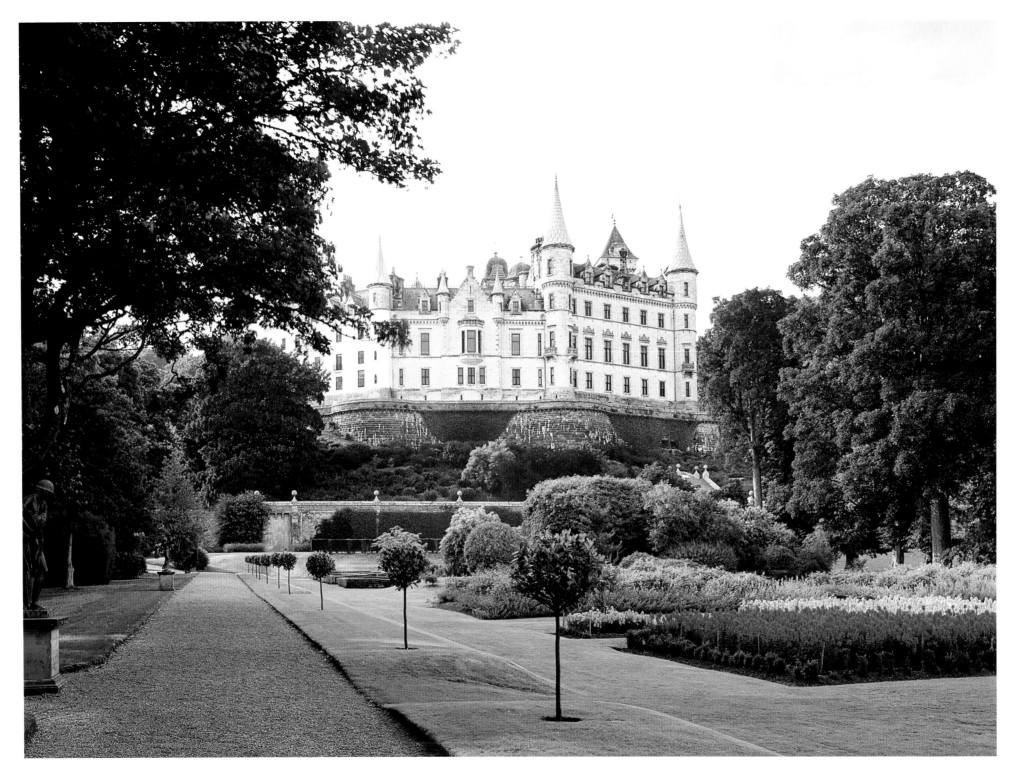

OPPOSITE: Dunrobin Castle, near Golspie, Sutherland, built between 1835 and 1850 by Charles Barry, architect of the Houses of Parliament in London.

LEFT: A Pictish carved stone monument, known as the Eagle Stone, at Strathpeffer, Cromarty.

RIGHT: *Detail of the Clach a'*
Charridh or Shandwick Stone, a
Pictish Christian stone monument
located near Shandwick on the
Tarbat peninsula in Easter Ross.

OPPOSITE: *The Rogie Falls on*
the River Blackwater in the
Highlands west of Dingwall.

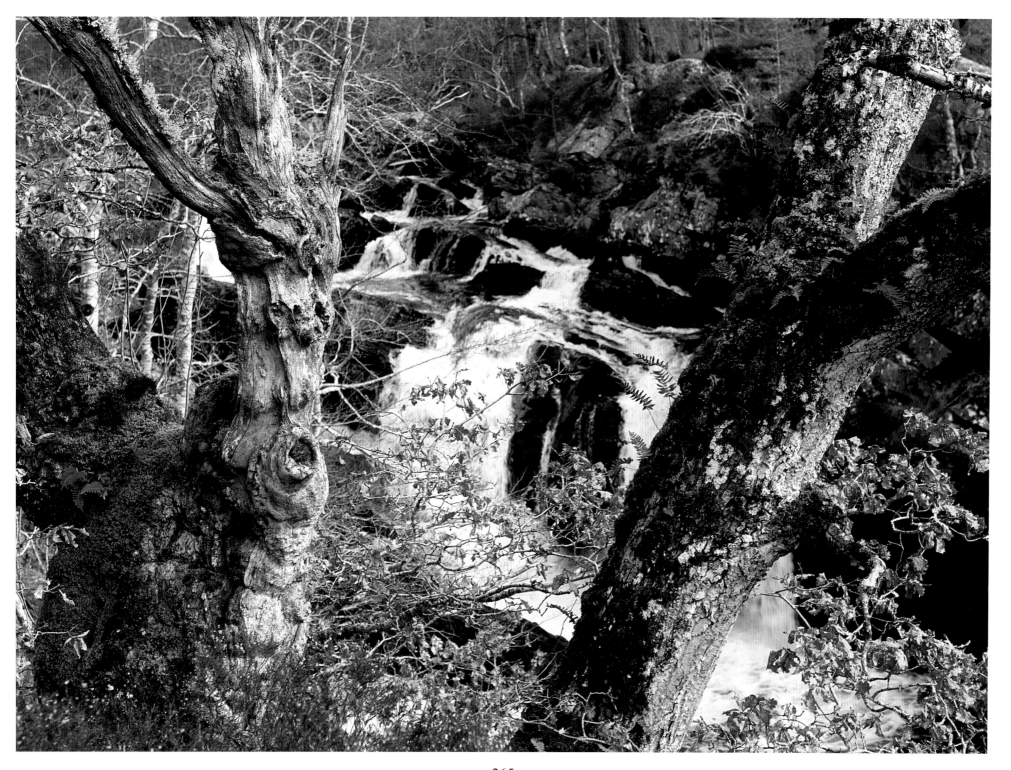

Clans may have several tartan setts, or patterns attached to their names, such as 'dress' tartans, usually light in colour and worn by the women of the clan; 'hunting' tartans which are darker and intended to camouflage the wearer; and 'ancient' tartans. Pictured here are the Ancient Campbell (left) and MacDonald.

CLANS & TARTANS

No visitor to Scotland can remain unaware for long of the importance to the Scottish tourist industry of the whole business of clan history and tartans. Outside gift and souvenir shops along the Royal Mile in Edinburgh, flapping in the breeze, are brightly coloured maps of Scotland, with dozens of surnames printed across them: here potential ancestors lived, here is the tartan you may like to wear. Inside the shop are piles of tins of shortbread biscuits or

cream fudge, decorated with gaudy tartans surrounding a picture of Bonnie Prince Charlie or Robbie Burns. Down the street, other shops are full of Scottish knitwear, racks of tartan kilts, trews, scarves, hose, and all the extras needed to kit yourself out as a full-blooded Highlander.

It is fashionable to deplore all this 'tartanry', dismissing it as an unattractive aspect of the modern tourist industry, demeaning to the real character of Scotland. Behind it all, however, lies some historical reality. The word clann *is Gaelic for 'family' or 'children', and refers to a system that can be traced back in Scottish life for many centuries. The idea of a clan began to have meaning round about the sixth century, when the Scots were spreading through the whole of the country, displacing earlier tribes. When powerful individuals took over parcels of land, they also acquired the people living there; later on, some of these powerful men, who were carving themselves small empires out of Scottish land, were not even Scots, the Bruces and the Cummings both having been descended from Norman knights, who had come to England with William the Conqueror in the 11th century.*

In time, the clan system developed characteristics which set it apart from other social forms. Because the life of the Highland Scot depended on cattle, defending the cattle from outsiders was essential; the men of a clan, not needed for farming, became clansmen, giving their chief their absolute (and willing) loyalty. A clan chief counted his wealth not in terms of rent but in terms of

clansmen he could call upon, and he could also establish the laws which governed life on his land. Loyalty to the clan was paramount over loyalty to the king, and while the clans often fought among themselves, in time, as the kings of Scotland began parcelling out land to 'buy' loyalty, clans which had held the land for generations found it necessary to fight those which had been granted land by the king.

The costume worn by these clans began as simple garments, held around the waist with a belt and with a long end thrown over the shoulders, which acted as covering, blanket and shelter from the weather. The plaid, a warm woollen cloth coloured with vegetable dyes, did not reach Scotland until wool became available. At first the fabric was dyed in colours which indicated the rank of the wearer, then the district from which he came, and, finally, the clan to which he belonged. Although the Scottish scholar and poet, George Buchanan, noted in the 16th century that the Highlander delighted in wearing 'variegated garments, especially stripes in their favourite colours of purple and blue', it was not until around 1700 that the distinctive tartan patterns, or setts, began to be developed. Different districts in the Highlands developed different setts, which really only became associated with a particular clan because that clan dominated the district in which the tartan had been woven.

It was also early in the 18th century that the one-piece plaid came to be made in two halves, the bottom section gathered around the waist becoming the permanently pleated kilt, and the top section becoming a separate garment.

The uniform plaid is held in place with a large brooch mounted with a cairngorm, a yellow or brown ornamental quartz traditionally used in Scottish jewellery.

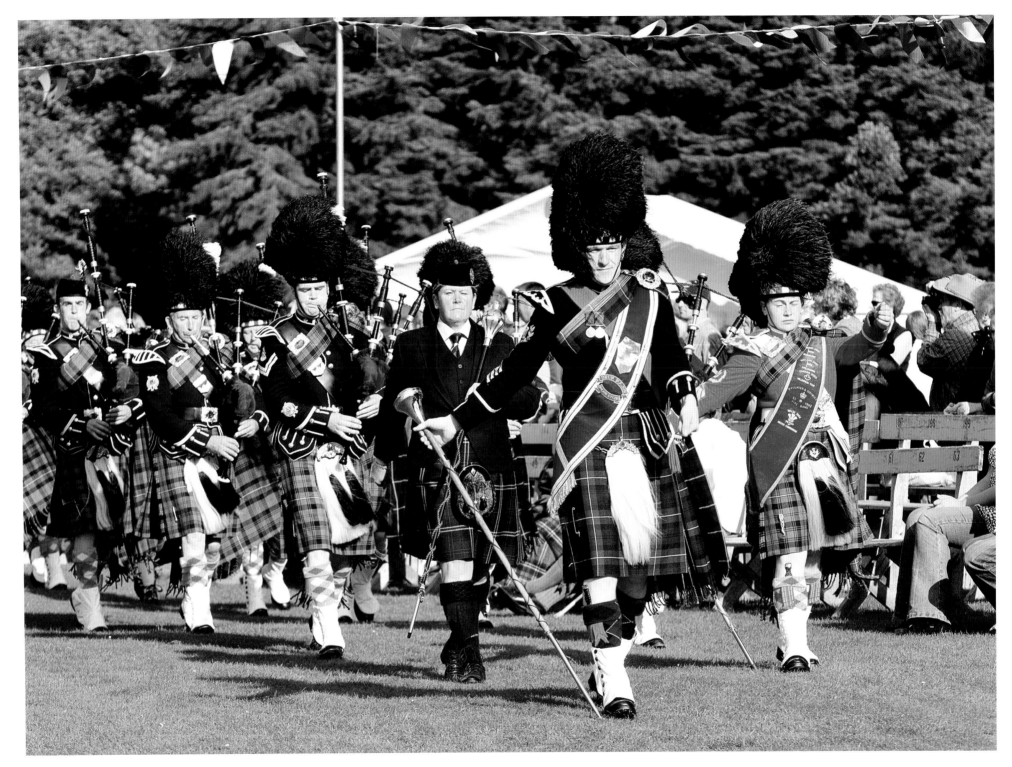

A CELEBRATION OF SCOTLAND

During the 36 years that the wearing of the tartan was proscribed after the Battle of Culloden, most of the old setts, carefully marked on sticks by the women who wove them, were lost, so that the majority of the tartans we know today are of 19th-century origin. The man most responsible for bringing them back into favour was the hugely successful writer, Sir Walter Scott. His romantic novels, read all over Europe, made Scottish history immensely popular, while the admiration felt for the tartan-clad Highland regiments of the British Army made the fabric a fashionable item.

Sir Walter Scott was, in effect, the first great public relations figure in Scottish history. He instigated the hunt for the Regalia of Scotland (it was found in a cupboard in Edinburgh Castle, where it had lain forgotten since 1707) and organized the successful State Visit of George IV to Scotland in 1822, during which time the king, staying at the Palace of Holyroodhouse, attended functions clad in the Royal Stewart tartan.

After George IV's visit, the demand for tartan reached such a pitch that the weavers supplying Edinburgh's tartan salesmen had to install dozens more looms. The fashion was given a boost when Queen Victoria and Prince Albert, furnishing their new castle at Balmoral, had a special Balmoral tartan designed, which was used for much of the carpets and furnishings and which the royal children wore. Today, when they are in Scotland, the members of the royal family still wear their own tartan, in kilts for the men and pleated skirts for the women.

For those without a tartan there is no need to despair, for there are plenty from which to choose and no rules to forbid their wearing. The Museum of Scottish Tartans at Comrie, near Crieff in Perthshire, holds more than 1,300 tartan setts belonging to the Scottish Tartans Society as well as a fine collection of everything to do with the making and wearing of the tartan. The collection of tartans, made by the historian of Scottish dress, J. Telfer Dunbar, is housed in the Canongate Tolbooth in Edinburgh.

OPPOSITE & BELOW: A pipe band in full Highland dress leads competitors onto the field at the Lonach Highland Games, Strathdon.

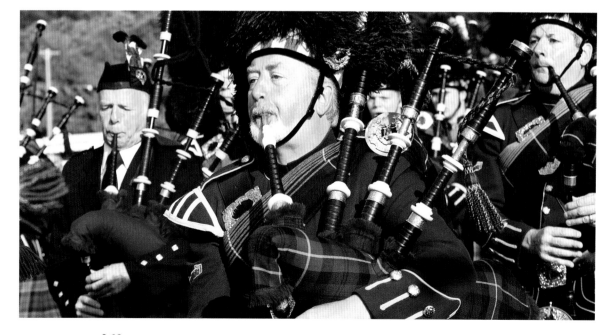

CHAPTER FIVE
THE SOUTH-WEST

BELOW: Dumfries sits close to the Solway Firth near the mouth of the River Nith.

OPPOSITE: Morton Castle, in the Lowther Hills above Nithsdale, was acquired in 1459 by the Douglases, who later became earls of Morton.

The gently green and rolling hill country that makes up much of Scotland's south-west is bounded in the north by country of a more 'Highland' character, bisected by Glen Dochart, Glen Lochy and the Pass of Brander, which the A85 follows on its way west to the eastern shore of Loch Linnhe and the Firth of Lorn, where the coastal town and ferry terminal of Oban lies. In the south, the boundary is the coast running east from the Mull of Galloway along the Solway Firth, while in the west, the northern part of the coast is as broken and indented and sprinkled with offshore islands as it is all the way to Cape Wrath, with the Kintyre peninsula and Knapdale forming a sheltering arm for the islands of Arran and Bute in the Firth of Clyde. South of the Clyde the coast, unbroken by sea lochs and dotted with popular seaside resorts and famous golf courses, such as Ardrossan,

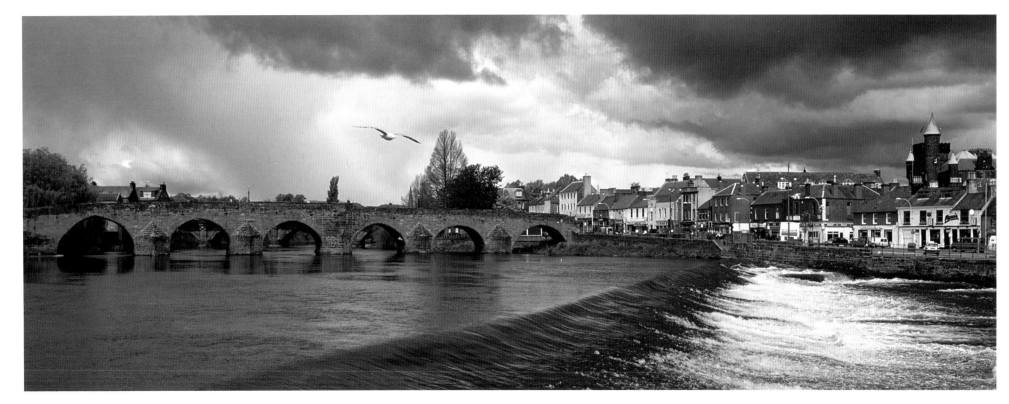

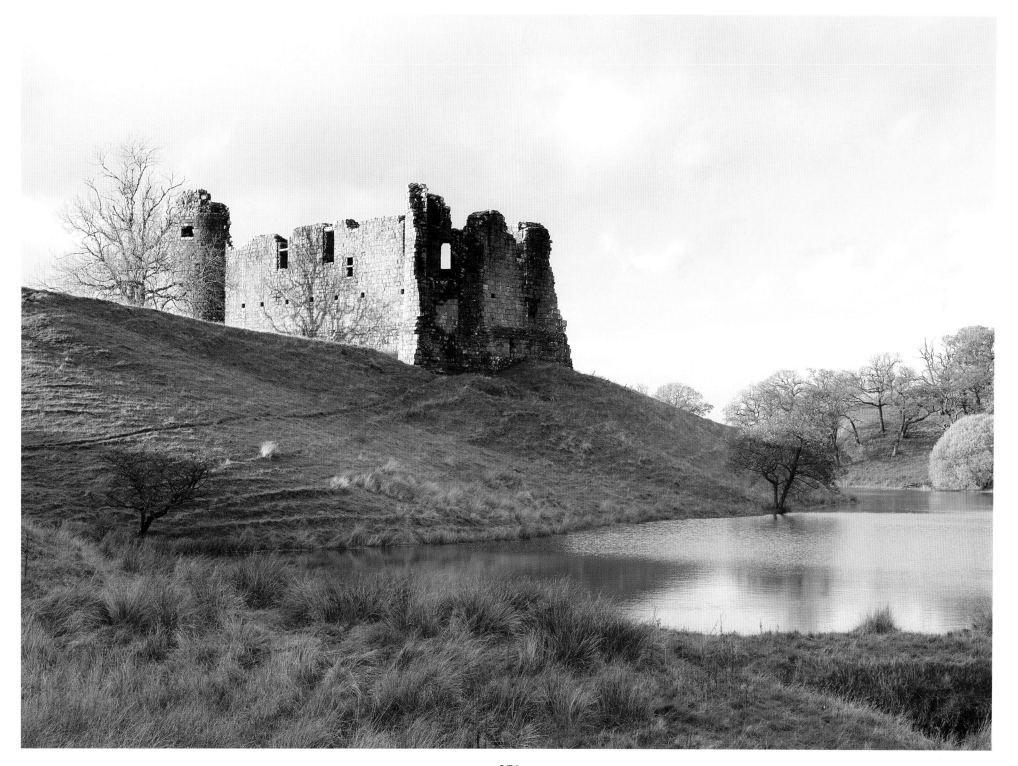

271

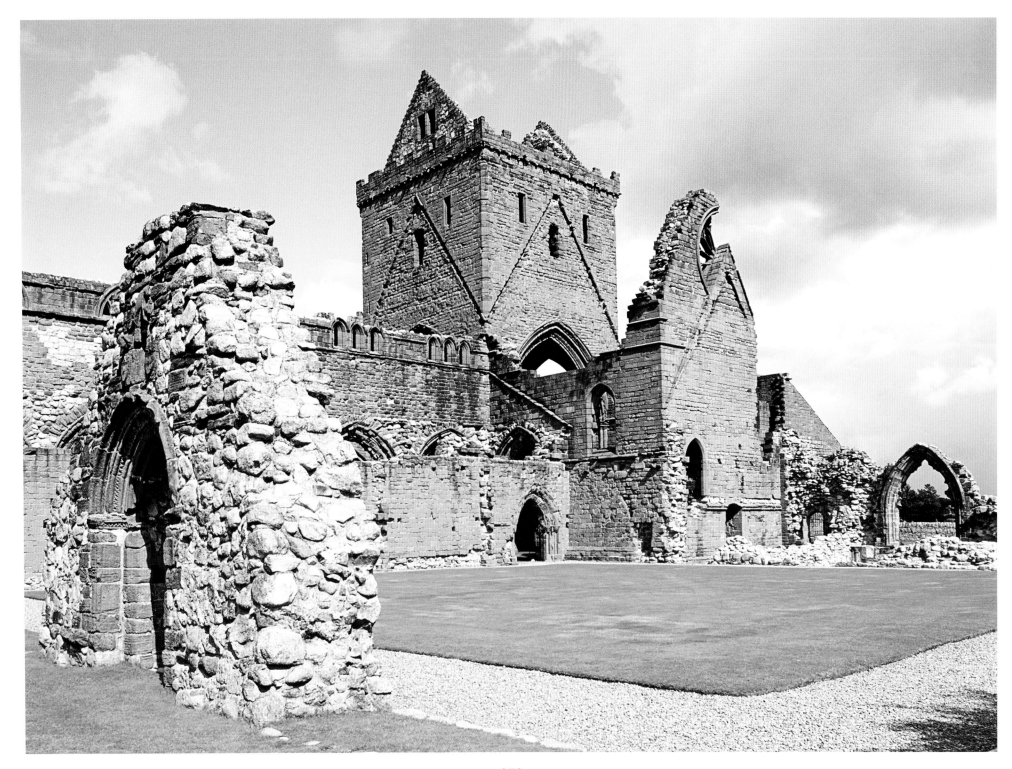

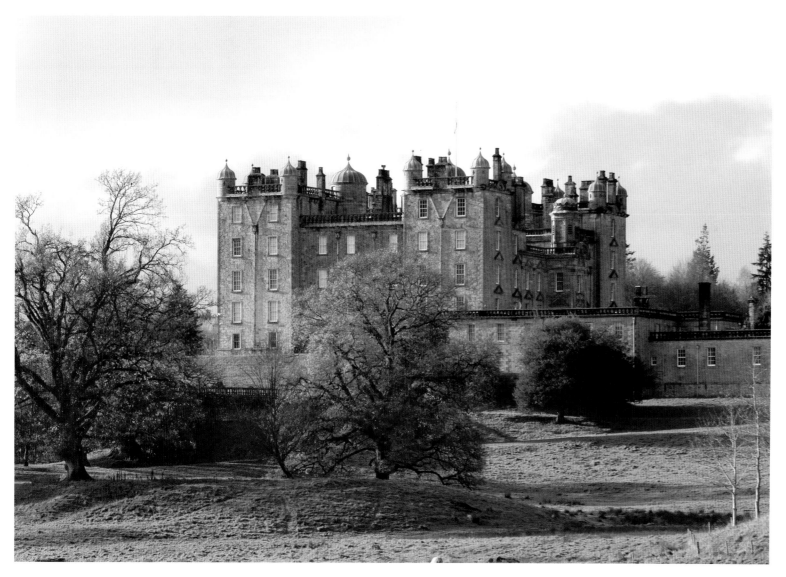

OPPOSITE: Sweetheart Abbey, near Dumfries, was a Cistercian monastery founded in 1275 by Dervorgilla of Galloway in memory of her husband John de Balliol. His embalmed heart, in a casket of ivory and silver, was buried alongside her when she died, following which the monks renamed the abbey in her honour.

LEFT: Drumlanrig Castle, north of Thornhill, is a unique example of late-17th-century Renaissance architecture. It was built by William Douglas, the 1st Duke of Buccleuch, on the site of an ancient Douglas stronghold.

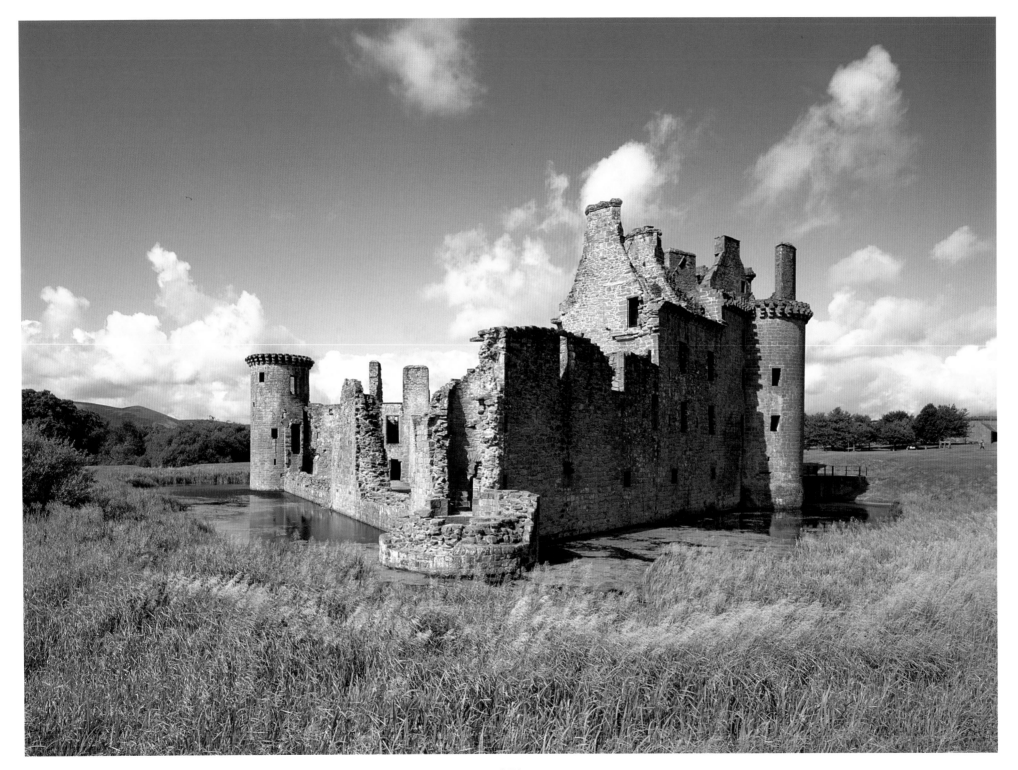

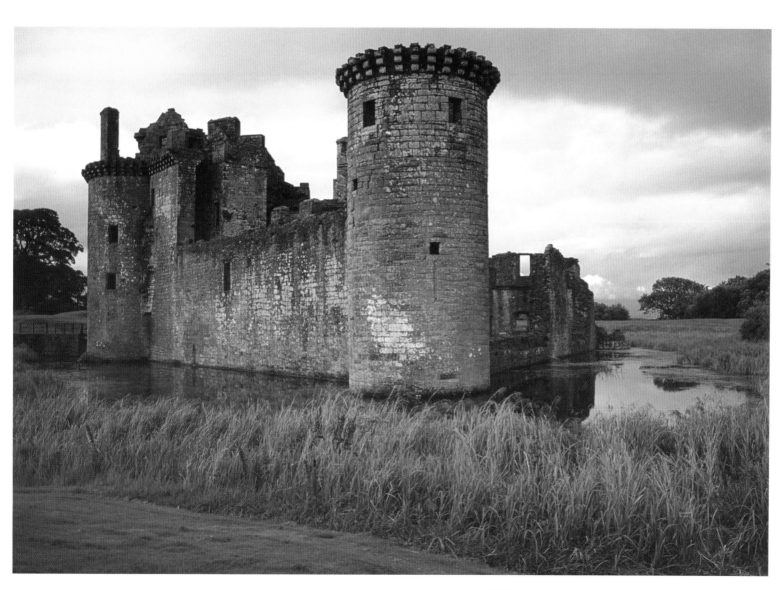

OPPOSITE & LEFT:
Caerlaverock Castle. Sir John de
Maxwell built an earlier castle
when he was granted the land in
1220, but it was too near the
Solway salt marshes and the present
castle was begun further inland in
1270, built on stronger foundations
of rock. The Maxwells inhabited
the castle for the next 400 years.

PAGE 276: The gaunt ruins of the
14th-century Threave Castle, on an
islet of the River Dee, was once a
stronghold of the Black Douglases,
so-called to distinguish them from
the light-haired branch of the clan,
the Red Douglases

PAGE 277: The High Street and
Old Jail at Kirkudbright.

PAGE 278: The imposing Georgian
façades fronting Kirkcudbright's
High Street.

PAGE 279: Maclellan's Castle,
Kirkcudbright.

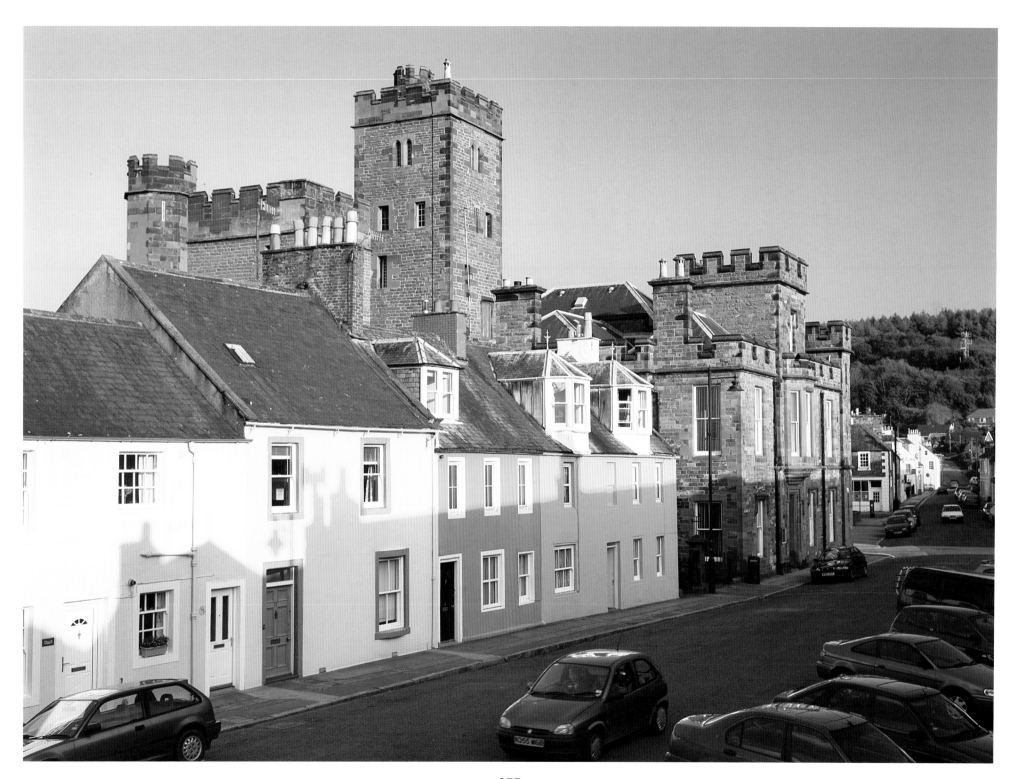

Troon, Turnberry, Ayr and Girvan, curves down to the hammerheaded peninsula of The Rhinns of Galloway.

Within this area, covered by two local government regions, Strathclyde and Dumfries & Galloway, is Scotland's most industrialized and heavily populated area, Clydeside, which includes Britain's third largest city of Glasgow; its most popular holiday areas are the Trossachs and the islands of the Firth of Clyde, also Ayrshire, where both Scotland's hero Robert the Bruce and its favourite son and finest poet, Robbie Burns, were born and where Burns wrote most of his best poetry. Another less heroic figure in Scottish history, the cattle-rustler Rob Roy MacGregor, who was transformed into a romantic Robin Hood figure in Sir Walter Scott's eponymous novel, also came from south-western Scotland; his home, and the places where the MacGregors hid their stolen cattle, was in the north of the area, beyond the head of Loch Fyne. Rob Roy is buried at Balquidder, north of Loch Katrine.

While this is the most heavily populated part of Scotland, with half of all the country's people living in Glasgow and its satellite towns, from Johnstone and Paisley in the west to Airdrie and Motherwell in the east, it also has its share of lovely countryside, marked with glens and lochs, including Loch Lomond, Loch Katrine and Loch Trool. Forest and country parks include the Argyll, where the Forestry Commission maintains two of its three tree gardens in Scotland, the Queen

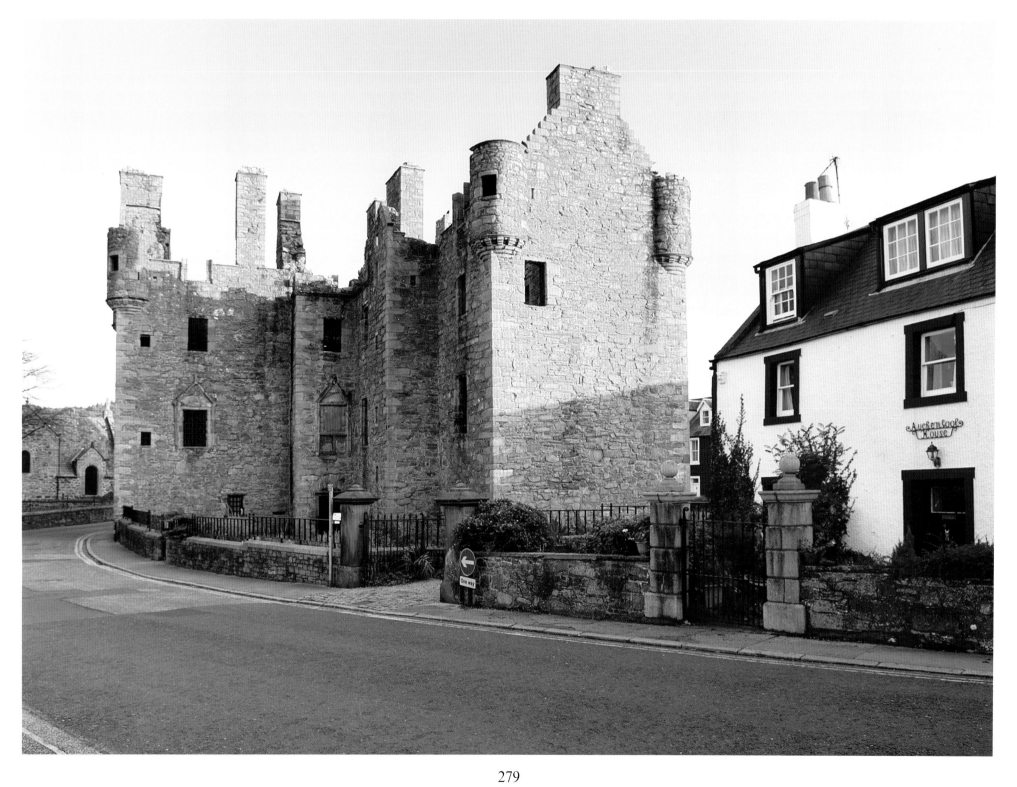

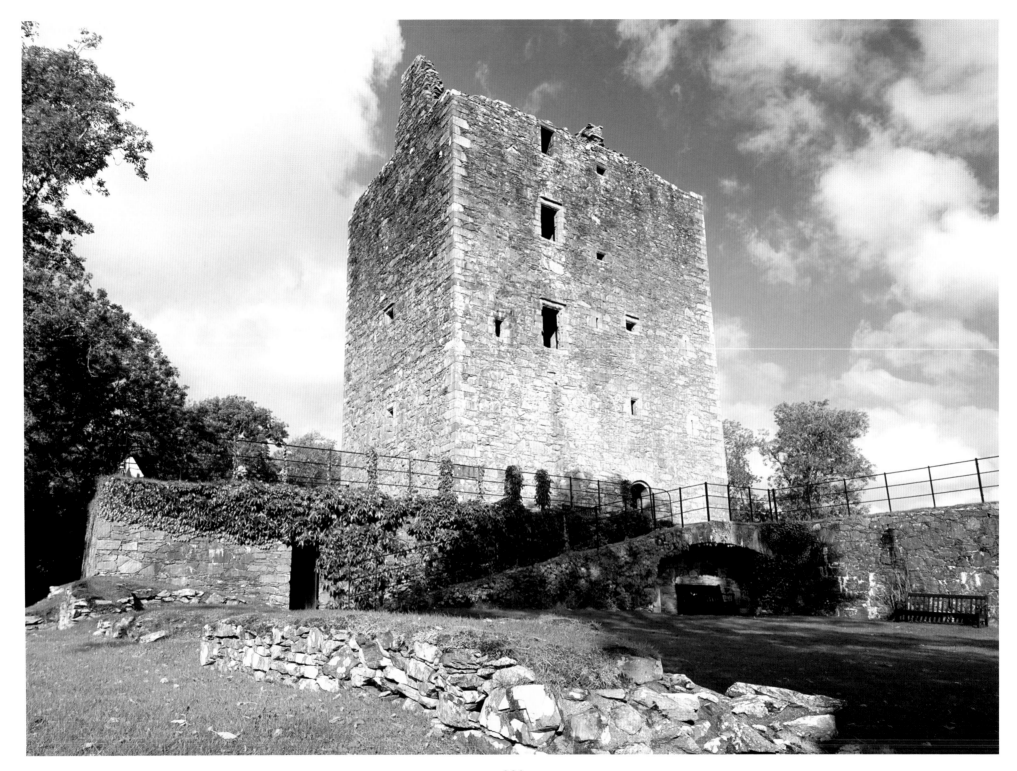

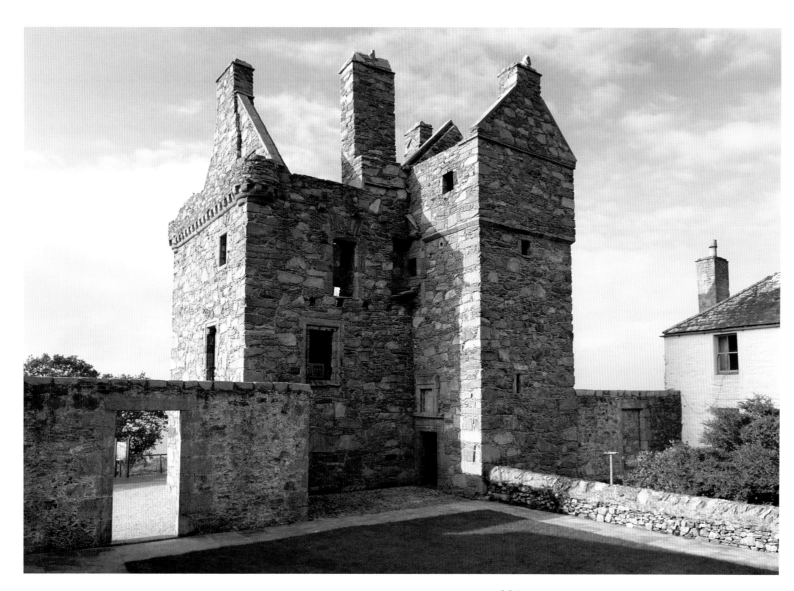

OPPOSITE: Cardoness Castle, Gatehouse of Fleet, a !5th-century tower house that was home to the McCullochs of Galloway.

LEFT: Carsluith Castle, Creetown, a 15th-century tower house with several later additions.

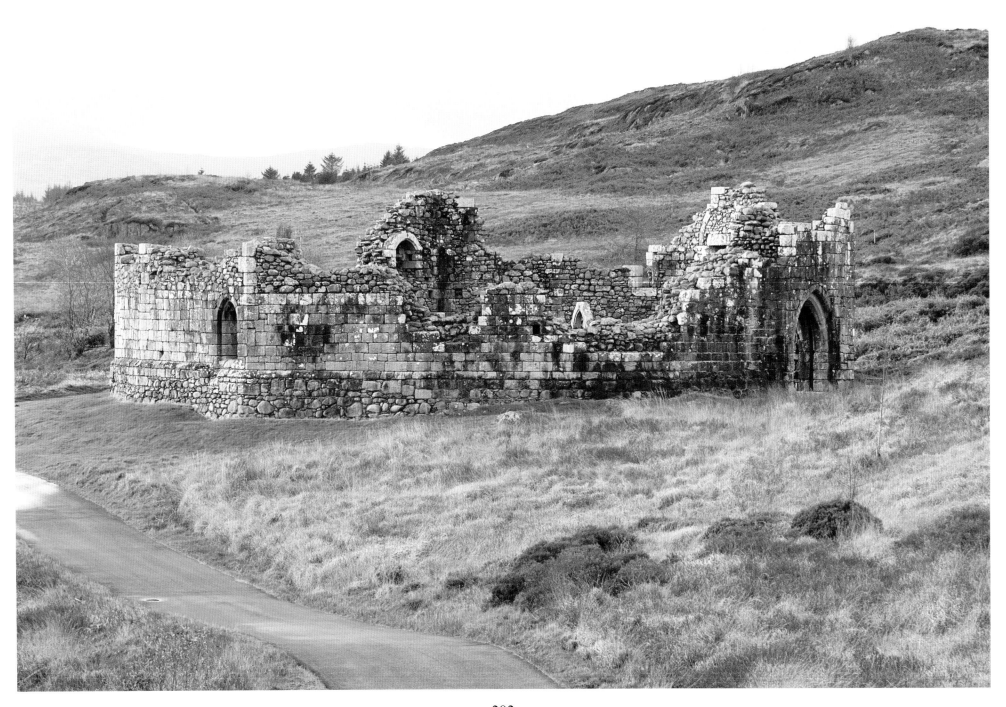

A CELEBRATION OF SCOTLAND

Elizabeth, and the Galloway Forest Parks and the Culzean Country Park, while the great rock of Ailsa Craig, 10 miles (16km) out to sea off Girvan, is an important breeding place for birds, and Troon's offshore Lady Isle is a bird sanctuary.

It is also a region with a good share of the country's most famous castles, including the Campbells' ruined Kilchurn Castle at the head of Loch Awe and their magnificent 18th-century Inveraray Castle on Loch Fyne (page 302). Set high above the Clyde, just before it reaches Glasgow, is Bothwell Castle, a 13th-century stronghold, whose red sandstone curtain walls are set with round towers, while further up the Clyde, west of Lanark, is Craignethan Castle, an impressive moated fortress built in the 16th century. Down on the Ayrshire coast are the legend-surrounded ruins of the Kennedy of Cassilis family's Dunure Castle and, in complete contrast, the same family's magnificent Culzean Castle (page 287), a supreme example of the work of Robert Adam. In Dumfries & Galloway are the moated Caerlaverock Castle on the Solway Firth (pages 274 & 275), its fine Renaissance interior façade the work of its 17th-century owner, Lord Nithsdale, head of the Maxwell clan, while in Nithsdale, away to the north of Dumfries, is the magnificent Jacobean pile of Drumlanrig Castle (page 273), which has a superb Rembrandt among its many treasures. The grim Threave Castle (page 276), a 14th-century stronghold of the Douglas family, is located in Galloway, near Castle Douglas.

As the River Tweed dominates the Borders, the eastern side of the Scottish Lowlands, so the Clyde, rising within a mile of the Tweed in the Southern Uplands, dominates the western side of the Lowlands. A third river, the Annan, also rises in the same hills, though it flows south to reach the sea at the Solway Firth.

In its upper reaches, the Clyde can be as lovely a river as the Tweed. It rises in the Lowther Hills in South Lanarkshire, formed by the confluence of two streams, the Daer Water (the headwaters of which are dammed to form the Daer Reservoir) and the Potrail Water. The Southern Uplands Way crosses both streams, which merge at Watermeetings to form the River Clyde proper. There is also the quietly pretty scenery of Clydesdale, an area of many market gardens and orchards which gave its name to the Clydesdale horse, many of which are still being bred, along with Aberdeen Angus cattle in the farms around Biggar, a delightful town, medieval in origin, on the border of Clydesdale and Tweeddale. Then there is the Clyde Gorge, with waterfalls such as the 90-ft (27-m) fall of Cora Linn, one of the Falls of Clyde which is near New Lanark (page 294), the industrial model village founded in 1784 by David Dale, a philanthropic cotton-mill owner. Once in North Lanarkshire, the Clyde is a major waterway, providing the water that once powered the industrial heart of Scotland and which still plays a major role in the Glasgow of today.

It was in the early 1780s that Glasgow began its extraordinarily rapid transformation into one of the great industrial cities of the

OPPOSITE: The early 14th-century Loch Doon Castle. Originally known as Castle Balliol, it once stood on an island in a remote loch south-east of Ayr until it was moved to its present site in the 1930s, to make way for a hydro-electric scheme.

OPPOSITE: Trout fishing at Inverawe, near Taynuilt, Argyll.

FAR LEFT & LEFT: Derek Kennedy produces kippers (smoked herrings) at the Inverawe Smokery, near Taynuilt.

PAGE 286: The Torhousekie neolithic stone circle near Wigtown, in Dumfries & Galloway, is one of the most easily accessible and most complete of its kind in Britain. It is a ring of 19 stones, with three more in the centre. Another three stones can be seen on a hillock nearby.

PAGE 287: Culzean Castle, south-west of Ayr, designed at the end of the 18th century by Robert Adam.

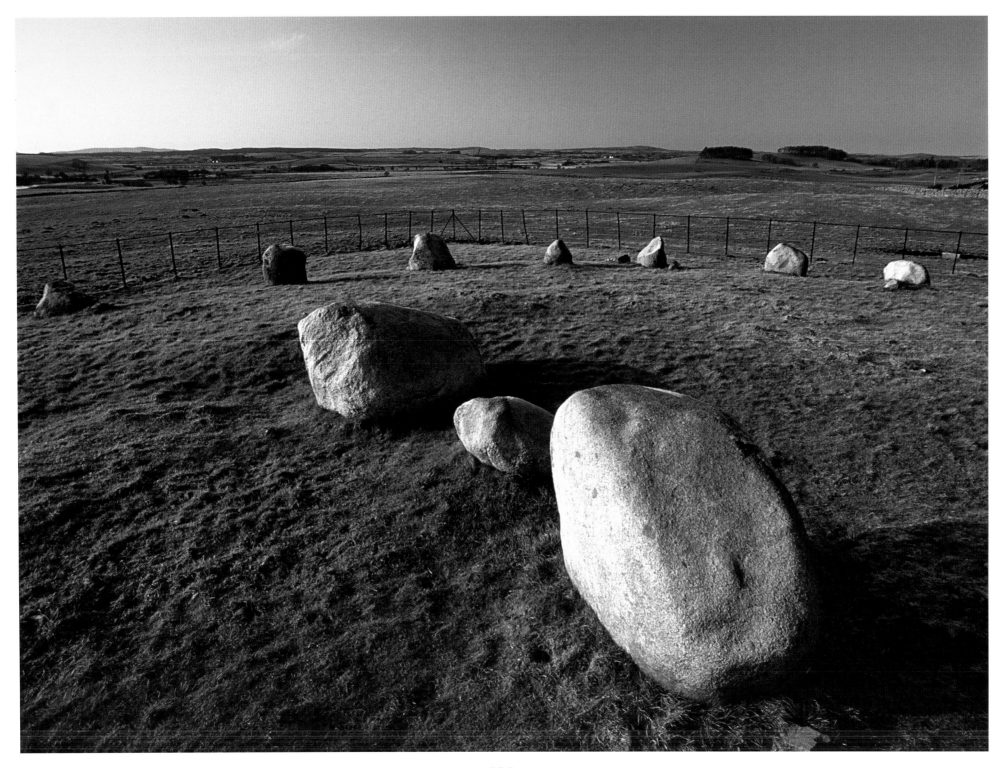

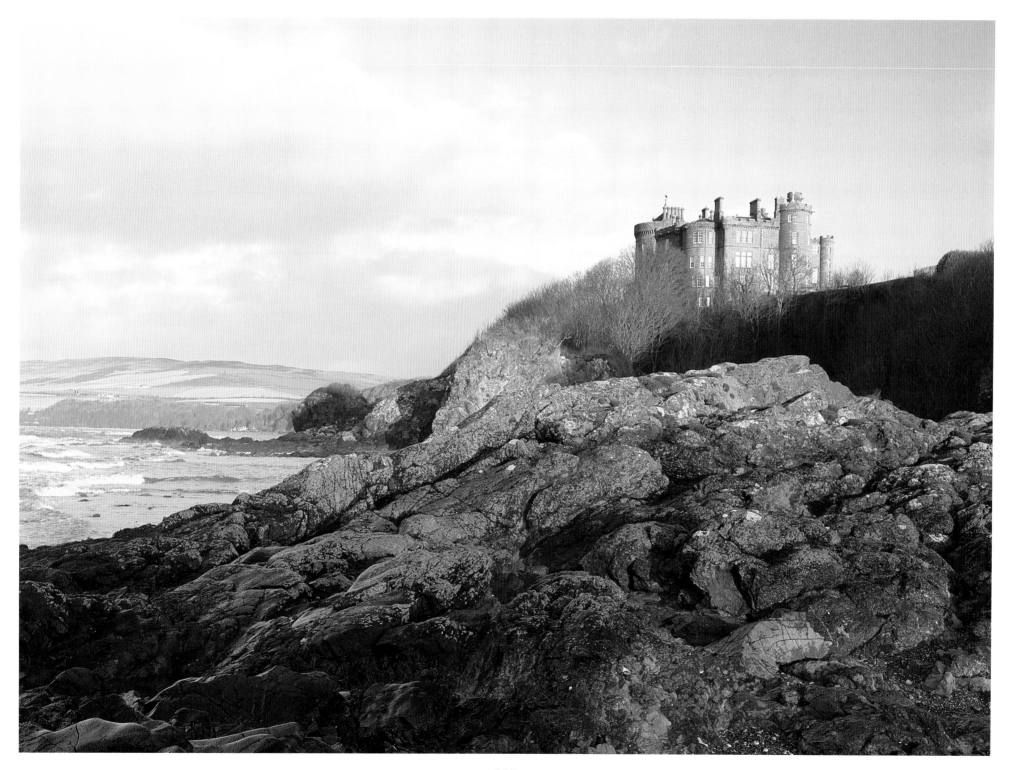

RIGHT: St. Mungo's Cathedral and the Royal Infirmary, Glasgow.

OPPOSITE: St. Mungo's Cathedral, the origins of which date to about AD 550, when St. Mungo, also known as St. Kentigern, founded a religious community here, based around a small church. The original church was built of wood, and was changed and enlarged over the following centuries, the first stone church on the site being that which was consecrated in the presence of King David I in 1136. St. Mungo's is one of the few Scottish medieval churches to have survived the Reformation unscathed.

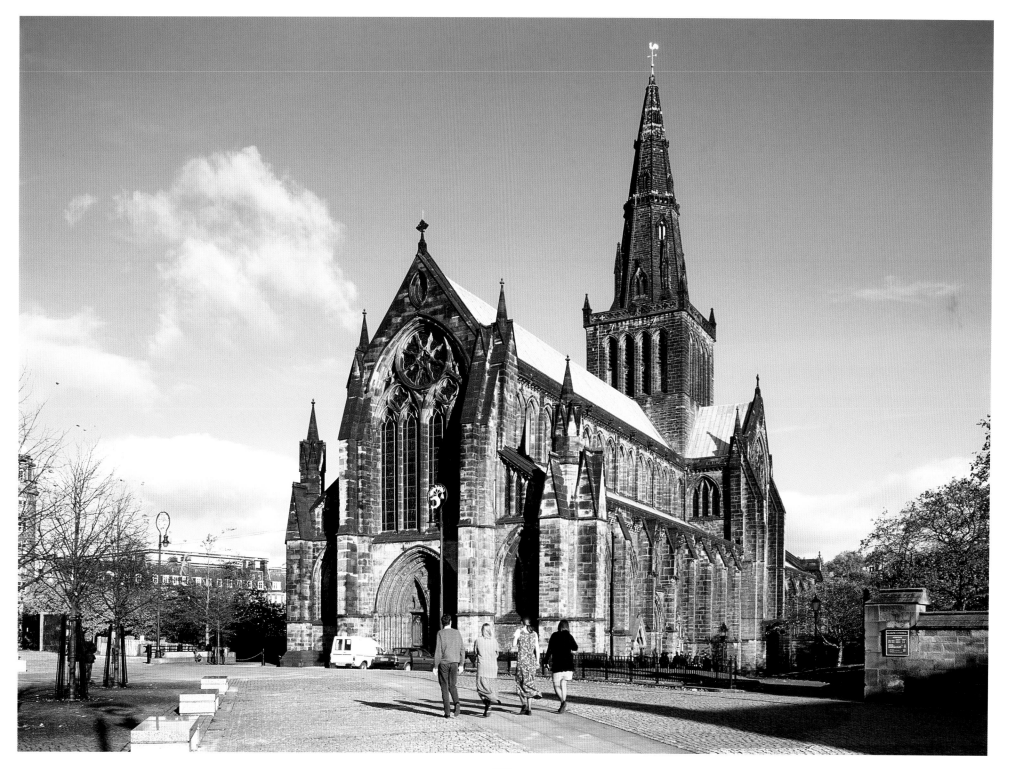

RIGHT & FAR RIGHT: The Italianate entrance and staircase of Glasgow's City Chambers in George Square. Completed in 1888 as an impressive symbol of Glasgow's political strength and historical wealth, the City Chambers has for over 100 years been the headquarters of successive city councils.

OPPOSITE: The Victorian Glasgow Necropolis, with its view of Glasgow beyond. Standing on a hill to the east of Glasgow Cathedral, only a short walk across the Bridge of Sighs, it is a memorial to the merchant patriarchs of the city, and was the resting place of almost every eminent Glaswegian of its day. One of the first and largest of the monuments is the one dedicated to John Knox, which was erected in 1825. The cemetery itself, like several in Edinburgh, was modelled on Père-Lachaise in Paris.

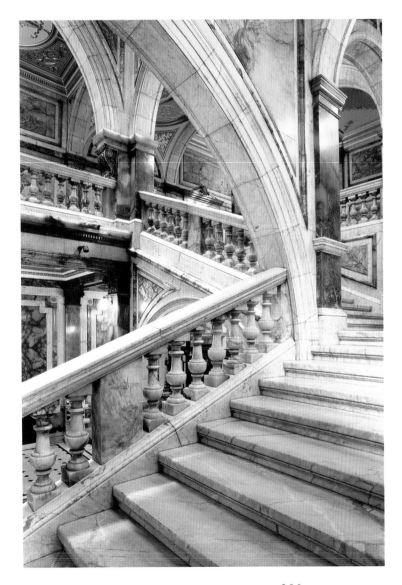

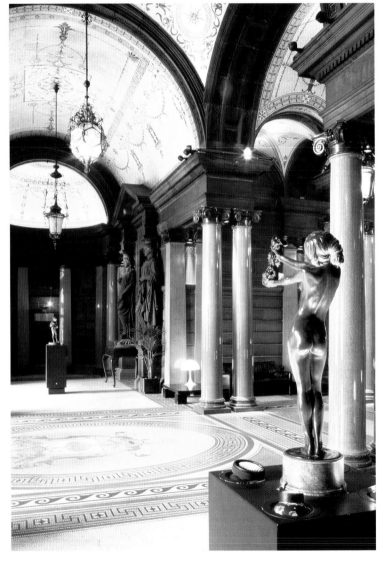

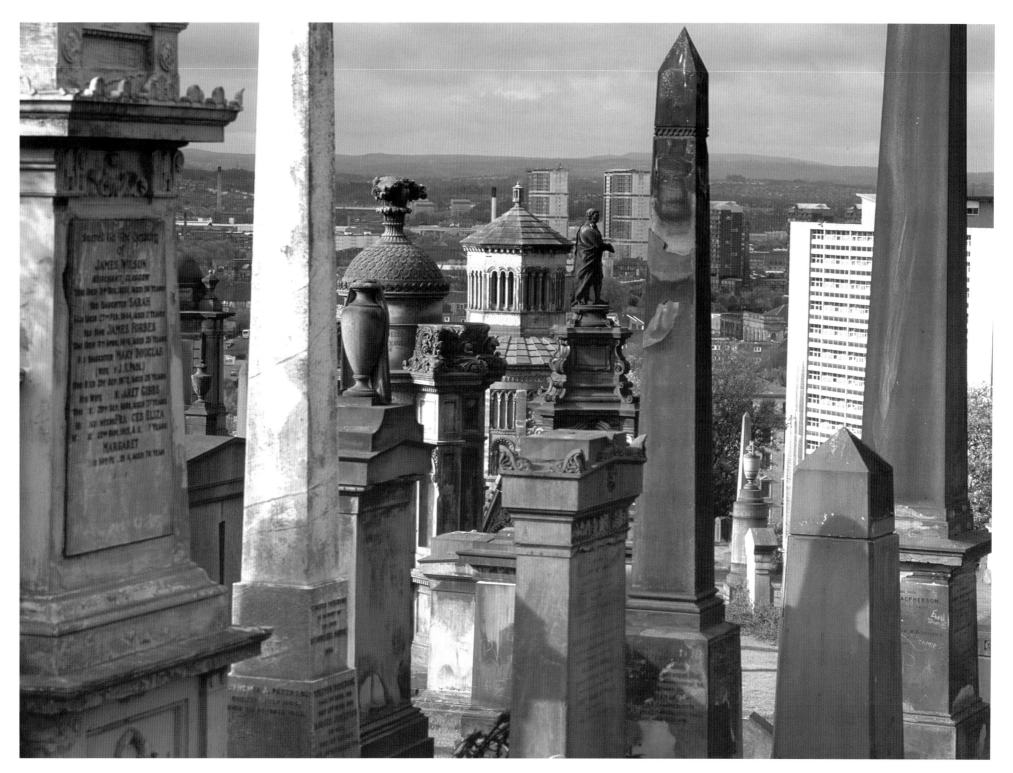

RIGHT: Templeton's Carpet Factory on Glasgow Green, dating from 1889, is also known as the Doge's Palace, due to the perceived 'Venetian' style of the building, designed by William Leiper.
It now forms part of the Templeton Business Centre, redeveloped by the Charles Robertson Partnership in 1984.

OPPOSITE: Statue of David Livingstone, the Scottish missionary and explorer in Africa, in front of Glasgow Cathedral.

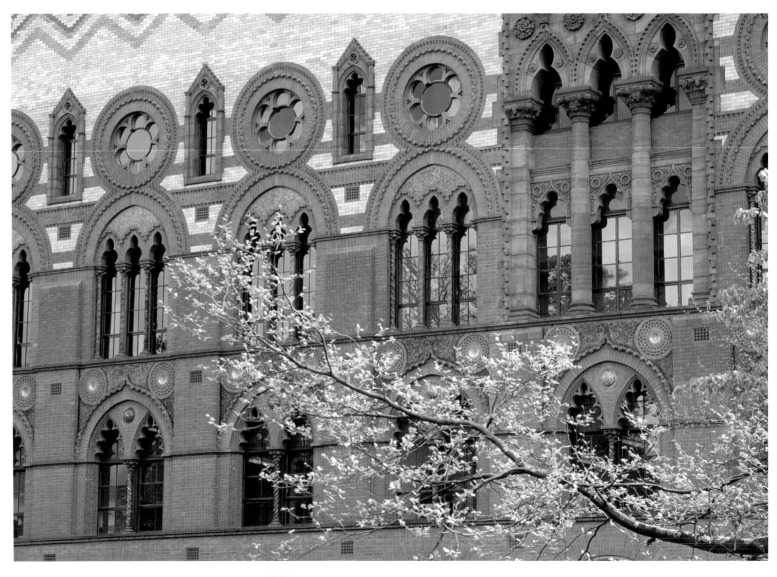

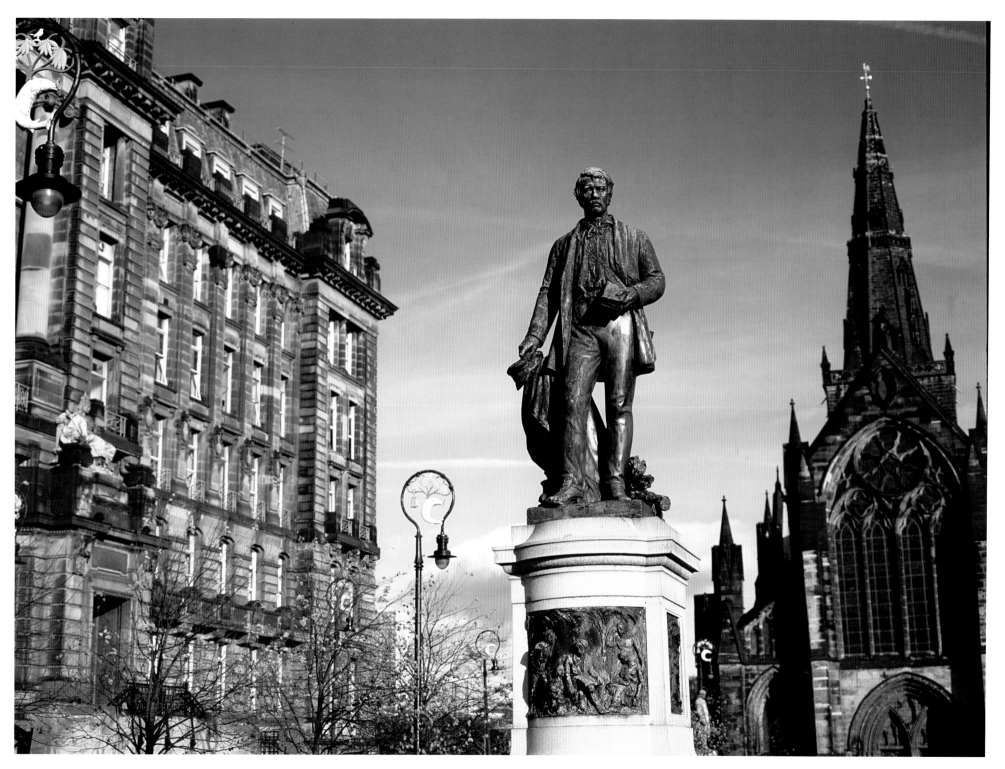

RIGHT: New Lanark, the site of David Dale's revolutionary cotton-mill village, located on the River Clyde south-east of Motherwell. The village has been carefully restored to give modern visitors an idea of what life would have been like in such a community over 200 years ago. It became an official UNESCO World Heritage Site in 2001.

OPPOSITE: Looking east over Loch Lomond, one of Britain's largest, most idyllic and unspoilt freshwater expanses. It is ideally situated for tourists, being only a short drive away from Glasgow and from Edinburgh to the east.

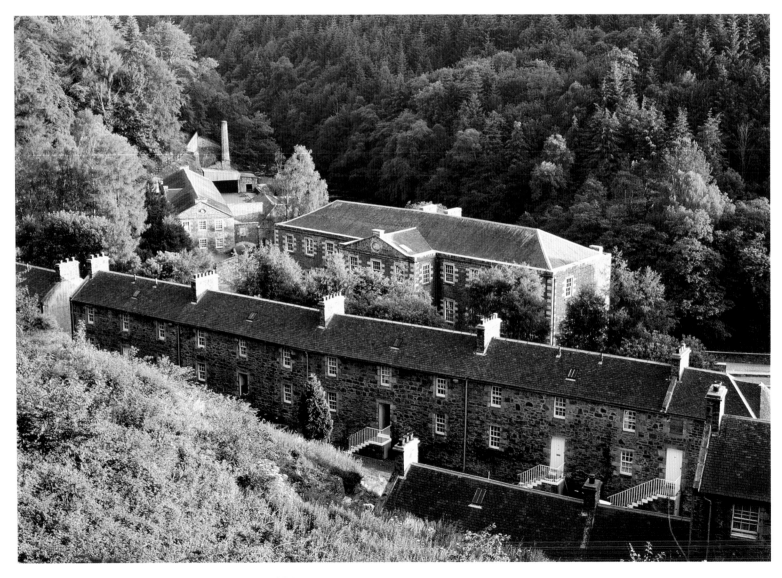

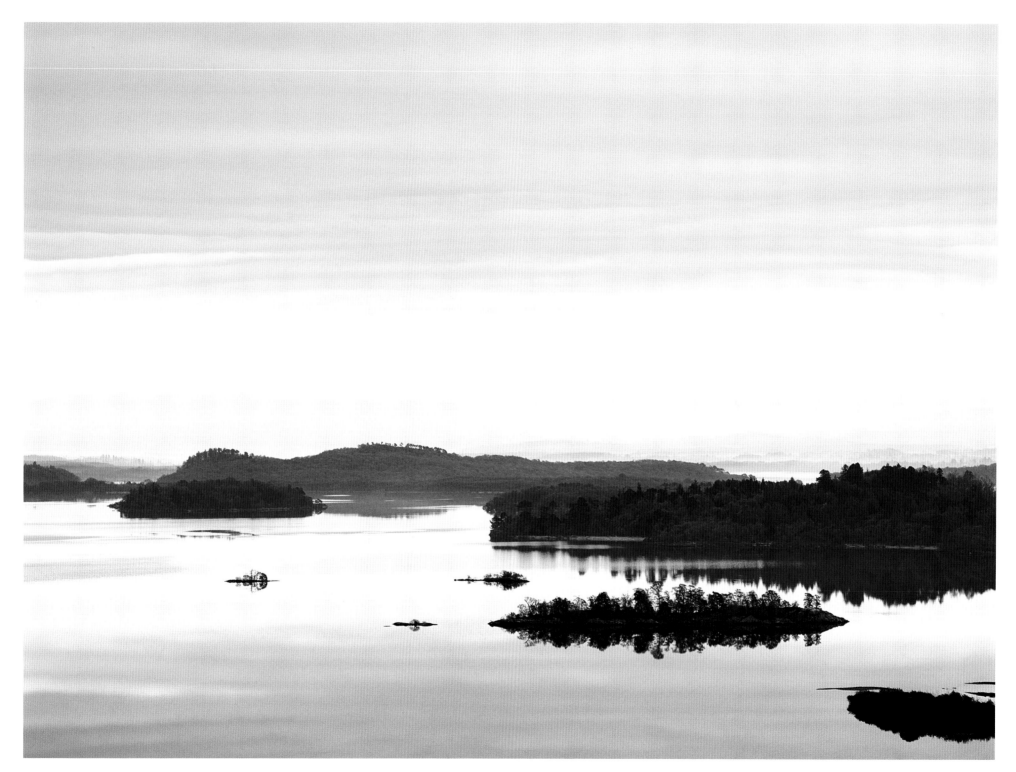

*FAR RIGHT & OPPOSITE: An ornamental fountain and courtyard buildings in the Benmore Botanic Gardens, situated between Dunoon and Loch Eck in Argyll & Bute. The gardens were acquired by the Royal Botanic Garden, Edinburgh, in 1929, primarily to house tree and plant specimens sourced by plant-hunter George Forrest in eastern China. Here many other magnificent trees, some of them over 150 years old, can be seen, including an avenue of Giant Sequoias (*Sequoiadendron giganteum*) plus several Douglas firs (*Pseudotsuga menziesii*), the tallest native trees in Britain. The avenue was planted in 1863 and several of the trees now exceed 150ft (45m) in height.*

RIGHT: One of the three Ballochroy standing stones, Kintyre, Argyll, thought to be a first millennium BC astronomical observatory.

world. Already prosperous through New World trade, including the tobacco trade with Virginia and Maryland, Glasgow grasped the opportunities of the Industrial Revolution with both hands, turning to cotton production based on immigrant labour, first from the Highlands and then from Ireland, creating in the process what would become, in the 19th century, some of the worst slums and areas of social deprivation in Britain. In the 1780s, the Clyde was deepened and widened where it flowed through central Glasgow to take larger river traffic to deal with the new trade. Then came the age of the steam engine, bringing the ship-builders, who based themselves downriver at Clydebank, the

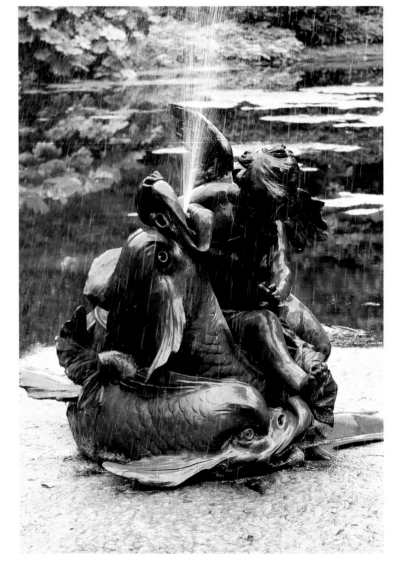

RIGHT: An ornamental astrolabe in Benmore's formal gardens.

OPPOSITE: The avenue of sequoias at Benmore was planted by Piers Patrick in 1863.

RIGHT: Part of the extensive Burrell Collection in Glasgow, opened to the public in 1983. Presented to Glasgow in 1944 by the millionaire shipowner Sir William Burrell, the collection was amassed over 80 years of his life and includes ceramics, prints, carpets, tapestries and paintings.

OPPOSITE: A coastal steamer at Inverary on Loch Fyne, Argyll.

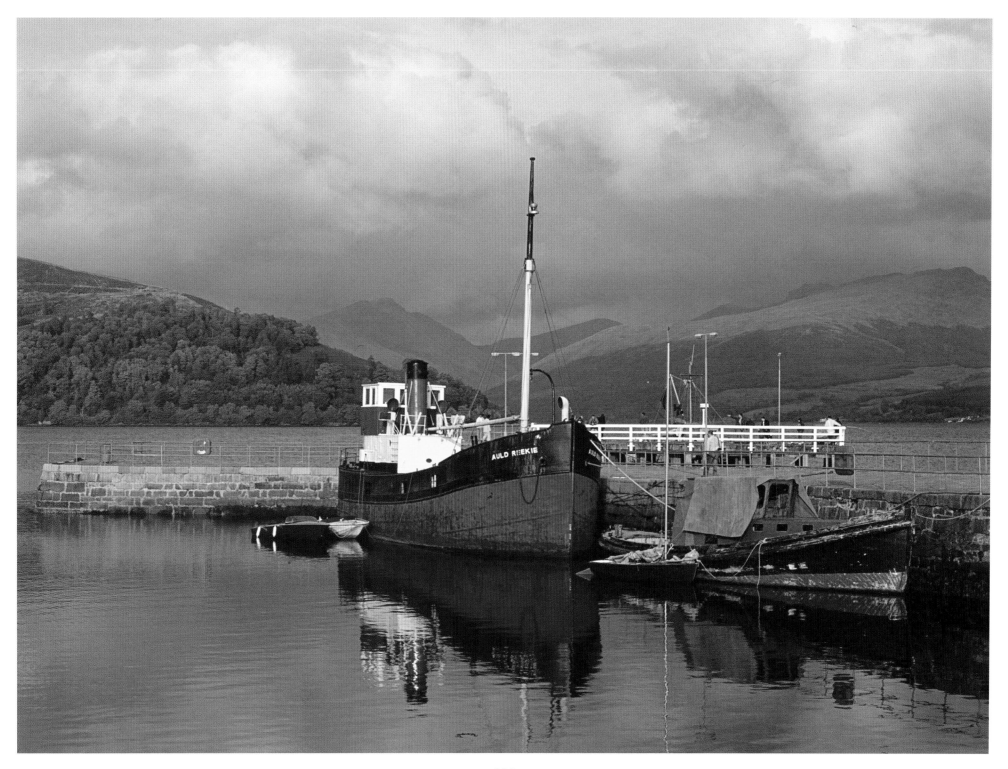

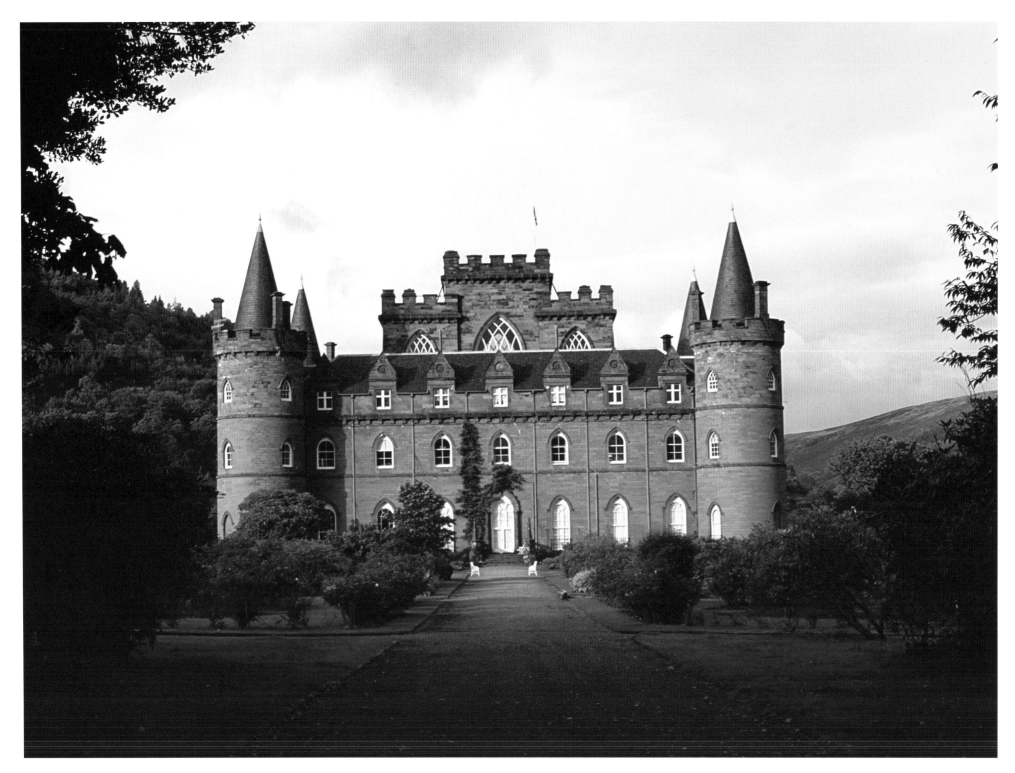

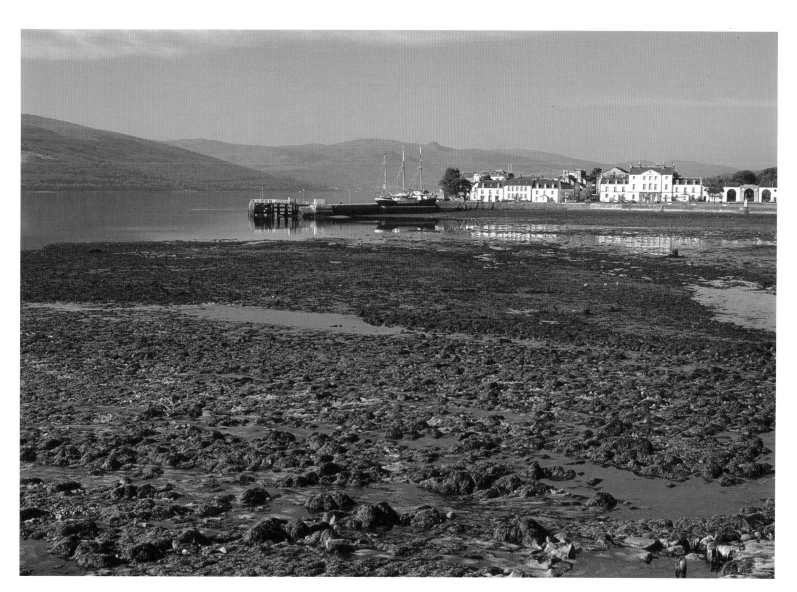

OPPOSITE: Inverary Castle, the seat of the dukes of Argyll, chieftains of Clan Campbell. The original castle, begun in 1744 by the third Duke of Argyll, was rebuilt in the mid-18th century together with the town of Inveraray itself.

LEFT: Inverary, on the shores of Loch Fyne.

PAGE 304: The walls of Carnasserie Castle, a ruined 16th-century tower house noted for its unusual plan and Renaissance detailing. It is located to the north of Kilmartin in Argyll & Bute.

PAGE 305: The small fishing village of Tarbert on Loch Fyne. Loch Fyne is internationally famous for the excellence of its seafood.

heavy engineering works and the steel-makers, their factories and workshops powered by coal from the Lanark coalfields.

In Glasgow today there is little to be found of the medieval seat of learning that was the old Glasgow, apart from the fine 12th- and 13th-century cathedral (page 289), built on the site of St. Mungo's sixth-century church, and Provand's Lordship, the oldest domestic building in Glasgow, built in 1470 to house the priest in charge of a nearby hospital.

Most of Glasgow today, with its amazing skyline of factories, tower blocks, chimneys and the occasional church spire, is either Victorian or very modern, for Glasgow's second miraculous makeover has occurred in our time. The city has overcome the devastation of its industrial base and the deaths of its great industries, rebuilding its worst slum areas and turning itself into what has been called 'Europe's first post-industrial city' as well as one of its great cultural centres.

Glasgow is a vibrant, lively place, the home of Scottish Opera and the Scottish National Orchestra, and a city where, among the larger shops in Argyle, Sauchiehall and Buchanan Streets, such gems as the Charles Rennie Mackintosh-designed Willow Tea Rooms in Sauchiehall Street can be found, together with his masterpiece, the Glasgow School of Art in nearby Renfrew Street. Go away from the centre, to Glasgow Green, one of the city's many fine parks, and you'll find the People's Palace, devoted to the social history of Glasgow. Further away, in Pollock Park, is

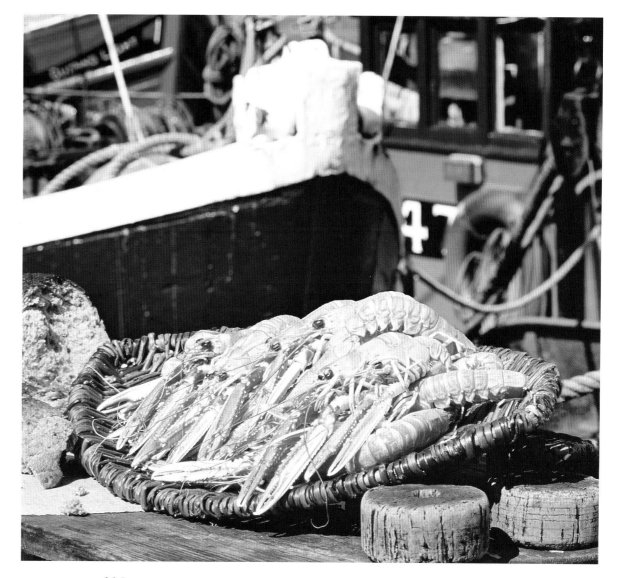

RIGHT: The gable end of a ruined croft, outlined against the sky at dusk in the Highland clearance village of Arichonan, located west of Lochgilphead.

OPPOSITE: Aerial view over the safe anchorage of Tayvallich, a small community built around a sheltered harbour on the shores of Loch Sween, west of Lochgilphead, Argyll & Bute.

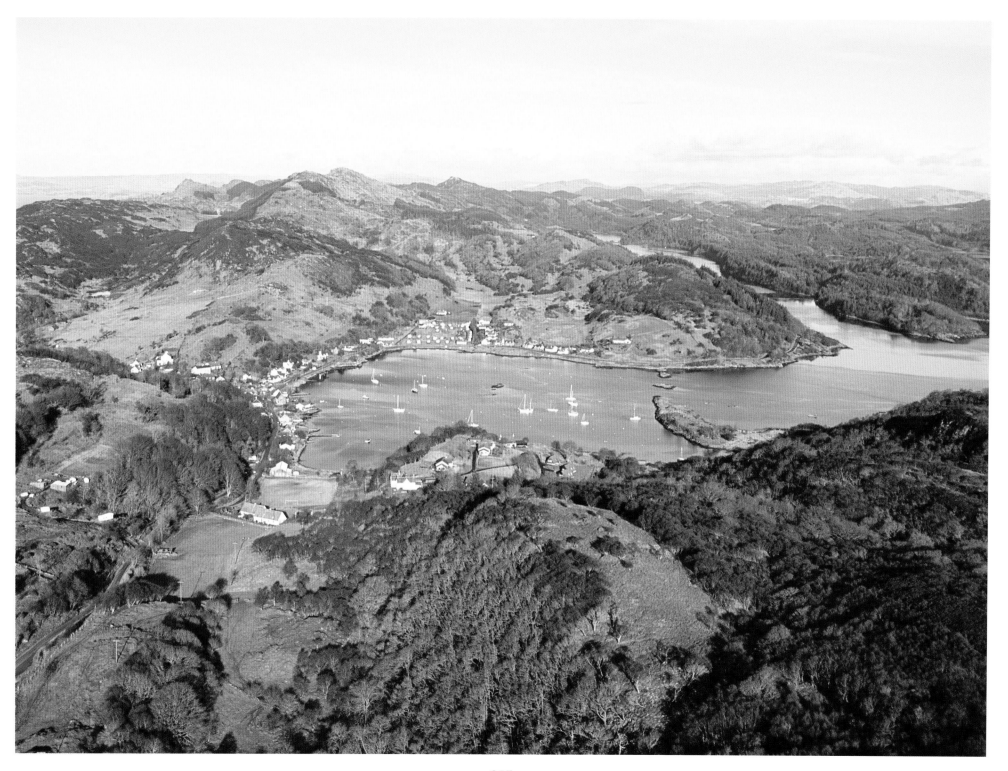

*FAR RIGHT: Charles Benson, in
Jacobite regalia, visiting the trophy
pavilion at the annual Cowal
Highland Gathering at Dunoon.*

BELOW: The piping judges.

OPPOSITE: The dancing contest.

the Burrell Museum, a wonderfully light and airy glass-walled building housing the art collection of the shipping magnate Sir William Burrell. Since the museum was opened in 1983 it has become Scotland's top tourist draw, attracting more visitors every year than any other tourist site in the country.

For Glaswegians in need of a holiday, or simply a day or so out of the city, two of Scotland's most popular holiday areas, the

islands of the Firth of Clyde with the Kintyre peninsula to their west, and The Trossachs, are hardly any distance away, the one downriver where the Clyde widens out into the great Firth of Clyde, the other away to the north-west, where Loch Lomond reaches up into the hills of Argyll.

Kintyre, the Cowal Peninsula and the Firth of Clyde islands, especially Arran and Bute, make a natural playground for the whole of western Strathclyde, easily reached from Glasgow and within good steamer services of the southern islands of the Inner Hebrides. The many lochs and streams, both on the mainland and

THE SOUTH-WEST

RIGHT & OPPOSITE: Innis Chonnel Castle, one of the earliest strongholds of the Campbell clan, is some 700 years old, its massive walls crowning the rocky south-western end of a small island, lying halfway down and very near to the eastern shore of Loch Awe.

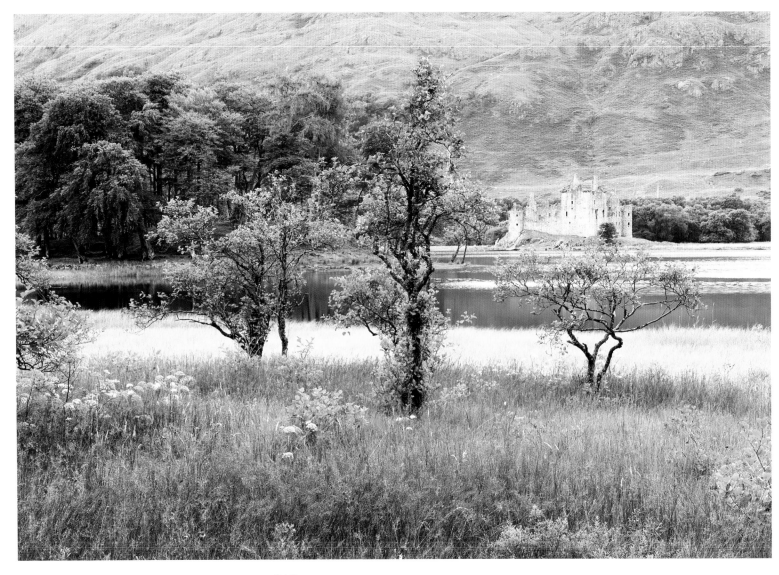

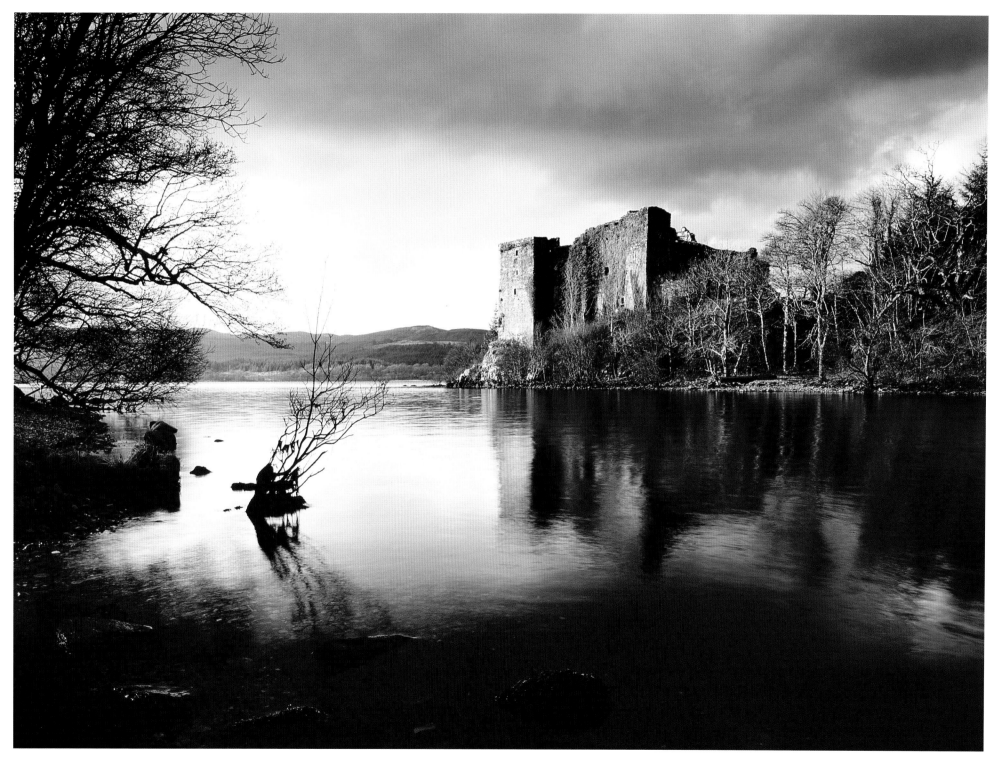

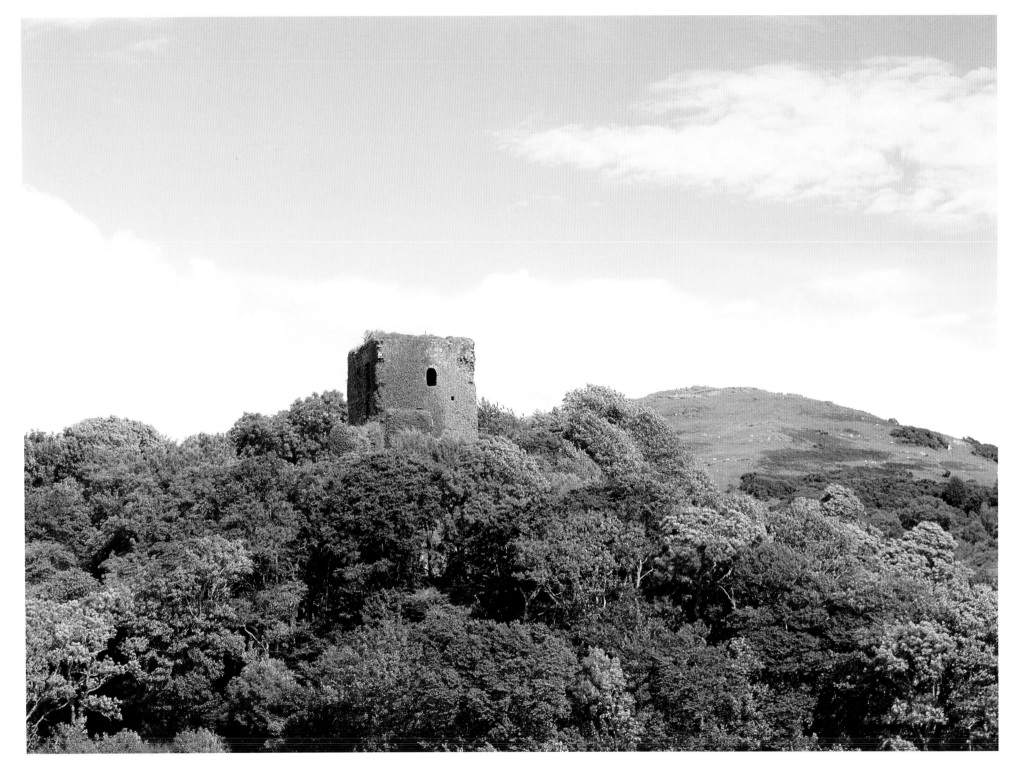

312

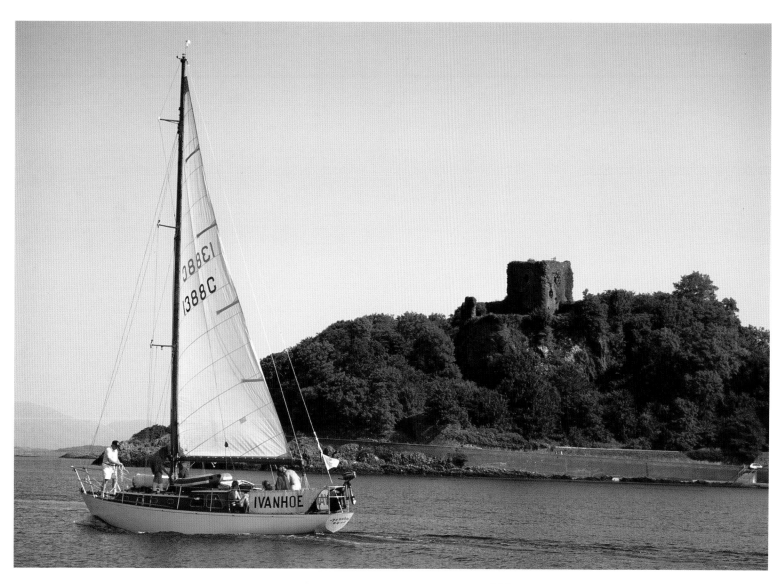

OPPOSITE & LEFT: Dunollie Castle, located at the mouth of Oban Bay.

PAGE 314: The pleasure steamer Sir Walter Scott *on Loch Katrine.*

PAGE 315: Morning mist on Loch Katrine, a beautiful freshwater loch in Stirling. It is the lake of Sir Walter Scott's narrative poem 'The Lady of the Lake', set in the Trossachs and first published in 1810.

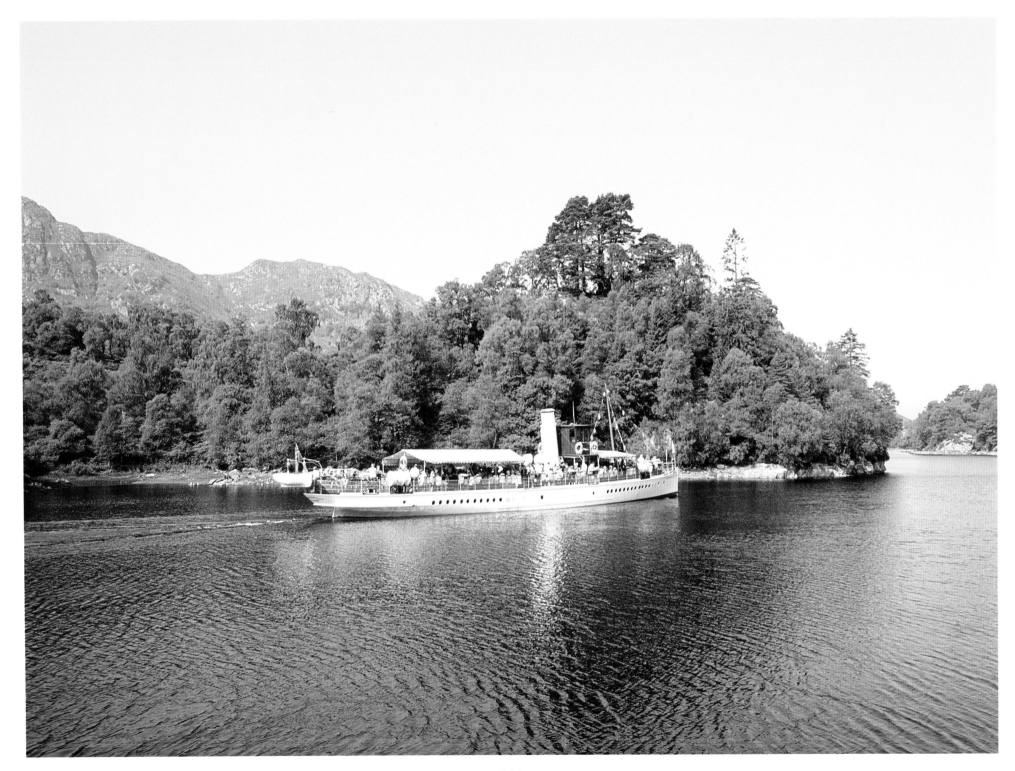

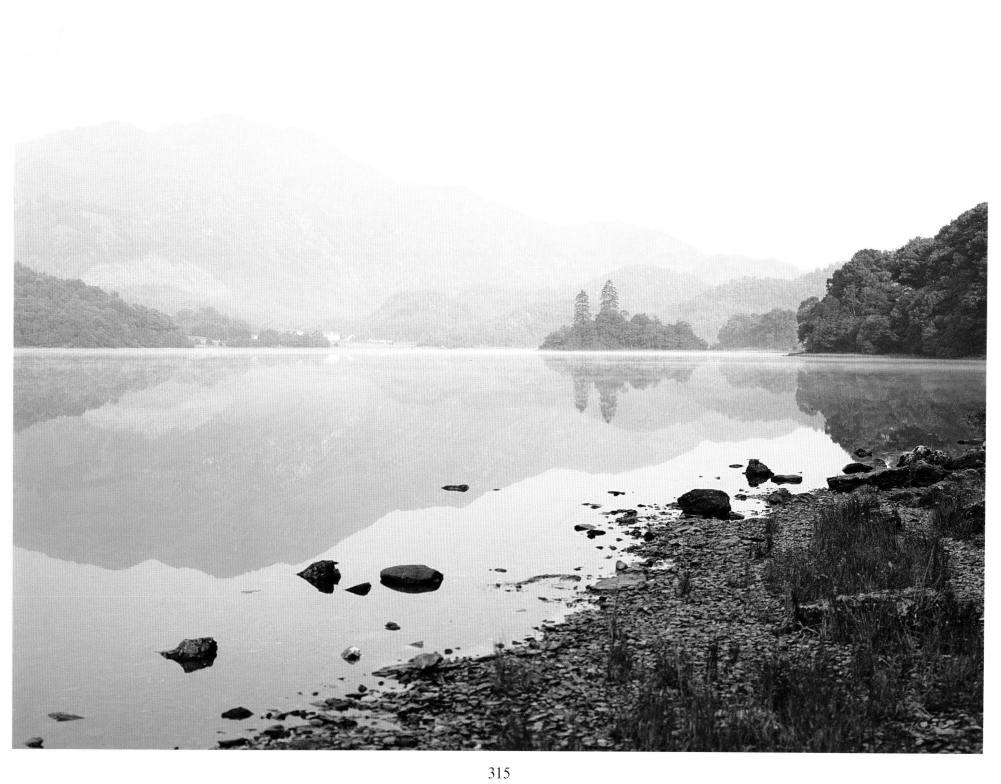

RIGHT: *A Celtic cross near Crinan, Argyll.*

OPPOSITE: *A winter sunrise intensifies the colours of the landscape around Crinan Bay.*

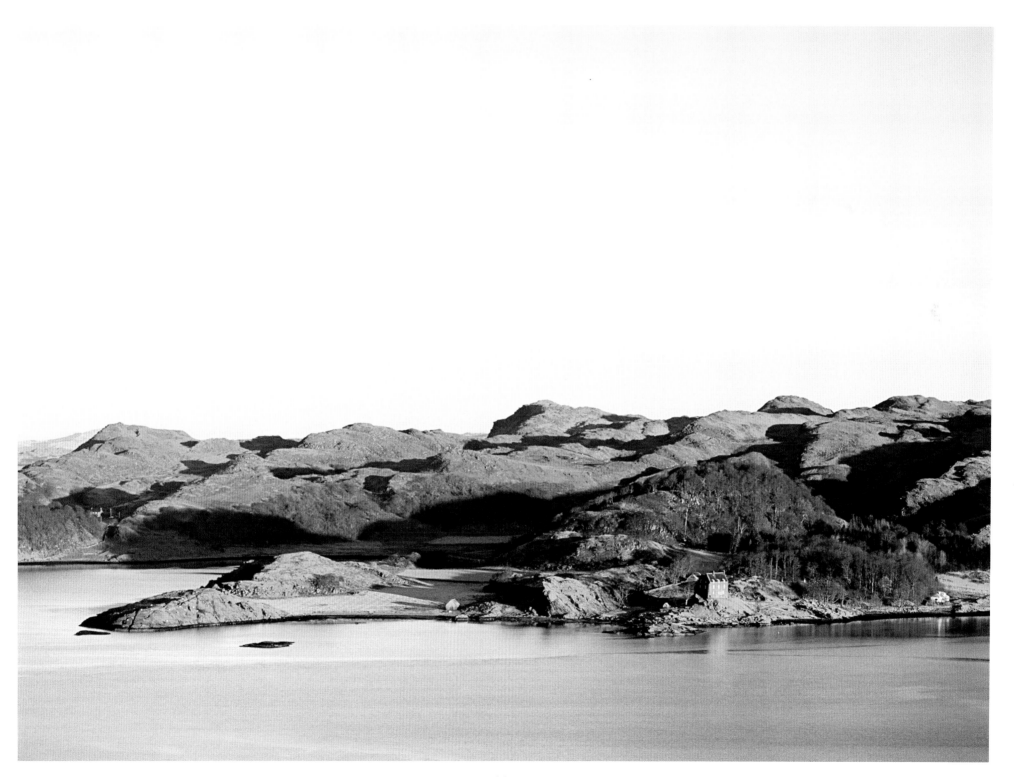

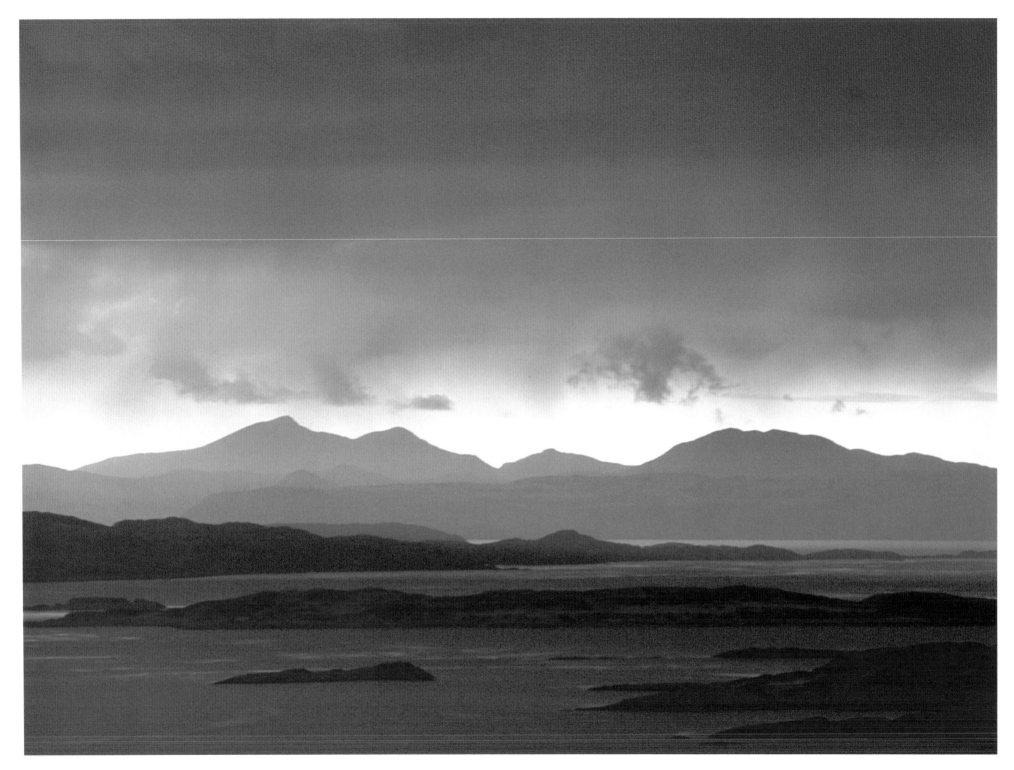

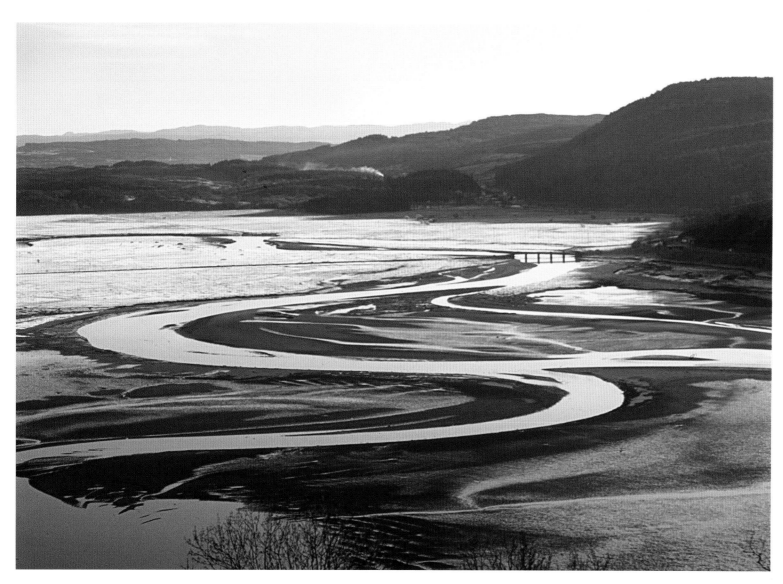

OPPOSITE: Loch Crinan, in Argyll & Bute, looking north-west towards the Isle of Mull.

LEFT: The River Add meanders through Loch Crinan's tidal flats.

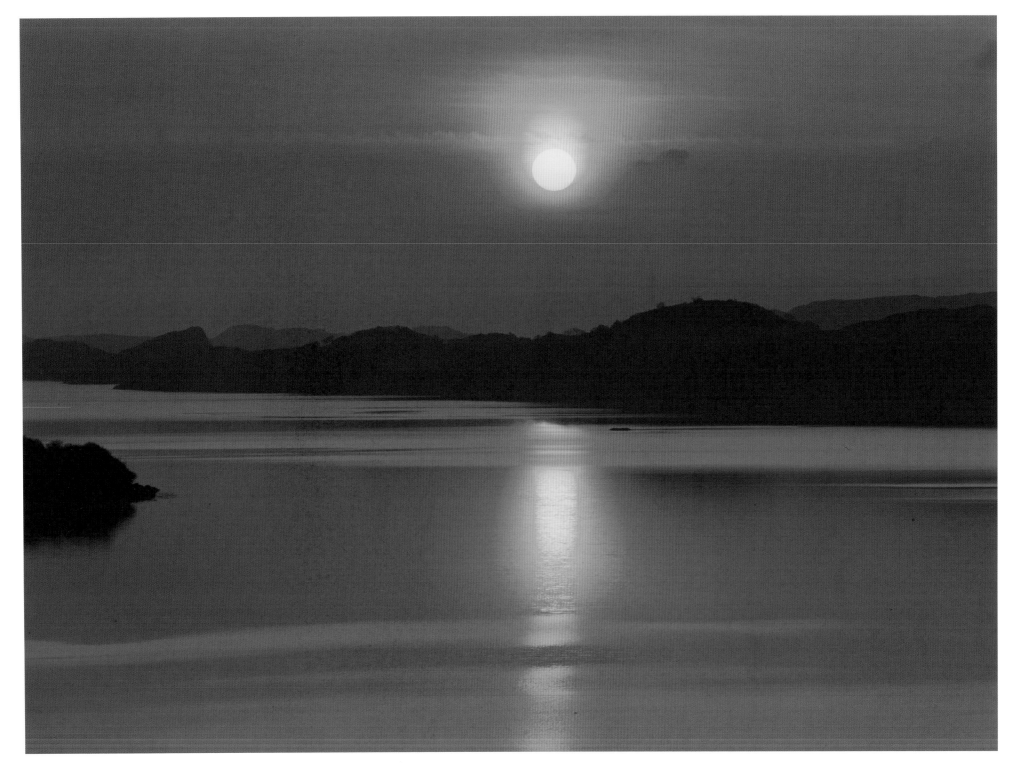

the islands, attract fishermen hoping for salmon, trout and sea-trout, while the calm, sheltered waters of the Kyles of Bute are ideal for holiday cruising and sailing.

Arran, largest of the Firth of Clyde islands, has been called 'Scotland in miniature' because of its fine mixture of lochs, glens, streams and mountains, including the 2,866-ft (874-m) Goatfell, which make up its scenery, especially in the north. Its attractive coastline is cut by many bays, some sandy, some rocky, many giving sheltered anchorages to sailing boats. Busiest of all is Brodick Bay, dominated by the 15th-century Brodick Castle, owned by the National Trust for Scotland and with spectacular gardens, including a fine collection of rhododendrons. Brodick, at the southern end of the bay, is Arran's holiday centre and main port, and is where the ferries from Ardrossan come in.

Near the west-coast resort of Blackwaterfoot are cairns, built in the Bronze Age, and the King's Caves, so-called because they gave shelter to Robert the Bruce when he returned from exile in Ireland. They are only two of the many sites which help to make Arran a walker's paradise, as well as a Mecca for bird-watchers and for geologists, who come because just about every rock type may be found.

Bute, at the foot of the Cowal Peninsula, and flatter and more fertile than Arran, is quieter, too, but just as popular with Glaswegians: not for nothing has 'The Day We Went to Rothesay-O!' long been a popular music-hall song, revived for the television

age by the late Andy Stewart, Rothesay being Bute's main town, reached by ferry from Wemyss Bay. Still surrounded by its deep moat, Rothesay Castle, once owned by the Stuart kings, has been a ruin since Cromwell destroyed it in the 17th century.

From Arran there are ferries to Kintyre and from Bute across the Kyles of Bute to the Cowal Peninsula in summer. Here, back on the mainland, it is possible to quickly head north to be in the remote, sparsely-populated mountain and forest country which characterizes much of Argyll. Stretching up the shores of Loch Long and across much of the north-eastern section of the Cowal Peninsula, almost as far west as Loch Fyne, is the great Argyll Forest Park, the first to be established by the Forestry Commission in Britain.

Loch Fyne is Campbell country, near to the head of which, on the western shore, is the elegant town of Inveraray, where Inveraray Castle (page 302), on the banks of the River Aray, has been the main fortress and home of the Campbell clan since the 15th century. The present castle dates from the 18th century and was built for the third Duke of Argyll by William Adam and Robert Morris; for those interested in discovering the land associated with Rob Roy, there is a walk of about 5 miles (8km) from the castle grounds up Glen Shira to the Falls of Aray and the home, now a ruin, of the hero himself.

The heart of Rob Roy MacGregor country is not here, however, but in The Trossachs, Glasgow's other favourite

OPPOSITE: The setting sun reflected in the waters of Loch Craignish, Argyll & Bute. The sea-loch lies at the northern end of the Sound of Jura and on the south-eastern side of the Craignish Peninsula. Several islands lie within the loch, the largest being Eilean Righ, Eilean Mhic Chrion and Island Macaskin.

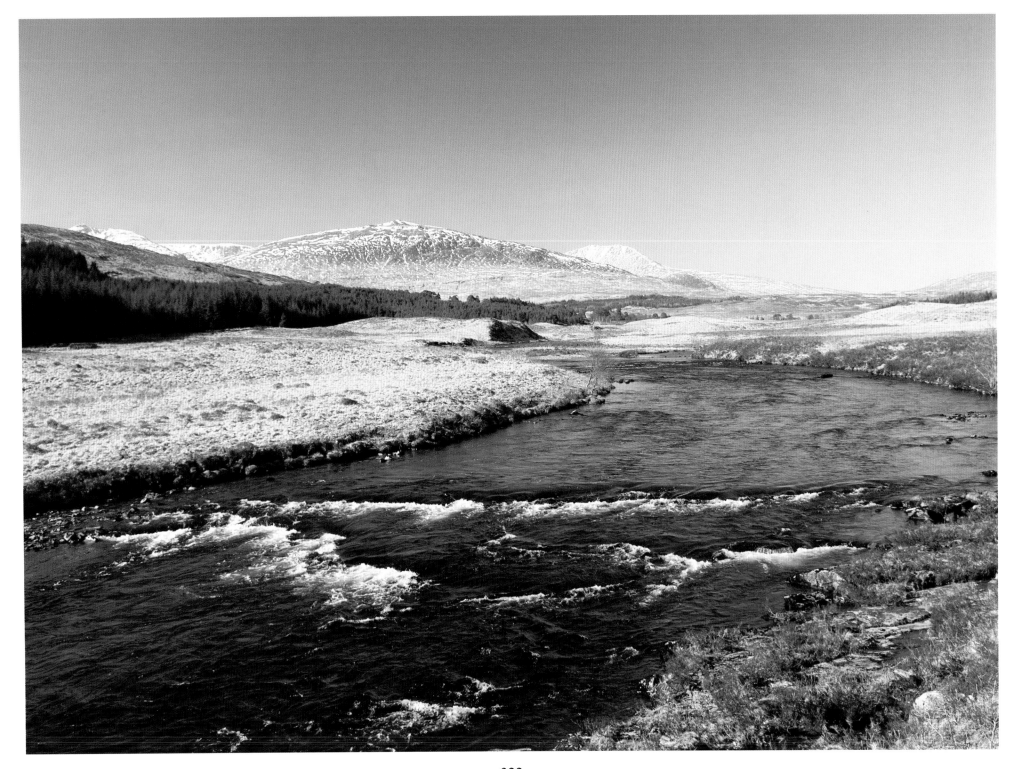

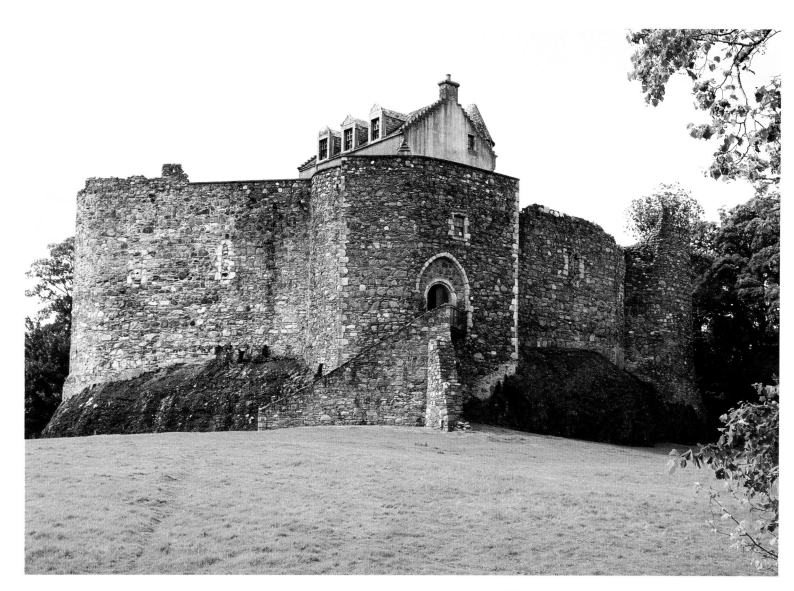

OPPOSITE: The River Orchy flows south from Loch Tulla at the hamlet of Bridge of Orchy in the south-western Grampians.

LEFT: Dunstaffnage, a partially ruined castle in Argyll & Bute, is located north of Oban. It occupies a promontory to the south-west of the entrance to Loch Etive, and is surrounded on three sides by sea. Much of that which remains today was built by the Macdougalls in the 1200s, the castle coming into royal possession when it was captured by Robert the Bruce in 1309. In 1470, custody passed first to Colin Campbell, Earl of Argyll, and then to his cousin in 1502, who became known as the Captain of Dunstaffnage, and in whose family stewardship of the castle remains.

THE SOUTH-WEST

playground. The Trossachs, which first became a fashionably romantic place to visit in the 18th century is, strictly-speaking, simply the short gorge linking two lovely lochs, Achray and Katrine. But the name has come to be given to the much wider region of lochs, rugged hills, and streams tumbling over stony beds, which stretches west from the attractive resort of Callander, at the foot of the Pass of Leny just 15 miles (24km) from Stirling, as far as Loch Lomond. The latter is Scotland's largest inland loch, stretching 23 miles (37km) from the outer suburbs of Glasgow almost to the edge of the Highlands.

Aberfoyle, lying between the Lake of Menteith (Scotland's only 'lake') and Loch Ard, is generally considered to be the main gateway to The Trossachs and to the Rob Roy country which embraces Lochs Ard, Chon, Venacher, Achray and Katrine. Out of season it is an attractive little town, but at the height of summer can be overwhelmed by the numbers of tourists and coach-parties which descend on it. But Aberfoyle is also at the centre of the Queen Elizabeth Forest Park, which is more than big enough to absorb thousands of visitors into its miles of forest paths, mountain walks, including climbs up the 2,369-ft (722-m) Ben Venue and 2,847-ft (868-m) Ben Ledi, and its picnic areas, without losing the attraction of its remote mountain and loch atmosphere.

The two main lochs of The Trossachs, Katrine and Lomond, offer boat trips in summer, those on Loch Katrine being on the

famous Dumbarton-built steamer, *Sir Walter Scott*, aptly named because it was he who first drew the world's attention to the loveliness of the loch in his poem 'The Lady of the Lake', the lady being the beautiful Ellen Douglas, after whom Ellen's Isle, at the eastern end of the loch, is named.

Sir Walter Scott never penetrated very far into Ayrshire or Dumfriesshire, south of Glasgow, partly because the Border country to the east was where he was happiest, but partly, perhaps, because he was very much aware of the overwhelming influence of the spirit of Robert Burns in this land.

Robert Burns, the son of a poor farmer, was born in 1759 in Alloway, then a small village near Ayr, and died in Dumfries in 1796. Apart from short stays in Edinburgh, where the youthful Walter Scott on meeting him at a party was greatly impressed by the strength of his personality, and tours of the Borders and the Highlands, Burns spent all of his life in Ayrshire and in Dumfries, where his work as an excise officer took him into all parts of the shires in what is now the local government region of Dumfries & Galloway.

Because most of his poetry grew out of his own emotions and his intense feelings for the lives of people close to him and for his country, Scotland, Robert Burns did not need the sight of spectacularly beautiful scenery as the impetus for his genius – though he did write some very fine verse while on his epic 600-mile (965-km) tour of the beautiful Highland country east of the

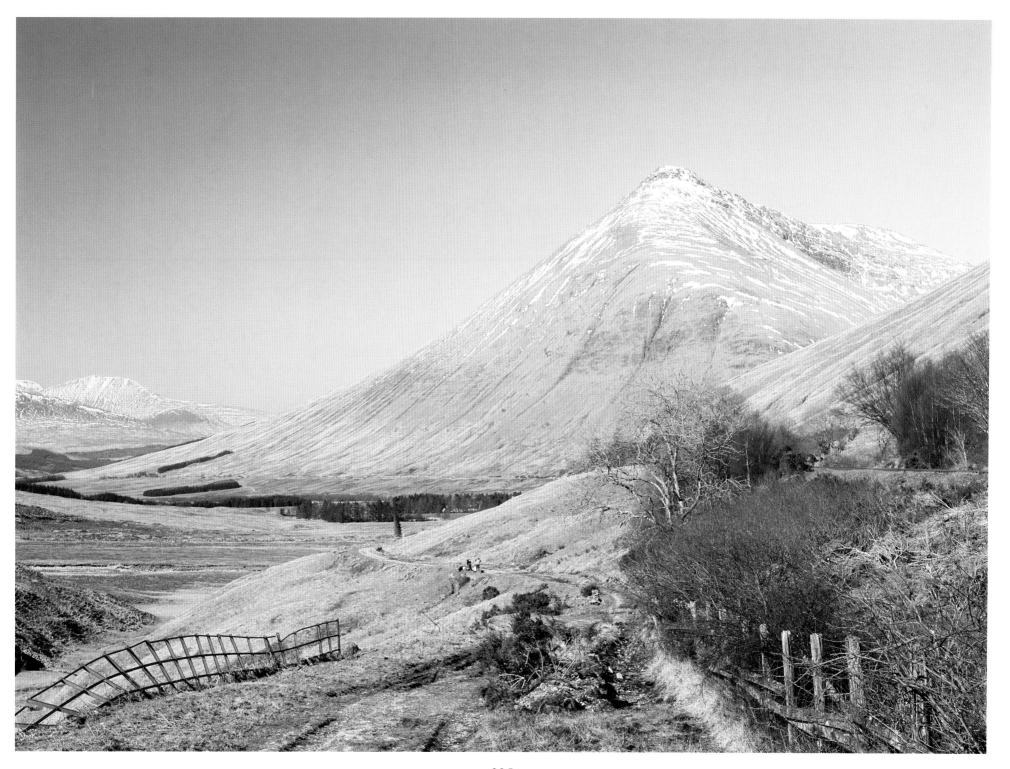

RIGHT: Early medieval Celtic Christian crosses in Keills Chapel, near Loch Sween.

OPPOSITE: Two of the megaliths at the Ballymeanoch site in the Kilmartin Valley, Argyll, one of the richest prehistoric environments in Europe.

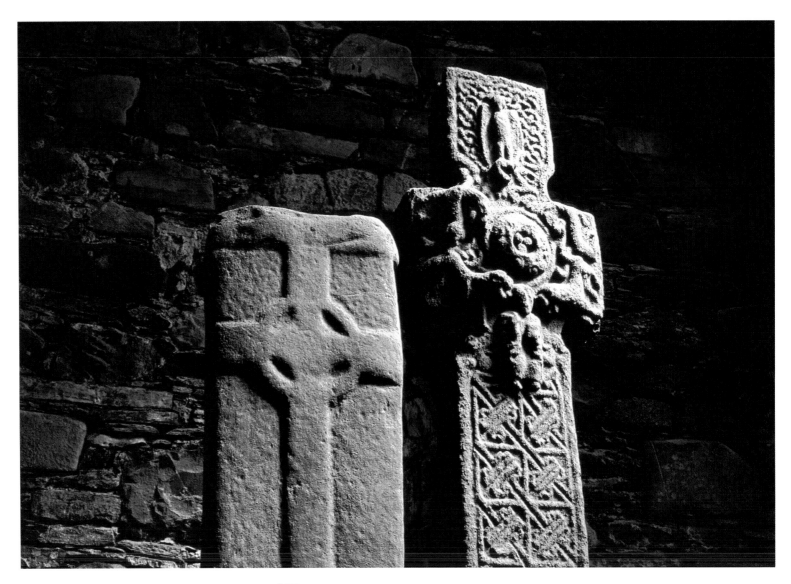

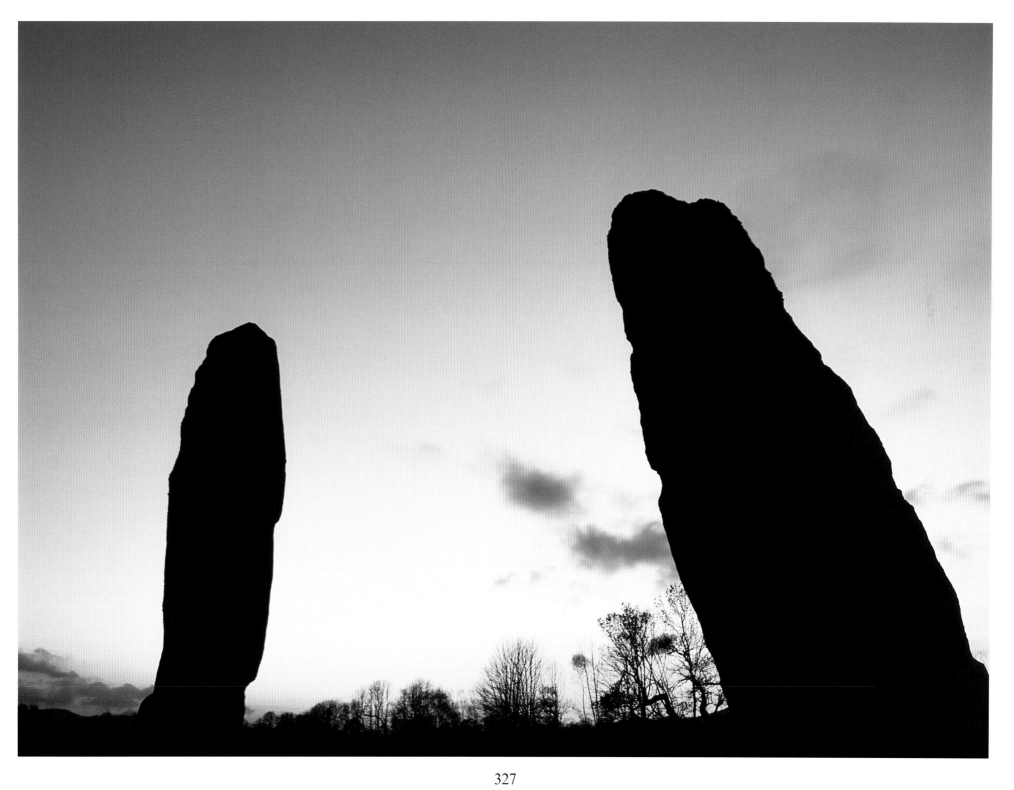

THE SOUTH-WEST

Great Glen. The quiet farming country of Ayrshire, with its green rolling hills and its gently flowing streams, was inspiration enough for some of his finest lyric poetry, while for his more rumbustious songs, what better could there have been than the snug, warm and friendly inns and pubs visited along his excise-collecting routes in Dumfriesshire and Galloway?

Both shires are rich in relics of Robert Burns's life and work, especially in Alloway, where much of the village is given over to the Robert Burns Heritage Park, and in Dumfries, where the house in which he spent the last years of his life is at the heart of the town's tourist trail.

An attractive feature of the area is that in few parts is it ever crowded. While much of the inland countryside is quiet farming land, with pleasant but hardly compelling scenery, down in the south there are many places of outstanding interest, like the seabird colony at Balcary Point on Balcary Bay, or the National Scenic Area at the Nith Estuary on the Solway Firth, where the Nature Conservancy Council has a nature reserve at Kirkconnell Flow, which is a rare raised peat bog.

The Solway Firth, a place of quiet towns and small villages, their harbours still sheltering fishing boats, is rich in the reminders of historical events. Among quietly attractive towns to visit along or just inland from the coast are Annan on the Solway Firth, ancient Dumfries, built on the banks of the Nith, and Kirkcudbright, since the late 19th century a lively artists' colony

in the ancient Stewartry land, so-called because in the 15th century, the kings of Scotland took the rule of the area from its ancient chiefs and put it into the hands of royal stewards. Near Kirkcudbright is one of those historic reminders: the ruins of Dundrennan Abbey. In this Cistercian Abbey, on 15–16 May 1568, Mary, Queen of Scots spent her last night in Scotland. Having escaped from Loch Leven, only for her supporters to be defeated at Langside, near Glasgow, she came here hoping to get help from her cousin, Elizabeth I of England, but hearing no word coming from England, the Queen of Scots decided to go there anyway, and boarded a boat at Port Mary, landing on the Cumberland coast. All that lay ahead of her was nearly 20 years of imprisonment, ended by her execution.

The far west of Dumfries & Galloway, an almost forgotten corner of Scotland, has a coast of cliffs and sandy beaches washed by the warm Gulf Stream, the cliffs being particularly rugged at the Mull of Galloway. Wigtown, on the Machars Peninsula, Glenluce on the Water of Luce, where the wizard Michael Scot is supposed to have entrapped the Plague in a vault of Glenluce Abbey in the 13th century, and, in the far west on The Rhinns of Galloway, the popular holiday town of Portpatrick, are just three of the many interesting places on a coast made for quiet pottering about.

Go inland, however, and things become more dramatic. Not only are there the lovely Eskdale, Annandale and Nithsdale, all

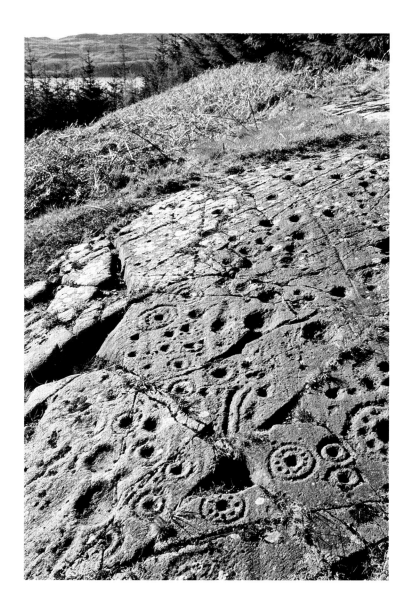

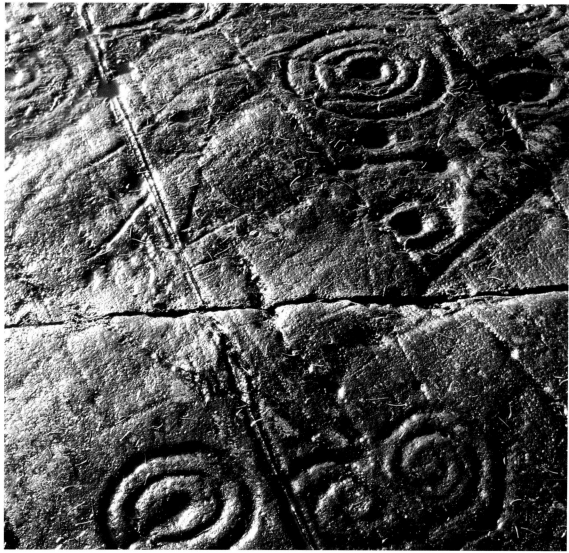

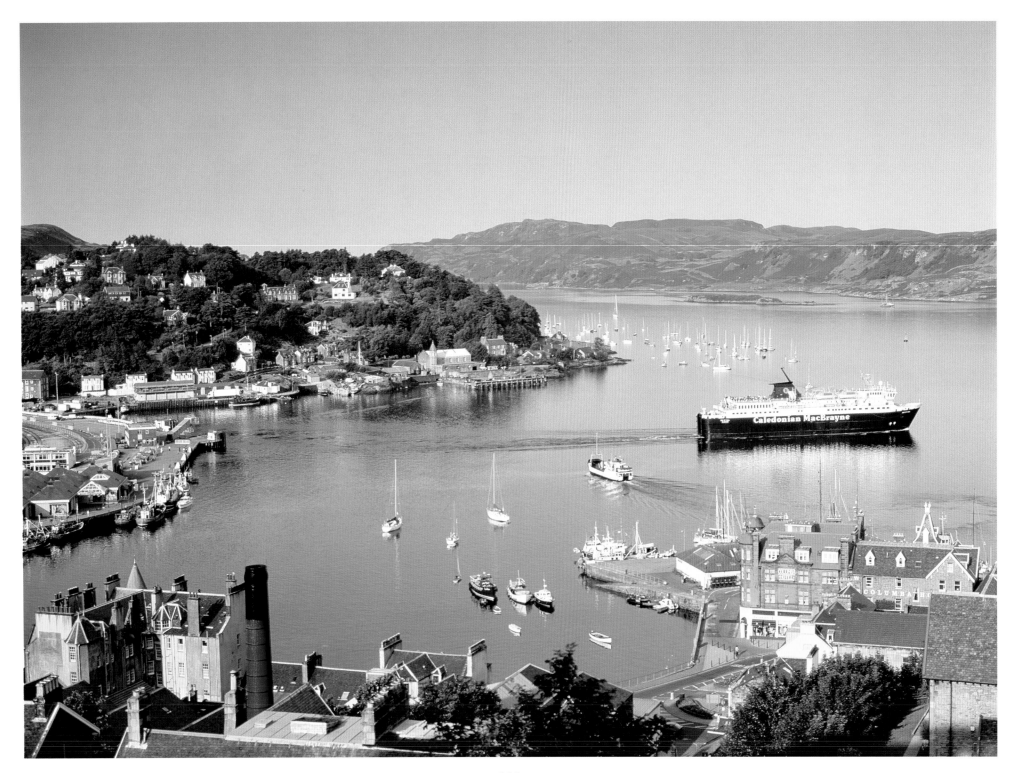

OPPOSITE & LEFT: The town of Oban in Argyll. From here, car ferries leave for many of the inner and outer Hebridean islands.

RIGHT: Farmed salmon, produced in many Scottish lochs, has become an important food product for Scotland.

OPPOSITE: The lighthouse on Eilean Musdile, a tiny uninhabited island located at the south-west tip of the rather larger island of Lismore at the entrance to Loch Linnhe, where the Sound of Mull joins the Firth of Lorn.

PAGE 334: The view west from Crinan across the Sound of Jura towards the island of Scarba.

PAGE 335: A re-enactment, by the Kilmartin House Museum, of St. Columba sailing the Sound of Jura in a cowhide coracle. Kilmartin House is an award-winning centre for archeology, established to protect, investigage and interpret this internationally important archeological landscape and the artefacts found therein.

three of them with interesting towns and villages, old castles and even prehistoric remains to explore, but in the Galloway Forest Park there is also much satisfyingly remote and wild countryside. Around Loch Trool, in steeply wooded Glen Trool, where the Buchan Burn has to plunge over the rocks of the Buchan Falls before reaching Loch Trool, are miles of invigorating walks. It was in this area that Robert the Bruce won a famous victory over an English army in 1307; from Bruce's Stone, overlooking the loch and the battle site on the far shore, there are fine views of the Galloway Hills.

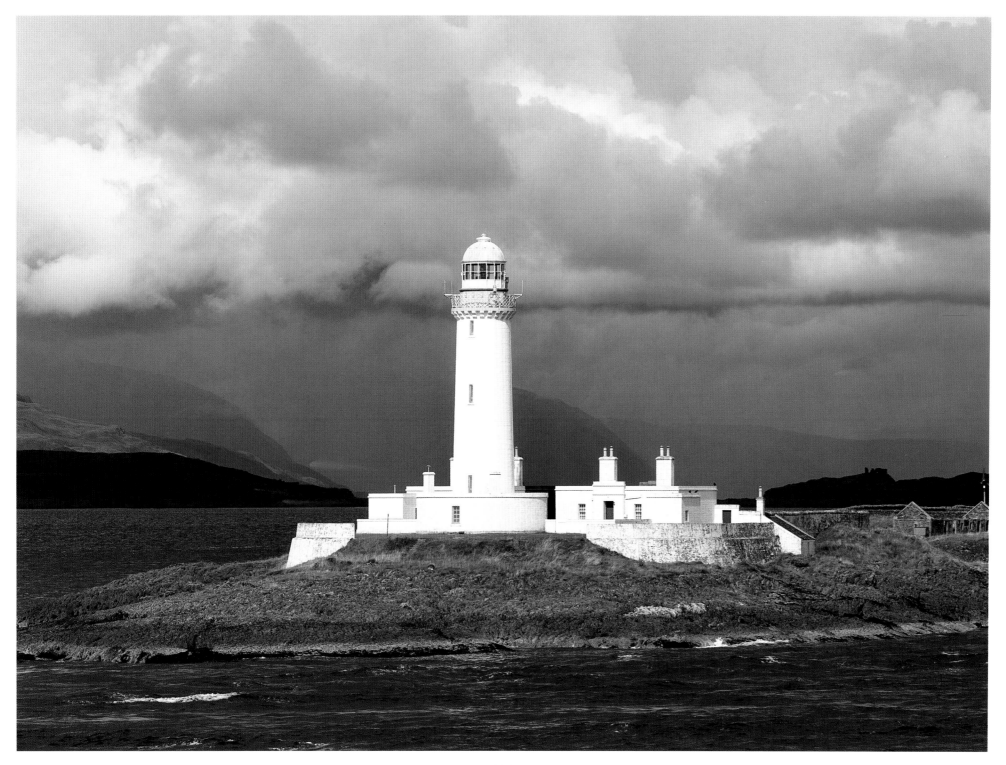

333

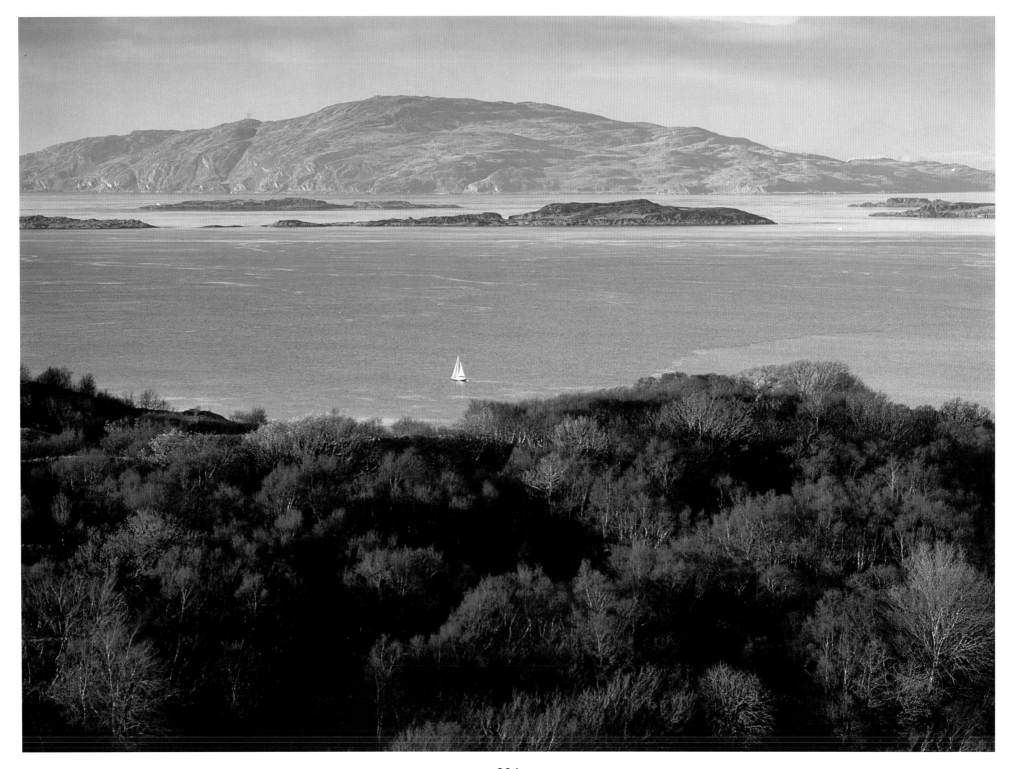

RIGHT: A carved slab in Ardchattan Priory, on the north side of Loch Etive, a Valliscaulian foundation built in around 1230.

OPPOSITE: Castle Stalker, a large stone 15th-century tower house, founded by Sir John Stewart, Lord of Lorn. Of four storeys and a garret, it stands on a small island in tidal Loch Laich in Argyll. It can be approached by boat from Portnacroish.

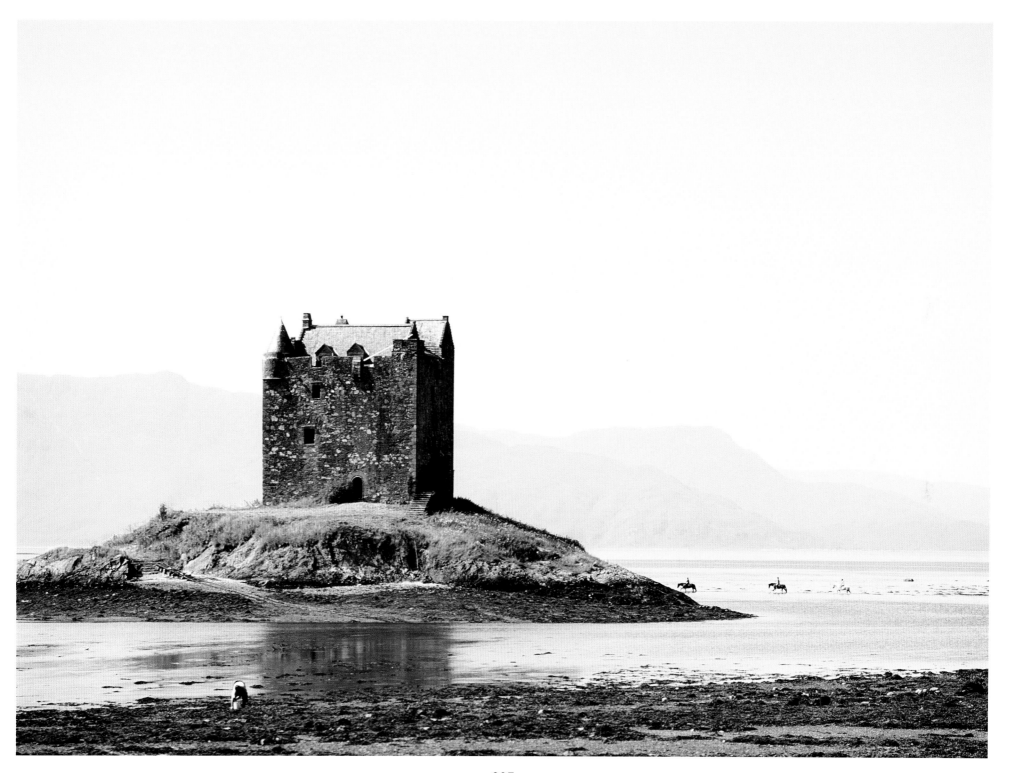

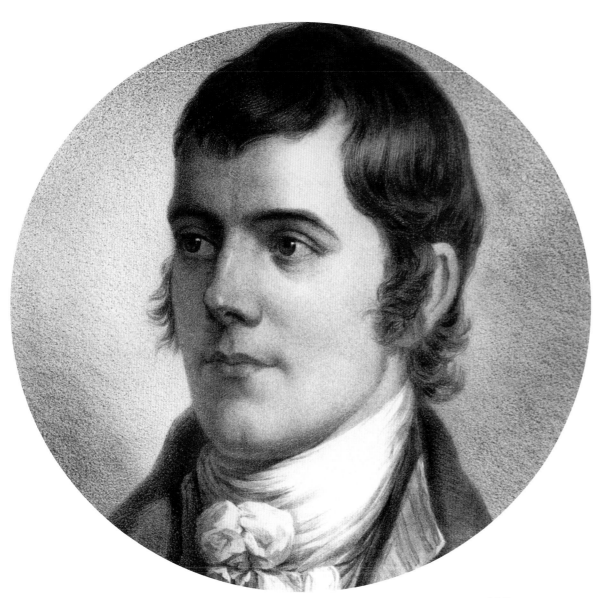

ROBERT BURNS, THE PLOUGHMAN POET

Robert Burns is Scotland's national poet, one of the world's finest lyric poets and a man so in tune with the feelings and aspirations of his fellow men that, more than 200 years after his death, he is revered all over the world. His birthday, 25 January, is kept as a special day of celebration by Scots and non-Scots everywhere.

Although Burns's admirers may find relics and reminders of him in many parts of Scotland, particularly along the routes of his two great tours through Scotland, one of which took him around the Border country in search of Scottish songs and poetry, and another on a 600-mile route through the Highlands of Scotland, it is to south-west Scotland, and Ayrshire and Dumfriesshire in particular, that people come from all over the world to discover for themselves what Robert Burns, often called the Ploughman Poet, was really like.

Among the many places in Ayrshire with which Burns had connections, none is more important than the small village of Alloway, now a suburb of Ayr, where he was born in 1759, the eldest son of a poor farmer, William Burnes and his wife, Agnes. William Burnes himself built the small thatched cottage that was to be his family's home for more than seven years. It still exists, carefully restored and lovingly cared for at the heart of the Burns National Heritage Park in Alloway, a bringing together of all the elements in the Burns connection with Alloway, completed in time for it to be at the centre of the celebrations of Burns's bicentenary in 1996.

OPPOSITE: A portrait of Robert Burns as a young man.

LEFT: The Burns Cottage in Alloway, where the poet was born in 1759.

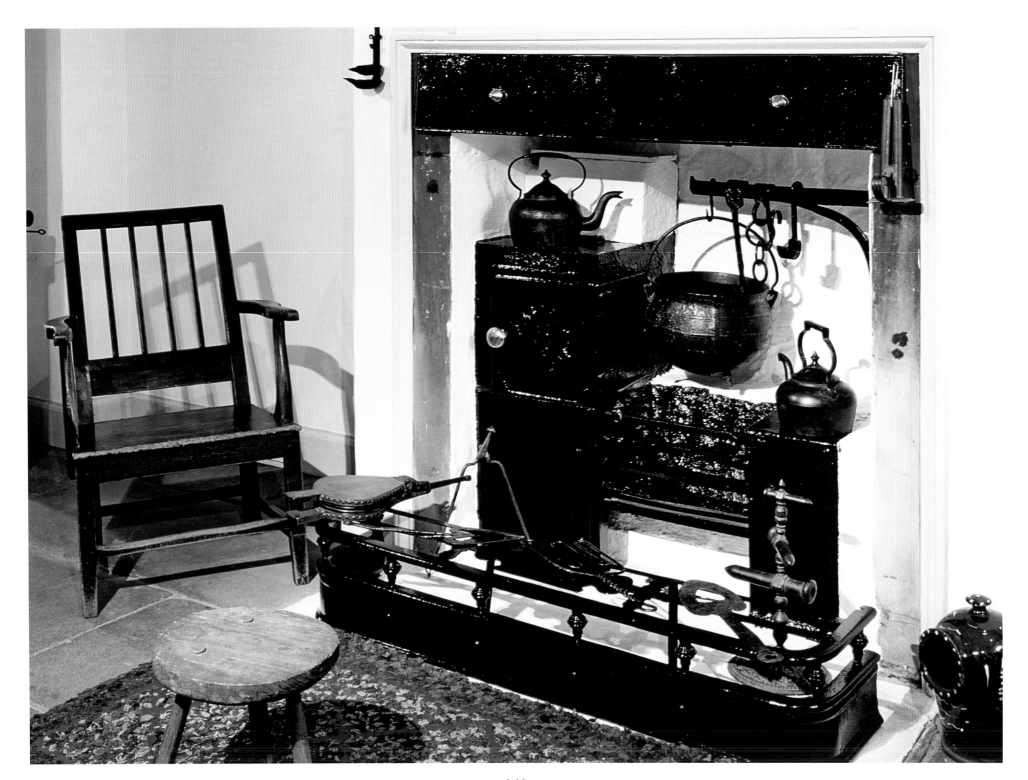

340

Within the Burns National Heritage Park are the Burns Cottage, with a museum containing a treasure-house of relics and memorabilia next door; The Tam o' Shanter Experience, which includes the former Land o' Burns Centre and two audiovisual theatres using multi-media techniques to introduce visitors to Robert Burns and his life, and then to tell the story of Tam o' Shanter, one of Burns's liveliest creations; the Burns Monument, also a small museum, set in fine gardens; and the Auld Brig o' Doon, across which Tam was chased by the witches from the Auld Kirk, and whose ruins are also in the Heritage Park.

In the centre of Ayr itself are other connections with Robert Burns, including the attractive old inn which Burns used as the setting for the convivial evening of merrymaking that nearly caused Tam o' Shanter's downfall.

Other places within a radius of a few miles of Ayr, which Burns knew well, include Tarbolton, the nearest village to Lochlea Farm, the Burns family's second financially unrewarding venture into farming, Kirkoswald, Mauchline, and Irvine. At Tarbolton, Robert Burns and his younger brother, Gilbert, joined together with like-minded friends to form the Bachelors' Club, an agreeable society where they could all come together to discuss important issues of the day, or just to have sociable get-togethers. The club was in a hall, also used for dancing classes which the Burns boys joined, next to an inn which they also frequented. On a more serious note, Robert Burns took his first degrees in Freemasonary at Tarbolton, while the

OPPOSITE: The kitchen of the Burns House in Burns Street, Dumfries, where Burns lived in later life.

LEFT: Portrait of Robert Burns's wife, Jean Armour Burns ('Bonnie Jean'), painted c.1820.

The Brig o' Doon, where Robert Burns set the climax of his roistering tale, Tam o' Shanter. *In Burns's day this was the main bridge over the Doon at Alloway, over which Tam naturally rode his horse at a gallop. Today the bridge is reserved for walkers only.*

Bachelors' Club, in the care of the National Trust for Scotland, is now an important stopping-point on the Burns trail in Ayrshire.

So, too, is a thatched cottage in Kirkoswald, also in the care of the National Trust for Scotland. This is Souter Johnnie's Cottage, called after the souter (or cobbler) who was Tam o' Shanter's crony. Burns based Souter Johnnie on his friend John Davidson, who lived in the Kirkoswald cottage.

The other main centre of interest for followers of Robert Burns lies in Dumfries, where the poet spent the last years of his life from 1788 until his death in 1796, while working as an excise officer. His work took him to many of the towns of Dumfries & Galloway, so that all over this attractive part of south-western Scotland are places where, often unexpectedly, can be discovered reminders of the poet.

The most evocative of the Dumfries connections with Robert Burns are the house in in which he lived with his wife, Jean Armour, and their children, and the Globe Inn, Burns's favourite howff (haunt), where visitors may see the chair he usually occupied.

These are more appropriate places to try to recall the real Robert Burns than, say, his mausoleum in the churchyard at Dumfries, for Robert Burns was a man who loved life and good fellowship, and who believed that:

> *'For a' that, an' a' that,*
> *It's coming yet for a' that,*
> *That man to man the world o'er*
> *Shall brother be for a' that.'*

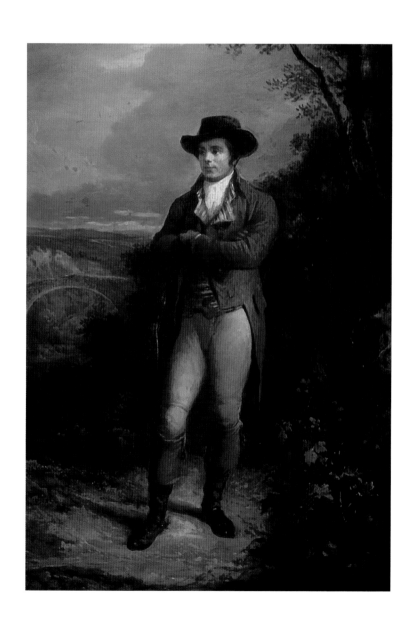

O, my luve's like a red, red rose
That's newly sprung in June
O, my luve's like the melodie
That's sweetly play'd in tune

As fair art thou, my bonie lass
So deep in luve am I
And I will luve thee still, my Dear
Till a' the seas gang dry

Till a' the seas gang dry, my Dear
And the rocks melt wi' the sun!
O I will luve thee still, my Dear
While the sands o' life shall run

Robert Burns

Alexander Nasmyth's famous portrait of Robert Burns was painted from life while the poet was living in Edinburgh from 1786–87.

CHAPTER SIX
SCOTLAND'S ISLANDS

RIGHT: Brodick Castle on Arran, an island in the Firth of Clyde, the site of which has been occupied by a stronghold of one kind or another since the fifth century. Parts of the present castle date from 1588, from the time of the 2nd Earl of Arran, who was heir presumptive to the throne after the accession of Mary Stuart in 1542 and was appointed her governor and tutor.

OPPOSITE: The ruined Lochranza Castle occupies one of the most spectacular settings on Arran. It is possibly a 16th-century reconstruction of an earlier building on the same site.

Scotland's many islands lie in the Atlantic Ocean, strung along the western coast and above the northern coast, stretching far up into the subarctic waters where the Atlantic meets the Norwegian Sea. In contrast, Scotland's eastern coast has virtually no islands at all.

Modern transport means that the islands, even remote St. Kilda, are not as isolated from mainland Scotland as once they were. Efficient car-ferry and shipping services link the islands with the mainland and with each other, though some of the smaller and more remote ferry links operate only in the summer, and airfields and runways, large and small, are scattered throughout the islands. The North Sea oil industry has, of course, brought very sophisticated helicopter and aeroplane services to Shetland and Orkney as well as to the mainland.

Sometimes 'progress' is not always universally welcomed. The large Inner Hebridean island of Skye got a bridge to replace the centuries-old Kyle of Lochalsh-Kyleakin ferry in 1995. Many people protested, partly because the tolls charged for all wheeled traffic using the bridge were the highest in Europe, and partly because the bridge was seen as destroying the independence of an island which Dr. Samuel Johnson, visiting it with James Boswell in the late 18th century, thought the finest of all the Scottish islands he had seen and which, more recently, the Gaelic poet Sorley Maclean described as 'the great beautiful bird of Scotland'. For a time, stories resembling an Ealing Comedy

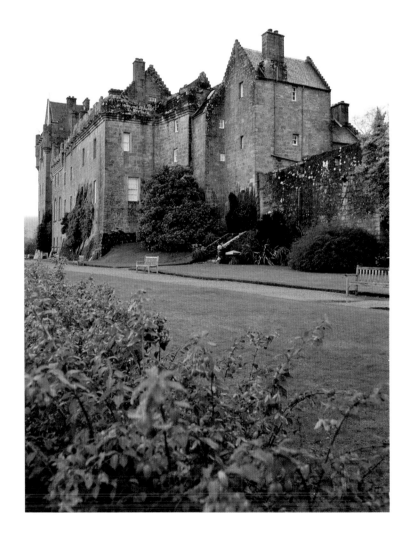

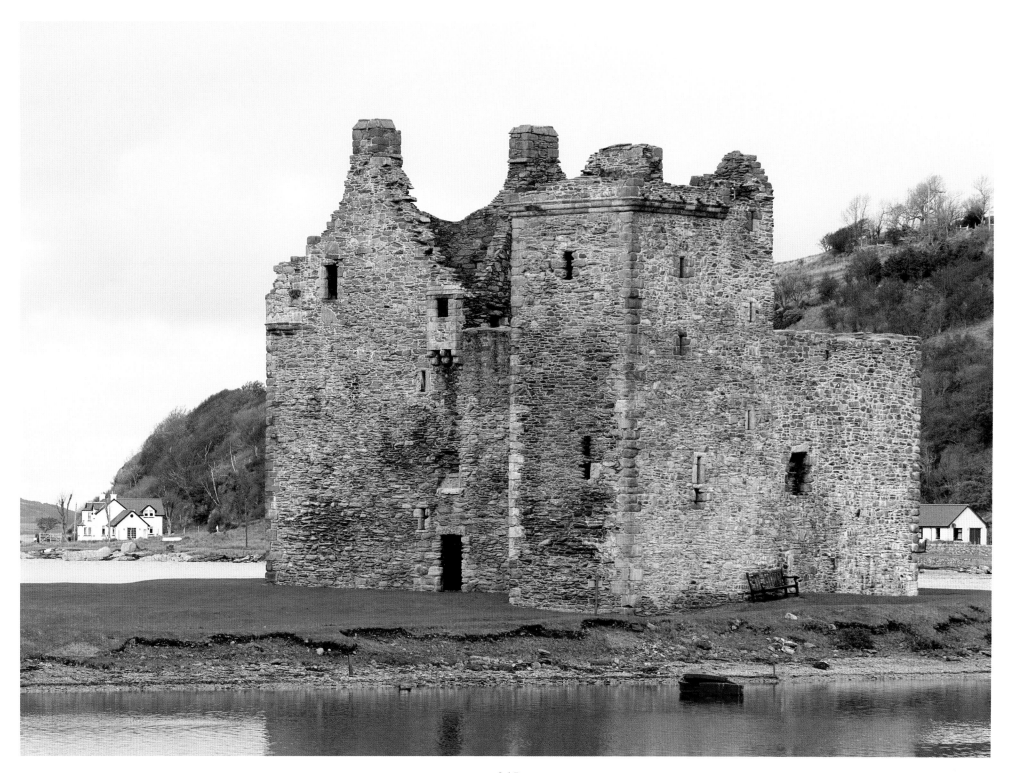

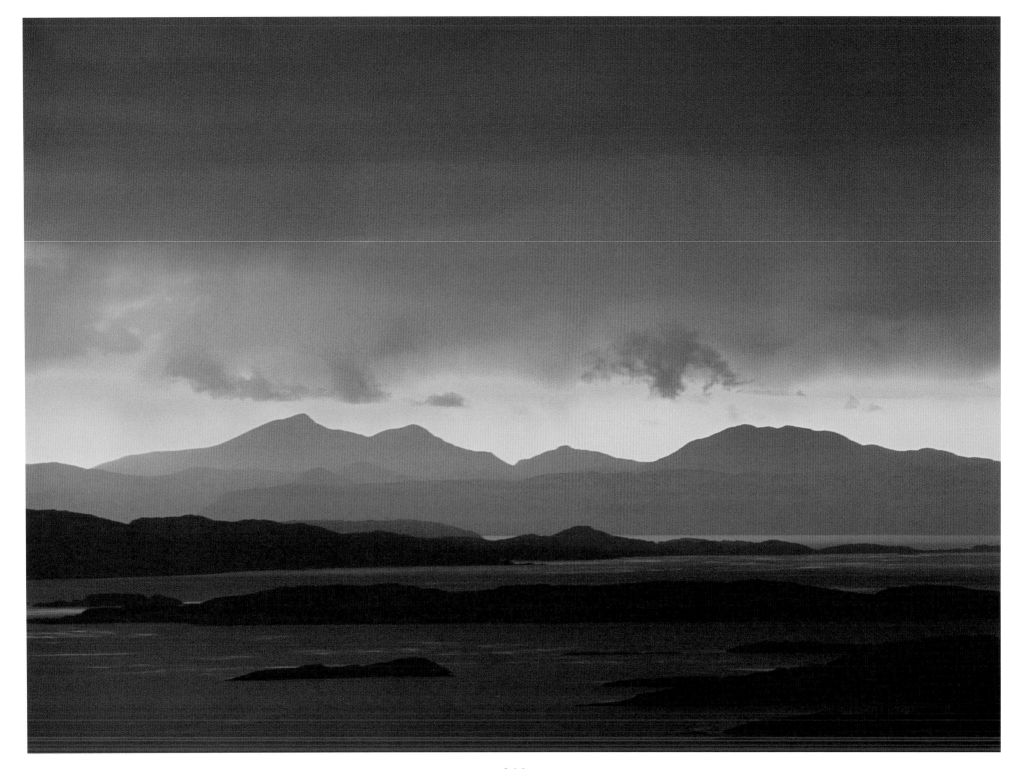

(*Whisky Galore*, perhaps, in which the residents of a small island win out against the rules and regulations of officialdom) filtered out from Skye and into the national press; lorryloads of sheep, readers of *The Times* were told, were being unloaded on one side of the bridge, driven across on foot, and reloaded onto another lorry on the other side, thus neatly avoiding the tolls.

The attitude of the residents of Skye to the new bridge is typical of the independence of the people who live on Scotland's islands, in not everyone there regards themselves as automatically belonging to Scotland; it's not unusual to hear people in Lewis in the Outer Hebrides, for instance, refer to the mainland not as the mainland but as Scotland, as if it were another country.

Scotland's islands fall into five well-defined groups, with other islands scattered among them. Stretches of often stormy seas, ranging from the large – the Pentland Firth, the North Minch and Little Minch – to the small, like the Sound of Sleat, where the winter gales were often strong enough to stop the Skye ferry and may well close the new bridge, separate them from each other and from the mainland.

Lying quite close to the mainland, in a string some 150-miles-long, are the Inner Hebrides. The large island, Skye, which has the islands of Rona, Raasay and Scalpay lying off its eastern coast, is the northernmost of the Inner Hebrides and Islay, off the Kintyre Peninsula, and the source of some of Scotland's finest malt whiskies, is the most southerly. Between these two are one more

large island, Mull, with its attendant islands of Staffa and Iona, and numerous smaller islands including the splendidly named Canna, Rhum, Eigg, Muck, Coll and Tiree. To the north of Islay lie Jura and Colonsay.

To the south of the Inner Hebrides, another group of islands, including Arran, Bute and Cumbrae, lie in the comparative quiet of the Clyde estuary and have been included in this book in the chapter on Scotland's south-west, which includes Glasgow and the Clyde.

Reaching further out into the stormy waters of the North Atlantic are the Outer Hebrides, or Western Isles. These wind-swept islands stretch for 130 miles (210km) from the Butt of Lewis, at the top of the most northerly island, Lewis, to Barra Head on the southern tip of Barra. The islands in the group are Lewis and Harris, which together make up Britain's largest offshore island in the north, North Uist, Benbecula and South Uist, which are linked by a causeway, and Barra (the island on which *Whisky Galore* was filmed in 1948). The only big town in the Outer Hebrides is Stornoway, on the east coast of Lewis.

As in the Inner Hebrides, there are numerous smaller islands, islets and barren reefs off the larger islands in the Western Isles. Among the most memory-charged of them is tiny Eriskay, a short ferry ride from the southern tip of South Uist. This is the place where Bonnie Prince Charlie first set foot in Scotland in 1745; it is also the island on which the whisky-laden SS *Politician* went

OPPOSITE: Looking north from above Crinan over the upper reaches of the Sound of Jura towards the mountains of Mull.

PAGE: 348: Seen from the vicinity of Keills, on the north-east coast of Islay, the Paps of Jura are three mountains dominating the south of Jura – also visible from the western coast of Kintyre.

PAGE 349: The Ardbeg Distillery on Islay.

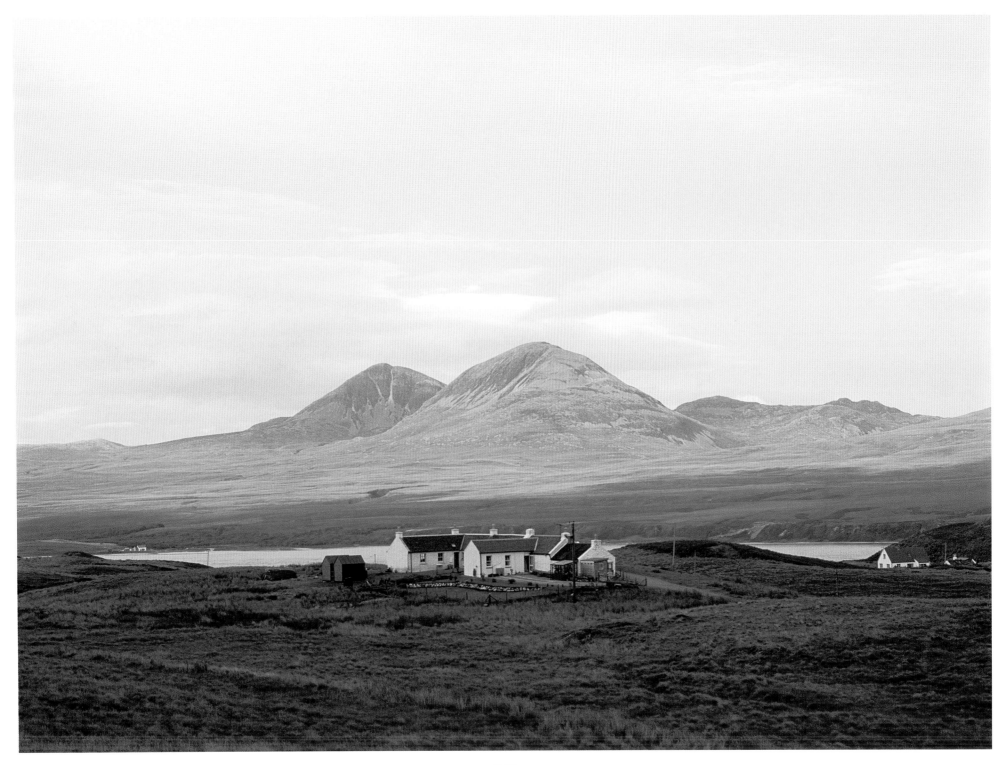

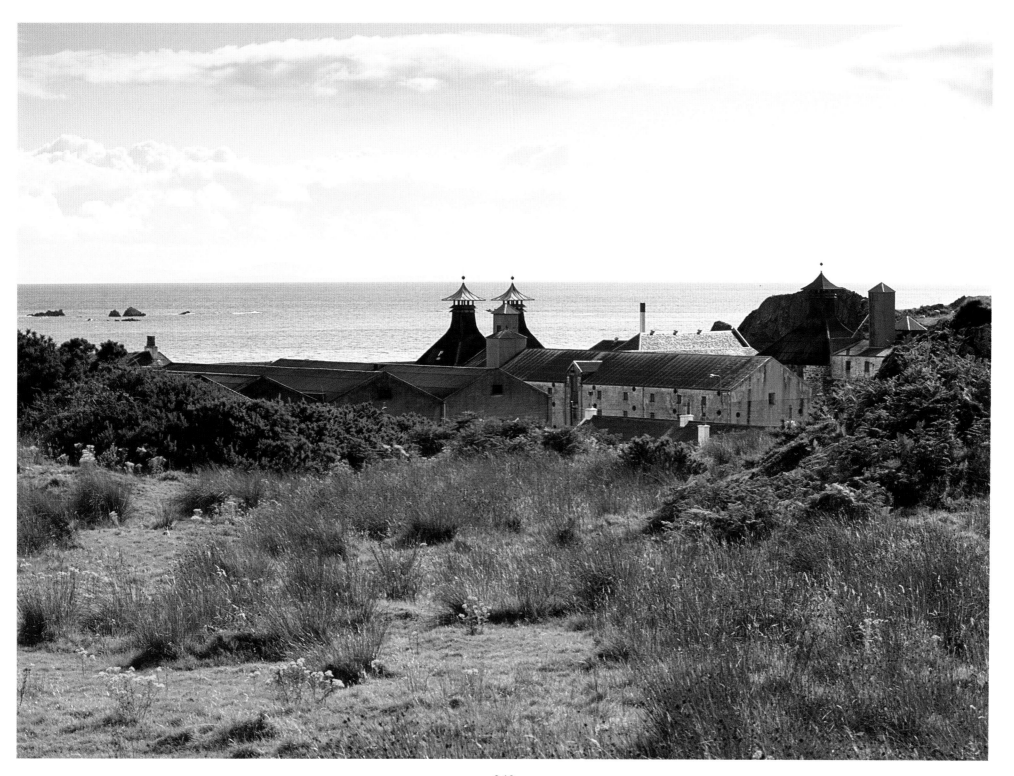

RIGHT: Drying barley on the malting floor at Laphroaig Distillery, Islay.

OPPOSITE: Checking levels in the spirit safes beside the copper stills in Laphroaig.

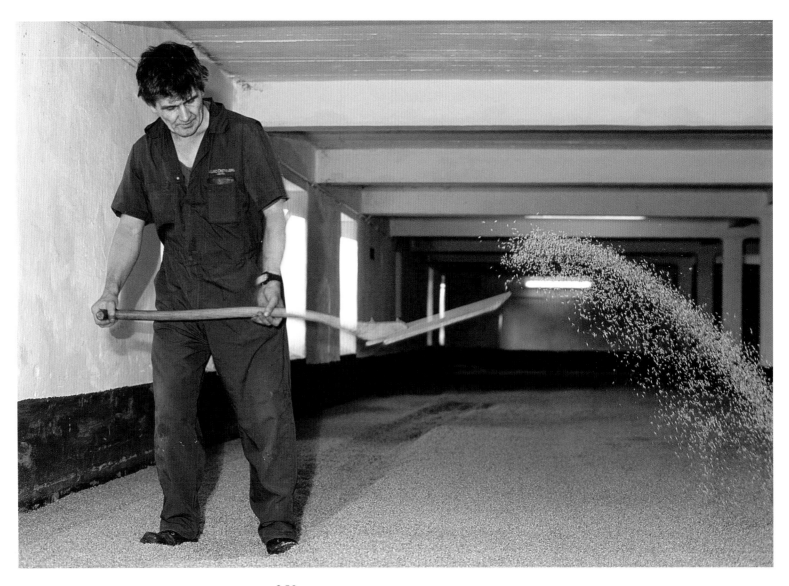

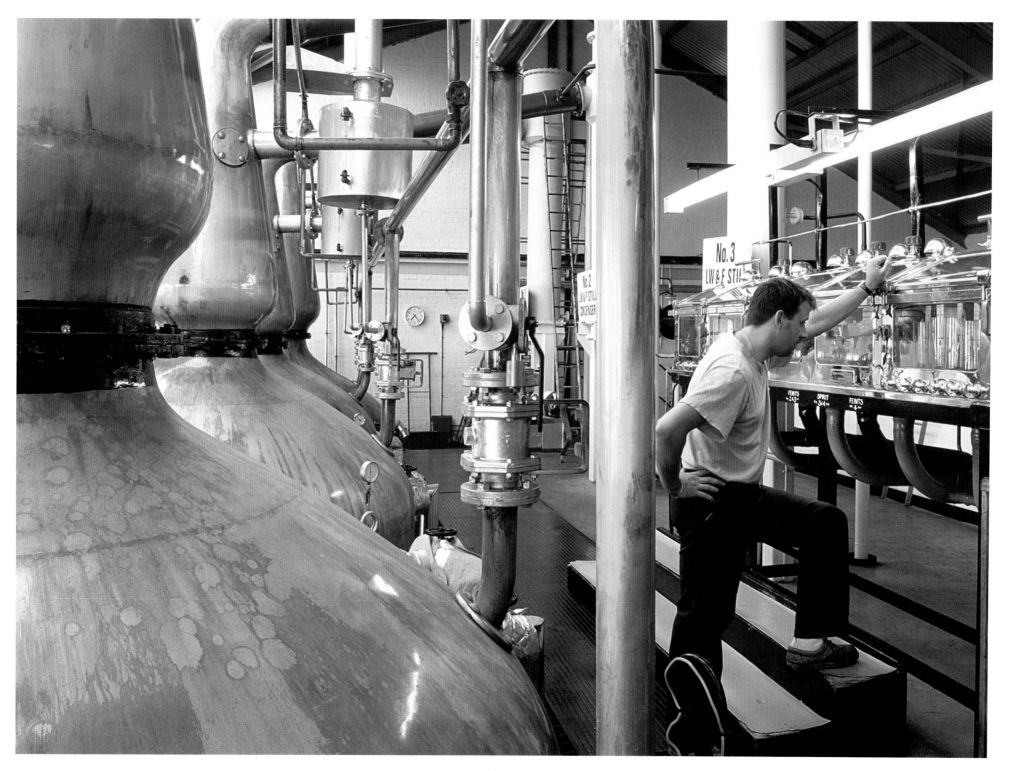

RIGHT: Carved from a single piece of epidiorite in the sixth century, this peerless Celtic Christian cross still stands proudly next to the ruins of Kildalton Church, on Islay, which it pre-dates by at least two centuries.

OPPOSITE: Seen during atrocious weather, the lighthouse Rubha nan Gall guards the end of the Sound of Mull, north of Tobermory on the isle of Mull. It was built in 1857 by the grandfather of Robert Louis Stevenson and became automated in 1960.

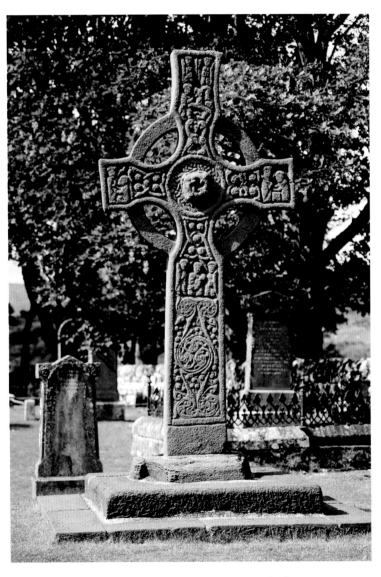

aground a couple of hundred years later, inspiring Compton Mackenzie's novel, *Whisky Galore*. The lovely Gaelic melody, 'The Eriskay Love Lilt', celebrates the romance of Bonnie Prince Charlie rather than Compton Mackenzie's comedy, while in that other well-known song about Bonnie Prince Charlie, 'The Skye Boat Song', the place from which the bonnie boat is speeding over the sea to Skye is Benbecula rather than the Scottish mainland.

Far out in the Atlantic, 45 miles (72km) west of North Uist, lies the St. Kilda group of four islands and numerous islets. The islands' population became so reduced early in the last century that in 1930 the remaining inhabitants on Hirta, the largest island, asked to be evacuated. Today the islands, in the care of the National Trust for Scotland and the Nature Conservancy Council, are largely sanctuaries for birds, accommodating the world's largest colony of gannets.

Orkney and Shetland lie above Scotland's northern coast. The Orkney group is the nearest to the mainland, some six to eight miles north of the coast at John o' Groats and separated from it by the Pentland Firth, in which the island of Stroma offers sanctuary to colonies of seals. There are about 70 islands and islets in the Orkney group, only about a third of them inhabited. Foremost among them is Mainland, with the Orkney capital and main harbour, Kirkwall, at its heart. Other Orkney islands, scattered between South Ronaldsay in the south and North Ronaldsay in the north include Hoy, Flotta, Shapinsay, Stronsay,

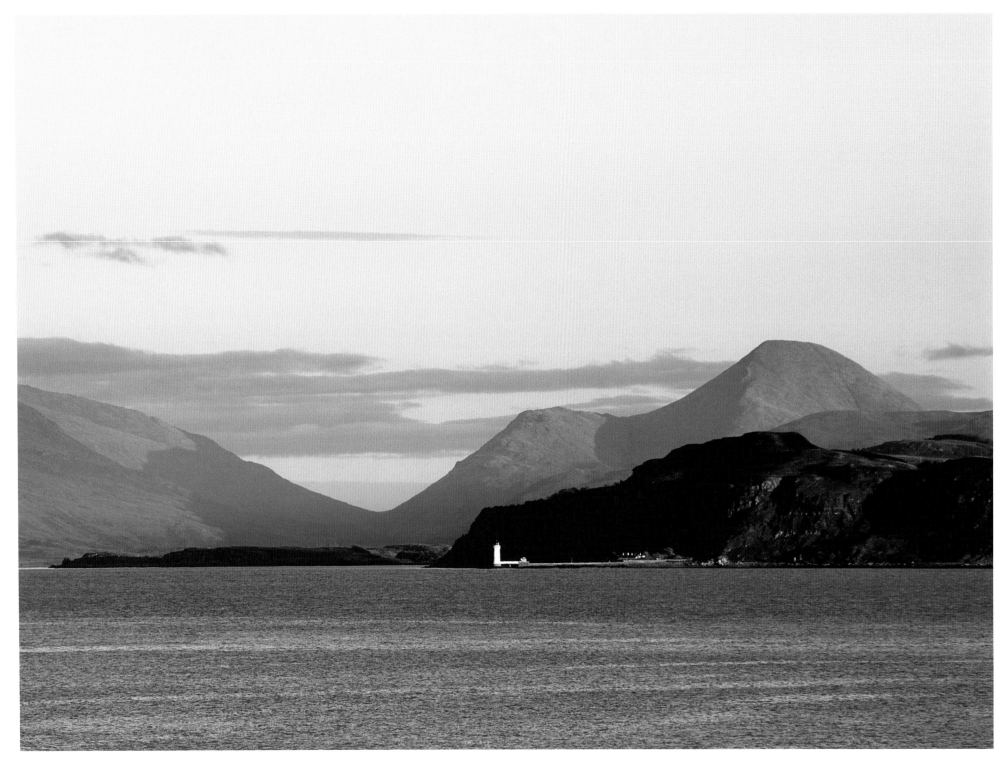

A CELEBRATION OF SCOTLAND

Rousay, Eday, Westray and Sanday. On the whole, the islands of Orkney are low-lying, largely treeless, and not particularly 'scenic', though they more than make up for this by the wealth of prehistoric remains and monuments scattered across them.

Sixty miles (96km) of often rough sea separate Orkney from Shetland, with Fair Isle, one of the Shetland islands famed for its bird sanctuaries and knitting patterns, lying between the two groups.

Shetland has an even higher ratio of uninhabited to inhabited islands than Orkney, with only 12 of its 100 or so islands having people living on them, as distinct from 'just visiting'. It has often been remarked that the main difference between the peoples of Orkney and Shetland is that the Orcadian is a farmer with a boat, while the Shetlander is a fisherman with a croft. While the advent of North Sea oil has obviously brought changes in Shetland's way of life, it should not be forgotten that its centuries-old position at a crossroads of the seas north of Britain has meant that it has always been a more cosmopolitan place than mainlanders might think.

The biggest island in Shetland is Mainland, some 50 miles (80km) long and with a coast so indented that its width varies from about 20 miles to a mere few yards. On Mainland are Shetland's capital, Lerwick, and the great North Sea oil terminal of Sullom Voe. Other islands in the Shetland group are Foula in the west, Whalsay, Out Skerries and Bressay off the eastern coast

of Mainland, and Unst, Yell and Fetlar to the north-east. High cliffs and fjords (called 'voes' here) give much of Shetland's coasts a rugged excitement, while away from the shores much of the land is peat upland dotted with lochs. Even this far north, in the same latitude as southern Greenland, the Gulf Stream influences the climate of Shetland, making frost infrequent and allowing snow to lie for an average of only 15 days in winter: the blizzards of Christmas 1995, which hit Shetland with great severity, may not have raised this average much, for it was 45 years since Shetland had experienced weather so severe.

The reasons why Scotland's islands fall into such a predominantly west and north pattern lie far back in prehistory. Some 250 million years ago, when Britain and Ireland were being formed out of the stretching and breaking-apart of the huge landmass which eventually broke away to form North America, Greenland and Europe, the land which became Britain began to fracture along its north-western edge into what became, after 200 million years or so, a series of blocks of rock, some higher than others. The broken pattern of the land was then fractured still further by the actions of many volcanoes, sited in the sea near the island of Lewis and on St. Kilda, Skye, Rhum, Mull and Arran; the ruined shapes of these volcanoes make up most of the landmass of the smaller islands today, while the jagged peaks of the Cuillins on Skye are reminders of volcanic action in the distant past.

OPPOSITE: Looking south down the Sound of Mull past Rubha nan Gall lighthouse towards Ben More, at the heart of the isle of Mull.

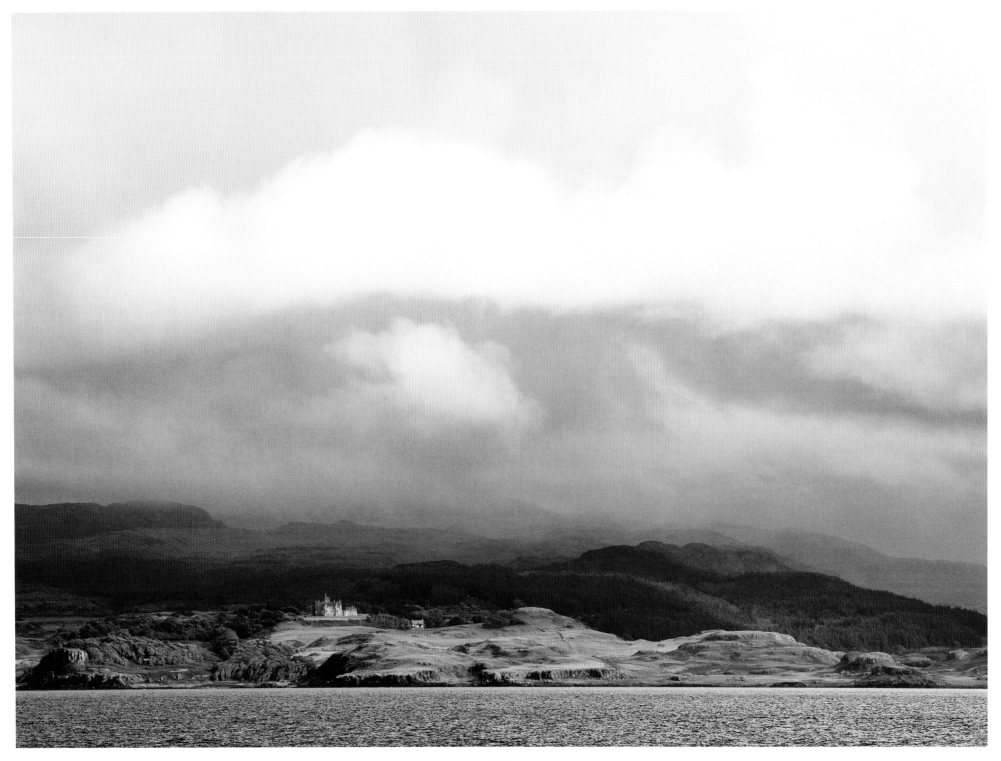

OPPOSITE: A rainstorm begins to clear over the Mishnish hills behind Glengorm Castle on the Isle of Mull.

LEFT: Five prehistoric standing stones in a forest glade near Dervaig, on Mull.

PAGE 358: The view south-east over Loch Frisa on the Isle of Mull.

PAGE 359: The mountains of Ardnamurchan rise beyond the Sound of Mull and Salen Bay on Mull.

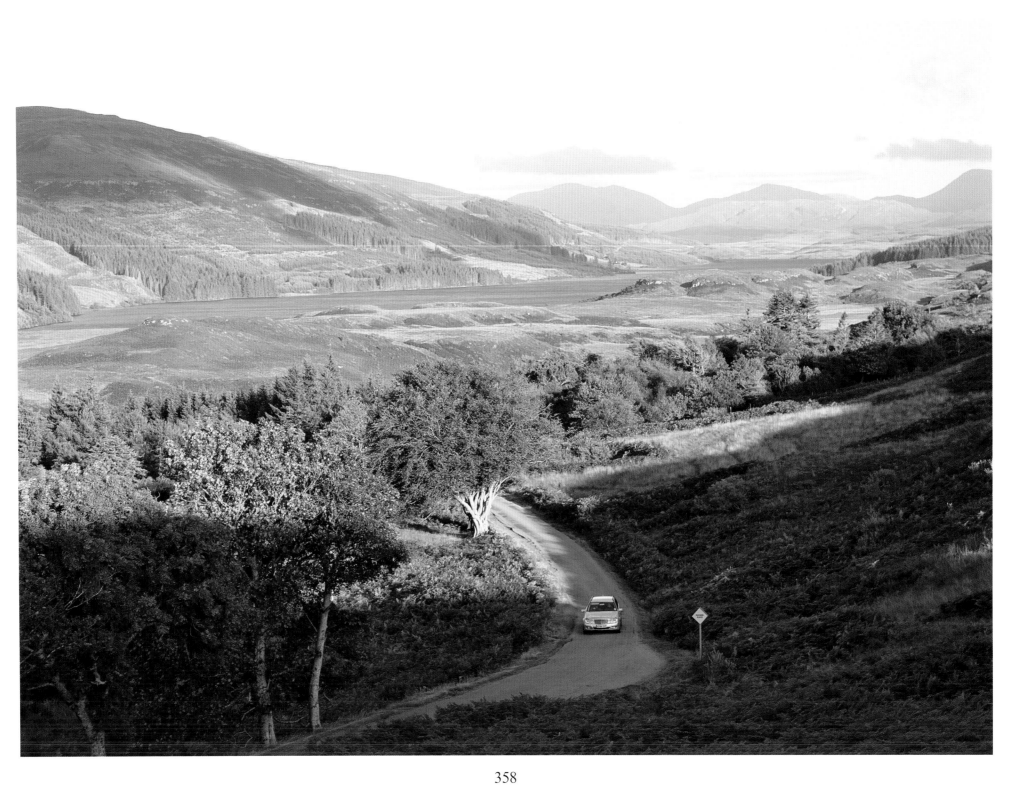

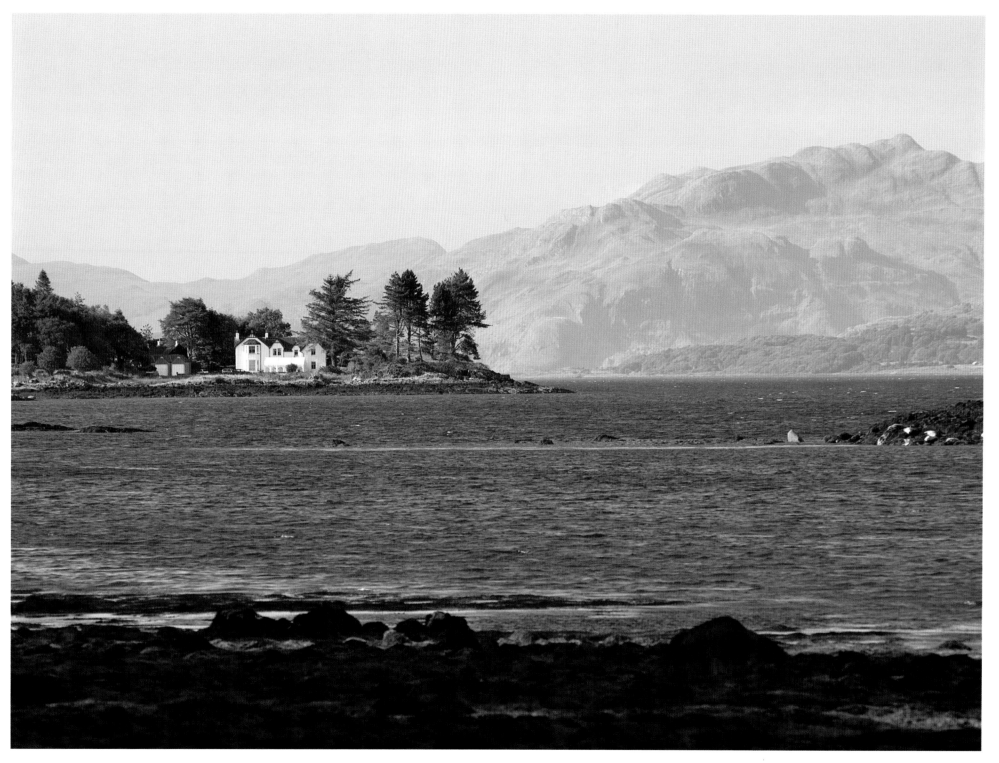

While it is necessary to have a geologist's trained eye to see signs of how Scotland's islands were formed, it is much easier to detect evidence of the peoples living here now that the volcanic activity and land shifts have quietened down. (They haven't ceased: the North Atlantic is still increasing in width by a few centimetres every year.) Scattered through Scotland's islands, especially in Shetland, Orkney and the Outer Hebrides, are many remains of people from the Stone, Bronze and Iron Ages.

North Uist, near Lochmaddy, has the finest chambered cairn in the Hebrides. Called Barpa Langass, the great pile of stones was built on the side of Ben Langass by the Beaker people of the Bronze Age and include a tunnel leading into a communal burial chamber.

Lewis, also in the Outer Hebrides, has, in the impressive Standing Stones of Callanish, a monument unique in Scotland and equalled in the rest of Britain only by Stonehenge on Salisbury Plain. It was only in the middle of the 19th century that archeologists, digging away the deep layer of peat that had built up around the stones on this ritual site, discovered just how tall they had been when they were set up in a cross-pattern fashion in around 1500 BC. The tallest megalith at Callanish is more than 15ft (4.6m) high. It was set up beside a cairn in the centre of a circle of 13 stones, the circle itself being approached by an avenue of 19 further stones.

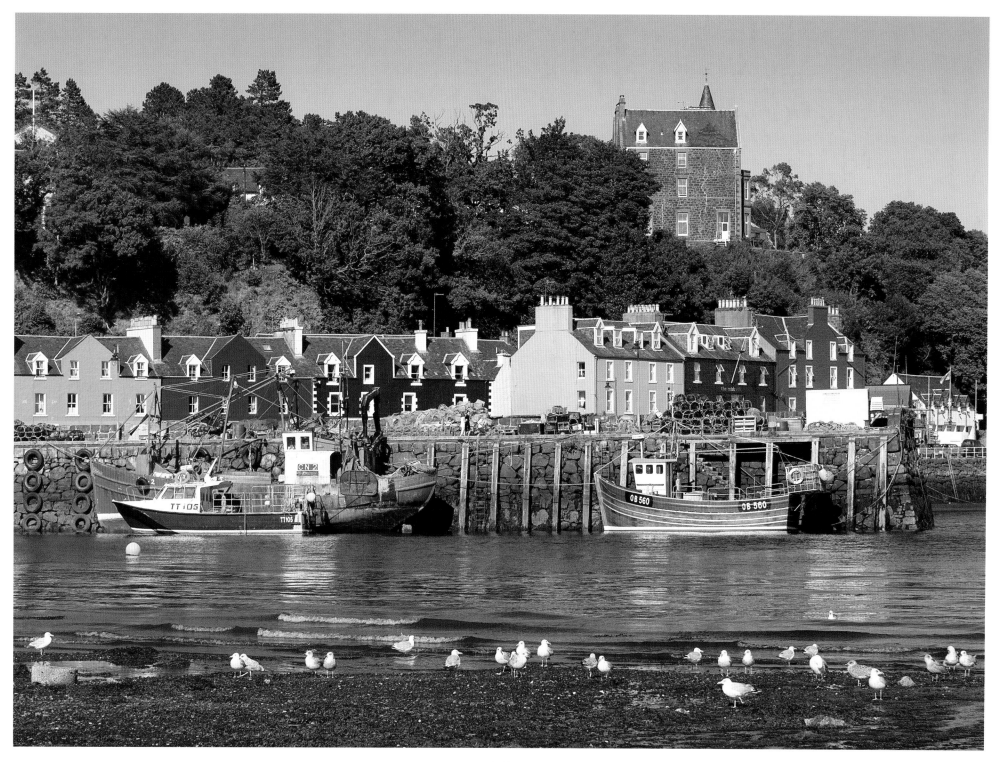

FAR RIGHT: At the Tobermory single malt whisky distillery.

BELOW: Mash man Colin Armour making gravity checks on the washback.

OPPOSITE: The still room.

North of the Standing Stones of Callanish, south of Loch Carloway, is Dun Carloway, a well-preserved broch, or Iron Age defensive round tower. There is enough of it left to give a good idea of the size and style of these buildings, unique to Scotland. Archeologists have identified the sites of about 500 brochs in Scotland, the best preserved of all being the one on Mousa, a small island off Shetland's Mainland. It is only a short boat trip

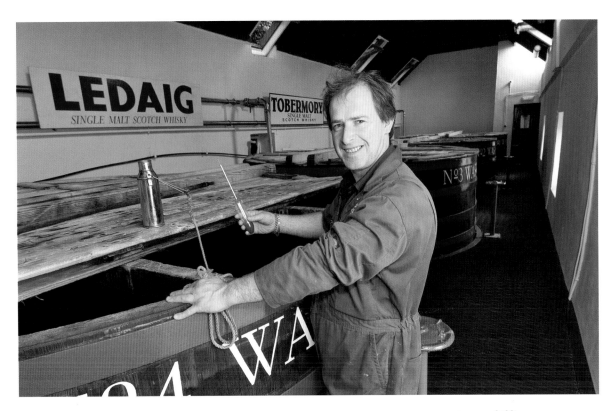

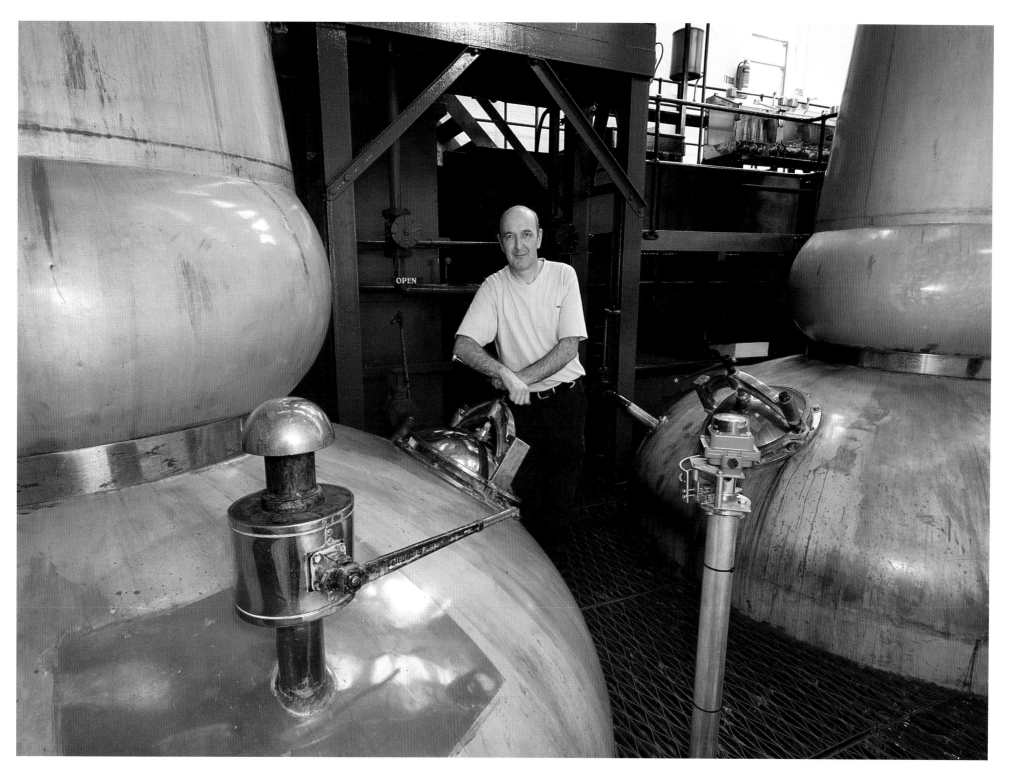

BELOW: An early Celtic Christian pillar carving on Iona.

FAR RIGHT & OPPOSITE: Iona Abbey, the most elaborate and best-preserved ecclesiastical building surviving from medieval times in the Western Isles.

from the pier at Leebotten, on the road to Sumburgh Head and Shetland's main airport, to Mousa, but the feeling that they have travelled far back in time is strong for many as they gaze upon the Mousa broch, standing nearly 50ft (15m) tall on the edge of the sea. Mousa shows very well the broch's unique double-walled construction, tapering in thickness from 12 to 7ft (3.6 to 2.1m). Mousa still has galleries and stairways inside and it is possible to

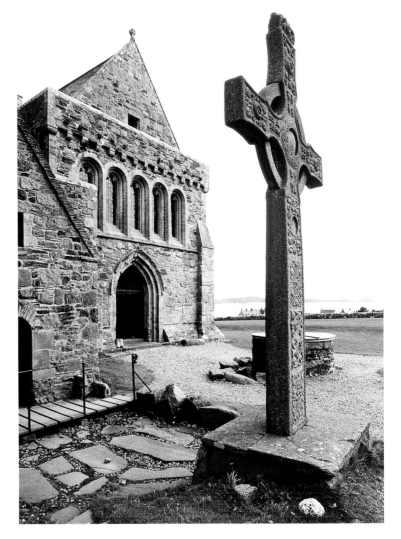

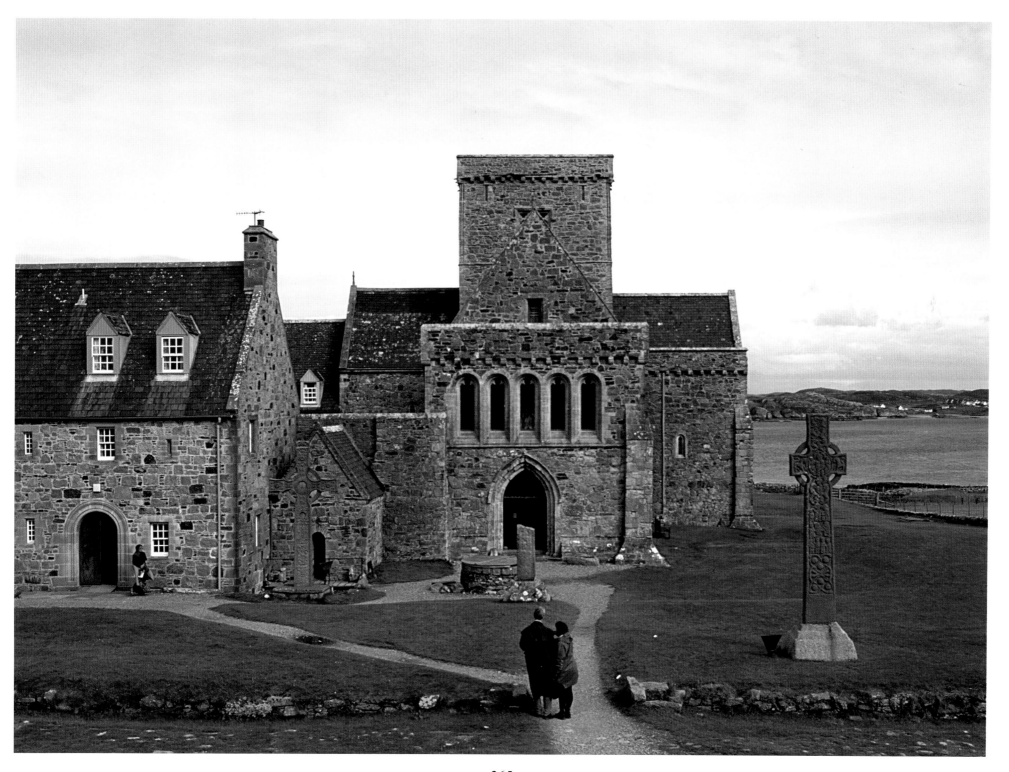

BELOW & FAR RIGHT: The volcanic basalt columns of Fingal's Cave on the isle of Staffa in the Inner Hebrides. Felix Mendelssohn, a German composer of the early Romantic period, was inspired to write the famous concert overture, The Hebrides (Fingal's Cave)*, in 1830, after visits made by him to Scotland around the end of the 1820s.*

OPPOSITE: Staffa's basalt columns can be clearly seen from the sea. The entrance to Fingal's Cave is on the right.

PAGE 368: The island of Eigg in the Inner Hebrides, seen from the Sound of Sleat.

PAGE 369: Castle Moil at Kyleakin, on the isle of Skye, looking east across Loch Alsh and the Scottish Highlands.

walk around the top, looking out to sea and across to Mainland in the same way that Picts and Norsemen would have done so many centuries ago.

Shetland has an even more important archeological site at Jarlshof, only a short distance from the southern end of Sumburgh Airport's main runway. The site is, in fact, inappropriately named; it was Sir Walter Scott's idea, looking for something romantic to put in one of his novels, to give a Norse name to this site, even though it dates from the Bronze Age and would seem to have been occupied by different peoples over a period of 3,000 years.

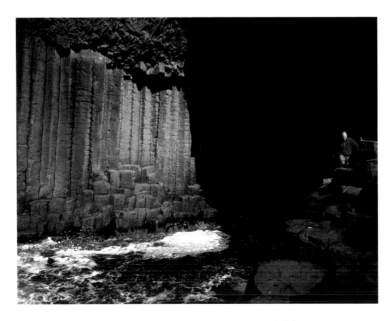

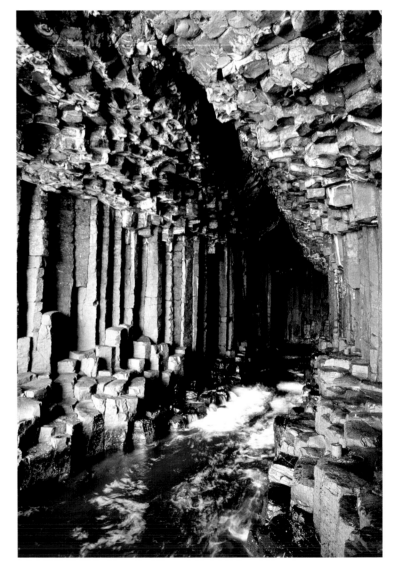

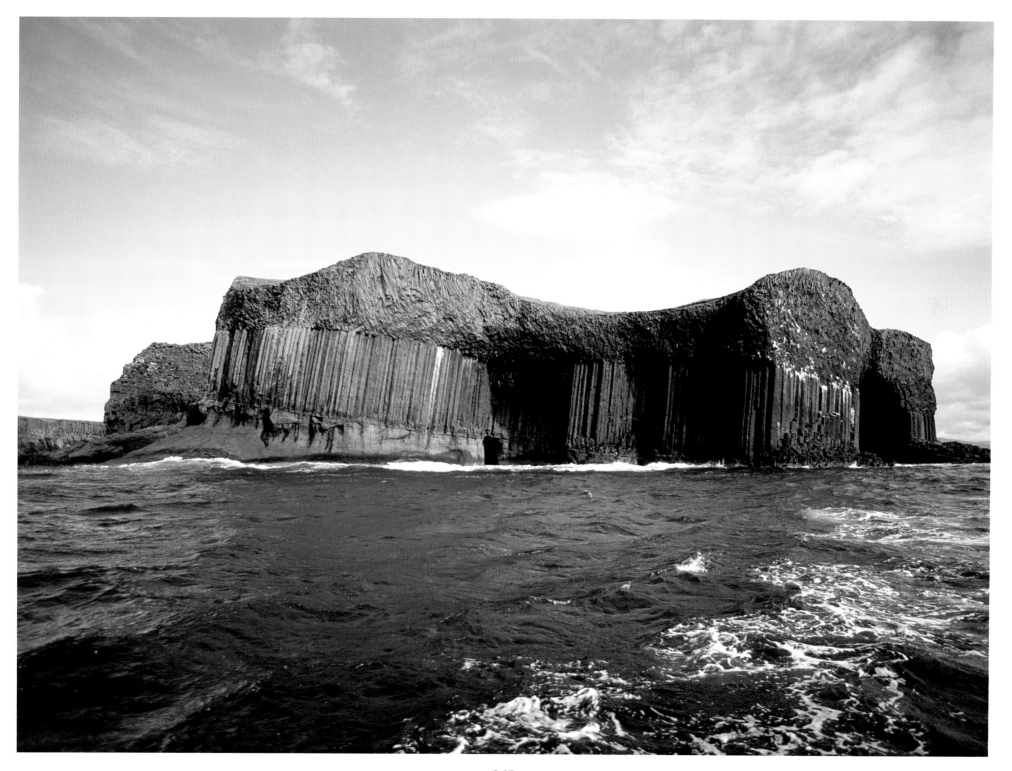

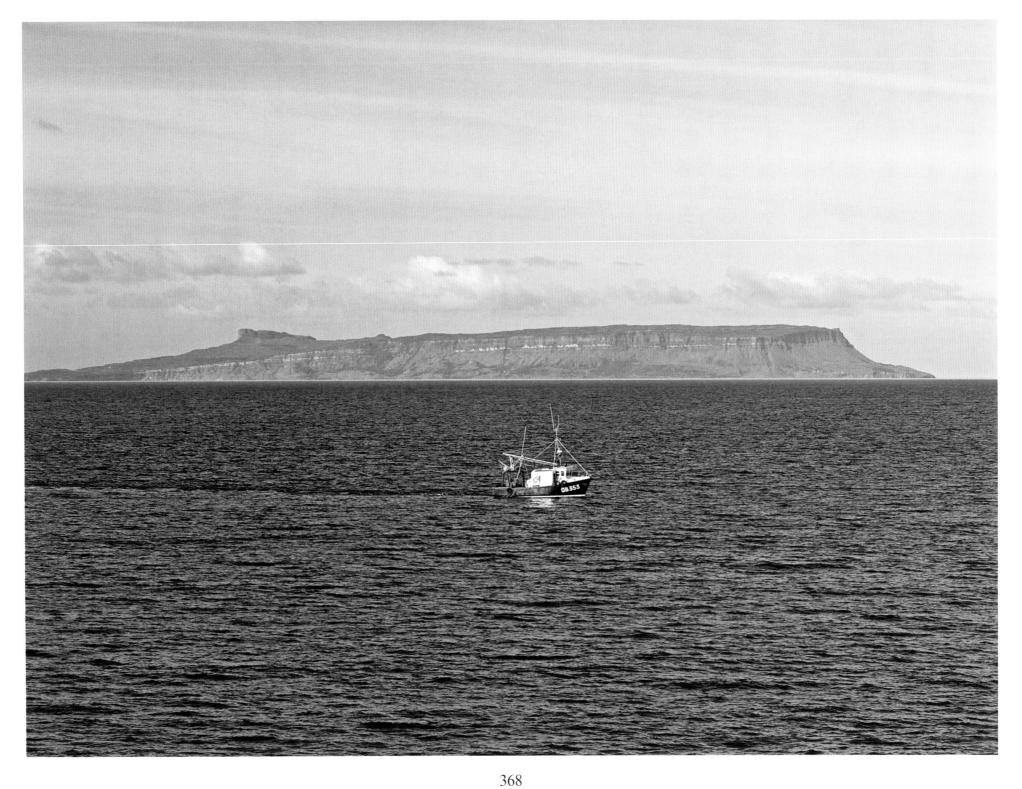

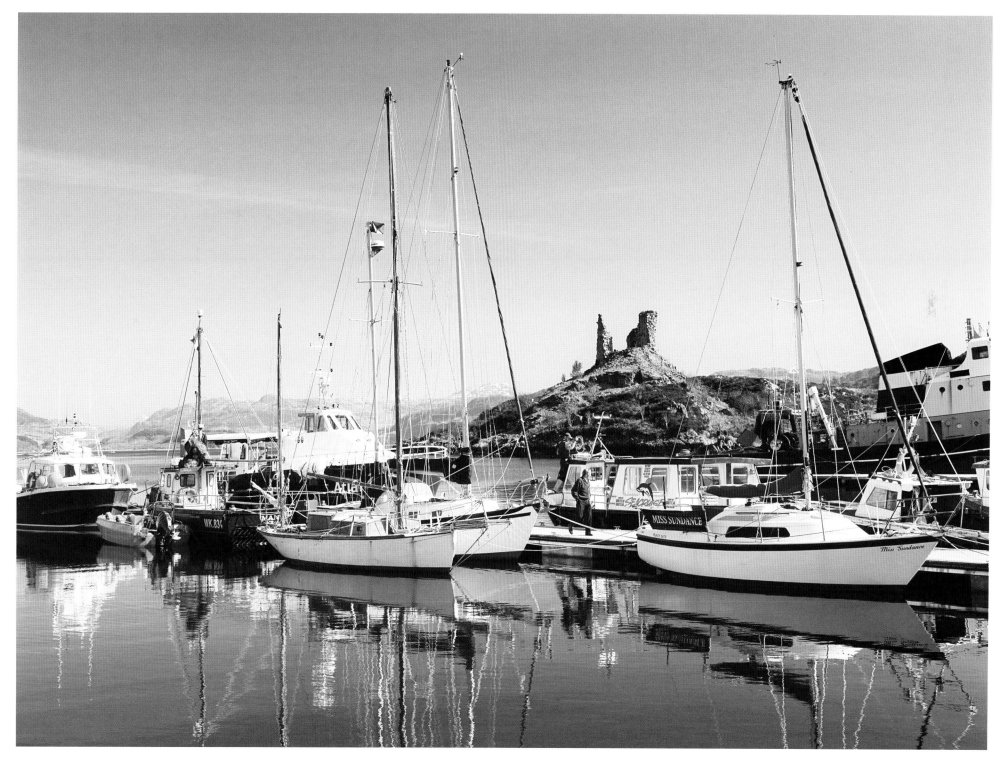

RIGHT: A sheep grazing on the shore of Loch Ainort, on Skye, looking west towards Beinn Dearg Mhor (left) and Glamaig mountain (distant right).

OPPOSITE: The view across the mouth of Loch Sligachan on the north of Skye, looking northwards to the Trotternish peninsula.

PAGE 372: The old stone bridge over the River Sligachan at Sligachan, looking towards the Cuillin Hills, Skye.

PAGE 373: Dun Beag Broch, an Iron Age fort near Bracadale on the isle of Skye. The cavity wall stairway is typical of a Scottish broch.

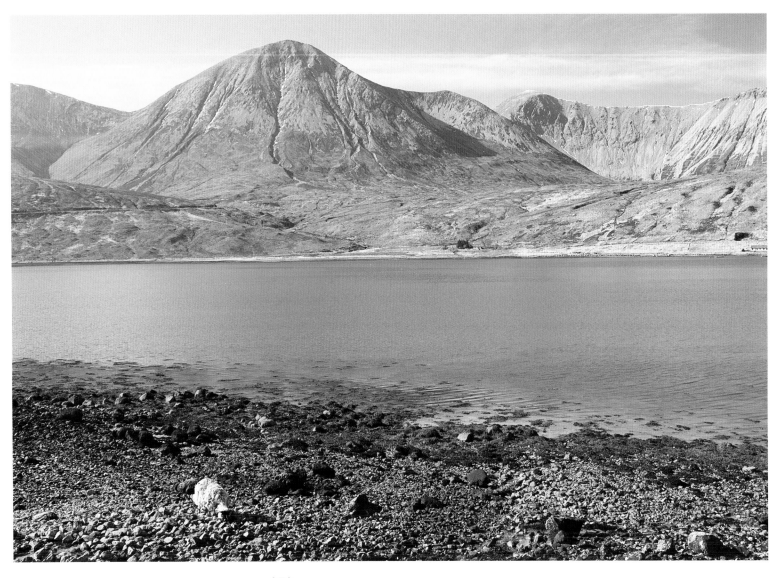

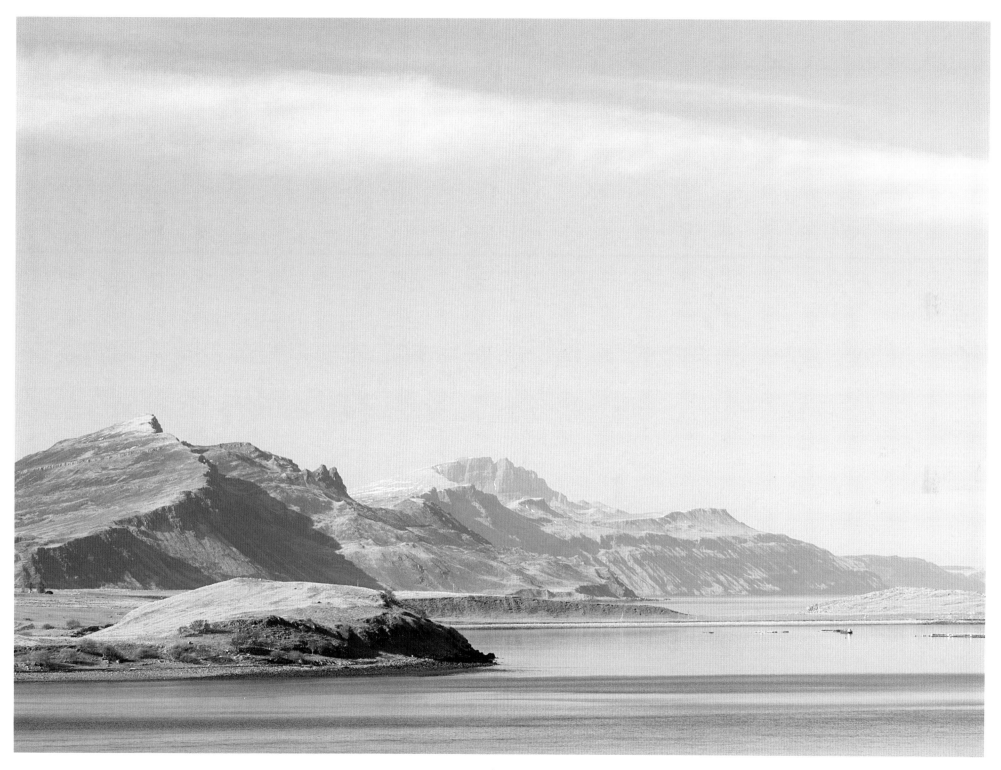

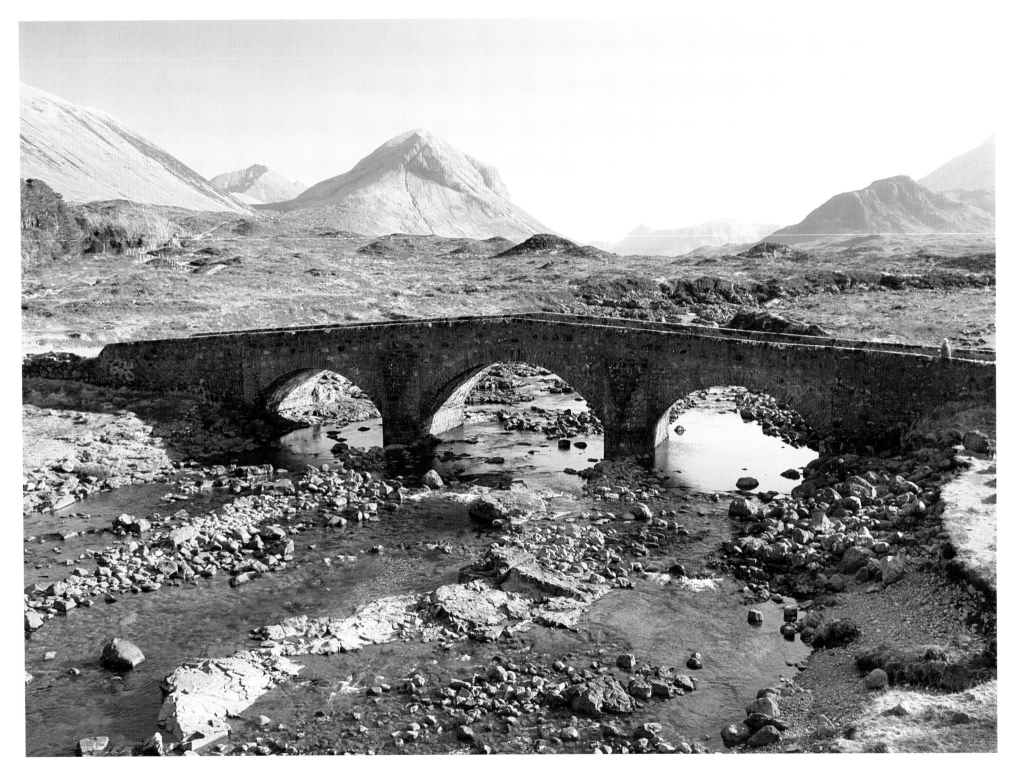

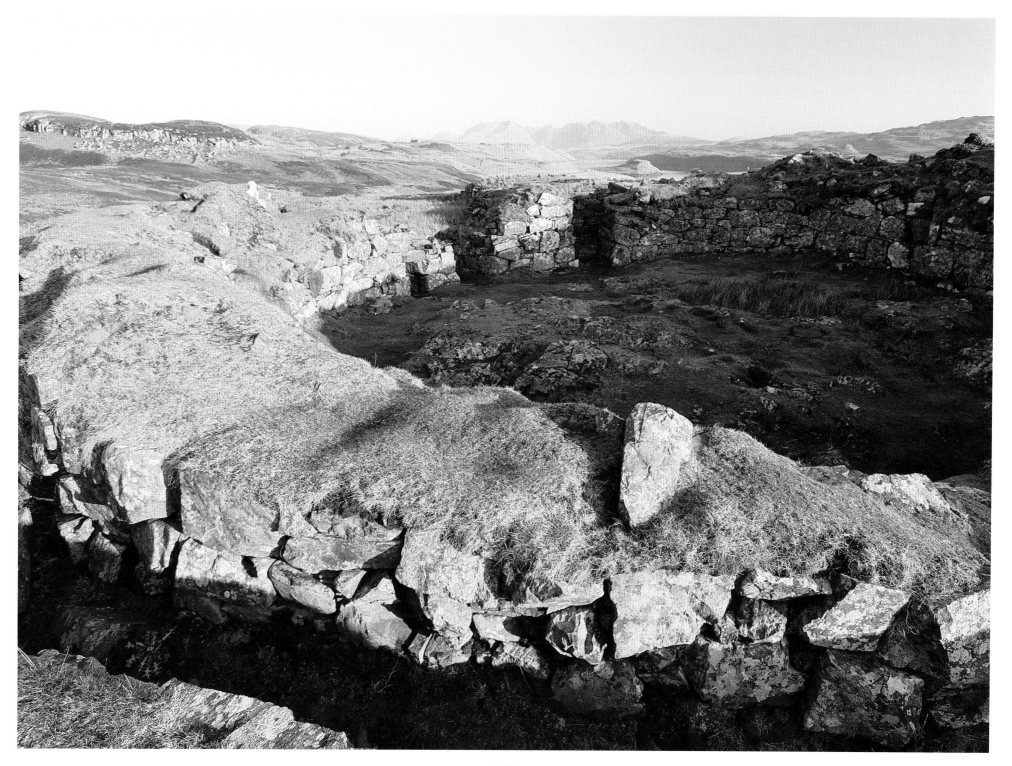

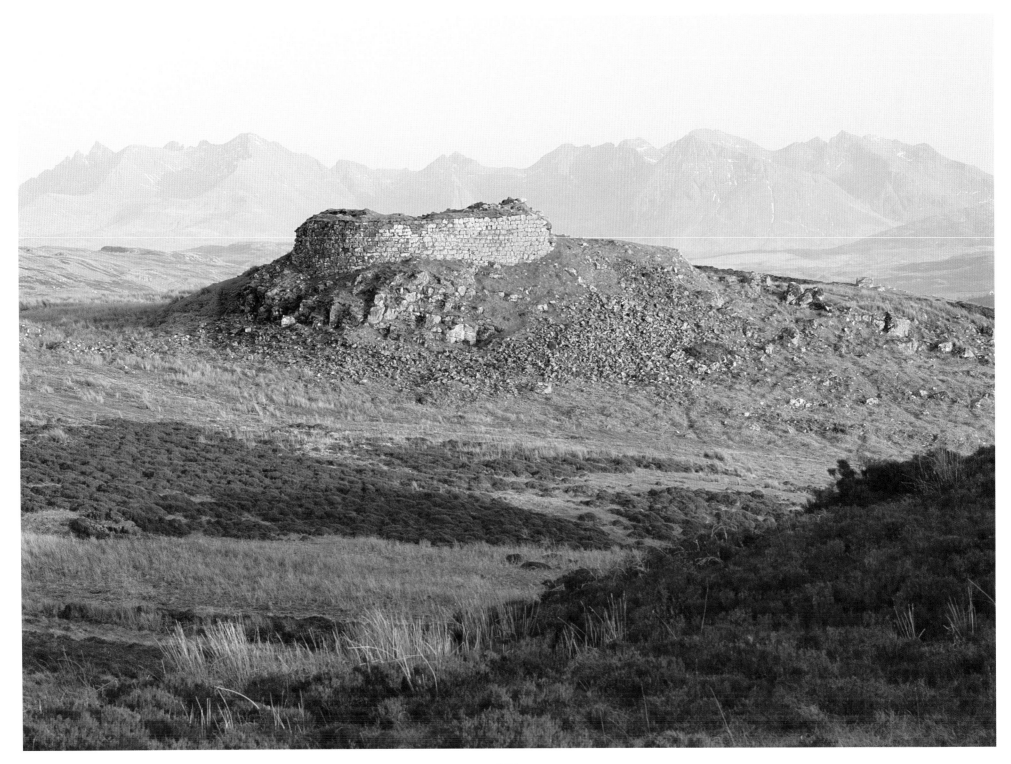

Jarlshof is spread over a 3-acre (1.2-hectare) area of green headland, with fine views over a bay edged with a sandy beach. Archeologists have uncovered in this relatively small area relics of the Bronze and Iron Ages, including Norse dwellings and even a Pictish cattle stall. The ovals of stone huts were preserved in the sand, as were many pieces of neolithic pottery, stone and bone implements, bronze swords and axes. Evidence has been uncovered to suggest that the northern Picts occupied the site, while the remains of the Norse settlement which grew up here between the nineth and 14th centuries are among the most complete found so far in Britain. No wonder archeologists, including those working for government departments, consider Jarlshof one of Britain's most important sites.

Orkney, too, has many important prehistoric remains. Indeed, it is not necessary to drive too far out of Stromness, once a major northern Scottish port and today the ferry terminal on the west coast of Mainland, to find reminders of the presence of man from the Stone Age to the early Christian era in Britain – that is, some 4,000 years of occupation – scattered over the land. The country around Loch of Stenness is particularly rich in prehistoric remains, including chambered cairns and stone circles. The great cairn of Maes Howe, generally considered to be the finest chambered tomb surviving in Europe, and thought to have been built for a line of chiefs in about 1500 BC, is quite close to the main road between Kirkwall and Stromness, and has been

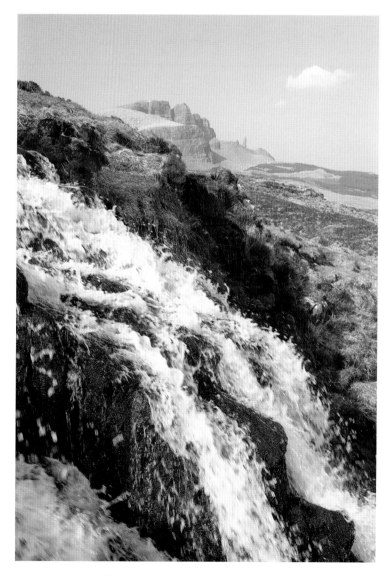

OPPOSITE: Another view of Dun Beag Broch, showing the structure of the outer wall.

LEFT: A stream tumbles down a mountainside on Skye. In the far distance are two pinnacles known as The Storr and the Old Man of Storr.

RIGHT: Houses at Balmacqueen on the Trotternish peninsula on Skye's northern tip.

OPPOSITE: Looking south from the slopes of Meall na Suiramach over Loch Leum na Luirginn and Loch Cleat in the Quiraing area of Skye.

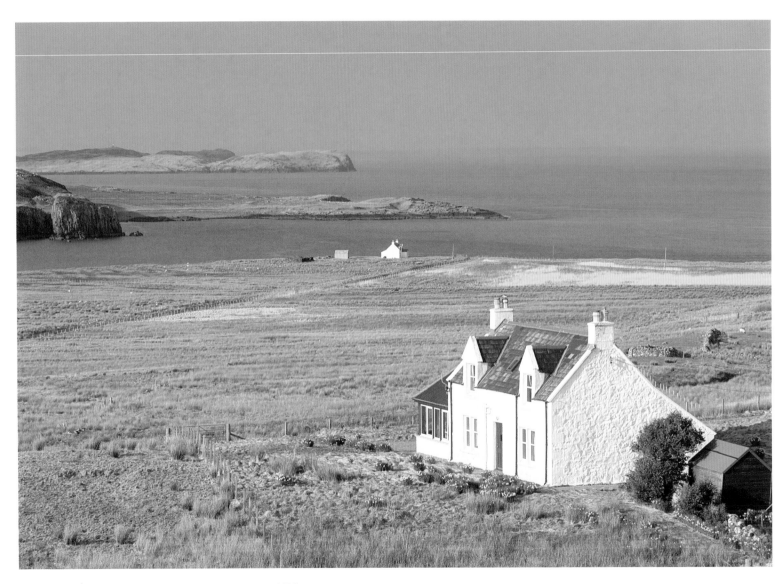

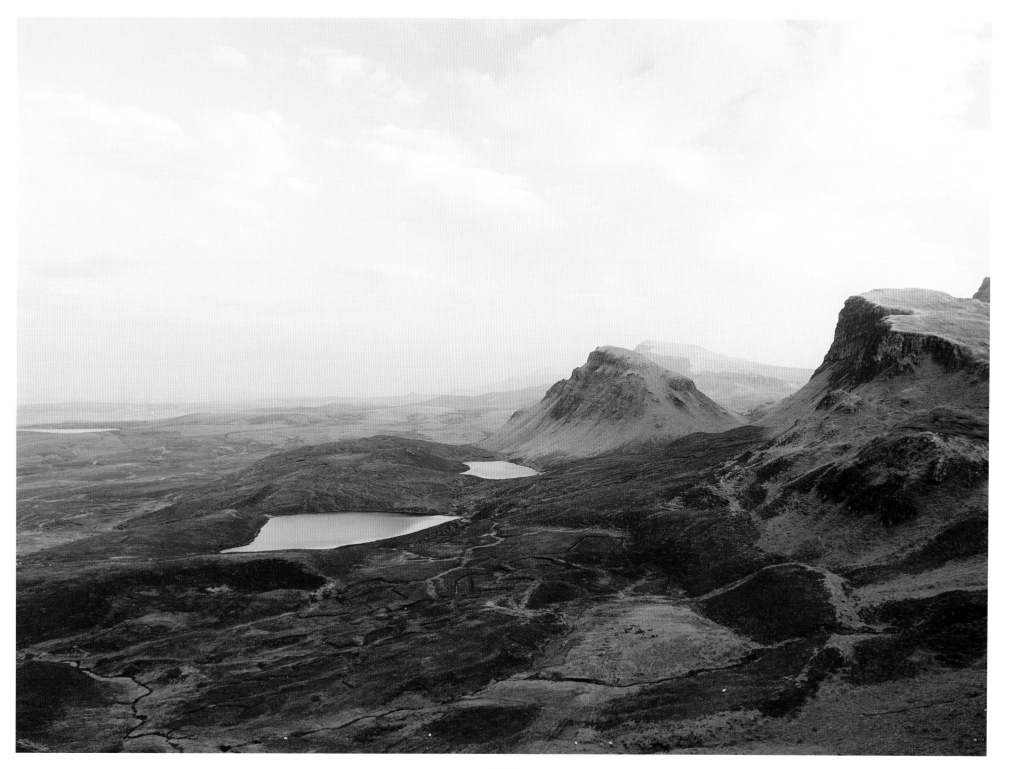

BELOW & FAR RIGHT: The interior of a croft cottage, dating perhaps from around the end of the Second World War, reproduced by the Museum of Island Life at Kilmuir, Trotternish, on Skye.

carefully excavated and preserved. The largest of the stone circles surviving near Maes Howe is the Ring of Brodgar, its 27 remaining stones set on a bleak tongue of land separating the Loch of Stenness from the Loch of Harray, a mile to the north of Maes Howe.

Of even greater interest, because it gives more than a hint of the way the people of these far-off times actually lived, are the

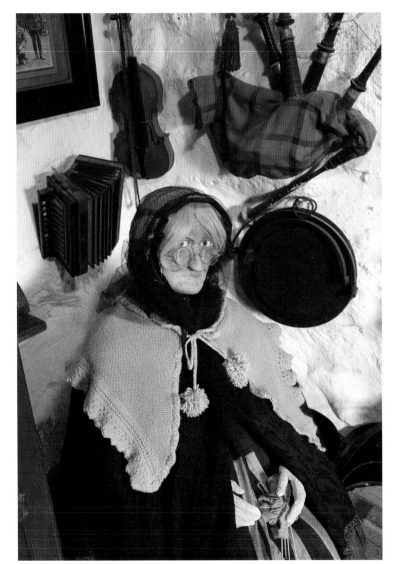

Exterior detail of a croft in the Skye Museum of Island Life at Kilmuir, the roof thatch secured against strong winds by means of large stones.

RIGHT: Portree, Skye's largest town.

OPPOSITE: Dunvegan Castle, located 22 miles (35km) west of Portree. Parts of the castle are thought to date from the ninth century, but building work has been carried out in almost every century since the 1200s, when the MacLeods moved in. Dunvegan is still the seat of the Macleod of MacLeod, chief of the major arm of Clan MacLeod. It is reputed to be the oldest continuously inhabited castle in Europe.

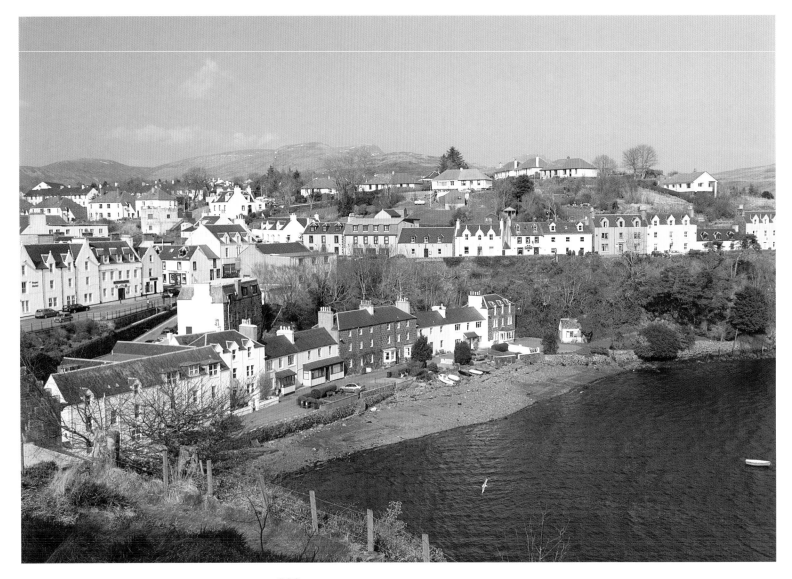

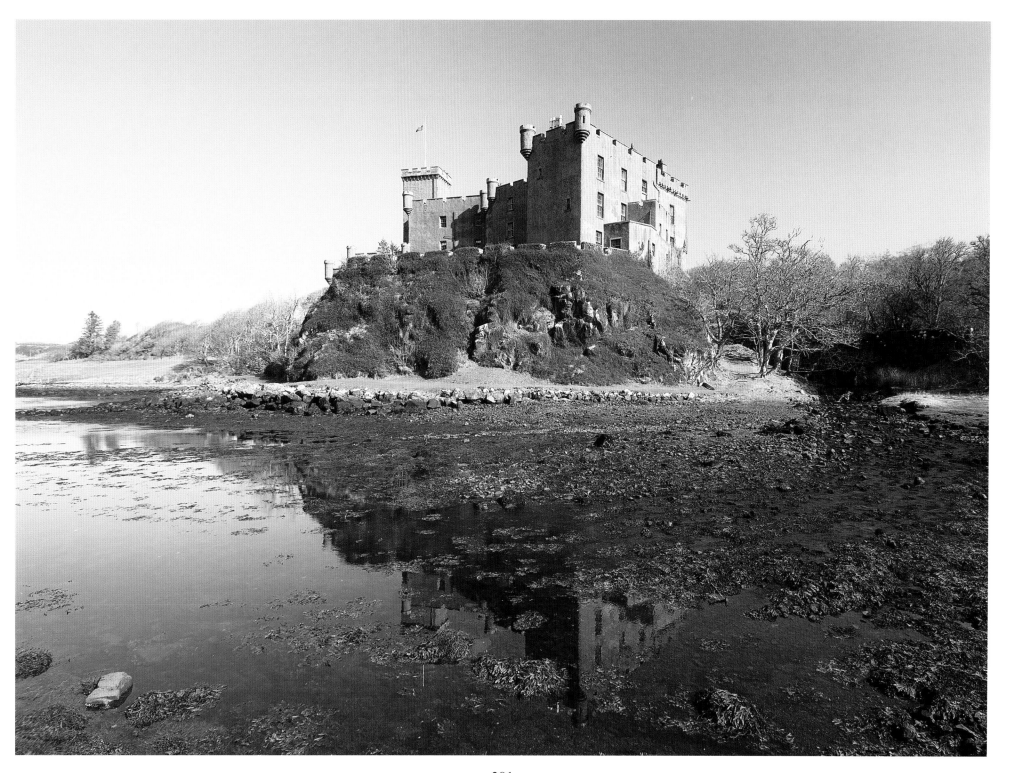

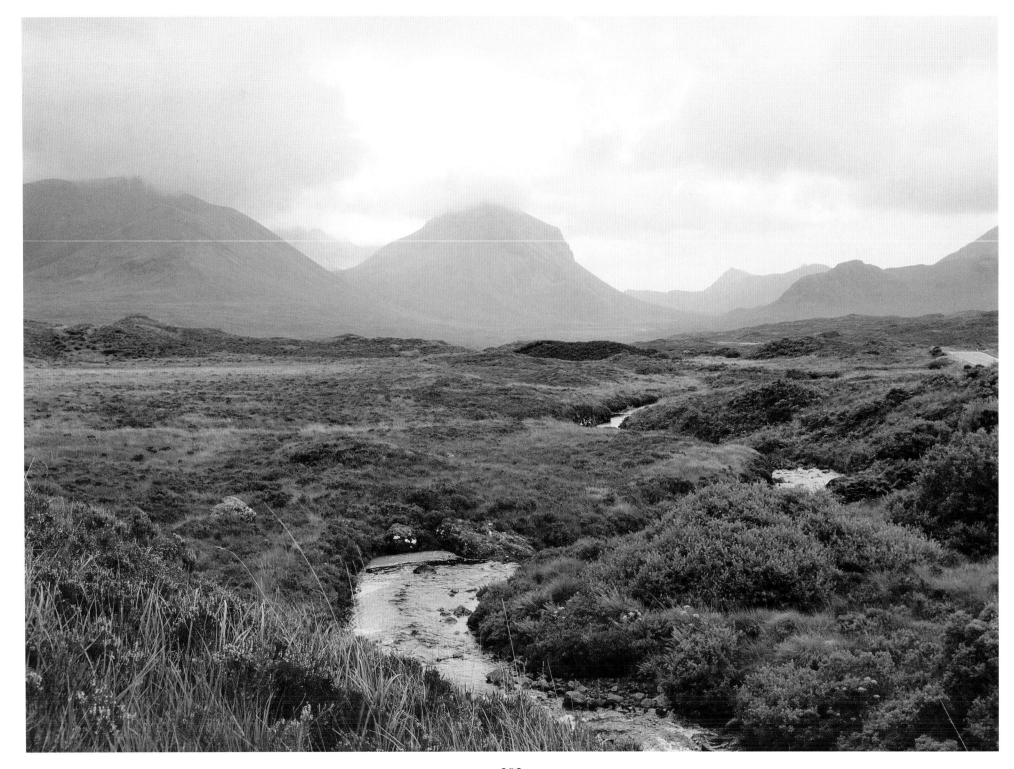

OPPOSITE: Looking south down Glen Varragill towards Sligachan.

LEFT: Roger Jagger, owner of Matheson's butcher's shop in Portree. He is holding such Scottish delicacies as Stornoway black pudding and haggis.

PAGE 384: A bank of peat above Loch Fada, Skye, that has been cut for fuel.

PAGE 385: A remote cottage, hidden away in rugged countryside on the Trotternish peninsula west of Kilmuir.

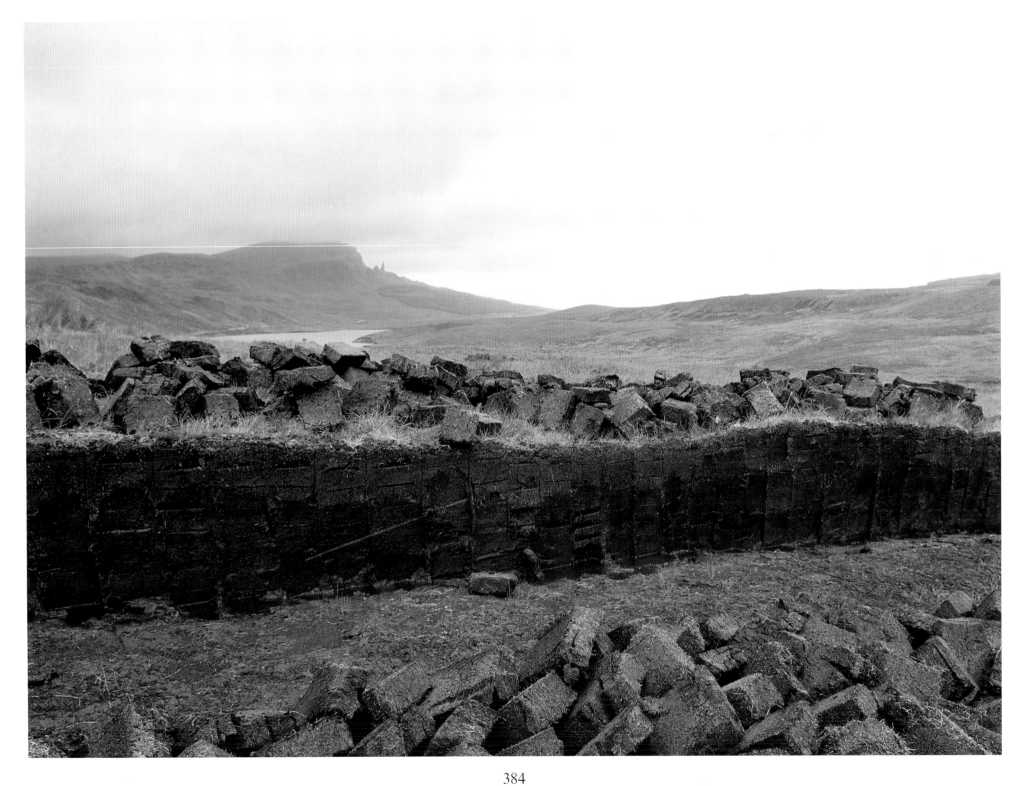

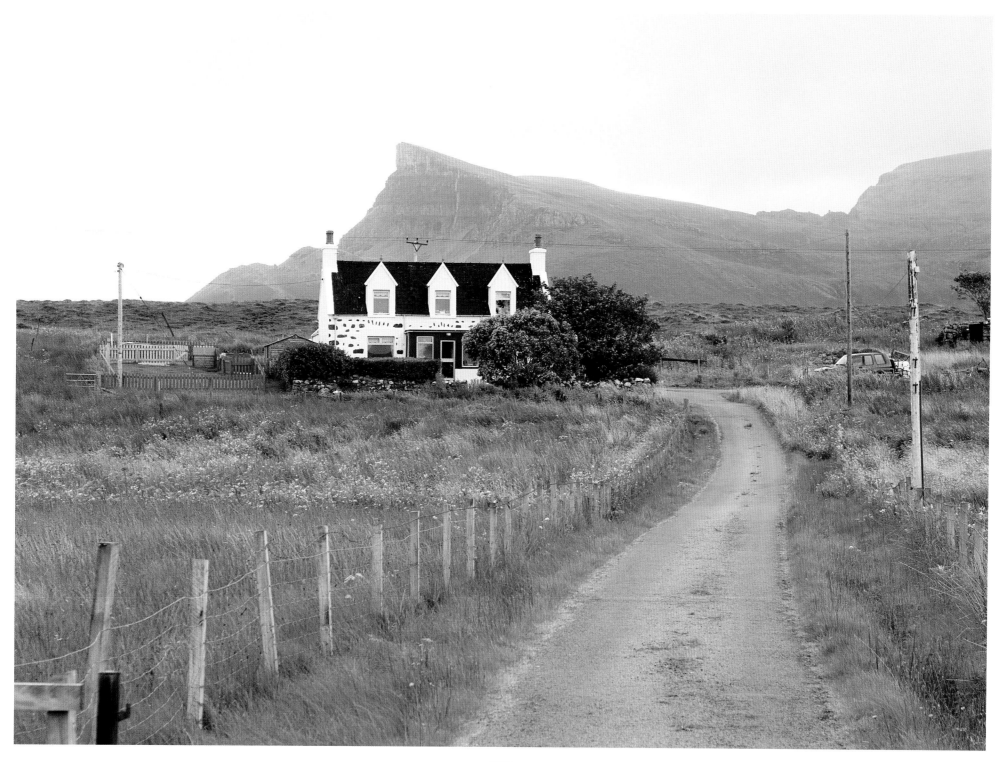

RIGHT: Copper pot stills at the Talisker Whisky Distillery on Skye.

OPPOSITE: The island of Berneray in the Outer Hebrides, looking north over the fishing village of Borgh.

PAGE 388: Looking north along the extensive dunes on Berneray's western side.

PAGE 389: Wildflowers and grasses growing in a dune meadow on Berneray.

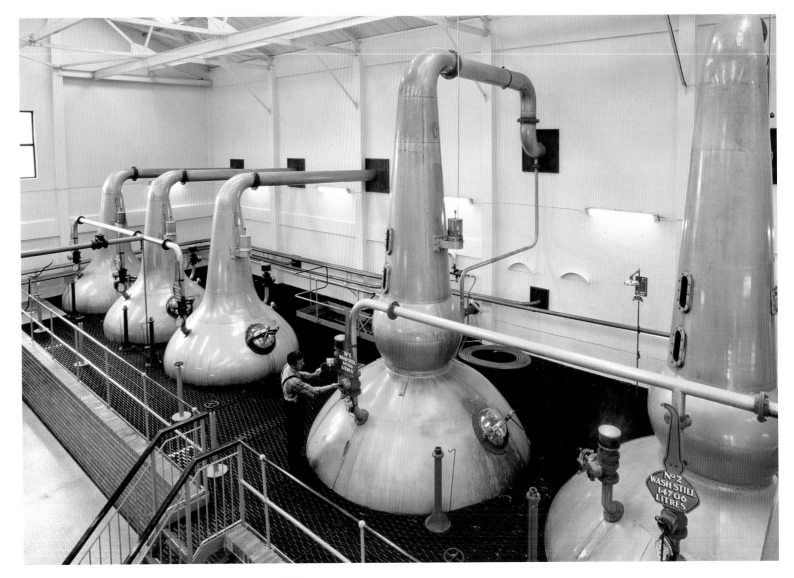

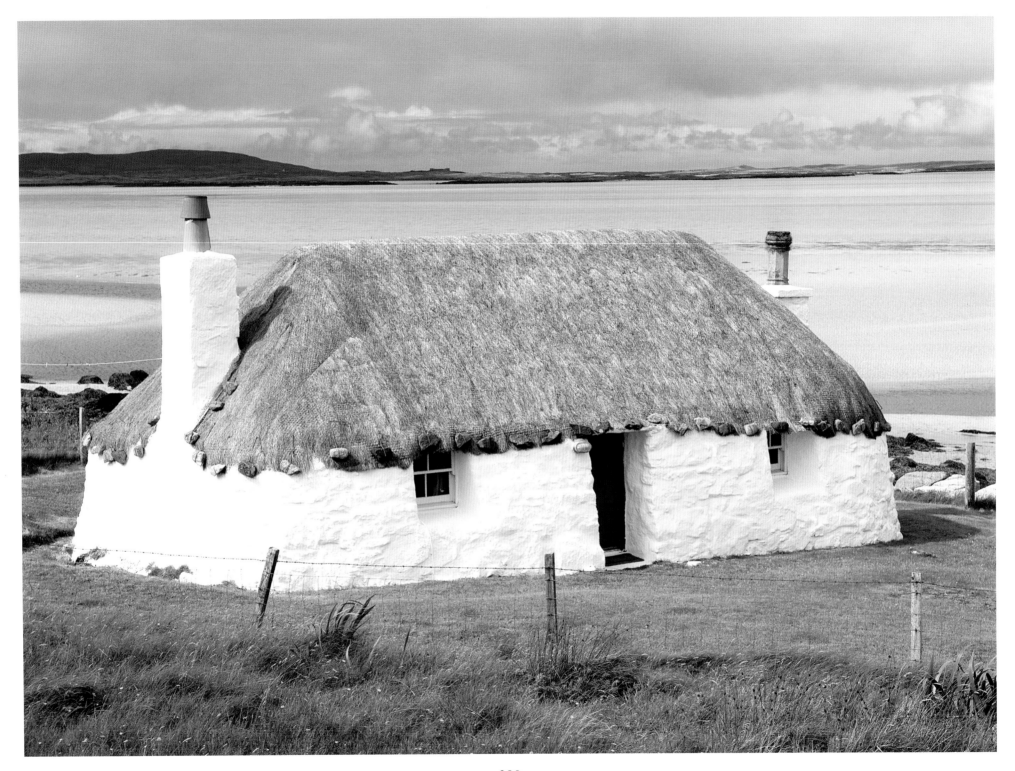

OPPOSITE: A thatched cottage at Malacleit, North Uist.

LEFT: Landscape near Lochmaddy on North Uist.

OPPOSITE: The view south over Loch nam Feithean at Hougharry, North Uist.

LEFT: Touring cyclists check directions in North Uist in the Outer Hebrides.

PAGE 394: Tigharry post office, North Uist.

PAGE 395: The folly tower at Scolpaig, North Uist, stands on the site of an Iron Age island dun or crannog.

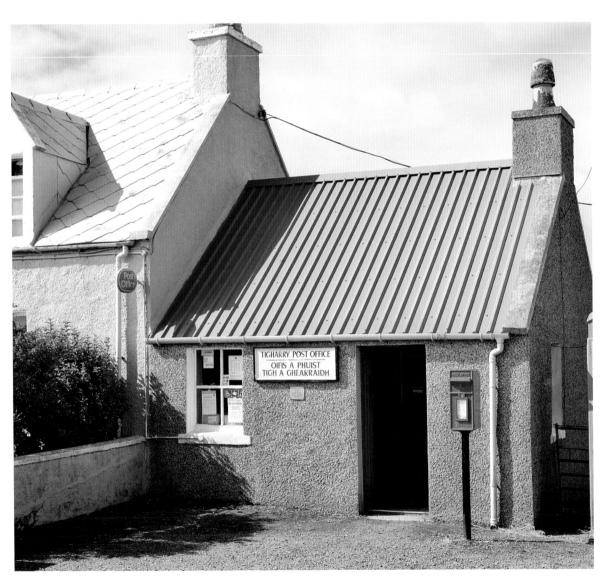

remains of an entire Stone Age settlement, Skara Brae, on the Bay of Skail, about 7 miles (11km) north of Stromness. Probably among the oldest archeological sites in Orkney, Skara Brae has been dated to 3000 BC, thought to have survived because it had become buried in sand over the centuries. A great storm in 1850 blew away enough of the sand to reveal 'houses' linked by passages and still containing signs of their hearths, fish-pools and stone beds.

At the north-western corner of Mainland, on Brough Head, is a more recent historic site, the early Christian and Norse settlement of Brough of Birsay. Here, the 21st-century traveller comes face to face with the fact that, until a mere five centuries ago, Orkney and Shetland (as well as, for a time, the Hebrides and large parts of mainland Scotland and pieces of Ireland) belonged to Norway. Weary of being raided along his western coasts by Vikings based in Orkney and Shetland, Harold Haarfagr, King of Norway, took control of the islands in 875, and from this time until 1468, when Christian I of Norway pledged the islands as part of the dowry of his daughter, Margaret, on her marriage to James III, Orkney and Shetland were governed by Norse earls of Orkney. From about the mid-13th century, however, the earls were all Scots, the Norse influence having begun to wane, especially after the deaths of the two Norse earls, Magnus and Rognvald, who were canonized because of their great works as Christians.

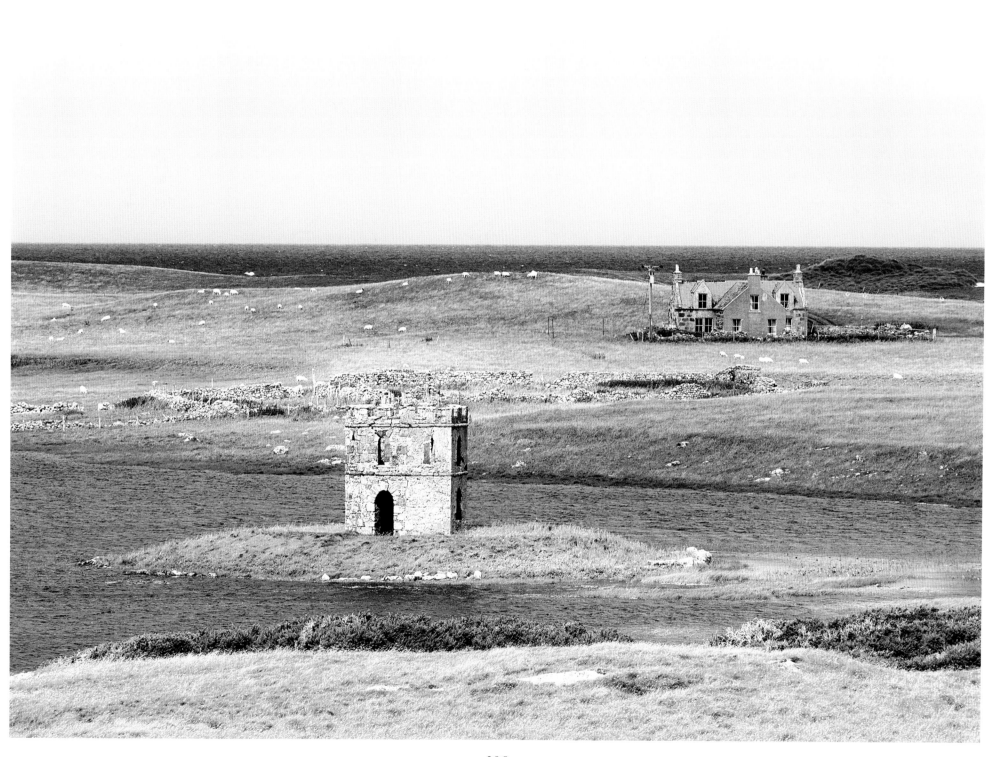

RIGHT: The tidal reaches of Traigh Bhalaigh on North Uist.

OPPOSITE: Surfing the waves at Traigh Stir, also on North Uist.

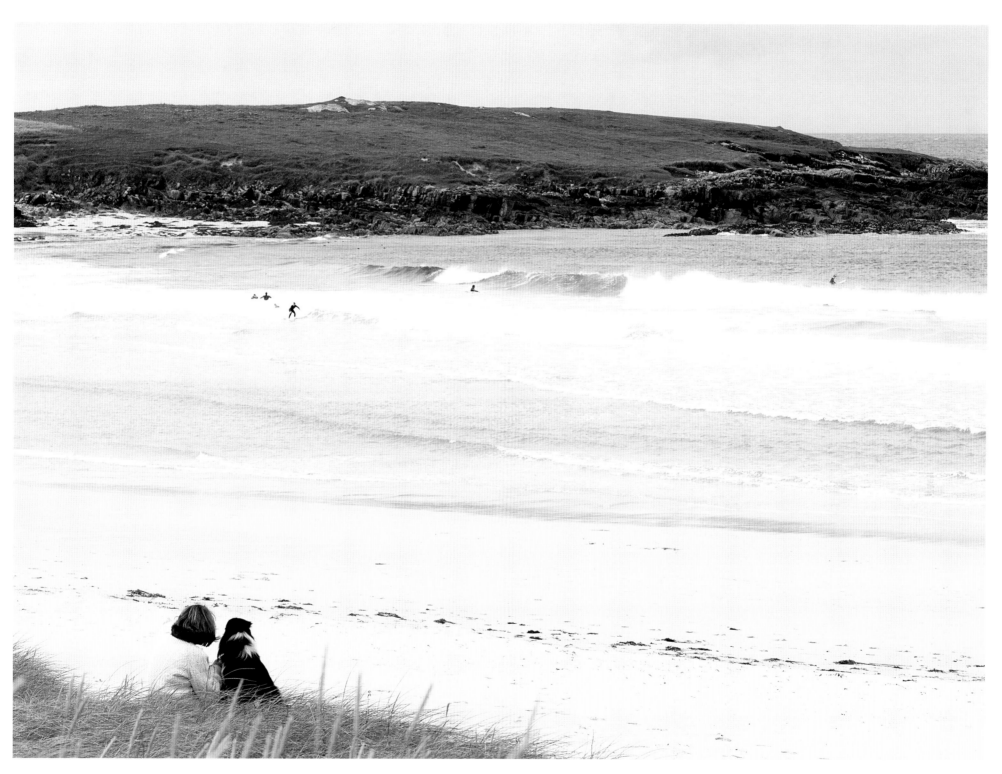

BELOW: Looking west to the Atlantic at West Gerinish on South Uist.

OPPOSITE: The white sands of Traigh nam Faoghailean, North Uist.

The 11th-century Norse earl of Orkney, Thorfinn the Mighty, had his great hall at Brough of Birsay, building Christ Church on the foundations of an earlier Celtic church nearby. The ruins of both may still be seen today, provided the tide is out and the visitor can walk across the causeway to the tidal island where Earl Thorfinn based himself. Thorfinn is known to have defeated Duncan of Scotland in battle, and he may also have sided with Macbeth after Duncan's murder.

With such a Norse heritage, it should not be surprising that a decidedly non-English and non-Scots cadence remains in the language of these islands and that a Norse influence should be apparent in placenames, architecture, the law, and even in local

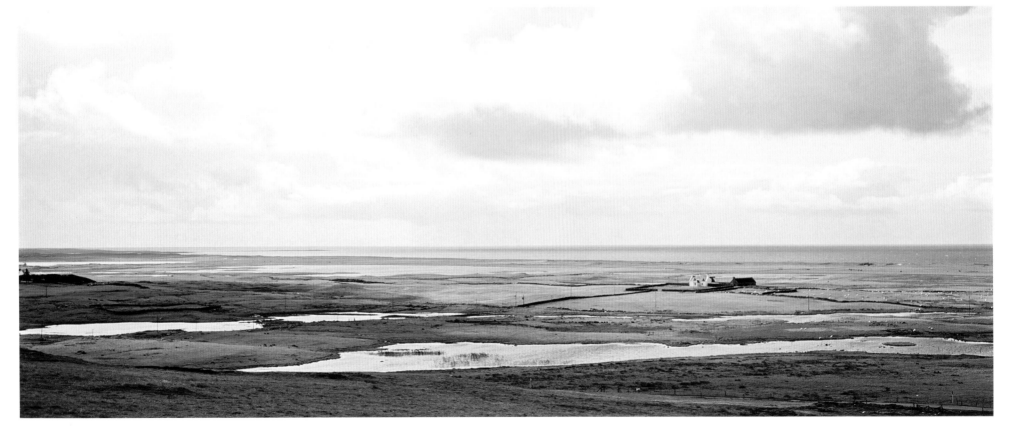

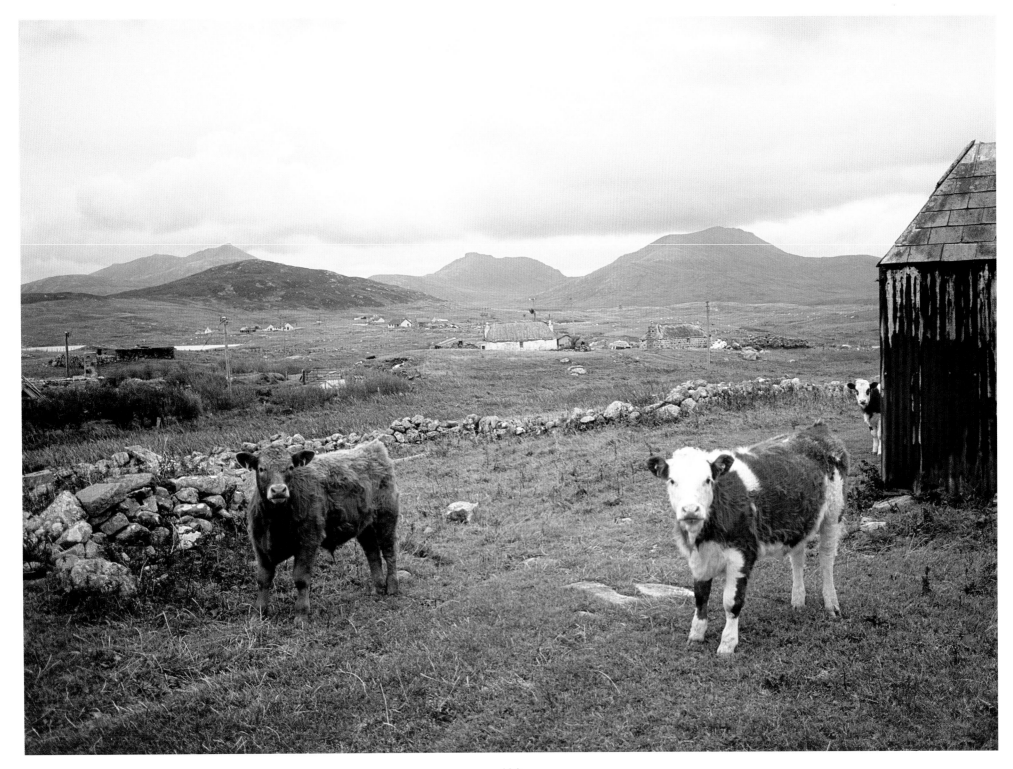

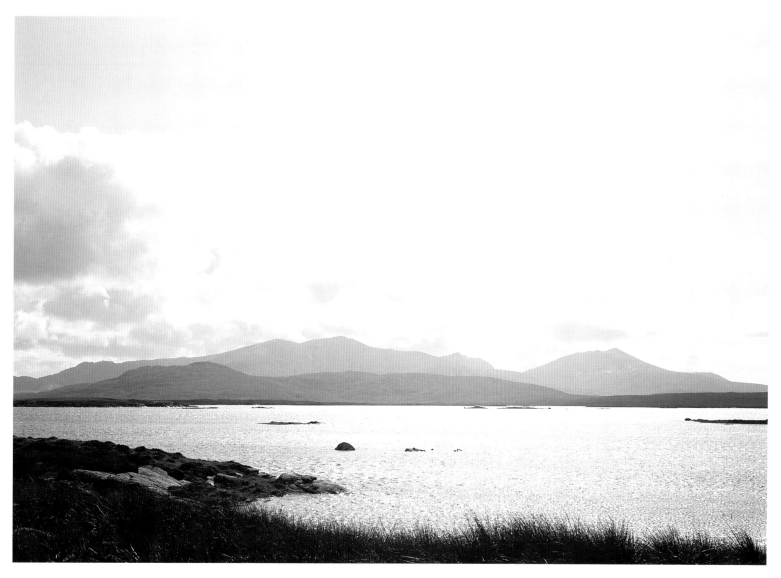

OPPOSITE: A farmstead on South Uist.

LEFT: Looking south over Loch Bee to Hecla and Beinn Mhor, South Uist.

RIGHT: A landscape near Torlum, Benbecula.

OPPOSITE: The Sound of Harris in the Outer Hebrides, looking towards Chaipaval mountain and Toe Head on Harris.

RIGHT: Tidal inlets at Northton at the southern end of Harris.

OPPOSITE: The fishing village and island ferry terminal of Leverburgh on south Harris.

festivals. Lerwick's far-famed fire festival, Up-Helly-Aa, which takes place at the end of January every year and involves the burning of a Viking longship, is a direct reference to Shetland's Norse heritage. Orkney's annual 'Ba' Game', 'played' around Kirkwall's Mercat Cross every New Year's Day by those who have survived Hogmanay, is certainly wild enough to have its origins in a piratical Viking and Norse past.

A different language survives in the Hebrides, too. This is Gaelic, once the main language of most of Scotland, brought into the country by Irish settlers but which is now confined largely to the Hebrides and remote corners of the Highlands. Even here very few people speak only Gaelic, for English, albeit spoken with distinctive Scottish accents, is the language of the country.

While many people are attracted to Scotland's islands because of their remoteness from the tumult of modern life, and for their close-knit way of life, often based on crofting – that is, the subsistence farming of agriculturally poor land combined with other forms of making an income, such as fishing, weaving, crafts and tourism – others come for the outdoor activities, be they walking, climbing in the Black Cuillins, sailing, or sea-angling and loch- and river-fishing, and for the islands' superb natural history. The islands' very remoteness, and the fact that they are cut off from the mainland, has given them a rich and often unique wildlife and an interesting flora.

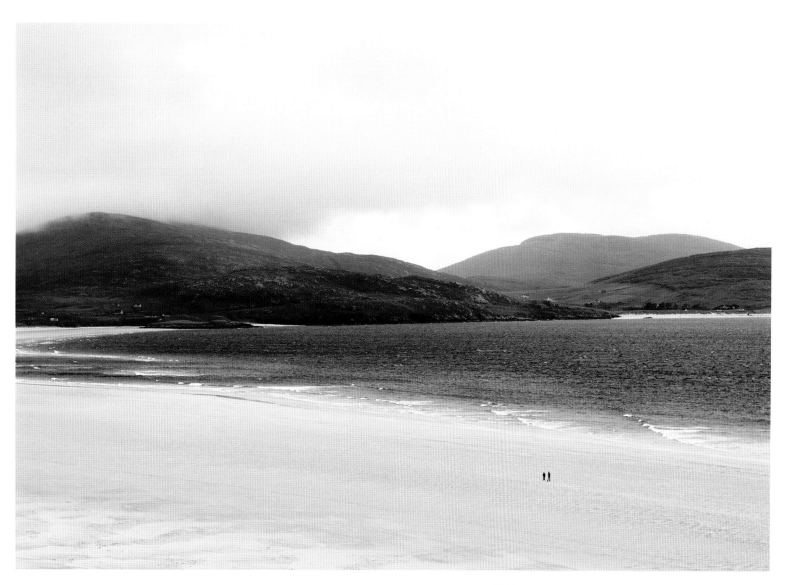

OPPOSITE LEFT: Donald John MacKay, a hand-weaver of the world-renowned Harris Tweed, in his workshop at Luskentyre.

OPPOSITE RIGHT: A sample of Donald's Harris Tweed, showing its subtle mix of colours.

LEFT: Looking across the strand at Luskentyre to the mountains of south Harris.

PAGE 408: Carved stone grave slabs inside St. Clement's Church in Rodel, isle of Harris. The church dates from c.1520–1540, and is widely regarded as the grandest building of its kind anywhere in the Western Isles.

PAGE 409: Details of carved stone and the tomb of Alexander MacLeod of Dunvegan and Harris in St. Clement's Church.

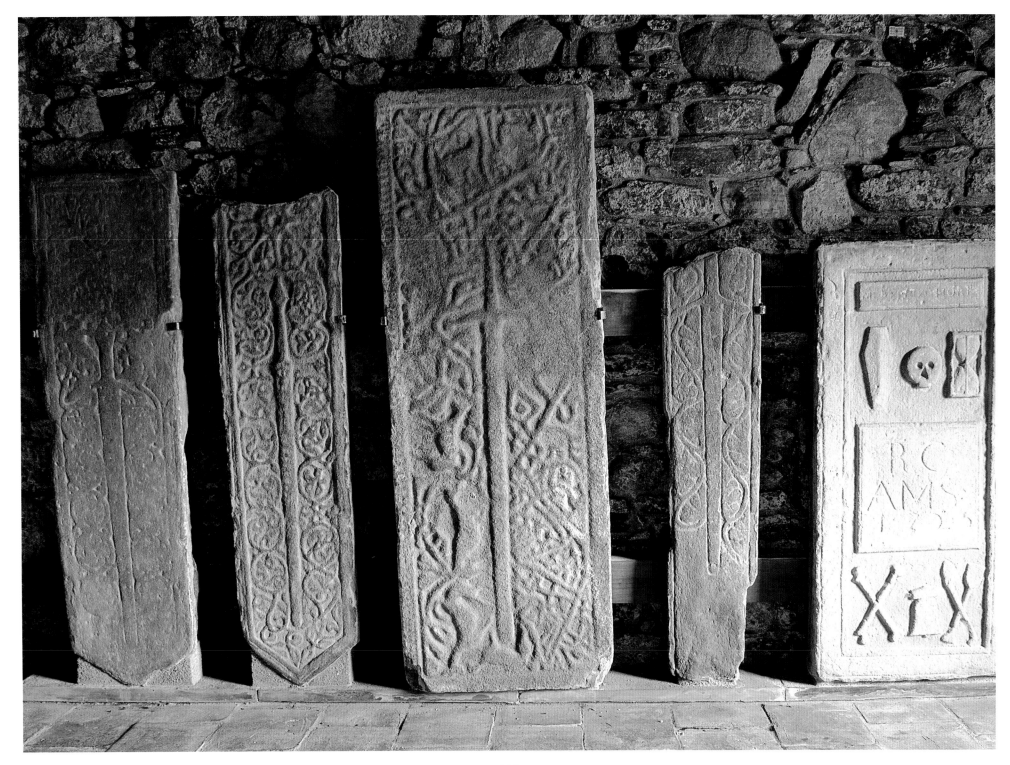

408

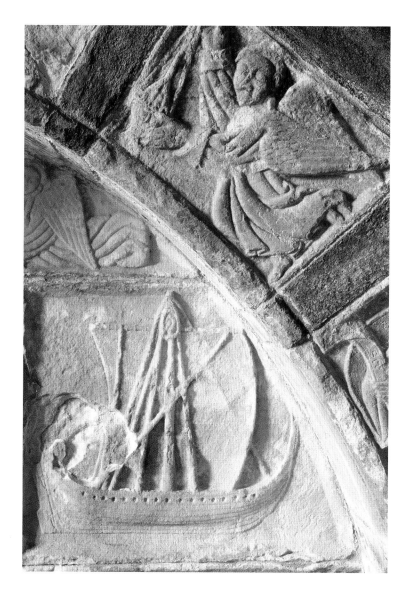

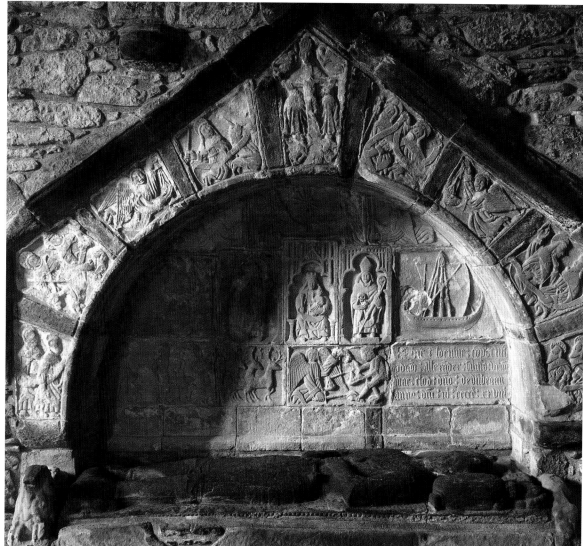

RIGHT: The view north-east over the green at Scarista, isle of Harris, where club manager Donald Morrison holds the flag at one of the world's most picturesque golf courses.

OPPOSITE: The view north-east of Traigh Scarista.

PAGE 412: The beach and dunes at Scarista.

PAGE 413: The main island road from Leverburgh to Tarbert near Scaristavore.

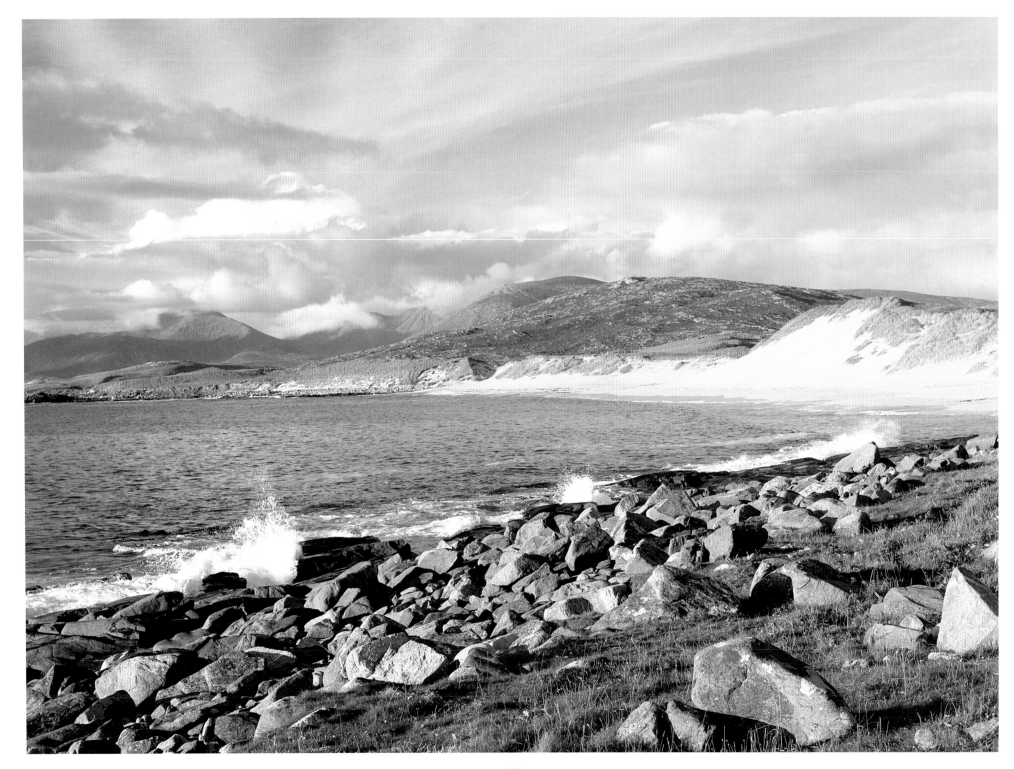

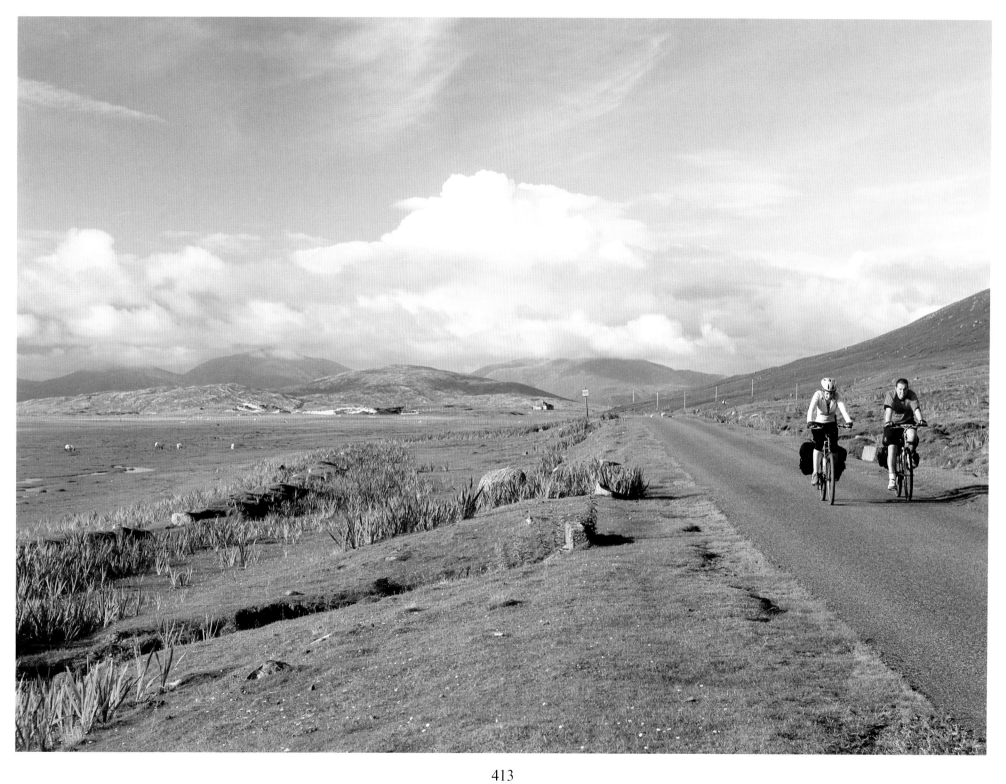

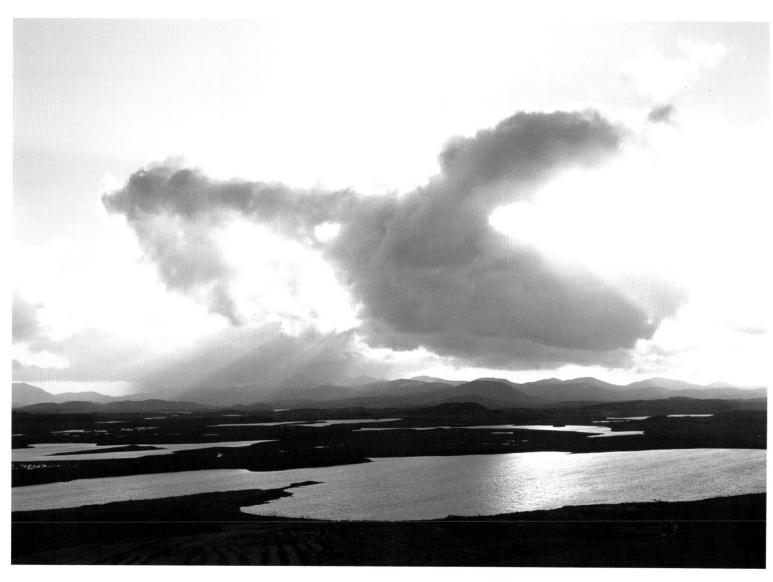

OPPOSITE: The view from the peaty moorlands of Lewis over to the mountains of Harris.

LEFT: Looking south-west from the recently discovered Achmore stone circle on Lewis to part of the extensive vista of the north Harris mountains..

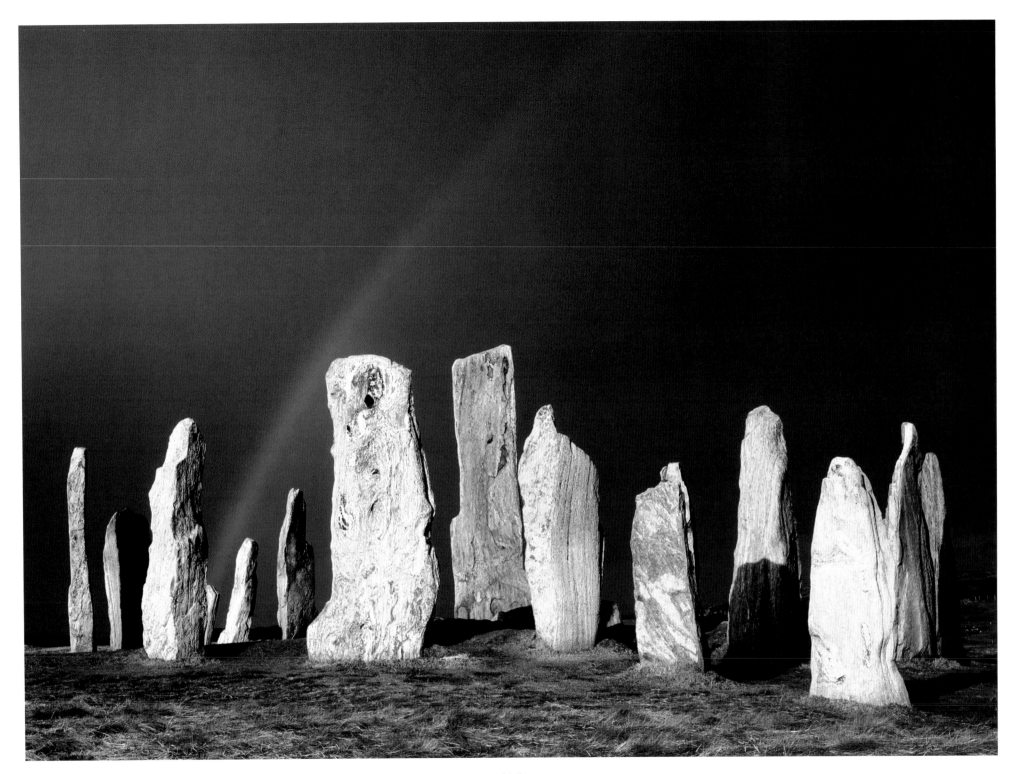

Birds are, of course, a main attraction, with spectacular sites for migrating, visiting and nesting birds attracting bird-watchers from all over the world, often to well-established areas such as the Balranald Nature Reserve on North Uist or to South Uist's Loch Druidibeg National Nature Reserve, which is Britain's most important breeding-ground for the greylag goose.

Seals are a common sight around most of the islands and even otters are regularly seen on many. Numerous islands, on the other hand, have species and types of animals that are unique to themselves. Shetland has its ponies, as does Rhum, while both

Rhum and St. Kilda can boast of a unique type of mouse, evolved from a mainland type long isolated from its origins. The St. Kilda group has had for at least 1,000 years the small, dark-brown Soay sheep, a primitive breed directly descended from neolithic rootstock. North Ronaldsay, too, has a breed of short-tailed sheep which feeds largely on seaweed, so that its dark-coloured meat has a uniquely rich flavour; this would probably not over-impress the inhabitants of Lewis, who believe that the heather cropped by their sheep gives the meat a particularly delicious flavour.

OPPOSITE: The prehistoric standing stones of Callanish on the west coast of Lewis.

BELOW: The island of Taransay in the Outer Hebrides, seen across the Sound of Taransay from the strand at Luskentyre, Harris.

PAGES 418 & 419: Views of the Ring o' Brodgar prehistoric stone circle on Orkney.

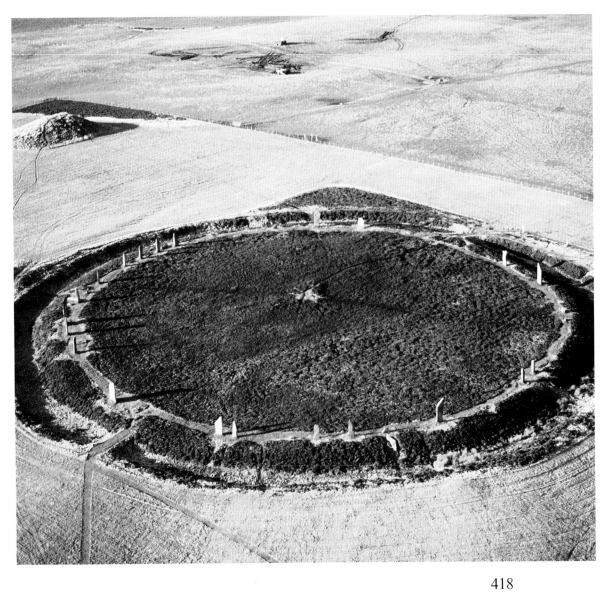

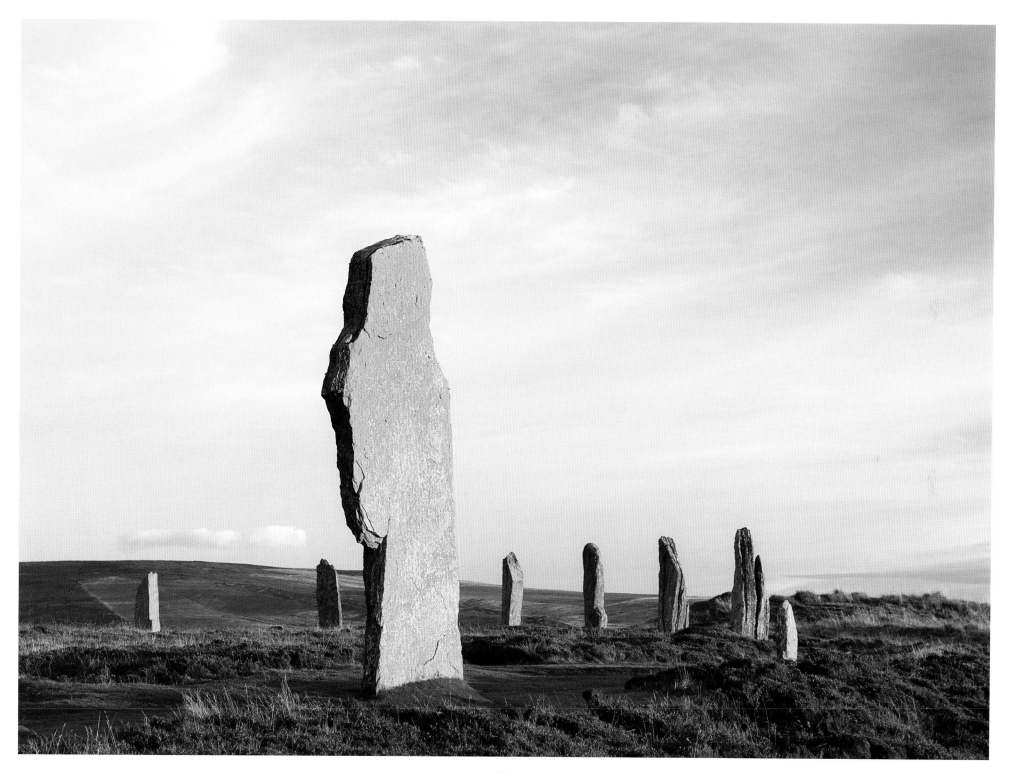

OPPOSITE: Part of the Churchill Barriers linking the south-western islands of Orkney, a Second World War anti-submarine measure designed to protect Scapa Flow.

LEFT: Second World War gun emplacements guard the southern approach to Scapa Flow, Orkney.

PAGE 422: The Cuilags rise at the northern end of Hoy, the hilliest of the Orkney islands,.

PAGE 423: The Old Man of Hoy, a giant sea stack of red sandstone on a plinth of igneous basalt, stands close to Rackwick Bay, rising above the Atlantic on the west coast of Hoy.

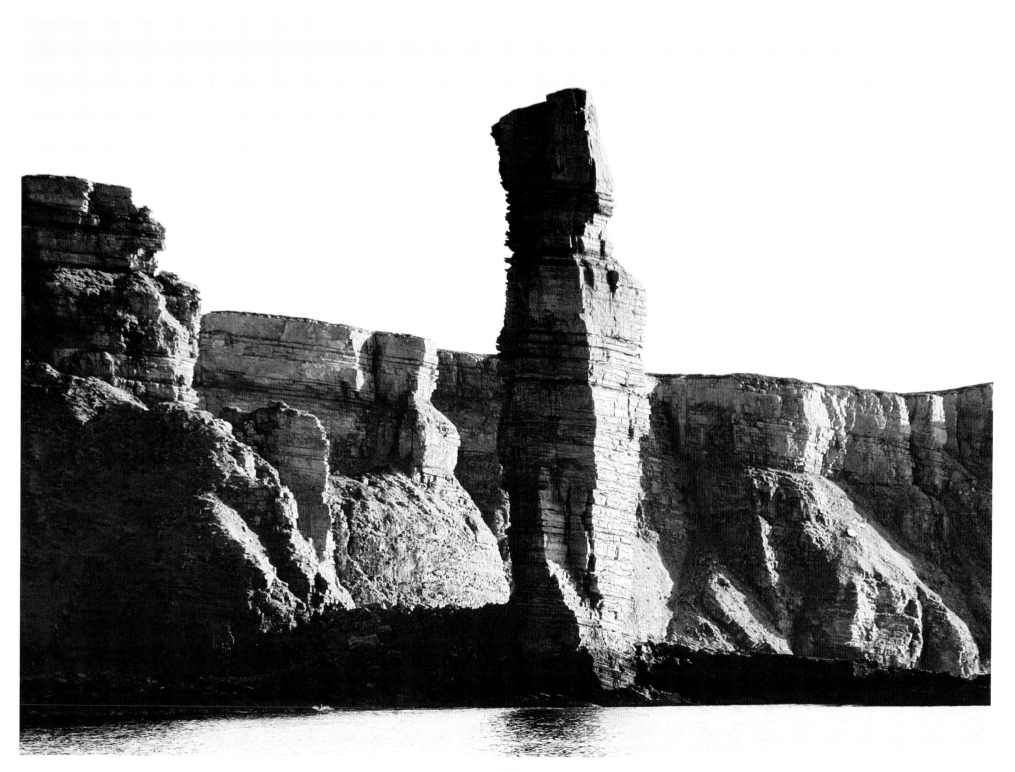

RIGHT: The textures of the tall, red sandstone cliffs at Rora Head on the west coast of Hoy.

OPPOSITE: One of the recently excavated houses at the prehistoric site of Barnhouse, Stenness, on the shore of Loch Harray on Mainland, Orkney.

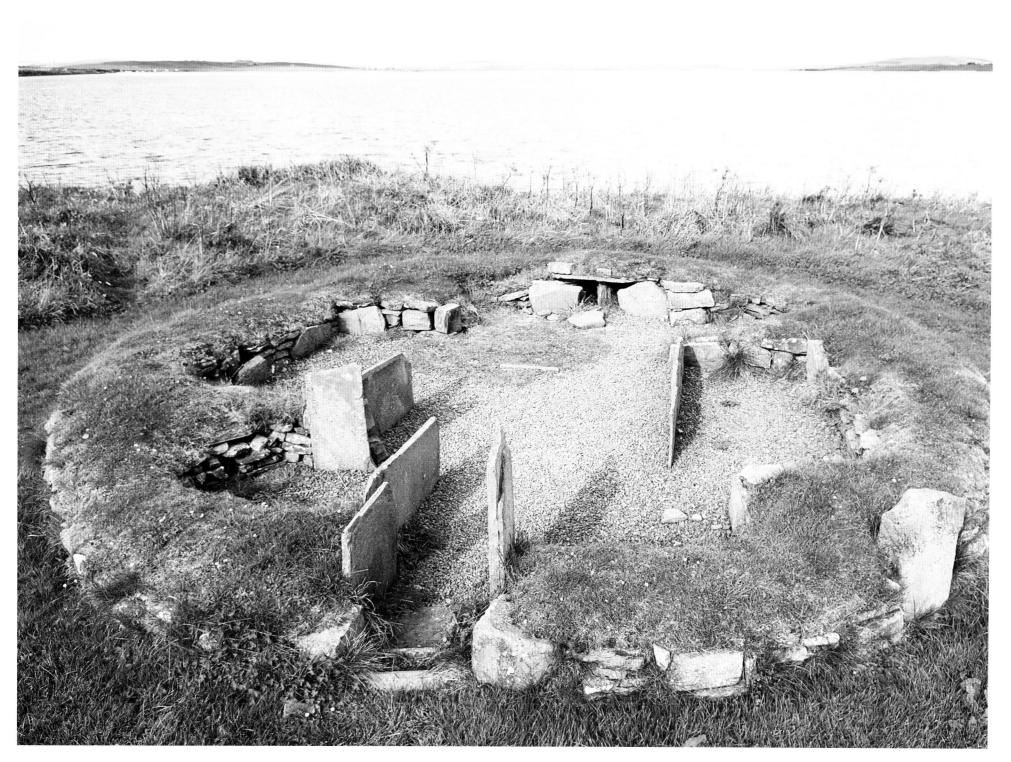

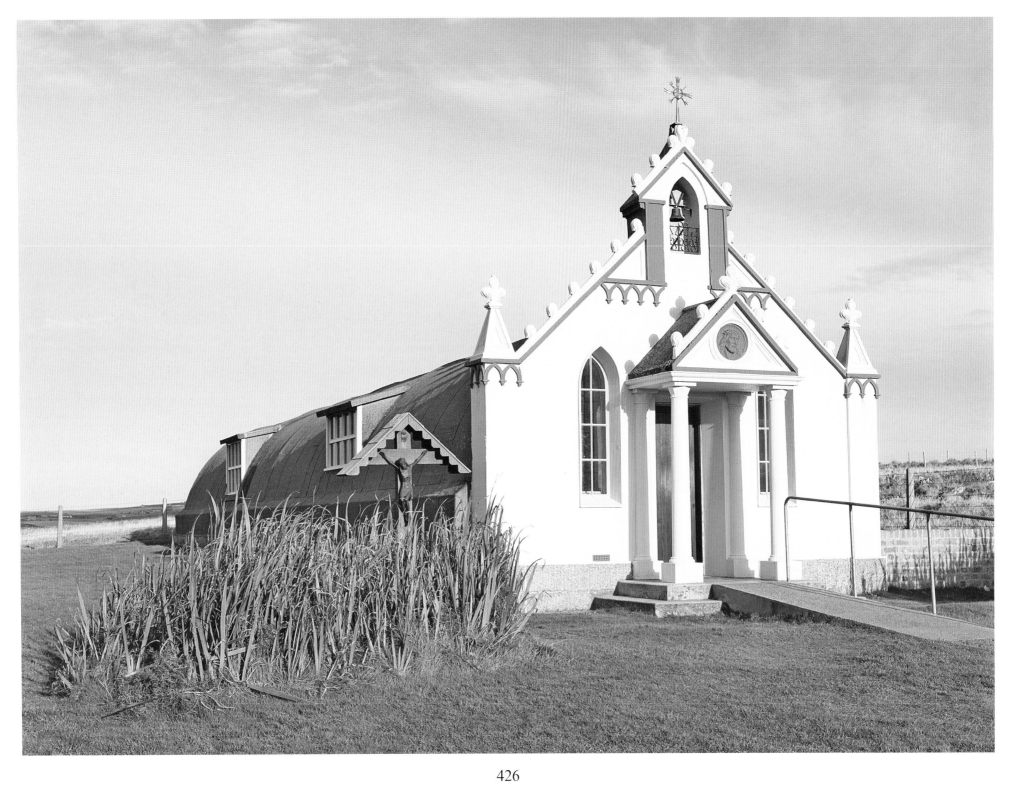

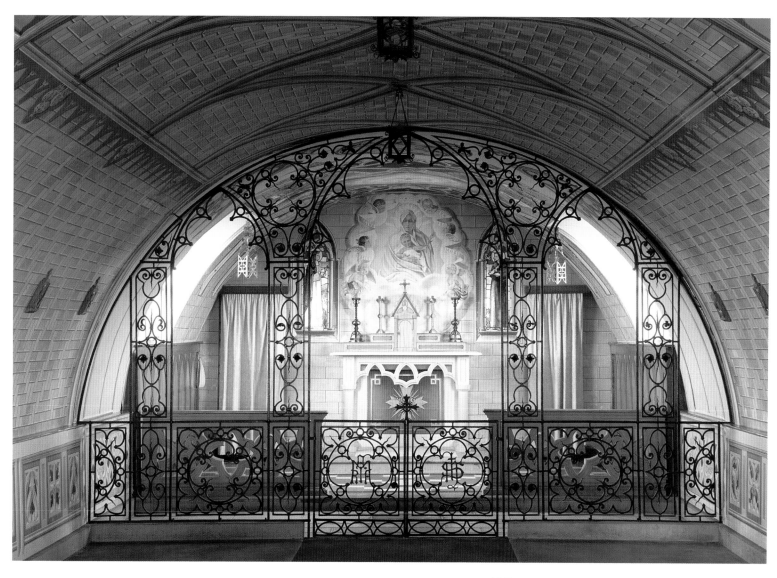

OPPOSITE & LEFT: The Italian chapel on the island of Lamb Holm, Orkney, built from two Nissan huts joined together by Second World War Italian prisoners-of-war when working on the Churchill Barriers protecting Scapa Flow.

PAGE 428: The Cathedral of St. Magnus in Kirkwall, the main town of Orkney, dates from 1137.

PAGE 429: A grey seal on Loch Stenness, Mainland, Orkney.

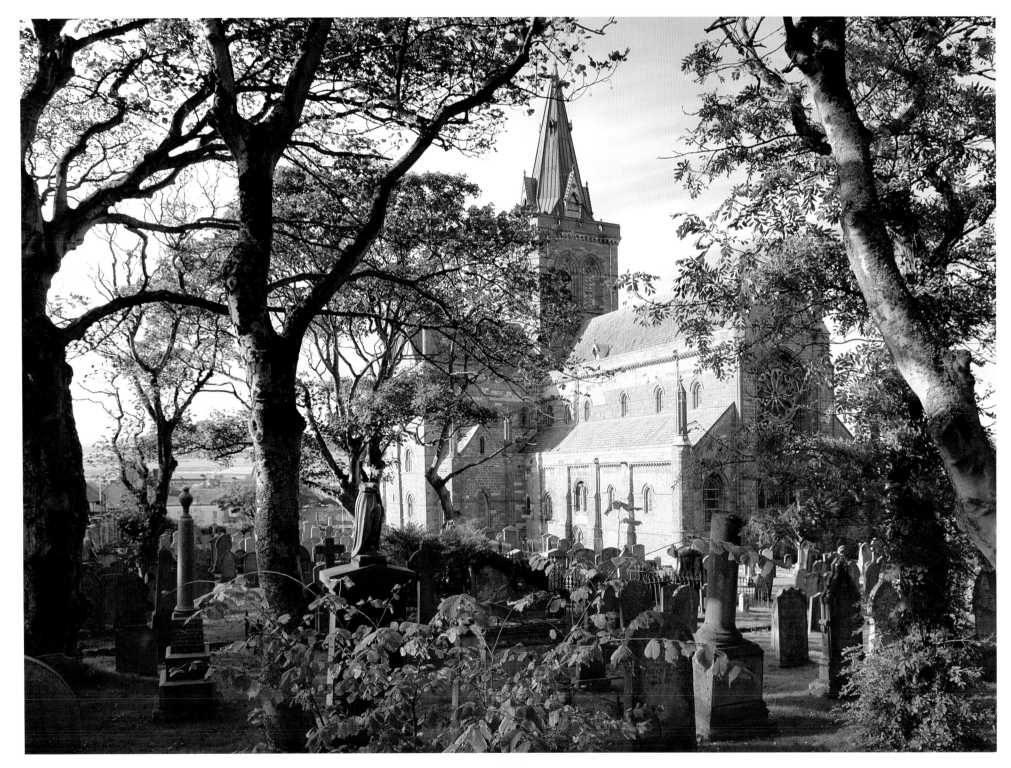

RIGHT: The mountains of Hoy are reflected in Loch Stenness.

OPPOSITE: Turning hay on farmland near Maes Howe, Mainland, Orkney.

PAGE 432: A neolithic farmstead at Knap of Howar on Papa Westray, another of the Orkney islands. It is the oldest standing house in Europe.

PAGE 433: The Stone Age village of Skara Brae, with its stone box beds, hearth and cupboards. Dating from 3100 BC, it was excavated from the sand dunes on the Bay o' Skaill on the west coast of Mainland, Orkney.

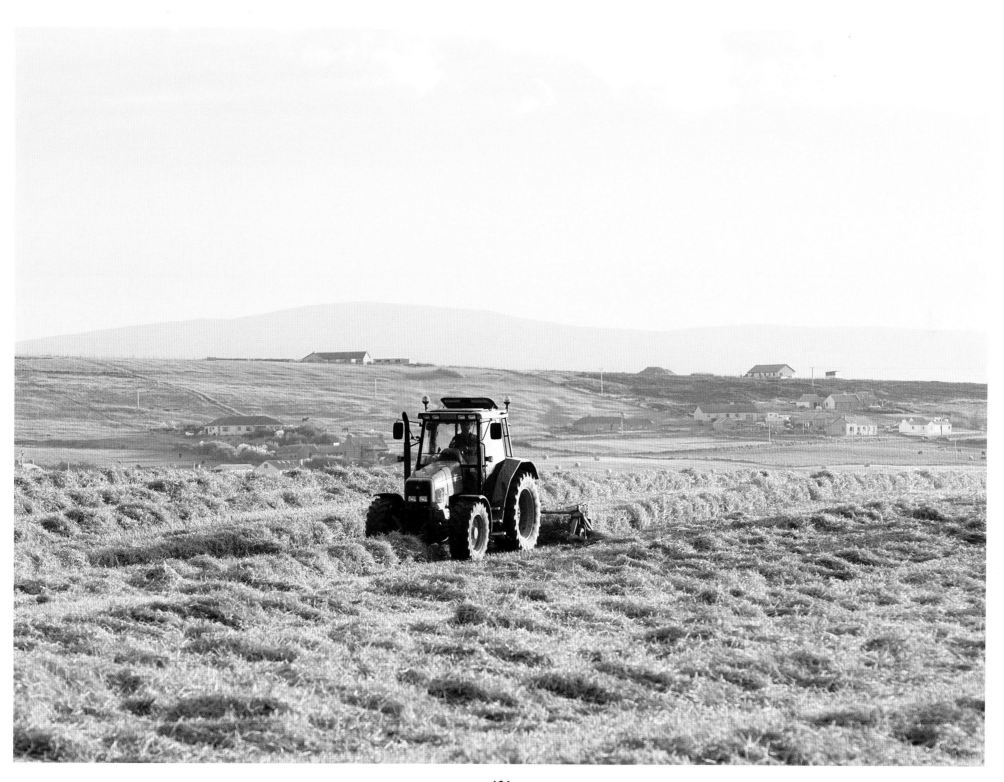

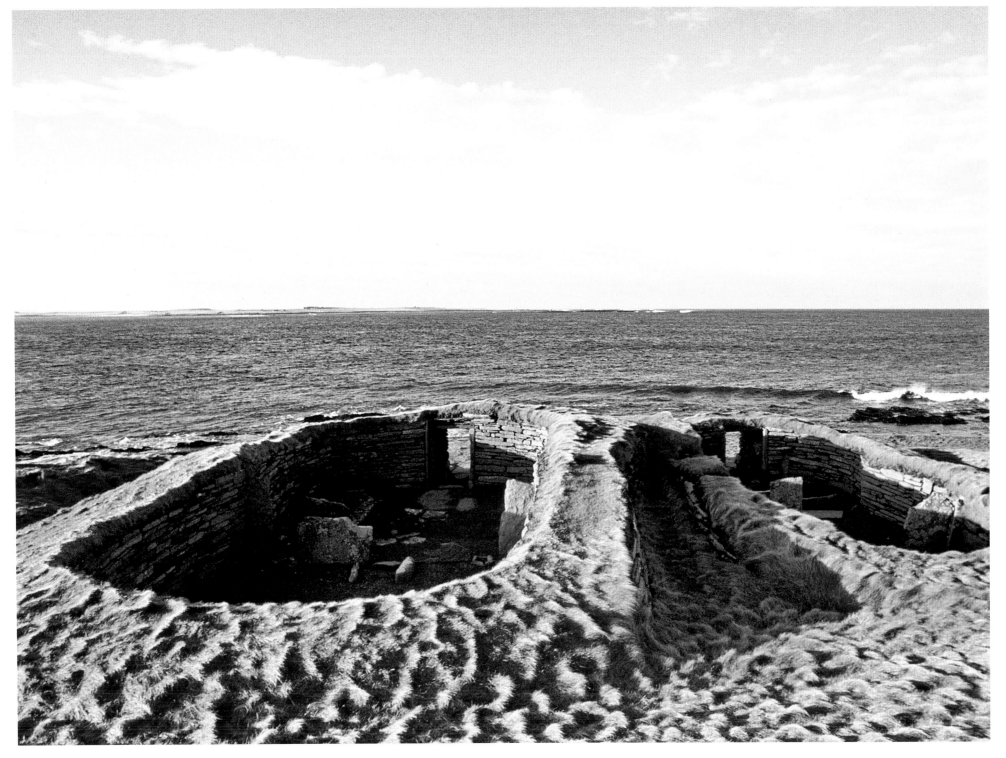

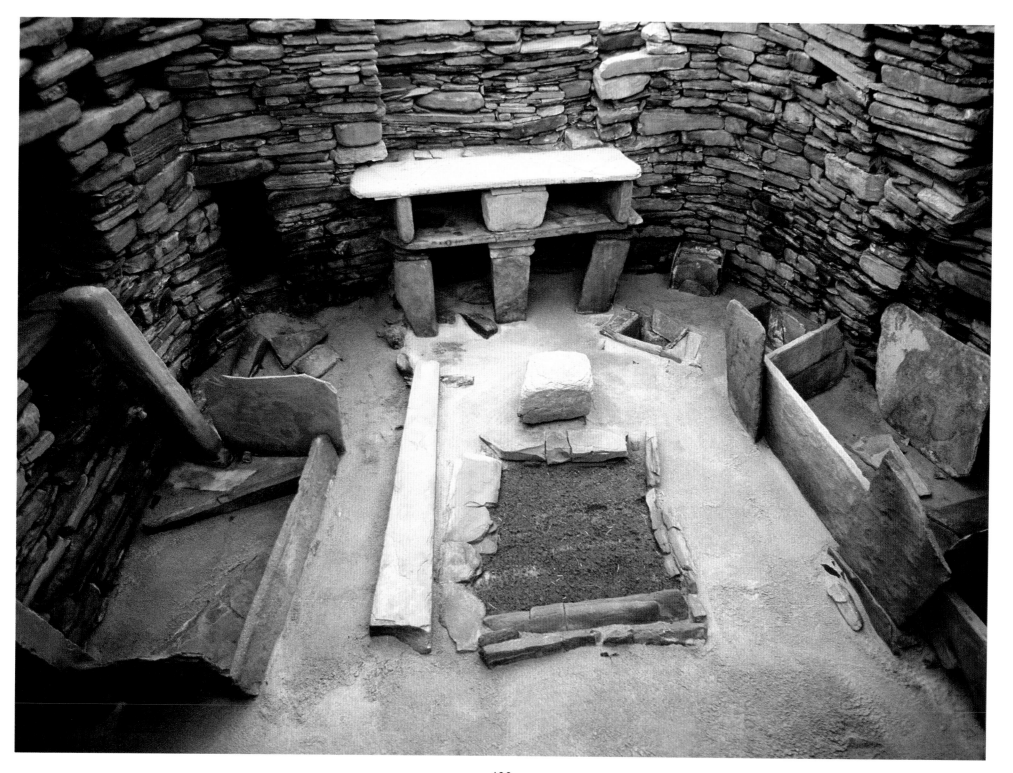

433

RIGHT: The view north-west over Scapa Flow from the vicinity of St. Margaret's Hope on South Ronaldsay, Orkney.

OPPOSITE: Looking north from St. Margaret's Hope over Water Sound, South Ronaldsay.

PAGE 436: The fishing harbour of Stromness, Mainland, Orkney.

PAGE 437: Old fishermen's houses go down to the water's edge in Stromness.

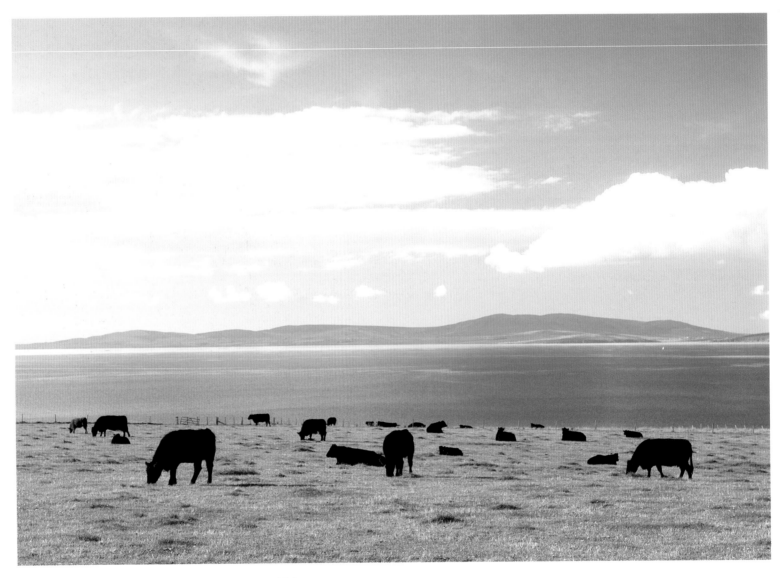

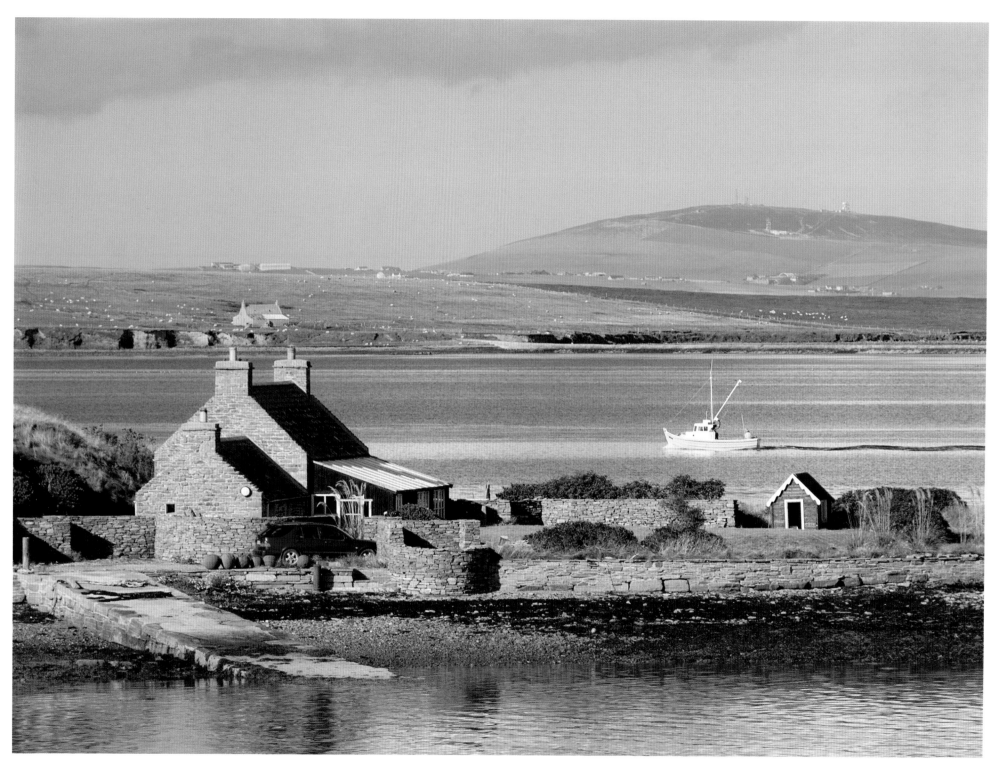

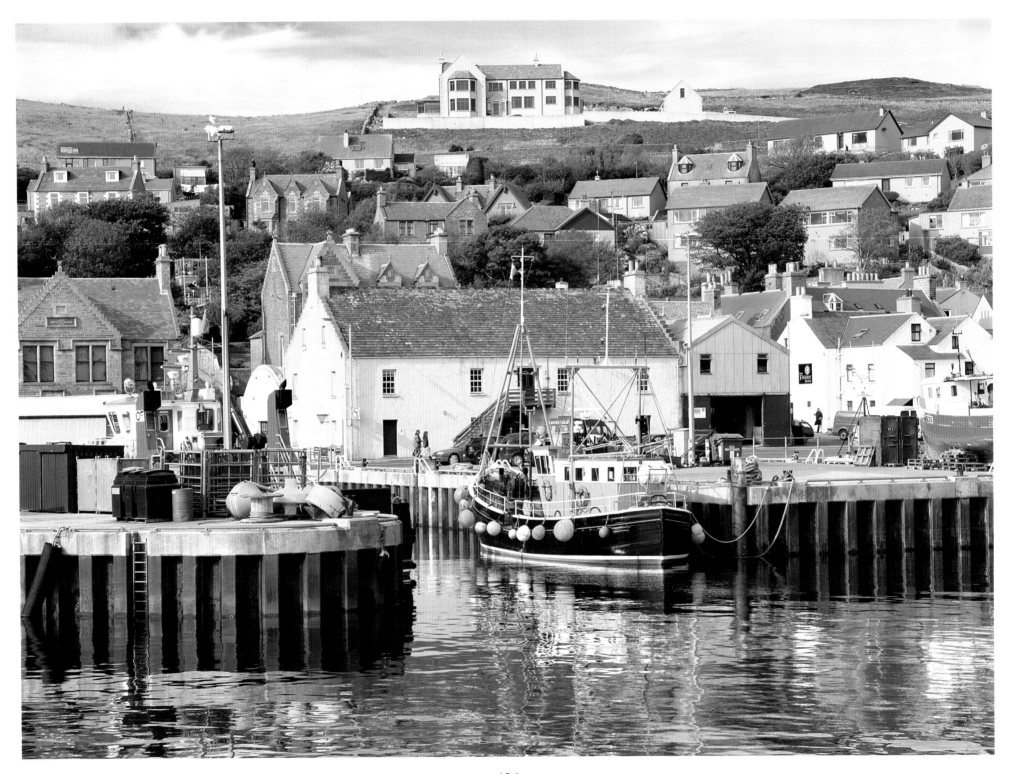

436

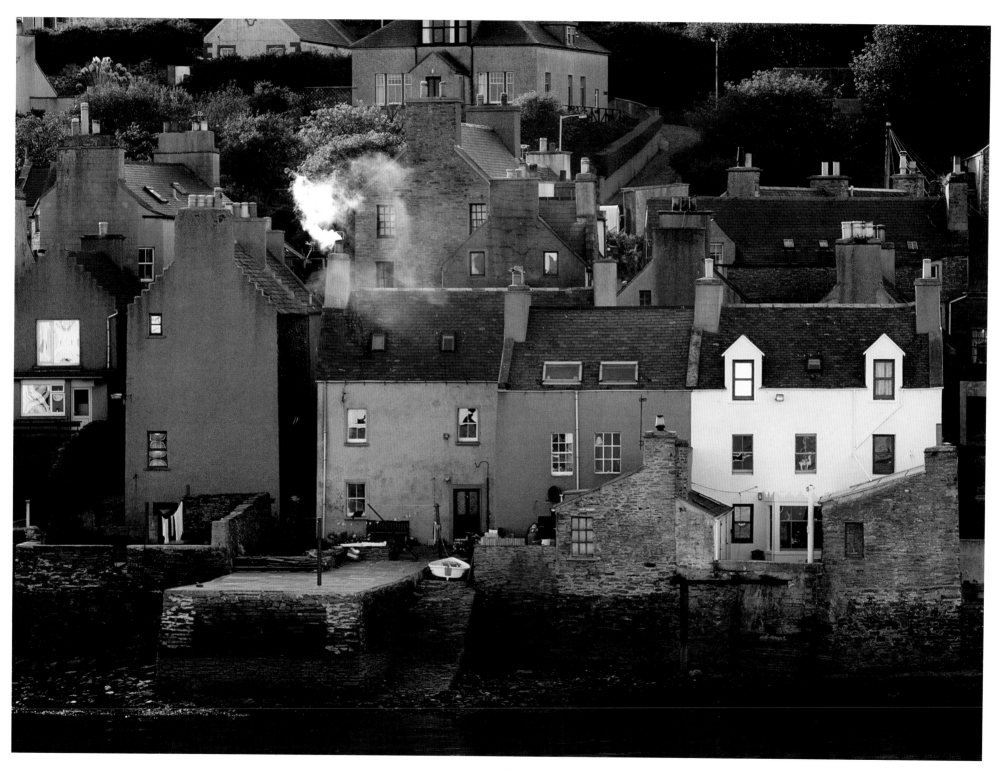

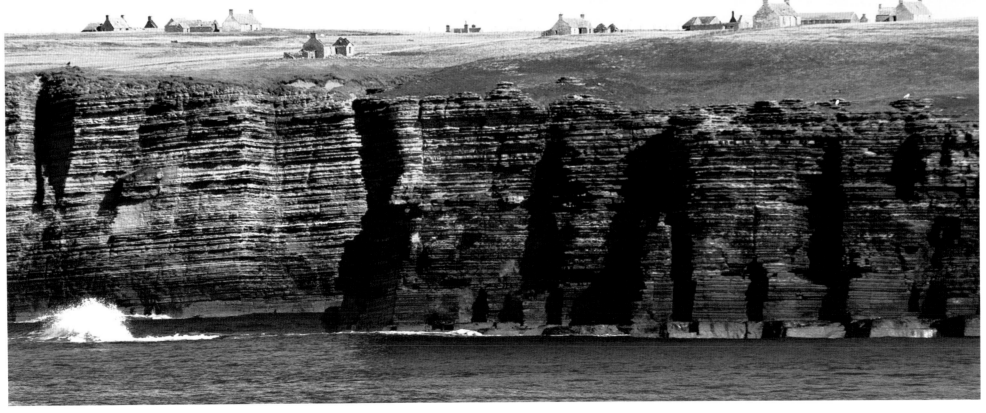

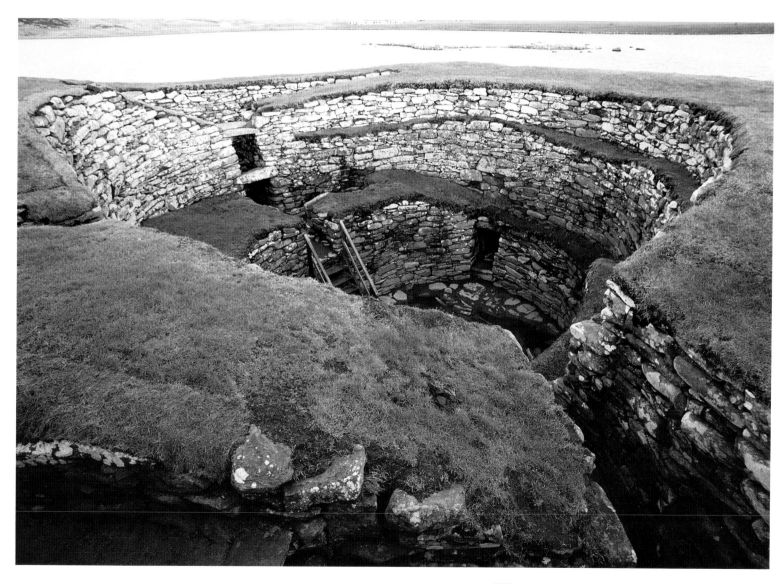

OPPOSITE: Crofts on the island of Stroma in the Pentland Firth.

LEFT: The massive walls and interior of the Clickhimin prehistoric broch on the edge of the town of Lerwick on Mainland, Shetland.

RIGHT: An oil rig outlined against the setting sun in a deceptively calm North Sea.

OPPOSITE: The North Sea oil terminal complex on the island of Flotta, Orkney.

SCOTLAND & NORTH SEA OIL

North Sea oil has brought many changes to Scotland, which early in its production were startlingly obvious: the spindly, space-age shapes of not yet completed steel production platforms began to rise on the horizon beyond towns such as Nairn and Inverness, at Nigg Bay in Cromarty and Methil in Fife, while round on the west coast, at Loch Kishorn and Ardyne Point in Argyll, the first reinforced-concrete gravity platforms were constructed. Supply bases began to take shape at Dundee and Aberdeen, manufacturers in the south, around Glasgow and Edinburgh, stepped up production of cranes, compressors, pumps and generators, and roads were upgraded and airports, especially at Aberdeen and Inverness, were extended.

While the changing nature of the industry has meant that many of the yards where the huge production platforms were built have now been closed, including the great west-coast yards at Ardyne Point, Hunterston, Loch Kishorn and Portavadie, other bases, at Lerwick, Wick, Peterhead, Montrose and Dundee have all grown to continue supplying and servicing the great rigs which rise like small, brightly-lit space-age islands from the stormy waters of the North Sea.

Drilling began on the first exploratory well in the North Sea in 1964, with the first to be drilled in Scottish waters begun in 1967. British Petroleum (BP) found the first big oilfield, the Forties Field, 100 miles (160km) east of Aberdeen in 1970. Within two years, the North Sea was recognized as one of the world's major oil-

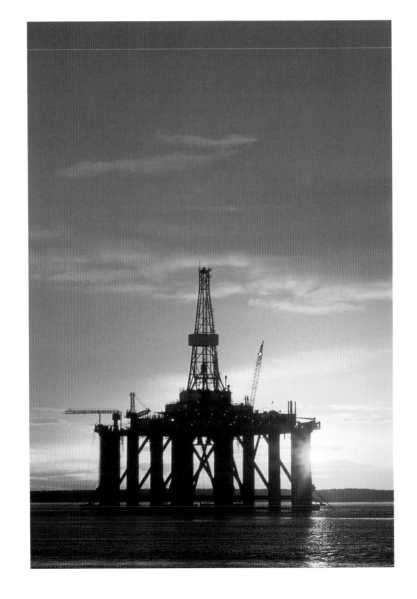

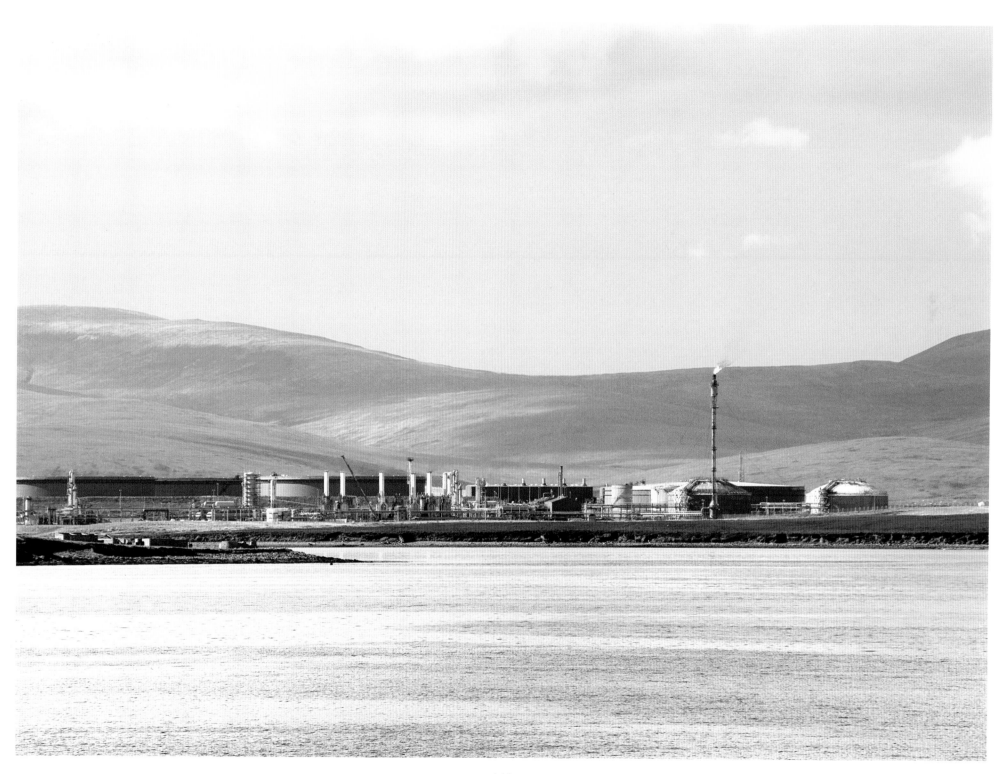

Tugs towing a North Sea oil rig into the Cromarty Firth.

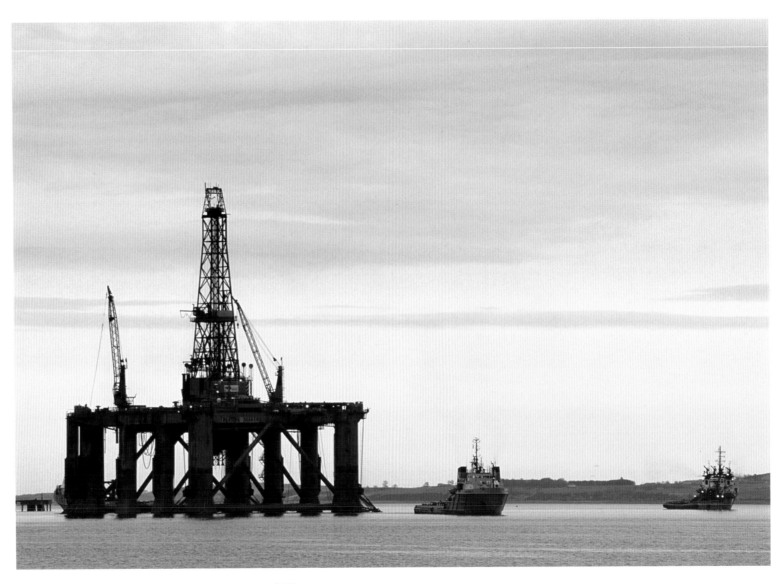

production areas and by the early 1990s some 50 oilfields and 25 gasfields were in production. The discovery in 1993 of a significant new reserve in the North Sea, west of the Shetland Islands, when hitherto the main fields were in the sector east of the Shetlands, ensured that the Shetlands would retain an important role in North Sea oil production for years to come.

While few areas of Scotland's life, social, political, financial, industrial and even academic have remained quite untouched by the discovery of oil in the North Sea, its greatest outward effects have been felt in Shetland, Orkney and along Scotland's north-eastern seaboard, particularly in Aberdeen, whose Dyce airport includes the busiest heliport in the world. In Shetland, the great oil terminal at Sullom Voe (a Norse name meaning 'a place in the sun'} now takes in oil via two pipelines from North Sea fields, whose names, including Magnus, Thistle, Brent, Ninian and others, have become as familiar as many placenames on the mainland. Gas from these fields as well as from fields further south, east of Aberdeen, is piped to St. Fergus and Cruden Bay north of Aberdeen on the mainland, and on down to Mossmorran and Braefoot Bay on the Firth of Forth. Orkney also has an oil pipeline terminal at Flotta, taking oil from the Piper, Tartan and Claymore fields which lie in the North Sea east of the northernmost tip of the Scottish mainland.

Oil has given Scotland a technologically advanced, highly-efficient industry, directly employing or underwriting the jobs of some 100,000 or more people. While this has not been enough to offset entirely the terrible loss of jobs in other once-vital traditional heavy industries, like ship-building, engineering and steel-production, it has still been a great asset to the Scottish economy. As new fields are discovered further out and deeper down in the bed of the North Sea, and as technological advances to cope with the new conditions are made, so there will be a long-continuing need for a large supply and service industry on the mainland and on many of Scotland's northern islands.

INDEX

INDEX